FLAUBERT AND THE PICTORIAL ARTS

GILBERT AND THE HEROIC ARTS

Flaubert and the Pictorial Arts

From Image to Text

ADRIANNE TOOKE

OXFORD
UNIVERSITY PRESS

OXFORD
UNIVERSITY PRESS

Great Clarendon Street, Oxford OX2 6DP

Oxford University Press is a department of the University of Oxford.
It furthers the University's objective of excellence in research, scholarship,
and education by publishing worldwide in

Oxford New York

Athens Auckland Bangkok Bogotá Buenos Aires Calcutta
Cape Town Chennai Dar es Salaam Delhi Florence Hong Kong Istanbul
Karachi Kuala Lumpur Madrid Melbourne Mexico City Mumbai
Nairobi Paris São Paulo Singapore Taipei Tokyo Toronto Warsaw

and associated companies in Berlin Ibadan

Oxford is a registered trade mark of Oxford University Press
in the UK and certain other countries

Published in the United States
by Oxford University Press Inc., New York

British Library Cataloguing in Publication Data

Data available

Library of Congress Cataloging in Publication Data
ISBN 0-19-815918-8

1 3 5 7 9 10 8 6 4 2

Typeset by Graphicraft Limited, Hong Kong
Printed in Great Britain
on acid-free paper by
T.J. International Ltd,
Padstow, Cornwall

For Kate, Alice, and Trevor,
in memory of Tom,
and in honour of Alison.

J'ai vu à Philippeville, dans un jardin tout plein de rosiers en fleurs, sur le bord de la mer, une belle mosaïque romaine représentant deux femmes, l'une assise sur un cheval et l'autre sur un monstre marin. Il faisait un silence exquis dans ce jardin. On n'entendait que le bruit de la mer. Le jardinier, qui était un nègre, a été prendre de l'eau dans un vieil arrosoir et il l'a répandue devant moi pour faire revivre les belles couleurs de la mosaïque.—Et puis je me suis en allé.

(*Correspondance*, 23 Apr. 1858)

Les animaux de son zodiaque se retrouvaient dans ses pâturages, emplissaient de leurs formes et de leurs couleurs son écriture mystérieuse.

(*La Tentation de saint Antoine*)

Ma thèse est toujours que son état d'esprit, la vision du détail physique, n'est point transmissible par l'écriture, mais seulement par la peinture. Sa réponse est que c'est là son état d'esprit, et l'état d'esprit moderne.

(Taine on Flaubert, Mar. 1862)

'I see that, but I'll sew this.'

(Old children's tale)

ACKNOWLEDGEMENTS

I should like to thank the Faculty of Medieval and Modern Languges of the University of Oxford for its generous support, financial and otherwise, and especially for a one-year Special Lecturership, and I should like to thank also Somerville College, my other employer, for the same and for many other acts of matter-of-fact kindness, support, and forbearance. This book has developed from a number of papers and lectures which have benefited immensely from comments and insights from colleagues at the Flaubert seminar of the ITEM group in Paris (especially Raymonde Debray Genette, Pierre-Marc de Biasi, and Jacques Neefs), and in the Universities of Oxford, Cambridge, and Leicester, and King's College London. Help came also from an unexpected quarter, in the shape of Paul and Gwyn Williams and the Geography Department of Auckland, New Zealand, who offered me facilities and time to write in 1995. I have learnt a great deal from the conversations and company of other friends and colleagues, especially Margaret Davies, Jim Hiddleston, Ann Jefferson, Barbara Kennedy, Robert Lethbridge, Tim Mathews, Alan Raitt, Juliet Simpson, and Eric Southworth, and from graduate students past and present, Peter Cooke, Eddie Greenwood, Ian Maclachlan, Jonny Patrick, and Elin Williams. My thanks are due also to Almut Suerbaum for shoudering an increased administrative burden in my absences, to Olive Sayce for her constant encouragement, and to Norma MacManaway for her help with preparing the manuscript. I could not have written the book without the support of long-suffering family members, especially Kate, and would like to give special thanks to Richard for reading it. Most of all I am indebted more than I can say to the incomparable Alison Fairlie, whose sharp criticisms, unobtrusive helpfulness, and ability to detect nonsense have been sorely missed.

I am grateful to *French Studies* for permission to reuse material from my article, 'Flaubert on Painting: The Italian Notes (1851)', *French Studies*, 48 (1994), 155–73.

CONTENTS

LIST OF PLATES

My thanks are due to the institutions listed for permission to reproduce the following illustrations

1. Artemisia Gentileschi, *Giuditta*, Naples, Museo di Capodimonte
2. Titian, *Amor sacro e profano*, Rome, Villa Borghese
3. Mosaic, apse of the church of S. Prassede, Rome (Istituto Poligrafico e Zecca dello Stato)
4. Mosaic, apse of S. Maria Maggiore, Rome (Istituto Poligrafico e Zecca dello Stato)
5. Pietro Testa (attr.), *Cimone ed Ifigenia*, Rome, Galleria Colonna (photo: Alinari)
6. Alessandro Allori, *Sacrificio d'Isacco*, Florence, Galleria degli Uffizi (photo: Alinari)
7. Michelangelo, *Sacra famiglia*, Florence, Galleria degli Uffizi
8. Maxime Du Camp, *Baalbek*, from *Égypte, Nubie, Palestine et Syrie, dessins photographiques recueillis pendant les années 1849, 1850 et 1851* (Gide et Baudry, 1852–3)
9. Maxime Du Camp, *Doums*, from *Égype, Nubie, Palestine et Syrie* (Gide et Baudry, 1852–3)
10. Joshua Reynolds, *Portrait of Dr Hunter*, Royal College of Surgeons, St Bartholomew's Hospital, London (the Courtauld Gallery, London)

ABBREVIATIONS

Flaubert's *Œuvres complètes*, 16 vols. (Société Les Belles Lettres, Club de l'Honnête Homme (CHH), 1971–5) are referred to by volume and page number, for example, 10: 353. Individual works in CHH edition are listed below along with other key editions of particular texts.

BP	*Bouvard et Pécuchet*, CHH.
C1–C4	*Correspondance* (Gallimard, Pléiade, 1973–98), i–iv (1830–75). For 1876–80, reference is made to the CHH edition.
CS	*Un cœur simple*.
CT	*Carnets de travail*, ed. P.-M. de Biasi (Balland, 1988).
CV	*Carnets de voyage*, Bibliothèque historique de la ville de Paris, série 61, nos. 1–9.
DIR	*Le Dictionnaire des idées recues*, ed. A. Herschberg Pierrot (Livre de Poche, 1997).
ES	*L'Éducation sentimentale* (1869), CHH.
ES1	*L'Éducation sentimentale* (1845), CHH.
IS	*Italie et Suisse*, CHH.
MB	*Madame Bovary*, CHH.
MB[nv]	*Madame Bovary*, new version, preceded by unpublished sketches, ed. J. Pommier and G. Leleu (Librairie José Corti, 1949).
MF	*Mémoires d'un Fou*, CHH.
Nov	*Novembre*, CHH.
PC	*Pyrénées et Corse*, CHH.
PCG	*Par les champs et par les grèves*, ed. A. Tooke (Geneva, Droz, 1987).
SJH	*La Légende de saint Julien L'Hospitalier*, CHH.
SNP	*Souvenirs, notes et pensées intimes* (1838–41; Buchet/Chastel, 1965).
TSA1	*La Tentation de saint Antoine* (1849), CHH.
TSA2	*La Tentation de saint Antoine* (1856), CHH.
TSA3	*La Tentation de saint Antoine* (1874), CHH.
VE	*Voyage en Égypte*, ed. P.-M. de Biasi (Grasset, 1991).
VO	*Voyage en Orient*, CHH.

Introduction

The idea for this study sprang in the first instance from a fascination with Flaubert's works of travel writing. They are wonderful texts, as great in their way as the *Correspondance*. Unfinished though they are, they are a mine of information and inspiration for the traveller, the general reader, and the scholar. The art-commentaries, which are our main preoccupation here, bring an extra imaginative dimension to visits to museums and art-galleries. Flaubert's quirky and highly personal approach to art makes his commentaries rank among the most provocative and stimulating I have read. More theoretical considerations inevitably followed on these earlier encounters of a purely pleasurable kind, concerning the relationship between the works of art which Flaubert saw, his descriptions of them, and the development of his own descriptive techniques. Thus, the broader question of the relationship between painting and writing, image and text, came into focus, and of what it means to say that Flaubert is a pictorialist writer.

The term itself is loose, and was applied to Flaubert by his contemporaries in a mostly uncritical way. Flaubert's writing was generally acknowledged to be 'painterly'. Both Leconte de Lisle and Fromentin hailed Flaubert as a kindred spirit—'un poète et un peintre comme il y en a peu', 'un grand peintre [. . .] un grand *visionnaire*' (C3 1209, 1210)[1]—and when the young Zola sent Flaubert a complimentary copy of his first novel *Madeleine Férat*, he did so as from one 'observateur et [. . .] peintre' to another.[2] Flaubert's writing has been compared by critics of his time and since with the work of a number of painters—Courbet (*Madame Bovary*), Chassériau, Decamps, Delacroix, Gérôme, Guignet, and Horace Vernet (*Salammbô*), Daumier, Gavarni, the Barbizon painters, and

[1] See Abbreviations for the key to references to Flaubert's correspondence and works of fiction.

[2] Zola, *Correspondance* ed. B. H. Bakker (Presses de l'Université de Montréal, 1975), ii. 189 (10 Jan. 1869).

sundry Impressionists (*L'Éducation sentimentale*), Gustave Moreau (*Hérodias*), and others.[3] Recently, however, this easy association has been questioned. Working within the framework of *la critique génétique*, Raymonde Debray Genette argued in an article in *Littérature* in 1974 that Flaubert did everything he could to avoid conforming to pictorialist models.[4] Indeed, she has since argued that Flaubert's writing avoids not only pictorialist models but pictorialist *effects* as well: 'les portraits de Flaubert [. . .] ne renvoient pas, contrairement à ceux de Balzac, à un code pictural: on ne pourrait pas *peindre* Félicité'.[5] Debray Genette compares Flaubert in this respect with Proust: Proust makes the young Marcel try to 'fix' the hawthorns into a pictorial image, framed by his fingers; but Proust's own evocation of the hawthorns destroys what she calls 'le statisme pictural' because of its many intra-textual references —to the church, to Gilberte, to Mlle Vinteuil. In short, 'toute description chez Proust est une aventure de l'esprit'.[6] And so with Flaubert: descriptive elements which are *potentially* or initially pictorial are determined, ultimately, by thematic and narrative considerations. Pierre-Marc de Biasi has on occasion taken this line of argument even further, suggesting that not only is Flaubert's writing not pictorial, it is not even visual, though it springs from

[3] Cf. esp. L. Hourticq, *La Vie des images* (1927), 205–23; *L'Art et la littérature* (1946), 191–8, 217–34; and L. Hautecœur, *Littérature et peinture en France* (1942; 1963), 116, 198. On connections between Flaubert and Realist painters in general, cf. C. Rosen and H. Zerner, *Romanticism and Realism* (1984), 156, and Hourticq, *L'Art et la littérature* (1946), 227 (for Hourticq, *Madame Bovary* represents Realism, *L'Éducation sentimentale* Impressionism). Cf. also H. Hatzfeld, *Literature through Art* (1952), 169, 178; P. Brooks, *Reading for the Plot* (1984), 182; F. Castellani, 'Flaubert e la suggestione dell'immagine', *Ricerche di storia dell'arte*, 40 (1990), 23–33, and A. Fairlie, 'Flaubert and Some Painters of his Time', in *Imagination and Language* (1981), 362–3. Comparisons have been made also with various lithographs and engravings (cf. M. Mespoulet, *Images et romans* (1939), 68, and Seznec, *passim*).

[4] Cf. Debray Genette, 'Flaubert: Science et écriture', *Littérature* (Oct. 1974), 41–51, esp. concluding paragraph. Cf. also Debray Genette, 'La Pierre descriptive', in *Métamorphoses du récit* (1988), 220, on the role of the pictorialist model: 'Flaubert est un des rares écrivains qui ait essayé de résister en théorie et en pratique [. . .]. Il a toujours, au contraire, cherché des procédés d'écriture autonomes, qui neutralisent réalisme et plasticité.'

[5] Debray Genette, 'Les Figures du récit dans *Un cœur simple*', in *Métamorphoses du récit* (1988), 280.

[6] Debray Genette, 'Traversées de l'espace descriptif', in *Métamorphoses du récit* (1988), 310.

the visual and incorporates visualization as an important step along the way.[7]

A great deal depends on how the concept 'pictorialism' is defined, however. Heffernan gives a good working definition in his *Museum of Words* (1993): pictorialism is the generation in language of effects similar to those created by pictures, as opposed to ekphrasis (the depiction in language of a real work of art) or 'notional ekphrasis' (the depiction of an imaginary art work). But this definition takes us only so far, and still begs the question of how we define a picture. For Debray Genette (after Lessing), a picture implies *statisme*, and it is by means of this definition that she argues that Flaubert's writing is not pictorial. But by other definitions Flaubert's writing is pictorial—Barthes's postmodernist definition of pictorialist writing as the writing of desire has been deftly turned by Biasi to apply to Flaubert.[8] It was in the nineteenth century, above all, that the term 'pictorial' began to shed its old connotations of *statisme*. Flaubert's writing in fact both reflects and anticipates this evolution in understanding of what constitutes the pictorial. He practises a wide range of what may be called pictorialist writing, from full-scale Parnassian-type descriptions (about which he was nevertheless very dubious—witness the famous description of Charles Bovary's hat, which seems designed to test the efficacy of such descriptions) to the evocation of painting-like effects by means of the lightest and slightest of sketches, thus anticipating the idea of *écriture impressionniste* as defined by Brunetière.

If we wish to anticipate what follows, and situate Flaubert within what has now become a huge field of study on the relationships between literature and the visual arts, we might say that he saw visual art not quite as a sister, nor quite as a rival but above all as a foil. He was continually aware of the limits of the respective arts of painting and literature, and mistrusted what he saw as the hybrid forms of his time—*peinture à idées*, for example, or, conversely, the kind of pictorialist writing exemplified by Leconte de Lisle (and Charles's

[7] Biasi distinguishes between *écriture visuelle* and what he calls *écriture du visuel*. Flaubert's writing belongs in the latter category, not the former, because it constitutes 'un vrai travail de réécriture et d'intégration [. . .]. Pour lui, les modes d'expression plastique et littéraire s'enrichissent mutuellement, mais sans pouvoir se juxtaposer', Flaubert, *Trois contes*, ed. P.-M. de Biasi (Seuil, 1993), 260, 269.

[8] For further discussion of this point, see Ch. 2.

hat), which, for Flaubert, signally failed to 'faire voir'. If writing
was to 'imitate' painting it could only be, as Cousin said, by
attending to the materiality of its own techniques. Some of the finest
and most original effects in Flaubert's writing are produced by the
never-resolved tension between image and text, between all that
Flaubert personally associated with the pictorial and the status of
his own art.

Flaubert was extraordinarily sensitive to the visual in general and
to painting in particular. His responses combine cool-headed intel-
lectual appraisal with more elemental feelings of delight, fear, and
horror, the latter having a great deal to do with the uncontrollable
proliferation of visual images associated with the nervous attacks
to which he was subject from 1844 onwards. These exacerbated the
feelings which images have always been said traditionally to
evoke.[9] Flaubert's experiences of hallucination meant that he could
never remain neutral about images, whether painted or otherwise.

Proust's narrator in *A la recherche du temps perdu* notices that
the painter Elstir pursues a particular 'arabesque' throughout all his
works.[10] One such arabesque in Flaubert's work is his preoccupa-
tion with images and their relation to his writing. It accounts in large
part for his lifelong fascination with the subject of Brueghel's
Temptation of Saint Anthony. The gesture of the painted saint, turn-
ing away from the hordes of images which beset him to take refuge
in the Book is the arabesque which informs the whole of Flaubert's
writing life. The present study will trace the same fundamental
pattern of this turning from image to text in a number of different
contexts and modes. Flaubert strove for impersonality, as is well
known. But his writing is permeated with personal preoccupations

[9] Cf. W. J. T. Mitchell, 'Going Too Far with the Sister Arts', in J. A. W. Hef-
fernan, *Space, Time, Image, Sign* (New York: Peter Lang, 1987), 4, who speaks of
'the peculiar status of imagery in Western culture, its role as an object of peculiar
reverence and fear'. This feeling is not confined to Western culture, however: cf. David
Freedberg, *The Power of Images: Studies in the History and Theory of Response*
(Chicago and London: University of Chicago Press, 1989), for a comprehensive and
authoritative review of the subject. The most important work on the relationship
between image and text in Flaubert has been carried out by J. Seznec and A. Fairlie.
See bibliography for studies by them and by Biasi (esp. 1982), Bruneau (1964),
Castellani, Debray Genette, and Jaffe. Cf. also discussions of Flaubert in more gen-
eral studies of the relationship between literature and the visual arts, by Hautecœur,
Hourticq, and Mespoulet.
[10] *A la recherche du temps perdu*, ed. J.-Y. Tadié, 4 vols. (Gallimard, Pléiade,
1987–9), ii. 206.

such as this one, thus ensuring that the author is 'présent partout' even if 'visible nulle part' (C2 204). Genetic criticism, to which this study is indebted throughout, has made increasingly apparent the extent to which all Flaubert's writing, texts and *avant-textes*, can be seen as forming a continuing intellectual adventure, transcending the usual limitations of autobiography but still constituting an autobiography of a kind, an 'autobiographie impersonnelle', as Biasi has called it.[11] Pictorial images are part of this adventure, of the personal subtext which drives Flaubert's writing.

Flaubert left no one body of writing about painting or the pictorial arts. His one and only 'aesthetic', which figures in the first *Éducation sentimentale* (1845) does not address itself particularly to painting. It is possible, however, to piece together a more or less coherent position from various sources. Most of what Flaubert had to say about painting is confined to his travel accounts, which belong almost entirely to the period between 1840 and 1851. Also relevant are his notes on the Great Exhibition which he visited in London in 1851, and on London museums and galleries (1865), and, dating from the 1860s and 1870s, the important letters he wrote in response to works of art criticism sent to him by Taine, Ernest Chesneau, and Fromentin. Finally, there is a substantial amount of material in the preparatory dossiers for *L'Éducation sentimentale* and *Bouvard et Pécuchet*. One file of notes on painting, intended for *Bouvard et Pécuchet*, is of particular relevance and has hitherto never been examined.[12]

Flaubert's interest in pictorial art was dual almost from the first. Once he had moved from an initial position of uncompromising resistance to anything that smacked of bourgeois 'culture', he came, like other writers—Stendhal, Baudelaire, Zola—to value pictorial art not only for itself but also for what it could contribute to the practice of his own art. But at the same time Flaubert also constantly measures writing *against* painting. If painting is there to be 'milked' (and Flaubert does milk it mercilessly), it is there also to be transcended. Flaubert's education in the pictorial arts belongs very much to the

[11] Cf. Flaubert, *Madame Bovary*, ed. P.-M. de Biasi (Editions Imprimerie Nationale, 1994), 51: 'En trouvant progressivement sa place "littéraire" [. . .], l'élément autobiographique ne perd peut-être rien de sa charge émotionnelle pour l'auteur [. . .], mais il se dépouille des signes visibles de son appartenance biographique: c'est encore lui mais ce n'est plus tout à fait lui.'
[12] See bibliography section 1 for these texts.

period of his literary apprenticeship, and ceases more or less in 1851, when he embarked on the writing of *Madame Bovary*. After that date, writing about painting is invariably incidental, or circumstantial. To some extent, Flaubert's trajectory resembles that of Stendhal, in that Stendhal's works of art criticism also predate his fictional works and cease when the latter begin. But there are also significant differences between the two writers. In his excellent book, *Stendhal et ses peintres italiens*, Philippe Berthier has argued that Stendhal's early experience of painting subsists as a kind of subtle infusion throughout his later fiction.[13] That is also the case for Flaubert. But Flaubert's writing remains far more obviously pictorialist than Stendhal's, and is overtly preoccupied with the pictorial, where Stendhal's is not.[14] The tension between image and text remains as a constant presence in Flaubert, where Stendhal's writing eludes it.

What emerges from this study is the picture of a writer whose relationship with pictures is as complex as that of other writers who are commonly regarded as touchstones in analyses of the relationship between nineteenth-century French realism and painting: Stendhal, Balzac, Gautier, Baudelaire, the Goncourt brothers, and Zola. Unlike these writers, Flaubert regarded his writing about painting as a purely private practice, and it is thus stranger and in many ways more compelling than the works of established art criticism. While I have tried throughout to situate Flaubert within the cultural context of his time, this study makes Flaubert its focal point. Part I is a synchronic overview of Flaubert's responses to pictorial art and his views in general terms on the optimum relationship between image and text. Some of those responses—the more instinctual and emotional—were already fully formed at the time of Flaubert's first encounters with the pictorial arts during his travels in the 1840s. Others—his firm views on art criticism, for example —were formed as a direct result of his experiences of art in the

[13] Cf. P. Berthier, *Stendhal et ses peintres italiens* (1977), 153: 'Derrière les visages, les paysages, les instants stendhaliens—mais aussi dans les événements, les caractères, le rythme et le style—il faut toujours rétablir la présence de certaines émotions picturales tellement incorporées à l'imaginaire qu'elles en deviennent la substance même et finissent par ne plus se distinguer de l'activité de l'esprit.'

[14] Point made by Berthier, *Stendhal*, and A. Jefferson in P. Collier and R. Lethbridge (eds.), *Artistic Relations* (1994).

course of those travel years. Part II will focus diachronically on the apprenticeship years 1840–51, tracing Flaubert's education in the pictorial arts and its effects on the development of his own writing throughout these years. Finally, Part III will explore the subsequent refinement and elaboration of pictorialist modes of writing in the major works of fiction, and some of the ways in which Flaubert's texts enact his continual preoccupation with the pictorial image. In this final section, we shall see some of the ways in which Flaubert substituted pictorial images of his own making for the actual painted images on which he was wont to feast his eyes.

I

Flaubert and the Image:
A General View

I

Images, Memory, and the Imagination

In the first *Éducation sentimentale* (1845), Flaubert set out the blueprint of a system of aesthetics which, though subsequently refined, was never substantially modified, as he later told Louise Colet.[1] One of the passages from this early text which relates closely to that system and on which Louise commented was the 'voyage en Italie' undertaken by the two main protagonists, Jules and Henry. Flaubert took her up on it: 'Tu as fait la même réflexion que moi à propos du *Voyage en Italie* [. . .]. J'avais deviné, voilà tout' (C2 30: 16 Jan. 1852). By this he must have meant that he had foreseen in 1845 the pattern his future travels with Du Camp were to take, to Brittany in 1847, and to the Orient in 1849–51— Du Camp playing Henry to his Jules.

But that is only part of the point of that seminal sequence of the first *Éducation* (8: 236):

Henry se levait de grand matin, courait par les rues, dessinait les monuments, compulsait les bibliothèques, inspectait tous les musées, visitait tous les établissements, parlait à tout le monde. Jules [. . .] [p]orté au hasard, où le poussait son caprice, perdu dans ses songeries [. . .], retournait dix fois voir la même figure dans un tableau, et il s'en allait ensuite sans connaître la galerie. Il aurait passé sa vie entière à voir ce qu'Henry voyait en un seul jour, et ce qui fournissait dix lignes à celui-ci, il lui aurait fallu tout un volume pour le dire; Henry rapporta un journal complet, Jules seulement de temps à autre écrivait quelques fragments de vers, avec lesquels il allumait son cigare.

Jules écoutait et Henry voyait, l'un s'inspirait et l'autre voulait s'instruire [. . .].

Each young man embodies a particular kind of traveller, a particular kind of viewer. One concentrates on the task in hand, takes copious notes, and fills his journal. The other drifts around in a

[1] '[. . .] je me suis affermi dans l'assiette que j'ai prise de bonne heure. *Je sais comment il faut faire*' (C2 29–30: 16 Jan. 1852).

dream, hardly knowing where he is, let alone names of paintings or painters. He may write a poem, thus illustrating Baudelaire's famous precept that a sonnet or an elegy may be the best literary commentary on a painting (the latter with its fitting connotations of a lament for the dead).[2] But Flaubert goes even further than Baudelaire: Jules's poem, elegy or no, will simply vanish in the smoke from his cigar, as if even this indirect relation between picture and literature remains too direct. The *real* response to the painting would be, not a few lines of art commentary, nor even the poem, but, ultimately, a *book*: 'Ce qui aurait fourni dix lignes à celui-ci [Henry], il lui aurait fallu tout un volume pour le dire.' Jules's eventual 'output' will be more valuable than either of these more immediate responses.

Jules is the real hero of *L'Éducation sentimentale*, and Jules is Flaubert, there is no doubt of that. But part of Flaubert is also Henry. Flaubert on his travels may have given the impression of drifting around in a dream for much of the time—Du Camp himself said so—but he also kept up his travel diaries, just like Henry. Both stereotypes, the 'Conscientious Traveller' and 'the Poet', are mocked; but both reflect his practice.

The duality exhibited through the figures of Henry and Jules informs Flaubert's encounters with works of visual art. On the one hand, he is Jules. The original image is, eventually, transcended, 'written out', we might say, in the creative process. Many critics have commented on this characteristic feature of Flaubert's style, whereby the original impression (of whatever kind—Flaubert himself does not distinguish) is progressively muted throughout successive manuscript drafts until it becomes a simple vestige of its original self.[3] Flaubert himself draws attention to this process, by means of a number of different metaphors. The most well known is that of the *spirale*, whereby images and impressions from various sources combine over time to produce a complex new reality: 'Mes voyages, mes souvenirs d'enfant, tout se colore l'un de l'autre, se met bout à bout, danse avec de prodigieux flamboiements et monte en spirale' (C2 55). Not only is this what naturally happens according

[2] 'Ainsi le meilleur compte rendu d'un tableau pourra être un sonnet ou une élégie' Baudelaire, 'Salon de 1846', *Critique d'art*, ed. C. Pichois (1992), 78.

[3] Of particular relevance for this study, see Bernard Vouilloux, 'Peinture, écriture et figuralité chez Flaubert' (CNRS–ITEM Séminaire Flaubert: 'Esthétique de Flaubert', 3 Apr. 1993).

to Flaubert, it *must* happen: 'La couleur, comme les aliments, doit être digérée et mêlée au sang des pensées' (C2 372); or, in a more earthy version, everything must mulch down to produce, he hopes, 'de bonne merde': 'Je vis comme une plante, je me pénètre de soleil, de lumière, de couleurs et de grand air. Je mange: voilà tout. Restera ensuite à digérer, puis à chier,—et de bonne merde!' (C1 562).

Flaubert's 'style cannibale', as he himself calls it (C3 43), exerts itself with regard to pictures and artists as to anything else. But cannibalism is not all there is. Pictorial art and artists were as much a source of pleasure and instruction in their own right as entities to be transcended. The part of Flaubert which is Henry gives the original image its due, storing the original impression 'sur le vif', recording for posterity.

The present study focuses on the movement from image to text in Flaubert's writing, while endeavouring to keep both moments of the trajectory firmly in mind, the point of departure as well as the point of arrival. This is by no means a simple process; and Flaubert has his own way of treading the path from icon to spiral which of course all writers take, to varying degrees.

This chapter will begin with a consideration of Flaubert's encounters with visual images in general, before turning to his encounters with works of visual art. In both cases we will see on the one hand the immense power accorded by Flaubert to the original image and on the other his insistence on the need to rein that power in.

'ÊTRE ŒIL': FLAUBERT'S SENSITIVITY TO THE VISUAL

The experience of looking at paintings, for Flaubert, had its roots in a visual acuity and a visual imagination which were quite exceptional, and certainly equal to those of Gautier and Zola, whose extraordinary capacities in these domains have long been recognized.[4] Looking was thus a highly charged activity for Flaubert. The instinctual side of his encounters with images, whether actual or artefacts, remained an important factor throughout his life, even

[4] See e.g. W. J. Berg, *The Visual Novel* (1992), *passim*, and Gautier's famous statement 'je suis un homme *pour qui le monde visible existe*' quoted by E. and J. de Goncourt, *Journal* (1989), i. 254: 1 May 1857.

later, when more technical and stylistic interests had come also to dominate. I shall argue that Flaubert's lifelong need to *temper* the image has as much to do with its considerable impact on his emotions as with any rational, intellectually respectable position, or involvement in the aesthetic questions of the day.

Flaubert's visual acuity is well attested. In the 1860s, for example, Taine set about collecting material for his book *De l'intelligence*, which dealt in part with the connections between visual sensitivity and the artistic imagination. He turned for information to a group of individuals with particularly well developed capacities in those areas—'cas spéciaux', 'hypertrophiés', in his words—artists, scientists, visionaries, and observers: a chessplayer who could play with his eyes closed, a mathematician who could carry out long calculations in his head, the artist Gustave Doré—and Gustave Flaubert: 'et vous en êtes un'.[5]

It would be no exaggeration to say that Flaubert had a *mystique* of vision. The sight of three waves simply ruffling the surface of the Nile could move him to prayer:

C'est alors que, jouissant de ces choses, au moment où je regardais trois plis de vagues qui se courbaient derrière nous sous le vent, j'ai senti monter du fond de moi un sentiment de bonheur solennel qui allait à la rencontre de ce spectacle, et j'ai remercié Dieu dans mon cœur de m'avoir fait apte à jouir de cette manière—je me sentais fortuné par la pensée quoiqu'il me semblât pourtant ne penser à rien—c'était une volupté intime de tout mon être. (*VE* 274)[6]

Looking is not only sensual ('j'éprouve presque des sensations voluptueuses rien qu'à voir, mais quand je vois bien', *C1* 234) but analytical ('je sais voir et voir comme voient les myopes, jusque dans les pores des choses', *C2* 30). Flaubert's gaze is the gaze of Dr Larivière which 'vous descendait droit dans l'âme' (*MB* 1: 332).[7] Vision is

[5] Taine's letter is quoted in full *C3* 1425–6. See bibliography for Taine's *De l'intelligence*. Barbey d'Aurevilly shared Taine's view that Flaubert's visionary powers were due to some deformity: 'Son style a, comme observation, le sentiment le plus étonnant du détail, mais de ce détail menu, imperceptible, que tout le monde oublie, et qu'il aperçoit, lui, par une singulière conformation microscopique de son œil', 'Flaubert, *Madame Bovary*', in *Le XIXe siècle* (1964), i. 212.

[6] For ease of reading, here as throughout, I have taken the liberty of omitting the numerous deletions recorded scrupulously by Biasi in his excellent edn. of Flaubert's *Voyage en Égypte*.

[7] Cf. Sartre's lengthy discussion of the 'coup d'œil chirurgical' of Flaubert's father and its intimidating effects on Flaubert (who seems none the less to have inherited it), *L'Idiot de la famille* (1971), i. 460.

central not only to painters ('Tout se concentre dans l'œil', says Flaubert of a self-portrait, attributed to Titian (*IS* 10: 368)), but to all artists: Flaubert urges his friend Le Poittevin to cultivate this gift: 'fais-toi prunelle' (*C1* 234), and in Egypt decides that he should himself practise his own precept and, simply, 'être œil' (*C1* 602).

However, an image of a lynx-eyed Flaubert, ever on the alert, would be far from the truth. It often seemed to outsiders as if Flaubert was not observant at all. According to Maxime Du Camp, his travelling companion in both Brittany and the Middle East, Flaubert never seemed to engage with what he saw. *Distrait* as his hero Jules, Flaubert registers nothing: 'Les temples lui paraissaient toujours les mêmes, les paysages toujours semblables, les mosquées toujours pareilles.'[8] Du Camp attributes this apparent lack of engagement to lethargy—Flaubert would really have preferred to travel lying down, while images rolled past as if on the screen of a panorama: 'Il eût aimé à voyager, s'il eût pu, couché sur un divan et ne bougeant pas, voir les paysages, les ruines et les cités passer devant lui comme une toile de panorama qui se déroule mécaniquement.' While lethargy and *ennui* were certainly a feature of Flaubert's experience of travel,[9] they do not seem to have inhibited a capacity for almost total recall. Du Camp notes with amazement that, despite apparently seeing nothing at the time, Flaubert manages to recall visual impressions years later with absolute clarity, in this respect resembling Balzac: 'Par un phénomène singulier, les impressions de ce voyage lui revinrent toutes à la fois et avec vigueur lorsqu'il écrivit *Salammbô*. Balzac était ainsi: il ne regardait rien et se souvenait de tout.'[10] Flaubert himself of course knew that there was more than one way of seeing—'Pas si rêveur encore que l'on pense, je sais voir et voir comment voient les myopes [. . .]' (*C2* 30). Flaubert sees with more than his eyes ('Jules écoutait').

Whether Flaubert appeared at the time to be looking or not, it is certain that he regarded the act of looking as a double-edged sword, particularly at this level of intensity. As is the case when Proust's Marcel looks too closely at Albertine's face, looking may reveal

[8] Du Camp, *Souvenirs littéraires* (1994), 314.

[9] Cf. e.g. *VE* 347 and *passim*. Flaubert did indeed complain at the eternal sameness of Egyptian temples ('les temples égyptiens m'embêtent profondément', *VE* 327).

[10] Du Camp, *Souvenirs littéraires*, 315. Cf. also Flaubert's niece cited in G. Faure, *Pèlerinages passionnés* (1919), 142: 'Sa nièce nous dit qu'il préférait l'image à la réalité. Les paysages qu'il a sous les yeux ne semblent pas le captiver; c'est plus tard qu'il se les rappellera.'

nothing useful. 'Par cela même que je connais les choses, les choses n'existent plus', remarks the Gymnosophiste (*TSA3* 4: 96); and when Antoine finally attains his goal at the end of the *Tentation* and sees into the very heart of matter, what he sees is only the 'cellule scientifique', in the shape of an eye. Looking is painful or dangerous; if Antoine yields to the *tentation* to gaze into the eyes of the Catoblépas he will die (*TSA3* 4: 168); while the experience of gazing into the heart of matter almost unhinges him.[11] Artists whose visual capacity is akin to Flaubert's own pay a high price for it: Molière 'souffrait des Diafoirus et des Tartuffes qui lui entraient par les yeux dans la cervelle' (*C2* 444); and Flaubert imagines the power of Veronese's gaze almost pulling his eyes out of his head: 'Est-ce que l'âme d'un Véronèse, je suppose, ne s'imbibait pas de couleurs continuellement, comme un morceau d'étoffe sans cesse plongé dans la cuve bouillante d'un teinturier? Tout lui apparaissait avec des *grossissements de ton* qui devaient lui tirer l'œil hors de la tête' (*C2* 444).

Flaubert's ambivalence towards visual images has a great deal to do with his experience of hallucinations. The questions Taine put to Flaubert in the course of his research on the artistic imagination sought in part to contribute to current debates (by Rood, Chevreul, and others) on the question of the connections between visual perception and the visual imagination. Flaubert himself had long believed that there were connections to be made. In a letter of 1853 to Louise Colet he attributes the hallucinations to which he was subject from 1844 onwards in part to an early tendency to feast his eyes to excess: 'Ma maladie de nerfs a été l'écume de ces petites facéties intellectuelles [. . .]. Chaque attaque était comme une sorte d'hémorragie de l'innervation. C'était des pertes séminales de la faculté pittoresque du cerveau, cent mille images sautant à la fois, en feux d'artifices. Il y avait un arrachement de l'âme d'avec le corps, atroce' (*C2* 377). In a state of hallucination, the self explodes as one's image-bank erupts into a giant firework display, as Flaubert explains to Taine: 'On sent les images s'échapper de vous comme des flots de sang. Il vous semble que tout ce qu'on a dans la tête éclate à la fois comme les mille pièces d'un feu d'artifice [. . .]' (*C3* 572). Hallucination is 'une maladie de la mémoire, un relâchement

[11] This sequence is based on personal experience, cf. *PCG* 300–2 ('nous regrettions que nos yeux ne pussent aller jusqu'au sein des rochers [*etc.*]'): Flaubert notes that on this occasion he himself became temporarily insane.

de ce qu'elle recèle' (C3 572). At such moments, death seems imminent: 'Dans l'hallucination proprement dite, il y a toujours terreur, on sent que votre personnalité vous échappe, on croit qu'on va mourir' (C3 562).[12]

MEMORY AND THE TRANSFORMING VISION

However Flaubert managed to look without seeing, he was certainly able to retain images for years: 'je vois encore mon père levant la tête de dessus sa dissection et nous disant de nous en aller' (C2 376). Taine remarked that Flaubert took photographs in his head.[13] Flaubert would deliberately cultivate this gift, taking mental snapshots of Kuchuk-Hanem, for example, and committing them to memory ('Je l'ai regardée longtemps, afin de bien garder son image dans ma tête': C1 635). These small, clear memory-images are reflected in the numerous tiny images 'parked' like irreducible little icons throughout Flaubert's mature works.

But that way madness lies, once more. A private note in Flaubert's *Carnets de travail* summarizes a passage from a book called *Les Hallucinations* by Brierre de Boismont, for some undefined future use. In this passage, the author gives the example of an English painter (not identified) who had total recall to the point that he could remember every detail of his absent sitter. This eventually drove the painter insane: 'Un peintre anglais qui peut se représenter intégralement son modèle. "Toutes les fois que je jetais les yeux sur la chaise, je voyais l'homme." (p. 39). Ce peintre devint fou.'[14] To this note Flaubert then adds a comment of his own, to the effect that

[12] In *L'Idiot de la famille*, Sartre makes Flaubert's first hallucinatory attack of 1844 the nub of Flaubert's writing, the centre from which all flows, the enabling flaw; but he does not mention images.

[13] Cf. *Taine, sa vie et sa correspondance* (1902), ii. 231, from the section 'Visite de Gustave Flaubert', Mar. 1862: 'Il voit les yeux fermés trop d'objets; sa tête est une photographie, il imagine aussi nettement la moindre fêlure du parquet que les grandes lignes de la chambre. C'est pourquoi, quand il commence a écrire, il est encombré, il ne sait quoi dire d'abord; il en met trop, il est obligé de réduire [. . .]'.

[14] CT 478 (from *Carnet 15* (1869–74?)). The book was first published in 1845 (*Les Hallucinations, ou Histoire raisonnée des apparitions, des visions, des songes, de l'extase, du somnambulisme et du magnétisme*); Flaubert notes that he reread it in 1869 ('relu en juillet 1869'). Taine quotes the same passage in *De l'intelligence*, i. 94–5, immediately after recounting Flaubert's anecdote about the *goût d'arsenic* he experienced while writing the death of Mme Bovary.

total recall is too much like photography, and has nothing to do with art: 'Ses portraits ne devaient pas être ressemblants. La mémoire *trop* exacte, agissant comme un appareil photographique, nuit à l'idéalisation qui seule fait vrai.'

The 'snapshot' image, then, is hardly less of a minefield than the immediate visual perception, or the uncontrolled hallucinatory image. Like other artists—Fromentin and Delacroix in particular—Flaubert preferred the original perception to be tempered by time.[15] Flaubert learnt very early the value of waiting before writing. *Pyrénées et Corse* (1840) sets out initially to record the young Flaubert's impressions while they are still fresh. But he finds to his dismay that the effect achieved is just the opposite. Writing too soon drains his impressions of life. The colours begin to fade as soon as they are on the canvas:

il n'y a rien de si fatigant que de faire une perpétuelle description de son voyage, et d'annoter les plus minces impressions que l'on ressent; à force de tout rendre et de tout exprimer, il ne reste plus rien en vous; chaque sentiment qu'on traduit s'affaiblit dans notre cœur, et dédoublant ainsi chaque image, les couleurs primitives s'en altèrent sur la toile qui les a reçues. (*PC* 10: 303)

So, giving up the attempt to write as he travels, he finishes *Pyrénées et Corse* from memory. Even when completed, *Pyrénées et Corse* remains, in his phrase, a 'mosaïque' (in the recognized, technical sense of a preliminary sketch for a painting, not of a mosaic of tiles), to be extended and refined gradually over the years (10: 331) until it becomes part of the spiral, or 'je ne sais quelle synthèse

[15] Cf. e.g. Delacroix: 'Je n'ai commencé à faire quelque chose de passable, dans mon voyage d'Afrique, qu'au moment où j'avais assez oublié les petits détails pour ne me rappeler dans mes tableaux que le côté frappant et poétique; jusque-là, j'étais poursuivi par l'amour de l'exactitude, que le plus grand nombre prend pour la vérité' *Journal* (1980), 369 (17 Oct. 1853). Cf. also the Goncourts on Fromentin: 'Il était curieux, parlant de lui, nous disant qu'il ne savait rien, pas un mot de la peinture, qu'il n'avait jamais travaillé d'apres nature; qu'il n'a jamais pris de croquis, pour se forcer à regarder simplement; que les choses ne lui reviennent que des années après, peinture ou littérature; qu'ainsi, ses livres du SAHARA et du SAHEL avaient été écrits dans la réapparition de choses, qu'il croyait ne pas avoir vues, et que c'est de la vérité sans aucune exactitude', *Journal*, i. 1166; and Fromentin speaking for himself, *Lettres de jeunesse*, ed. Pierre Blanchon (Plon, 1909), 191, quoted in B. Wright and J. Thompson, *La Vie et l'œuvre d'Eugène Fromentin* (1987), 68: 'Le souvenir, en vieillissant, se concentre, se simplifie, et comme les vins de bon cru devient plus limpide et en quelque sorte plus généreux [. . .]. En passant par le souvenir, la vérité devient un poème, le paysage un tableau'.

harmonieuse', a 'grand mélange suave de sentiments et d'images' which he can then savour at leisure ('remâcher') (10: 338).

Not only is it normal and natural for impressions slowly to mature but they *must* do so, before writing takes place—so Flaubert advises Louise Colet, who is on the point of undertaking a fact-finding mission to La Salpêtrière, to flesh out her tale, *La Servante*:

Ce n'est pas une bonne méthode que de voir ainsi tout de suite, pour écrire immédiatement après. On se préoccupe trop des détails, de la couleur, et pas assez de son esprit, car la couleur dans la nature a un *esprit*, une sorte de vapeur subtile qui se dégage d'elle, et c'est cela qui doit animer en *dessous* le style. Que de fois, préoccupé ainsi de ce que j'avais sous les yeux, ne me suis-je pas dépêché de l'intercaler de suite dans une œuvre et de m'apercevoir enfin qu'il fallait l'ôter! (C2 372)

Visual recall, then, is essential to the artist, but needs to be transcended. The memory-image has to be stirred around with many others in the *spirale*. The image of the *spirale* is crucial: Flaubert may have access to a bank of images in his mind, a gallery of mental pictures,[16] but this is only so much raw material—he emphasizes tirelessly the role of time and the imagination, transforming and idealizing, as in one of his letters of reply to Taine: 'L'image intéressée [*sic*][17] est pour moi aussi vraie que la réalité objective des choses,— et ce que la réalité m'a fourni, au bout de très peu de temps ne se distingue plus pour moi des embellissements ou modifications que je lui ai donnés' (C3 562).

The image which Flaubert himself used to express the peculiar nature of his own imagination was that of the stained-glass window. It runs throughout the whole of his *œuvre*, surfacing from time to time, and finding its full development in *La Légende de saint Julien l'Hospitalier*. Flaubert first applies it to himself in a letter of 1853, looking back on his youth. He compares himself to a late Gothic cathedral, vigorous, ornate, and with stained-glass windows for eyes, which transfigure everything he sees: 'J'étais comme les cathédrales

[16] Cf. Jules in the first *Éducation sentimentale*: his past is 'comme une galerie de tableaux' (*ES1* 8: 128). Gautier uses the same image: 'si je pouvais ouvrir un trou dans ma tête et y mettre un verre pour qu'on y regardât, ce serait la plus merveilleuse galerie de tableaux que l'on eût jamais vue', *Mademoiselle de Maupin* (1966), 258.

[17] Bruneau suggests 'intéressée', but 'imaginée' makes better sense. (The original of this letter has been lost, cf. Bruneau's note, C3 1425.)

du XVe siècle, lancéolé, fulgurant [. . .]. Entre le monde et moi
existait je ne sais quel vitrail peint en jaune, avec des raies de feu,
et des arabesques d'or, si bien que tout se réfléchissait sur mon
âme, comme sur les dalles d'un sanctuaire embelli, transfiguré et
mélancolique cependant' (C2 278).[18]

Flaubert's obsession with this image will often be apparent in what
follows. To take the year 1853 alone, when he first formulated
the image, he had already bestowed a similar kind of artistic vision
on Emma Bovary, when he sits her in a summerhouse at La
Vaubyessard and has her look at the landscape through panes of
differently coloured glass (C2 89). The fact that Flaubert eventu-
ally deleted this sequence no doubt reflects his feeling that it was
too great an intrusion of his private subtext.[19] Later in 1853, in a
rain-sodden Trouville imbued with memories of dead or departed
loved ones and lost selves, Flaubert identifies this transforming
vision of his with the very act of writing, referring to his 'désir cuisant
de transformer par l'art tout ce qui est *de moi*, tout ce que j'ai senti',
so that Trouville fishing-boats might turn into more exotic craft,
and local sailors into naked savages on scarlet beaches: 'J'arrange
les barques en tartanes, je déshabille les matelots qui passent pour
en faire des sauvages, marchant tout nus sur des plages vermeilles'
(C2 412); 'Je suis dévoré maintenant par un besoin de métamor-
phoses. Je voudrais écrire tout ce que je vois, non tel qu'il est, mais

[18] Other writers have used optical imagery to refer to their artistic vision. Cf.
M. Iknayan, *The Concave Mirror* (1983), 150–1, for some instances: for Hugo,
Delécluze, Quatremère de Quincy, and Balzac, writing is a concave mirror. For Gautier
and others it is a prism (cf. R. Snell, *Théophile Gautier* (1982), 58). We could add
to the list Stendhal's magic lantern ('Ma tête est une lanterne magique; je m'amuse
avec les images, folles ou tendres, que mon imagination me présente' *L'Italie en 1818*
in *Voyages en Italie* (Gallimard, Pléiade, 1973), 238), Baudelaire's 'phares' and panes
of clear or coloured glass ('Le Mauvais Vitrier'), Zola's *écran* with its varying degrees
of transparency (cf. his letter to A. Valabrègue, 18 Aug. 1864, *Correspondance* (1978),
i. 373–82), Proust's microscope, telescope, magic lantern, and stained-glass window,
Gide's kaleidoscope (*Si le grain ne meurt*), Robbe-Grillet's distorted window pane
(*La Jalousie*), and others.
[19] *MB nv* 216. Two earlier references emphasize the metaphorical connotations
of coloured glass, e.g. *MF* 11: 506–7: 'il y a des peintres qui voient tout en bleu,
d'autres tout en jaune et tout en noir. Chacun de nous a un prisme à travers lequel
il aperçoit le monde; heureux celui qui y distingue des couleurs riantes et des choses
gaies'; and *C1* 209 to L. de Cormenin: 'Vous connaissez ces verres de couleur qui
ornent les kiosques des bonnetiers retirés. On voit la campagne en rouge, en bleu,
en jaune. L'ennui est de même. Les plus belles choses vues à travers lui prennent sa
teinte et reflètent sa tristesse.' But not till *Saint Julien* does the image acquire all its
intensity.

transfiguré' (C2 416). Flaubert's remark about Veronese's sensitivity to 'grossissements de ton' also dates from the same period and reflects the same preoccupation with his own way of seeing.

Flaubert's transforming vision needs only the sketchiest of trampolines, or none at all. Writing to Jeanne de Tourbey in June 1860, he tells her how he pored over 'une affreuse image' in a journal depicting the auditorium of the Porte-Saint-Martin theatre and eventually succeeded in transforming 'un petit pâté d'encre' into an image of Jeanne in her box. This example also, incidentally, illustrates already what we will see to be a characteristic of Flaubert's way with pictures—disintegration and subsequent constitution of an image of his own making: 'La vue était prise du côté gauche, si bien que dans votre loge un petit pâté d'encre surmonté d'un cercle figurant un chapeau de femme m'a fait rêver à vous, belle dame.—Et comme un idiot, je suis resté longtemps devant la petite tâche [*sic*] de boue noire, où je découvrais par le souvenir des sujets de ravissement' (C3 99). A smudge can become a face, or a whole world, a knothole an eye.[20] In Flaubert's world, images lurk everywhere, even where, ostensibly, there is nothing at all to be seen: 'on ne voit plus rien, et cependant on regarde' (*PCG* 98). The artistic image, as he tells Taine (C3 562), differs from the hallucinatory image in that one is a source of joy, the other of terror. But the terror was never very far away.

Images are as dangerous, then, as they are vital and exciting. All Flaubert's works play on this ambivalence, and pictorial art works affect him in the same way.

RESPONSES TO PICTORIAL ART AND ARTISTS

Emotion and the Intellect

In 1853, Louise Colet wrote to ask Flaubert for his help with a one-act play she was writing about the painter Filippo Lippi.[21] Louise had intended to make of her bandit protagonist who captures the

[20] Cf. the drafts for *Hérodias*, quoted by R. Debray Genette, *Métamorphoses du récit* (1988), 195: 'Ceux que l'ivresse engourdissait, inclinés sur les tables, y devinaient dans les veines du bois des questions, des nuages.'

[21] *La Rançon du génie*, the third of three scenes in Colet's *Enfances célèbres*, published initially in *Historiettes morales* (Royer, 1845), see Bruneau's note, C2 1191–2.

young Lippi an admirer of the great fresco of the *Last Judgement* in Pisa's Camposanto, assumed at the time to be the work of Orcagna.[22] Since Flaubert had seen this fresco in 1851, she asked him to help her draft a description which she could then put into the mouth of her bandit. Flaubert declines, for once, to help, on the grounds that the responses of a modern viewer of art, a hard-core 'amant du pittoresque' (such as himself), are entirely different from what those of a medieval viewer would be. Such a description, coming from him, would be anachronistic. A medieval viewer would have been thrown into a state of holy terror, driven to confession, not to a study of artistic form and the discovery of a vocation:

Et puis, si je fais la description du *Triomphe de la mort*, ce sera une description *artistique*, et fausse conséquemment, dans la bouche de ton personnage. Si elle est *naïve*, si elle n'exprime que l'étonnement de la chose, je veux dire l'effet brutal produit par le dramatique du sujet, quel rapport cela aura-t-il à la vocation de peintre? L'effet que cette fresque a dû produire sur un homme comme Buonavita et dans son temps, c'est de le faire aller en confesse, ou entrer dans un couvent, en sortant de là.—Nous ne pouvons pas faire de cet homme un amant du pittoresque, ce serait sot. (C2 397)

Flaubert is in fact being disingenuous here—he is perfectly capable of imagining both kinds of response, because he habitually experiences both. He has been on many occasions both the cool-headed appraiser, the 'amant du pittoresque' and the naïve viewer—his later remark to Taine that he was 'ravagé' by these same frescos (C3 547) is not the language of the cool, modern *amateur*. In Flaubert's responses to pictorial art, emotion and the intellect both play a role: 'Appréciations particulières', as he says, are 'une question de nerfs et de tempérament autant que de goût' (C3 807); and, as with all visual images for Flaubert, the emotion in question is not all pleasure.

It is hardly possible to exaggerate the emotional impact of pictorial images on Flaubert's imagination, whether in childhood or in adult life. We need think only of Flaubert's references during the writing of *Madame Bovary* to the engravings in the adventure books which he coloured as a child—blue rocks, green trees—and which he still, as an adult, finds disturbing:

[22] Now regarded as anonymous. It was largely destroyed in the last war. Baudelaire's poem 'Le Mauvais Moine' takes its inspiration from these frescos.

Je viens de relire pour mon roman plusieurs livres d'enfant. Je suis à moitié fou, ce soir, de tout ce qui a passé aujourd'hui devant mes yeux, depuis de vieux keepsakes jusqu'à des récits de naufrages et de flibustiers. J'ai retrouvé des vieilles gravures que j'avais coloriées à sept et huit ans et que je n'avais [pas] revues depuis. Il y a des rochers peints en bleu et des arbres en vert. J'ai rééprouvé devant quelques-uns (un hibernage dans les glaces entre autres) des terreurs que j'avais eues étant petit [. . .]. Il y a une histoire de matelots hollandais dans la mer glaciale, avec des ours qui les assaillent dans leur cabane (cette image m'empêchait de dormir autrefois), et des pirates chinois qui pillent un temple à idoles d'or. (C2 55: 3 Mar. 1852)[23]

Flaubert never lost this ability to engage passionately and personally with pictorial images. The tendency of the adolescent hero of *Novembre* to faint with desire before paintings and statues ('je me pâmais devant des tableaux ou des statues': 11: 633) is reflected in the impulse of the 23 year old to kiss the marble armpit of Canova's *Psyche* (*IS* 10: 377) and lingers on in the 56 year old, still 'perdu de rêveries devant les statuettes antiques' (16: 80: 5 Sept. 1878). Images exert an almost irresistible appeal. Like Baudelaire's child, 'amoureux des cartes et des estampes', Flaubert the adult dreams over atlases and pictures of foreign places: 'quelle chose énorme qu'un atlas, comme ça fait rêver!' (C2 587: 15 Aug. 1855).

The more particularly *intellectual* breakthrough came somewhat later, in 1845, with Flaubert's encounter with Brueghel's *Temptation of Saint Anthony* in Genoa (see below, Part II, for further discussion). Emotion and intellect came together here. This painting inspired Flaubert's first full art commentary, and lay the foundations for his ideas on the relationship between text and image. His view of the importance of the visual arts to the study of form was henceforth established, and ultimately received its first explicit formulation in *Par les champs et par les grèves* (1848): 'La plastique, mieux que toutes les rhétoriques du monde, enseigne à celui qui la contemple la gradation des proportions, la fusion des plans, l'harmonie enfin' (*PCG* 594). Arguably the greatest influence on his literary development, the *Voyage en Orient* proved conclusively to him that literature was unthinkable without the other arts. Here,

[23] This detail—colouring illustrations—is recalled later. Almost breaking through into the final text of *Madame Bovary* (*nv* 633: 'Berthe [. . .] illuminait des estampes'), it finally surfaces in *L'Éducation sentimentale*, when Frédéric and Louise colour the illustrations to *Don Quixote* (3: 251). Cf. Bruneau's note *C1* 839 on Flaubert's illustrated edition of *Don Quichotte*.

more than anywhere, Flaubert saw pictures and wrote about pictures, and this experience left its mark on his mature fiction in ineradicable ways.

Attitudes to 'Culture'

Precisely *because* looking at pictures was a matter of passion for Flaubert, he was inclined to be sarcastic about current cultural clichés and fashions—like his hero Saint Julien, whose hunting was far more serious and subversive than the ordered, gentlemanly pursuit indulged in by others of his class. The *Dictionnaire des idées reçues* contains several entries relating to the ever-increasing contemporary mania for 'culture' of the visual kind: 'Exposition: Sujet de délire du XIXe siècle'.[24] Philippe Hamon points out that the nineteenth century began to be invaded by images, in advertising, shop signs, newspapers, and so on. Museums, exhibitions, and *Salons* all rearrange themselves to cater for what even at the time was caricaturized as the goggling bourgeois, all eyes.[25] Flaubert, too, observed this phenomenon, while in the very act of visiting an art gallery and thus contributing to it. 'J'étudie tous ceux qui viennent au musée. Sur cinq cents il n'y en a pas un que cela amuse, certainement. Ils y viennent parce que les autres y viennent. Le lorgnon sur l'œil, on fait le tour des galeries au petit trot, après quoi on referme le catalogue et tout est dit' (*C1* 760: Naples, 1851).

The first Murray's Guides, the first Baedekers, date from these years. All Flaubert's male heroes 'take in' art, as a matter of course: Henry's initiation to Paris begins with a trip to the musée de Versailles; Henry and Jules together make the obligatory trip to Italy; Frédéric Moreau drifts lovelorn around the Louvre; Bouvard and Pécuchet mark the beginning of their life together with visits to Paris museums and galleries.[26] And, for all his irony, Flaubert does exactly the same: 'O la nécessité!! faire ce qu'il faut faire. Etre toujours selon les circonstances (et quoique la répugnance du moment vous en détourne) comme un jeune homme, comme un voyageur,

[24] Cf. P. Hamon, 'Le Musée et le texte', *Revue d'histoire littéraire de la France*, 1 (Jan.–Feb. 1995), 6, quoting Balzac's *Monographie du rentier*: 'Le rentier existe par les yeux. La girafe, les nouveautés du Muséum, l'exposition des tableaux ou des produits de l'industrie, tout est fête, étonnement, matière à examen pour lui.'

[25] Cf. P. Hamon, 'Images à lire et images à voir', in S. Michaud *et al.* (eds.), *Usages de l'image* (1992).

[26] *ES1* 8: 32, 236; *ES2* 3: 102; *BP* 5: 45.

comme un artiste, comme un fils, comme un citoyen, etc. doit être!'
(*VE* 327–8). This is Henry wishing he were Jules. Later, about to
visit the Exposition Universelle in Paris, in June 1855, Flaubert writes
to Bouilhet, 'Je me livrerai à la peinture, aux Beaux-arts, *cela pose
un homme*' (C2 585). Later, he teases Charpentier for wasting time
at the *Salon*: 'ce qui est un prétexte à bocks [. . .]. Est-ce que j'y
vais, moi, au Salon!' (15: 566). The answer of course is: 'yes'.

He visited the *Salons* of 1857, 1876, 1879, and 1880, and prob-
ably others.[27] But, typically, his recorded impressions are succinct.
In 1857, he confines himself to remarks on paintings of rabbits and
one or two 'grands hommes que tu connais', for the benefit of the
11-year-old Caroline (C2 707). In 1876, though we are sure that
he saw Moreau's *Salome* paintings, which almost certainly nudged
him into the writing of *Hérodias*, he says nothing about them at
all, simply referring instead, characteristically, to 'deux ou trois
tableaux vantés qui m'exaspèrent' (15: 449: 2 May 1876). His
comments on the 1879 and 1880 *Salons* are purely business-like,
focusing mainly on the portraits submitted by his niece (16: 221,
358, 359, 361). He also attended the various Great Exhibitions, which
were such a major feature of the second half of the nineteenth cen-
tury, going to London for the Great Exhibition of 1851,[28] seeing
the second (the Exposition Universelle) in Paris in 1855 (already
mentioned), and the third, in Paris, in 1867 (C3 675—'je suis
tanné de l'Exposition, gorgé, saturé'). We should not ignore,
either, the Exhibition in Rouen of 1874, which did nothing to
dispel Flaubert's negative impressions of the standard of culture
in his home town.[29] He also visited museums in and around the
capital: the Louvre ('à éviter pour les jeunes filles', *DIR*), the musée
de Versailles (*DIR*: 'Belle idée du roi Louis-Philippe, [retrace les haut
plus belles preuves hauts faits de la gloire nationale]'),[30] and the musée

[27] Cf. a letter from Caroline of 7 July 1843: 'L'Exposition est ouverte; on parle
beaucoup d'un tableau de Coignet' [sic] (C1 179: this was *Le Tintoret et sa fille*).
[28] Cf. *Flaubert à l'Exposition de 1851*, ed. Jean Seznec (Oxford: Clarendon Press,
1951).
[29] 'J'ai voulu me retremper par la contemplation du Beau et je me suis transporté
à l'Exposition de Rouen [. . .]. Quelles peintures! Te rappelles-tu un tableau
représentant Louis XVII arraché à Marie-Antoinette? Est-ce assez lamentable!' (C4
811: 16 June 1874).
[30] Cf. C1 119 on the *bêtise* of this museum, which lengthened a painting by Gros,
judged to be too short (a remark later attributed to Pellerin, *ES2* 3: 162). Du Camp
calls this museum 'la nécropole de notre peinture d'histoire', *Souvenirs littéraires*,
250.

de Saint-Germain (C4 784: Mar.–Apr. 1874). There are also references to the Musée des Beaux-Arts in Rouen (C1 159, 161–2).

But the major part of Flaubert's experience of painting came from travelling. Here too of course the contemporary mania for culture had left its mark (Flaubert's characters are always going off or wanting to go off to look at paintings in Italy). In the nineteenth century more and more of the great collections of Europe were opening their doors to the public, and the public began to flock to see them. Flaubert enjoyed the great privilege of being among the first middle-class travellers to take advantage of the new opportunities, despite his grim awareness of forming part of the thin end of a wedge. Only Stendhal visited as many French provincial collections as Flaubert,[31] and Flaubert had as great an acquaintance with museums and collections outside France as, say, Gautier, and more than either the Goncourt brothers or Baudelaire.[32] Gautier himself makes the point that those who had access to Old Masters in the original were still at this time rare and privileged beings.[33] Flaubert's knowledge of Italian collections was particularly extensive. His 1845 trip took him to Genoa and Milan, the *Voyage en Orient* of 1849–51 included four months in Naples, Rome, Florence, and Venice. He was also able to observe the art of Egypt *in situ*, and to become familiar with the art of the Holy Land (educational rather than a great aesthetic experience) and the Middle East generally. The Great Exhibition at the Crystal Palace in 1851 introduced him to art of the Far East, and his later visit to London of 1865 introduced him to painting of the English and Dutch schools. For all his irony and teasing, he urges others, his niece particularly, not to miss any opportunity for looking at paintings.

[31] Cf. *Mémoires d'un touriste* (1837). Mérimée covered a great deal of ground in his role as Inspecteur des Monuments historiques, but his brief was architecture.

[32] See bibliography for travel accounts by Gautier and the Goncourts, and cf. G May, *Diderot et Baudelaire* (1973), 44–5: Diderot knew collections in Russia, Baudelaire in Belgium. Even Delacroix failed to go to Italy.

[33] 'Ils sont rares, ceux qui peuvent, accomplissant un pieux pèlerinage, visiter les tableaux des grands maîtres dans les églises, les palais et les musées d'Italie, d'Espagne, d'Angleterre et de France', Gautier, 'Sur l'art de la gravure' in *Critique artistique et littéraire* (1929), 85. In *ES1*, Henry is clearly wrong to regard himself as an expert on art, since he is familiar only with engravings: 'En fait de tableaux, il en connaissait les gravures; en fait d'histoire, il savait par cœur les résumés; mais il se sert des termes techniques d'atelier et il cite les sources' (*ES1* 8: 229). Flaubert regarded such engravings as watered-down and over-accessible, cf. *PCG* 595, and below.

Her duty is made clear: in England, 'passer de longues séances au British et au National Gallery, ainsi qu'à Kensington' (C4 240: 1870); in Venice, to give due time to Veronese, Titian, Tintoretto, Giorgione, and Bellini (C3 389: 18 Apr. 1864); in Sweden, to tell him about the paintings she has seen and to bring some home with her (C4 742).

Ironic detachment certainly did not preclude a serious commitment to the viewing of pictures.

Taste

Even when Flaubert's tastes seem to correspond to what might be called the artistic taste of the time, they always have a particular slant, which makes them both original and highly personal. What he says he responds to most in art is the capacity to 'faire rêver', and in this he resembles Diderot, Delacroix, and Baudelaire:

Ce qui me semble, à moi, le plus haut dans l'Art (et le plus difficile), ce n'est ni de faire rire, ni de faire pleurer, ni de vous mettre en rut ou en fureur, mais d'agir à la façon de la nature, c'est-à-dire de *faire rêver*. Aussi les très belles œuvres ont ce caractère. Elles sont sereines d'aspect et incompréhensibles. (C2 417)[34]

Flaubert is drawn to enigmatic art, of the kind which evokes a feeling he describes excellently as being 'comme un souvenir de choses que je n'avais pas vues' (PC 10: 341). When Jules de Goncourt sends Flaubert drawings made by himself ('à votre intention') of bas-reliefs of various grotesque figures in the museum of Leiden, Flaubert's response is illuminating—the one he prefers (three legs dancing on a bull) is the one he understands not at all: 'la 3ᵉ (les trois jambes dansant sur un taureau) me fait le plus grand plaisir, bien que je n'y comprenne goutte' (C3 176). Later, on receiving Maurice Sand's playful 'dessins fantastiques' for the *Tentation*, Flaubert laughs at the way his imagination is triggered by his passion for searching for meaning he knows he will not find: 'Peut-être y a-t-il un symbole profond caché dans le dessin de Maurice? mais je ne

[34] Cf. Baudelaire, 'Salon de 1846', *Critique d'art* (1992), 81: 'Rembrandt est un puissant idéaliste qui fait rêver et deviner au-delà.' Cf. also Diderot, *Salon de 1765* (1985), 193: 'plus l'expression des arts est vague, plus l'imagination est à l'aise'. Cf. also C3 416 on the 'but de l'art, qui est *l'exaltation vague*', idea attributed also to Pellerin, *ES* 3: 84.

l'ai pas découvert . . . rêverie!' (*C4* 490: 3 Mar. 1872).[35] The idea that art plays with the inexpressible is of course an old and familiar one; but it is of particular relevance to Flaubert. His feeling for the incomprehensible takes him into areas which other artistic commentators do not care to penetrate. It was part of what drew him to Brueghel, who for most of his contemporaries was simply a formless collection of head-aching conundrums, best ignored.[36] Flaubert himself remarks how the other visitors to the palazzo Balbi do not even look at the Brueghel which so captivated him (*IS* 10: 368), or, if they do, they consider it very bad (*C1* 230). The lure of the enigmatic also accounts for Flaubert's later attraction to Moreau, who was another closed book to most of Flaubert's contemporaries, and also earned a reputation for obscurity.[37]

Flaubert took great pleasure in contemplation of the incomplete: the hero of *Novembre* 'se perdait en contemplations devant les statues antiques, surtout celles qui etaient mutilées' (11: 669), and one of Flaubert's most enthusiastic discoveries in Rome was of the famous *Torso* in the Vatican. This, once again, was not just a reflection of current debates on the status of the sketch, the unfinished, and the fragment.[38] It expresses something at the very core of Flaubert's being, his sense of his own incompleteness. He

[35] Cf. Gautier: 'celui de mes talents que j'estime le plus est de ne pas deviner les logogriphes et les charades', *Mademoiselle de Maupin* (1966), 45. Not the least of the Queen of Sheba's bizarre charms for Saint Antoine was her habit of posing riddles.

[36] Few writers mentioned or valued the Brueghels. But cf. Arsène Houssaye's *Histoire de la peinture flamande et hollandaise* (1846), which includes a section on the three Brueghels; and Baudelaire's short but penetrating analysis in 'Quelques caricaturistes étrangers' (1857), *Critique d'art*, 232–4. See below, Part II, for Flaubert's commentary on Brueghel's *Temptation*. H. van der Tuin's only comment on Brueghel, *Les Vieux Peintres des Pays-Bas* (1953) is that Balzac owned two, p. 104 n. 2.

[37] Cf. Du Camp, *Les Beaux-Arts* (1867), 144–5: 'Le reproche principal qu'on peut adresser à la conception même des tableaux de M. Moreau, c'est qu'elle n'est pas suffisamment claire. Le Français est ainsi fait qu'il veut voir et comprendre au premier coup d'œil; tout ce qui n'est point parfaitement net et même un peu banal n'a pas le don de lui plaire; il n'aime point les sens mystérieux et cachés [. . .]. J'avoue que je ne suis pas ainsi, et qu'un peu de rébus ne me déplaît pas [. . .]'.

[38] Cf. N. Bryson, *Word and Image* (1981), 102–3, for a selection of quotations in praise of the 'non-finito' in visual art and in literature, from Roger de Piles (1699) onwards. On the 'sketch-finish' debate in the 19th cent. in France, see esp. A. Boime, *The Academy and French Painting in the Nineteenth Century* (1971), *passim*, and C. Rosen and H. Zerner, *Romanticism and Realism* (1984), 24, on the Romantic preference for the fragment, which they compare with the contemporary taste for ruins (a taste which Flaubert also shared) and the growing appreciation for sketches and a sketchy finish, as opposed to the 'léché' surface of official art.

is very well aware that his aesthetic responses, his world-view, what he himself calls his 'système', rests on this urge to find an echo to the monster inside himself, an eternal 'coup de sifflet' which will add the piquancy and savour without which things might be too perfect: 'mon système [. . .], mon cœur [. . .], ma nature peut-être, qui, incomplète d'elle-même, cherche toujours l'incomplet' (*C1* 279).[39]

Flaubert's *other* side, however, the joyous, rumbustious side, was drawn to the kind of art which gives the sense of a super-abundance of life ('Malheur à qui ne comprend pas l'excès!' Jerusalem, 10: 564)—hence, the immediate appeal to Flaubert of Brueghel's *Temptation*. He seems to have yearned for a *living* art (as do Zola and Huysmans after him)—'mouvementé', 'heurté' are terms of high praise for him. This yearning lies at the heart of the aesthetic of the first *Éducation sentimentale*. Flaubert applies the Kantian idea that art at its best imitates the natural processes (not nature itself) in uniting the incongruous, in an 'harmonie discordante' (*PCG* 512), an 'harmonie de choses disparates' (*C2* 283).[40] The aesthetic of 1845 is an *organic* theory of art, and as such draws on central concepts of Romantic theory. Where Flaubert's aesthetic differs from that of other writers such as Hugo, for example, is in the extent to which he gives difference its full due, while never abandoning the idea of overall pattern or unity. The various ramifications of this central idea—such as the recuperation of monsters and the fantastic into the general scheme of things—are everywhere apparent in Flaubert's responses to paintings.[41] That is why he is fascinated by

[39] Cf. C2 283: 'Je veux qu'il y ait une amertume à tout, un éternel coup de sifflet au milieu de nos triomphes, et que la désolation même soit dans l'enthousiasme'.

[40] This is an effect which few critics of Flaubert have noted; but cf. L. Rétat, 'Flaubert, Renan et l'interrogation des religions', in B. Masson (ed.), *Gustave Flaubert 3: Mythes et religions (2)* (Minard, 1988), 12 ('l'effet lui-même artistiquement cohérent—d'incohérence') and J. Neefs, 'La Nuit de Noël: Bouvard et Pécuchet', ibid. 35 ('juxtapositions faites de "hasard" (mais l'effet narratif, lui, est alors parfaitement concerté)'.

[41] One of the most important models for Flaubert's 1845 aesthetic was that of the natural scientist Geoffroy Saint-Hilaire, who envisaged a precarious kind of zoological system which accommodated the kinds of life-forms which appear most resistant to it—monsters and freaks do not escape nature's limits but are, on the contrary, subject to natural laws and a sign of nature's exuberance. Cf. Geoffroy Saint-Hilaire, *Philosophie anatomique* (1818), 260: 'il n'y a pas de monstres, et la nature est une'. See also C2 450–1: Saint-Hilaire is 'ce grand homme qui a montré la légitimité des monstres'. Balzac also refers to Saint-Hilaire as a model in his *Avant-propos* to the *Comédie humaine*, but not from the point of view of the recuperation of the monster into nature's overall unity.

Callot, Brueghel, and others, who give the illusion of reality to the most blatantly monstrous or 'impossible' of forms.[42]

Colour

Connoisseurs of art in the 1840s and 1850s were practically obliged to be partisans of either colour or line.[43] But, once again, Flaubert's love of colour was a matter of instinct rather than fashion or intellectual choice. Already in the very early *Souvenirs, notes et pensées intimes*, he notes that he is a colourist of the most ardent hue: 'les demi-teintes ne me vont pas—aussi j'aime l'épicé, le poivré ou le sucré, le fondant aussi, mais le délicat point—la couleur, l'image avant tout' (p. 106).[44] Colour is life itself—hence Flaubert's loathing for 'l'art néochrétien', which, with its 'amour de la maigreur, du gris—de l'anti-physis' is 'la négation de la peinture'.[45]

Colour has to come from within as much as from without, for Flaubert.[46] If the poetry of Auguste Lacaussade, who was born in La Réunion, reveals nothing of the colour we might expect from such a volume, it must be because colour is a child of the grey North rather than the exotic South (though it could simply be that Lacaussade would be a bad poet wherever he was):

[42] Cf. *C1* 307 (21–2 Aug. 1846): Flaubert acquires Callot's *Tentation de saint Antoine*. Callot made two engravings of the *Tentation*, one in 1617, the other in 1634. Flaubert acquired the latter, reproduced *Album Flaubert*, 56–7 (cf. Seznec's notes on Flaubert, Taylor Institution, Oxford, section 1). On Callot, cf. also *PCG* 690, *ES* 3: 76, *VO* 11: 153–4.

[43] The bibliography of this subject is vast. Colour was apt to accrue connotations to itself. During Flaubert's lifetime e.g. it was associated first with Romanticism and then with Realism. Cf. Iknayan, *Concave Mirror*, 172, on hostile contemporary reactions to Horace Vernet's *Mazeppa*, where the *image* was felt to be more striking than the *idea* which the image was intended to symbolize: 'This is what strikes the critics and often displeases them: the predominance of the concrete and the colourful, even when used emblematically.' Fromentin associates colour with Realism: 'La doctrine qui s'est appelée *réaliste* n'a pas d'autre fondement sérieux qu'une observation plus saine des lois du coloris', *Maîtres d'autrefois* (1972), 203. For a detailed survey of connotations of colour throughout the ages, cf. John Gage, *Culture and Colour: Practice and Meaning from Antiquity to Abstraction* (1993).

[44] Cf. *Novembre*: 'J'ai toujours aimé les choses brillantes' (11: 616), *C1* 278 on 'les tableaux colorés' and *C1* 771 on 'les tintamarres de la couleur'. Cf. also, still, 15: 512 to his niece: 'Tu sais bien, Loulou, que pour orner le grand panneau de l'escalier, tu *me* dois un Vénitien, quelque chose de royal et *d'archicoloré*' (15 May 1876).

[45] BMR, ms g 226[1] 162.

[46] Cf. this rather obscure comment to Bouilhet in a letter written from Rome, *C1* 778 (4 May 1851): 'La violence de la couleur ne s'obtient que par l'exactitude de la couleur même, pénétrée de notre sentiment subjectif.'

Une réflexion esthétique m'est surgie de ce vol[ume]: combien peu l'élément extérieur sert! Ces vers-là ont été faits sous l'équateur et l'on n'y sent pas plus de chaleur ni de lumière que dans un brouillard d'Écosse. C'est en Hollande seulement et à Venise, patrie des brumes, qu'il y a eu de grands coloristes! Il faut que l'âme se replie. (C2 349: 6 June 1853)

Flaubert was not the only artist at the time to entertain the idea that colour is a product of the North;[47] but he was pleased enough with it to apply it to himself shortly afterwards—suffering from the current lack of colour in his own life, he seeks compensation in art:

L'inaction musculaire où je vis me pousse à des besoins d'action furibonde.— Il en est toujours ainsi. *La privation radicale d'une chose en crée l'excès.*— Et il n'y a de salut pour les gens comme nous que dans l'excès. Ce ne sont pas les Napolitains qui entendent la couleur, mais les Hollandais et les Vénitiens. Comme ils étaient toujours dans le brouillard, ils ont aimé le soleil. (C2 543–4)

Colour, coming from within, is something Flaubert himself likes to supply, both literally, when as a child he colours illustrations in his books, and metaphorically, as an adult.

Colour is not only poetic but frightening. When he relives his early fears on rereading his childhood books for *Madame Bovary* he does so in part just *because* he had coloured them in strange colours. Flaubert extends the implications of that remark a year later to an old edition of the *Contes des fées* by Mme d'Aulnoy, which he is currently rereading. Here, too, he had coloured in the pictures years ago and created strange new forms such as pink dragons and blue trees. In one of them, everything is coloured red, including the sea: 'Je lis maintenant les contes d'enfant de Mme d'Aulnoy dans une vieille édition dont j'ai colorié les images à l'âge de six ou sept ans. Les dragons sont roses et les arbres bleus; il y a une image où tout est peint en rouge, même la mer' (C2 359: 20 June 1853).[48] The letter goes on to talk about 'un de mes vieux rêves', which is to write 'un roman de chevalerie', where the element of colour will

[47] Among Flaubert's contemporaries, cf. also Baudelaire 'Salon de 1846', *Critique d'art*, 81, and in the Goncourt *Journal*, ii. 79: 23 Apr. 1867.

[48] See bibliography for Mme d'Aulnoy's *Contes des fées* (1698, illustrated by 'Raymond'). Cf. Baudelaire, quoted by Jules de Levallois in his *Mémoires d'un critique*: 'Je voudrais, disait Baudelaire, avec son air de pince-sans-rire, des prairies teintes en rouge et les arbres peints en bleu. La nature n'a pas d'imagination.' (Cited by N. Savy, 'Charles Baudelaire ou l'espoir d'autre chose', in *Regards d'écrivain au musée d'Orsay* (1992), 51.

be supplied metaphorically rather than literally, through what he calls 'terreur' and 'poésie large': 'Je crois cela faisable, même après l'Arioste, en introduisant un élément de terreur et de poésie large qui lui manque.' It is in *La Légende de saint Julien l'Hospitalier* that this procedure will best be seen.

Colour was generally considered at the time to be subversive and barbaric, and that is one reason why Flaubert liked it so much— 'Plus vous aurez de couleur, de relief, plus vous heurterez' (C2 358).[49] Flaubert pushed the enjoyment of colour to extremes. His relish for the sensitivity to the 'grossissements de ton' which he found in Veronese extends to a love of the gaudy. Also, colour is the essence of the painterly. Fosca, building on Mérimée's assessment of Stendhal, equates sensitivity to colour with a sensitivity to non-literary qualities in painting:

Admirateur passionné des grands maîtres des écoles romaine, florentine et lombarde, [Stendhal] leur a prêté souvent des intentions dramatiques qui à mon avis leur furent étrangères [. . .]. Beyle faisait peu de cas des coloristes [. . .]. Il méprisait profondément Rubens et son école, il reprochait aux Flamands et même aux Vénitiens la trivialité des formes et la bassesse de l'expression.[50]

A statement by Mérimée himself about what he sees as Stendhal's lack of response to form and colour shows how unusual a sensibility like Flaubert's was felt at the time to be: 'C'est encore la façon de juger en France, où l'on n'a ni le sentiment de la forme, ni un goût inné pour la couleur. Il faut une sensibilité particulière et un exercice prolongé pour aimer et comprendre la forme et la couleur [. . .]. C'est le propre des Français de tout juger par l'esprit.'[51] For Flaubert, on the contrary, colour was often the dominant element in a painting, to the exclusion of all else: 'Admirable couleur qui

[49] Cf. Gautier, 'Le Salon de 1869', in *Tableaux à la plume* (1880), 323: 'La couleur choque toujours un peu les peuples de civilisation raffinée qui se plaisent aux teintes neutres ou sobres, comme plus *distinguées*, c'est-à-dire de celles que ne choisiraient pas un paysan, un sauvage, ou tout être encore naïf'. See also Francis Haskell, 'Art and the Language of Politics', in *Past and Present in Art and Taste* (1987), 66, and Kenneth Clark, *Landscape into Art* (1961), 106: 'To read what was said of colour by Ingres, Gleyre, Gérôme, and the other great teachers of the nineteenth century, one would suppose that it was some particularly dangerous and disreputable form of vice. That was a rearguard action of idealist philosphy.' Cf. also below for the Goncourts' wincing assessment of this and other barbaric tastes in Flaubert.
[50] F. Fosca *De Diderot à Valéry* (1960), 40.
[51] Mérimée, *H.B.* (1983), 32–3.

passe sur tout', he notes in 1851 of Rosa's *Cristo tra i dottori* (11: 121). Flaubert was quite aware that what he liked in painting above all else was the painterly: 'Les œuvres d'art qui me plaisent par-dessus toutes les autres sont celles où l'art *excède*. J'aime dans la peinture, la Peinture, dans les vers, le Vers' (*C3* 111).[52]

While it may be useful or illuminating to identify the particular characteristics of Flaubert's taste, as we have just done, it is true, also, that the idea of 'taste' is often irrelevant to the question of Flaubert's responses to painting. When he kissed the armpit of Canova's *Psyche* in the villa Carlotta in Como (*IS* 10: 377), he did so not because he had a taste for Canova, because he had not[53] —the gesture simply reflected a sudden spontaneous tenderness for that particular sculpture. Similarly, bad art, which was only very perversely to his taste, was nevertheless all grist to his own aesthetic mill, regardless. However, his tastes in painting are good indicators, reflectors of his own aesthetic aims, and, occasionally, counterweights to them.

Specific Painters and Genres

The qualities Flaubert liked he found in the old masters, not in contemporary painting of the kind which made its way into the *Salons*, or aspired to do so.[54] He also found them in non-Western art.

Old Masters

Flaubert's ideal of painting was expressed above all in the works of the greatest masters—the colourists, Titian, Veronese, and Velvet

[52] Cf. Delacroix, *Œuvres littéraires* (1923), ii. 138: 'On trouve un mystérieux plaisir, et j'allais dire un plaisir plus pur et plus dégagé de toutes les impressions étrangères à la peinture, dans la contemplation de ces scènes dont les sujets sont sans explication; la peinture seule y triomphe comme la musique dans une symphonie.'

[53] Cf. e.g. the disparaging reference to the tombs of the family of Mehemet Ali, 'd'un goût déplorable, rococo, canova' (*VE* 228).

[54] Flaubert resembles painters of the avant-garde of the 1860s, who drew inspiration directly from the works of the masters, rather than obeying the principles the masters were deemed to have bequeathed, cf. J. Rewald, *The History of Impressionism* (1946), 64: 'For many painters of their generation [*the 1860s*] the Louvre became a healthy counterbalance to the instruction at the *École*' and they find 'in the works of the past a guidance congenial to their own longings'. Cf. also N. Savy, *Regards d'écrivain*, 44, of Baudelaire: 'Il attend décidément autre chose.' Cf. also A. Brookner, *The Genius of the Future* (1971), on the perceived need in the 19th cent. for a genius, and the sense that his/her time was yet to come.

Brueghel; painters whose works Flaubert regarded as being on a grand scale (Michelangelo and Rubens); and Rembrandt.[55] Flaubert was attracted above all to the painterly painters of the Venetian school, the 'école voluptueuse', as Stendhal called it.[56] Stendhal was not drawn to this group of painters because for him they were 'des peintres sans idéal'.[57] Flaubert, on the other hand, reluctant as ever to separate 'matière' and 'esprit', is convinced that poetry and the ideal are to be found precisely in the work of these so-called 'matérialistes': 'Je compte être à Venise vers le commencement de juin et je m'en fais une fête. Je m'y foutrai une bosse de peinture vénitienne dont je suis amoureux. C'est définitivement celle qui m'est la plus sympathique. On dit que ce sont des matérialistes. Soit. En tout cas ce sont des coloristes et de crânes poètes' (C1 774).[58] This is the kind of painting which satisfies his instinct for colour and surfaces, and 'dans la peinture, la Peinture'.[59]

Flaubert's love of excess, of art pulsing with energy and life, drew him to Michelangelo and to Rubens. Michelangelo gives the sense of a hyper-reality, a 'grossissement de ton' projected before one's very eyes: 'Les bonshommes de Michel-Ange ont des câbles plutôt que des muscles' (C2 385).[60] Michelangelo was regarded by Flaubert's contemporaries as being pure plasticity. For Stendhal, 'Michel-Ange n'est que terrible',[61] and that is the reason the French cannot

[55] This list is not of course exhaustive. Cf. e.g. on La Tour (C3 659).

[56] *Histoire de la peinture en Italie*, in *Œuvres complètes* (1969), i. 177.

[57] *Rome, Naples et Florence*, in *Voyages en Italie* (1973), 489. In this respect, Flaubert's taste coincided with that of Gautier, see M. C. Spencer, *The Art Criticism of Théophile Gautier* (1969), ch. 4. Cf. Du Camp, *Souvenirs littéraires*, 497, on the relative popularity of the Old Masters in the artistic circles in which he and Flaubert moved in their youth. 'Out' were David, Guérin, Gérard, Girodet, Raphael ('poncif'), and Leonardo ('rococo'); 'in' were only Michelangelo and Titian.

[58] Cf. also C1 780: 'Je suis très exalté relativement à l'école vénitienne.'

[59] For Gautier, too, Veronese gives the pleasure of painting in its purest form, 'le plaisir de la peinture en elle-même poussé à sa dernière puissance, en dehors de l'idée, du sujet et de la vérité historique' (*Guide de l'amateur du Musée du Louvre* (1882), 41). Gautier defends Veronese against the view that he is merely an 'éblouissant décorateur', and that his painting 'manque de cœur et d'idéal': Veronese's paintings reflect an *intention*—to show that happiness can exist here and now, cf. Gautier, *Tableaux à la plume* (1880), 14.

[60] Cf. Stendhal on the *beau idéal* of Michelangelo: 'exagérer le renflement des muscles dans leur contraction', *Idées italiennes sur quelques tableaux célèbres*, *Œuvres complètes*, xlvii. 137.

[61] *Vie de Rossini*, *Œuvres complètes*, xxiii. 431; cf. P. Berthier, *Stendhal et ses peintres italiens* (1977), 71—Michelangelo's is 'une peinture anti-picturale qui évacue les délicieuses et subtiles nuances de la vie intérieure au profit d'une expression purement plastique'.

appreciate his painting, it is too strong meat, of a 'formidable *incivilité*'.[62] Flaubert was one Frenchman who *could* appreciate Michelangelo, and for precisely these reasons: what better antidote, as Stendhal says, to 'les grâces de la lithographie et les keepsakes anglais'.[63]

'Dans les bacchanales de Rubens on pisse par terre' (C2 385).[64] Nineteenth-century views of Rubens tended to emphasize the animal exuberance of his paintings: Delacroix, commonly referred to at the time as the modern Rubens, talks of Rubens's 'manière exubérante' —'son tableau ressemble à une assemblée où tout le monde parle à la fois'[65]—and admires him (in Taine's words) for his depiction of 'les dégradations bestiales, les origines animales de l'homme'.[66] Baudelaire highlights other aspects of Rubens which make him congenial to Flaubert when he says that he gives the effect of several firework displays all going off at once: 'Il y a des tableaux de Rubens qui non seulement font penser à un feu d'artifice coloré, mais même à plusieurs feux d'artifice tirés sur le même emplacement.'[67] If Veronese is 'la couleur paradisiaque et comme d'après-midi', Rubens is 'l'abondance prolifique, rayonnante, joviale presque'.[68] Those who did not admire Rubens accused him of crude materialism.[69] Flaubert knew that to admire Rubens was to offend against the canons of contemporary good taste, and so he thanks Taine for giving due prominence in his *Philosophie de l'art dans les Pays-Bas* to 'le grandissime Rubens que les gens de goût méprisent et que moi j'idolâtre' (C3 822).

Flaubert was extremely receptive to Rembrandt, as he says in letters both to Fromentin[70] and to Taine, when he comments on Taine's *Philosophie de l'art dans les Pays-Bas*. The latter case is illuminating. Flaubert actually *says* very little about Taine's presentation of Rembrandt, simply that he admired 'pages 162–3, la

[62] Berthier, *Stendhal*, 73.
[63] *Correspondance* (1968), iii. 322 (24 Jan. 1840).
[64] Flaubert has a precise painting in mind, the *Baccanalia* (see Appendix A, Uffizi).
[65] Delacroix, *Journal*, 365: 12 Oct. 1853.
[66] Taine, *Notes sur Paris: Vie et opinions de M. Frédéric-Thomas Graindorge* (Hachette, 1857; repr. Éditions d'aujourd'hui, 1982), 283.
[67] Baudelaire, 'Salon de 1859', *Critique d'art*, 286.
[68] Baudelaire, *L'Œuvre et la vie d'Eugène Delacroix*, *Critique d'art*, 404.
[69] Cf. P. G. Castex, *La Critique d'art en France au XIXᵉ siècle* (n.d.), 16.
[70] 'Deux figures dominent l'ensemble, celle de Rubens et celle de Rembrandt. *Vous faites chérir* la première, et devant la seconde on reste rêveur' (15: 470).

psychologie de Rembrandt' (*C3* 822). However, if we turn to those two pages in Taine, we discover some revealing points of connection between Taine's assessment of Rembrandt and his assessment of Flaubert himself, included in *De l'intelligence*. Taine emphasizes Rembrandt's visual acuity ('la délicatesse et l'acuité natives de ses perceptions optiques', 'la sensibilité excessive de ses organes'), his qualities of sympathy and compassion for humanity ('il est peuple; du moins il est le plus humain de tous; ses sympathies plus larges embrassent la nature plus à fond; aucune laideur ne lui répugne, aucun besoin de joie ou de noblesse ne lui dissimule aucun bas-fond de la vérité'),[71] and, more importantly still, his astonishingly powerful visual imagination, which Taine compares with that of Balzac, but which Flaubert will almost certainly have recognized in himself: 'Celui-ci, collectionneur, solitaire, entraîné par le développement d'une faculté monstrueuse, a vécu, comme notre Balzac, en magicien et en visionnaire, dans un monde construit par lui-même et dont seul il avait la clef.'[72] The fact that, having 'dealt with' Taine's *Philosophie de l'art dans les Pays-Bas*, Flaubert then passes, with no transition, to ask how Taine's other current *opus De l'intelligence* is coming along, for which he himself had been such a willing guinea-pig, indicates beyond reasonable doubt that Flaubert recognized the connections between the strange faculties attributed by Taine to Rembrandt, and the strange faculties recognized by Taine in Flaubert. Flaubert's transition from one of Taine's books to the other is a transition from one pair of visionaries (Rembrandt, Balzac) to the visionary that he himself represents, for Taine.

Non-Western art

Those who have accused Flaubert of seeing art and nature through Western eyes only[73] are ignoring, among other things, the breadth of his experience and appreciation of other kinds of art. Few connoisseurs of Flaubert's time extended their appreciation of art to

[71] Taine, *Philosophie de l'art dans les Pays-Bas* (1868), 161, 163–4. Cf. Flaubert himself: 'Je ne veux avoir ni amour, ni haine, ni pitié, ni colère. Quant à de la sympathie, c'est différent. Jamais on n'en a assez.' *C3* 786 (10 Aug. 1868).

[72] Taine, *Philosophie de l'art dans les Pays-Bas*, 161.

[73] Cf. esp. E. Said, *Orientalism* (1978), and, after him, Timothy Mitchell, *Colonizing Egypt* (1988). See D. Gregory, 'Between the Book and the Lamp', *Trans. of the Inst. of British Geographers* (1995), for a counter-argument.

Byzantine mosaics, for example, but Flaubert found them fascinating, and devoted considerable space to them in his notes on Rome of 1851 (see below, Part II), noting himself that his taste for them is unusual: 'qui est-ce qui a étudié le byzantin? (*VO* 11: 151).[74] Its attraction for Flaubert, as we shall see, was due in part to its lack of realism in the received Western sense. To Western forms of realism Flaubert was on the whole blind.[75] He hardly registers Dutch genre painting, for example, so popular at the time, though his writing has often been compared with it.[76] There is only one reference to Dutch realist painting in Flaubert's travel notes up to 1851 (Frans van Mieris, *The Painter's Family* in the Uffizi, *VO* 11: 169), and that is rather dismissive of what Flaubert perceives as its air of cosy intimacy.[77] His visit to England in 1865 necessarily brought more painters of the Dutch school to his attention, but that encounter was not enough to make him feel he was in any sense an expert, as he says to Turgenev in 1876: 'Fromentin m'a envoyé son livre sur "les maîtres d'autrefois". Comme je connais fort peu la peinture hollandaise, il manque pour moi l'intérêt qu'il aura pour vous' (15: 460–1). The only kind of realism which attracts Flaubert in Western art is of a deviant nature, what might be called 'hard

[74] This situation was in the process of changing, cf. especially, in England, the work of Owen Jones, *The Grammar of Ornament* (1856), which includes discussion and illustration of the ornamentation in early Christian mosaics. Two remarks by Delacroix, thirty years apart, reflect the change in attitudes towards Byzantine art during this time: *Journal*, 91: 4 Oct. 1824, speaking of 'M. Auguste' and his superb sketches of Neapolitan tombs: 'Il parle du caractère neuf qu'on pourrait donner aux sujets saints, en s'inspirant des mosaïques du temps de Constantin', and ibid. 515: 17 June 1855, the Byzantine has become an established model, copied rather than emulated—modern imitators 'n'en prennent que la raideur, sans y ajouter de qualités propres'. Stendhal mentions Byzantine mosaics with approval, but only in passing (*Voyages en Italie* (1992), 947). Taine's presentation of Byzantine art in his *Voyage en Italie* (ii. 209 ff.) earns a mild expression of approval from Flaubert (*C3* 548).

[75] Cf. Gage, *Culture and Colour*, 47, for the two main schools of thought concerning Byzantine art, one emphasizing its verisimilitude, the other its hieratic, ideal, and spiritual qualities.

[76] Cf. e.g. the very astute remark by D. Roe: 'Flaubert had a painter's eye for effects of light and shade, like the Dutch masters with whom he is often compared for his general ability to transform banal subjects. Like them, too, he knew how to invest the everyday with a discreet symbolic weight, though his code, unlike theirs, is a private one, opening much of his texts to a plurality of readings', *Gustave Flaubert* (1989), 47.

[77] Baudelaire was also unfamiliar with Dutch painting, despite what might have been assumed from *L'Invitation au voyage*, cf. Baudelaire, *Curiosités esthétiques*, 366 n. 1.

realism'—the kind of naturalism which, like his writing, pulls no
punches, such as Artemisia Gentileschi's *Judith* which is 'd'une vérité
canaille', or tilts the viewer into some extreme state of feeling to
which any conventional idea of 'aesthetics' seems irrelevant or
inadequate. *Contemporary* realism is certainly altogether far too
pallid for Flaubert, except when it takes on the deviant form of
caricature.

Otherwise, Flaubert prefers anti-naturalism, or stylization. Thus,
his notes on the examples of Chinese art displayed in the Great
Exhibition of 1851 not only display his great admiration for their
splendour, their brilliant colours, and wonderful inventiveness, but
also, more coolly, register the blatant lack of naturalism in the treat-
ment of everyday subjects.[78] Flaubert's interest in Chinese art was
a rare phenomenon at the time. When Chinese art came to Paris
later, as part of the Exposition Universelle of 1855, only Gautier
and Baudelaire made any reference to it. Even then, Gautier was
clearly uneasy with the unfamiliar forms.[79] Baudelaire's reaction was
closer to that of Flaubert, daring to pronounce it an 'échantillon de
la beauté universelle', where others saw just strangeness and *laideur*
or no art at all.[80]

Flaubert is attracted to the same combination of realism and
stylization in ancient Persian miniatures, which he was able to con-
template during the *Voyage en Orient* and which he compares to
'les vieux dessins moyen âge' in their ability to 'faire rêver' (10: 593).
This was an interest shared by Ingres and, later, Degas.[81] Flaubert
is particularly intrigued by Persian erotica, noting how its aim, the

[78] Cf. Seznec (ed.), *Flaubert à l'Exposition de 1851* (1951), 37: 'il n'y aucune inten-
tion d'imiter la nature'.

[79] Cf. Gautier, 'Collection chinoise' in *Les Beaux-Arts en Europe* (1856), i.
131–2: 'les Chinois cherchent le laid idéal; ils pensent que l'art doit s'éloigner autant
que possible de la nature, inutile selon eux à représenter [. . .]; mais composer un
monstre qui ait les apparences de la vie, inventer des paysages chimériques, peindre
de couleurs fictives des êtres imaginaires, faire tenir dans le même cadre des objets
que la perspective sépare, voilà à quoi un maître se reconnaît. Un tigre bleu-de-ciel,
un lion vert-pomme [. . .]'. Cf. also the revealing phrase in the subsequent state-
ment that 'De telles figures, *en dehors de tout art*, peuvent cependant faire rêver
[. . .]', ibid. 134 (my emphasis).

[80] Cf. Baudelaire, 'Exposition universelle (1855)', in Baudelaire, *Critique d'art*,
597 n. 2.

[81] On Ingres's interest in Persian miniatures, cf. L. Hautecœur, *Littérature et
peinture en France* (1963), 49, and Baudelaire, 'Exposition Universelle (1855)', *Critique
d'art*, 248. On Degas's later manifestation of interest, cf. Fosca, *De Diderot à
Valéry*, 281.

realistic depiction of sexual organs, is so strong (in the interest of arousing the viewer) that it defeats its object, tilting it out of realism and into pure stylization and surrealism.

Japanese art comes into the picture later, and once again Flaubert's response is part sensual, part intellectual. Flaubert becomes aware of Japanese art at much the same time as his contemporaries do, that is, at about the same time as the Goncourts began to pursue their fascination, and, indeed, often discusses it with them. Colour was once more part of the attraction—the Goncourts' albums of *japonaiseries* over which Flaubert pores are 'régals de couleur', of a splendour against which the task he *should* be engaged in, the writing of *Bouvard et Pécuchet*, makes a very poor *grisaille*.[82] Like other artists of his time, Flaubert was drawn also to Japanese art by the attractions of unfamiliar perspectives, as his letter to Chesneau shows (questions of perspective having exercised him greatly in his art commentaries and travel descriptions). Chesneau makes the point that Westerners do not understand that the distortions characteristic of paintings on Japanese vases are designed to allow for the fact that they would be seen from below.[83] Flaubert also concurs with Chesneau's analyses of a realism which is stylized without distortion of basic forms, and a fantastic which gives the illusion of reality, in its depiction of monsters which are none the less 'vrais'.

Though Flaubert's enthusiasm for these new and exciting forms was shared by contemporary painters and writers, it did not extend to the ramifications of some of its effects in their work. Nor, typically, could Flaubert bear the current vogue for *japonaiserie*—he was all too conscious that something of real value and interest was in the process of being vulgarized. By 1879, that process is complete, and Japanese art has become a cliché—Japanese-style patterning is everywhere, even in the poor illustrations to Mme Régnier's fairy story *La Princesse Méduse*: 'Et les cassures japonaises en bas des

[82] Cf. 16: 317 (11 Feb. 1880): ''L'ami Flaubert' s'est bassiné l'œil cet après-midi avec vos Albums japonais. Mais je ne voudrais pas me livrer souvent à de pareils régals de couleur, car je retombe plus gémissant sur mon roman *philosophique*!!!' Cf. also C4 753—Cernuschi is to show him 'ses curiosités japonaises'—and C4 664 (20 May 1873) on Flaubert's own 'portraits de japonaises'. Cernuschi's splendid collection eventually became the musée Cernuschi.

[83] Cf. Ernest Chesneau, *Peinture—Sculpture—Les Nations rivales dans l'art* (1868), 420–1: 'Qui ne s'est rendu compte de l'effet déplorable que produisent ces imitations de peinture lorsqu'elles sont appliquées sur des surfaces tournantes comme celles d'un vase, ou lorsque ce vase lui-même n'est pas posé à la hauteur voulue pour que le regard occupe précisément le point de vue du tableau représenté.'

draperies. Pourquoi le Japon? Mais le chic! le chic!' (16: 272). Such standardization is typical of contemporary art, in Flaubert's view.

Contemporary Western Art (Major Painters)

Flaubert's remarks about contemporary art are almost all derogatory, with some few exceptions—John Martin, the painter of huge, complex, imaginary monuments, certain caricaturists and satirists (Daumier, Gavarni, and Grandville), and Moreau.[84] He regards most mainstream contemporary art as being locked in the past. Where Flaubert turns to the art of the Old Masters to create something *new*, contemporary art simply aims at reproducing their effects. History painting is set in stone—Flaubert was scathing about the neo-Pompeian school, of which Gérôme was the recognized leader,[85] and sums up his objections in a typically pithy comment: 'Il y a toute une école de peinture maintenant qui, à force d'aimer Pompéi, en est arrivée à faire plus rococo que Girodet' (C2 749: July 1857); Gérôme is simply another *copiste*, painting the letter of the past, not the spirit, and his artificial reconstruction of lost generations by means of an exhaustive incorporation of historical detail, was all too close to what Flaubert feared he might be construed as doing in *Salammbô*.[86] The art of portrait painting also has made little advance on the stylized modes of the preceding generation, 'où l'on vous peignait en manteau et chevelure au vent' (PCG 193).[87] 'Painterly' pantings are in short supply.[88] What passes for realism

[84] For John Martin, cf. *PCG* 112 and *VO* 10: 569 and Seznec, *John Martin en France* (1964). Flaubert draws extensively on Gavarni for *L'Éducation sentimentale*, cf. A. Fairlie, *Imagination and Language* (1981), 376, on the costumes for Rosanette's ball. Flaubert's one reference to Grandville is appreciative (*VO* 11: 126).
[85] Cf. Du Camp, *Souvenirs littéraires*, 249, of Gérôme's *Combat de coqs*, shown at the *Salon* of 1847: 'Gautier ne s'était pas trompé, une nouvelle école venait de naître: le chef des Pompéistes s'était révélé.'
[86] On the connections between Flaubert and Gérôme, cf. Fairlie, *Imagination and Language*, 362.
[87] Flaubert's target here seems once again to be Girodet (cf. his famous portrait of Chateaubriand). Girodet is associated by Flaubert with abuse of a particular kind of 'vert épinard', cf. Flaubert, *Conte oriental*, ed. J. Bruneau (Denoël, 1973), 96: 'clair de lune derrière des cyprès, vert et bleu—s'écarter du vert épinard de Girodet'. (But cf. *DIR*: 'PAYSAGES de peintre: Toujours des "plats d'épinards"!')
[88] The Goncourts shared this view, cf. *Journal*, i. 435 (16 Jan. 1859), of a painting of 'un bœuf ouvert et pendu. Voilà la peinture, décidément, et un peintre! Le reste appartient au livre. De Poussin à Delaroche en passant par David, que de fruits secs des lettres!'

is timid and half-hearted. All are adulterated, etiolated products of a society that has run itself dry. Though Flaubert's comments on Horace Vernet's *Judith* in 1845 were favourable (see below), a mere three years later Vernet figures along with Scribe and Eugène Sue as being very light fodder indeed: 'quelque chose de digestion facile et qui ne tienne pas de place au ventre pour qu'on en puisse manger davantage' (*PCG* 595).[89] Contemporary painting resembles contemporary engravings and lithographs for Flaubert: all are just *copies*, intended for quick and easy consumption. However, the fact that these lightweights were to be joined shortly on Flaubert's hit-list by Courbet is proof that vigour in itself was not sufficient.

Flaubert responded vigorously to the stars of each successive generation of painters throughout his life: Delacroix, Ingres, and the Barbizon school in the 1840s, Courbet in the 1850s, Moreau in the 1860s, and, finally, Manet and the Impressionists.

The 1840s: Delacroix, Ingres, and the Barbizon school

Flaubert's sympathies went to Delacroix rather than to Ingres, less because of the perceived polarities of colour and line than because Delacroix represented an attempt to find a way forward and Ingres was locked into the past. Thus, in *Par les champs et par les grèves*, Flaubert notes Delacroix's *Le Kaïd*, recently acquired by the Musée des Beaux-Arts of Nantes, as a painting which was very much to his taste, as against the kind of painting admired and imitated by the current curator, whom Flaubert suspects of being addicted to allegorical landscape painting *à la* Bertin and to history painting 'à grand renfort de lances en queue de billard, et de casques en pot à l'eau' (*PCG* 173).[90] Ingres, on the other hand, simply reproduces old, dead forms: Flaubert states his entire agreement with Chesneau's views on that subject in *Les Nations rivales* (*C3* 807).[91]

[89] For similar sentiments cf. *C3* 403 (9 Aug. 1864). Flaubert had much the same opinion of Meissonnier, cf. *CT* 562. Baudelaire expresses similar sentiments but changes the metaphor, cf. 'Salon de 1846' on Vernet's 'masturbation agile et fréquente', *Critique d'art*, 130.

[90] Delacroix, *Le Kaïd, chef marocain*, exhibited at the 1838 *Salon*, was acquired by the Musée des Beaux-Arts of Nantes in 1839. Victor Bertin (1775–1842) was noted for his historical landscapes. For other brief references to Delacroix, cf. *ES* 3: 162 (the shortening of his *Bataille de Taillebourg* by the musée de Versailles) and 3: 297 (Frédéric proposes a grant for Delacroix and for Hugo).

[91] Cf. Chesneau, *Les Nations rivales*, 215: 'Ingres, et après lui Flandrin, en fondant le type accepté de l'art religieux, ont arrêté pour longtemps toute espèce de

Otherwise, Flaubert ignores Ingres almost entirely. All he can find to say about the *Paolo e Francesca* exhibited in Naples is that Paolo's neck is far too long (*VO* 11: 122).[92]

However, Flaubert's opinions are not set in stone, however passionately expressed. The unknown woman with whom he falls in love on sight in the church of S. Paolo fuori le mura in Rome in 1851 is an Ingres, or a Lehmann (Ingres's pupil) (*VO* 11: 155);[93] and he is fascinated by George Sand's account of a conversation with Delacroix, in her *Impressions et souvenirs*, the 'deux pages curieuses sur ce qu'il pensait du père Ingres' (*C4* 669), where Delacroix reveals himself to be far less dogmatic and hostile to Ingres than his own supporters are. The passage is amusing. Protesting that he cannot say a word because he has laryngitis, Delacroix still manages to hold forth at some length on the subject of Ingres, and, in particular, on his use of colour which he compares to that of an up-ended 'pavé de mosaïque' (which gives it a strange merit).[94]

Flaubert never names any of the painters of the Barbizon school, though its influence is apparent in his travel account, *Par les champs et par les grèves*. His travelling companion on that excursion, Du Camp, is far less reticent on the question of painterly influences.[95] But when Flaubert refers there to a conversation he has about art with Du Camp, the subjects of that conversation (Isabey and Pradier, specified in the notes) are reduced in the final text to the most distant of allusions: neither is named, and their art works are reduced to mere fragments, 'des coins de tableaux [. . .], des façons de draperies' (*PCG* 519). But in the evocation of Fontainebleau

manifestation originale en ce sens [. . .]. L'art chez Ingres et chez Flandrin n'a plus rien de jeune, il n'a rien des œuvres qui sont un commencement. Il est absolument et uniquement un résultat, et chez Flandrin surtout un résultat débile.'

[92] Ingres may well be one of the painters behind Léon's composite conception of Emma as the *odalisque au bain* (*MB* 1: 285); and so may Delacroix . . . Ingres's portrait of Cherubini serves simply as a historical marker in *L'Éducation sentimentale* (3: 75).

[93] Fairlie, *Imagination and Language*, 361, makes this point.

[94] See bibliography for Sand's article.

[95] Looking back on 1847, Du Camp sees it as a particularly exciting year for painting. He names Isabey, Delacroix, Couture, Gérôme, and the Barbizon painters, Diaz *et al.*, as being the most exciting of all: 'Diaz, encore peu connu, dénonçait de fines qualites de luminariste dans son *Dessous de forêt*. Les rapins allaient, venaient, couraient de Diaz à Isabey, d'Isabey à Delacroix, de Delacroix à Couture, de Couture à Gérôme et criaient: "David est mort, vive la couleur!" ' *Souvenirs littéraires*, 249. Also, Du Camp dedicates ch. 4 of *PCG* to Luminais, the painter of Breton scenes and landscapes.

in *L'Éducation sentimentale*, there is a tiny vignette of a painter, poised by his outdoor easel, painting the forest. At this point (novel time 1847) and in that place this little figure can only be a painter of the Barbizon school; Flaubert's own version of the Barbizon painters' favourite subject (the forest of Fontainebleau) thus comes complete with a little relic of the past, a tribute to those now outmoded outdoor painters. We shall see, in Chapters 3 and 7, that they influenced his own evocations of landscape in 1847 and again in *L'Éducation sentimentale*.

The 1850s: Courbet

It is customary to make connections between Flaubert's writing and Courbet's painting, and of course illuminating comparisons can be and have been made. But Flaubert himself had serious reservations about Courbet. This was partly because the Courbet Flaubert saw was not the Courbet we see. We gloss over Courbet's public pronouncements, but for Flaubert they were impossible to ignore, and indeed obscured the artist in his eyes. Courbet committed the cardinal sin, for Flaubert, of trying to *explain* his art, of trying to supplement images with words. Courbet was guilty of painting to a theory, and thereby *necessarily*, in Flaubert's eyes, falling short of the greatest art. Flaubert never forgave him for this. As late as 1878, writing to the Belgian Naturalist Camille Lemonnier to thank him for his book on Courbet, Flaubert fastens on one phrase and gives it his enthusiastic support: 'Un mot profond m'a fait rêver: "Il n'a pas eu la peur sacrée de la Forme", rien de plus juste, et c'est pourquoi cet habile homme n'était pas des plus grands [. . .]. Du reste je n'aime les doctrinaires d'aucune espèce [. . .]' (16: 53).[96]

All Flaubert's references to Courbet spring from his objection to this basic point of principle. It is such a firm principle that it makes him distort the critic Ernest Chesneau's recent mild defence of Courbet into an attack. Chesneau's point is that Courbet's art is better than his theory—in theory Courbet is not an 'idéaliste', but in practice he is, so he offers the viewer something better than brute realism or crude *trompe-l'œil*. But Flaubert twists Chesneau's term 'idéaliste' to make it mean a 'peintre à idées', in the usual, pejorative sense, and this enables Flaubert to nail Courbet yet again to the

[96] For the phrase in question, cf. C. Lemonnier, *Gustave Courbet et son œuvre* (Alphonse Lemerre, 1868), 38.

cross of crude realism and ideological fanaticism: 'Je pense comme vous: "Dès qu'il y a interprétation dans l'œuvre d'un peintre, l'artiste a beau s'en défendre, il fait fonction d'idéaliste" [. . .]. Bref, on n'est idéal qu'à la condition d'être réel et on n'est vrai qu'à force de généraliser' (C3 807). Flaubert found Courbet essentially anti-Romantic, and Proudhon, who praised him, to be tarred with the same brush. Proudhon is in fact worse than Courbet: 'Chaque phrase est une ordure. Le tout à la gloire de Courbet et pour la démolition du romantisme' (C3 454).

Zola, later, was able to sideline Courbet's rhetoric in a way Flaubert never could: 'Courbet a pour frères, qu'il le veuille ou non, Véronèse, Rembrandt, Titien.'[97] But Courbet's immediate contemporaries were less able to do this: Flaubert is not alone in this respect—Gautier, Baudelaire, Champfleury, all expressed serious reservations about Courbet and his claims.[98] Statements such as these from Courbet were intended to be provocative and succeeded: 'Le fond du réalisme, c'est la négation de l'idéal'; 'Faire des vers, c'est malhonnête'.[99] Flaubert himself copied out phrases from Courbet's famous alternative Exhibition catalogue of 1855 in the file entitled *Esthétique*, and these phrases were obviously intended to be used against Courbet in *Bouvard et Pécuchet*.[100] One of these phrases is a sideswipe at the principle of *l'art pour l'art*, with which Flaubert was broadly in favour: 'ma pensée n'a pas été davantage d'arriver au but oiseux de *l'art pour l'art*'. The other betrays a wholesale commitment to commitment itself which was anathema to Flaubert: 'Savoir pour pouvoir, telle fut ma pensée. Être à même de traduire les mœurs, les idées, l'aspect de mon époque, selon mon appréciation, être non-seulement un peintre, mais encore un homme.' Flaubert's deep resistance to such phrases made it impossible for him to *see* Courbet's painting.

[97] Zola, 'Proudhon et Courbet', *Mes haines*, in *Écrits sur l'art* (1991), 50.
[98] Gautier begins by being favourably disposed towards Courbet (1849), but begins to have reservations from the time of the *Enterrement*, exhibited in the 1851 *Salon*: cf. S. Guégan, 'Le Théâtre idéal de Théophile Gautier', *Regards d'écrivain*, 9–41. Baudelaire followed an inverse path, at first denouncing the idea of Realism in his article of 1855, 'Puisque réalisme il y a' (a phrase of Courbet's), then, in *Peintres et aquafortistes* (1862) paying homage to Courbet, but with reservations, cf. Savy, in *Regards d'écrivain*, 70: 'Le poète tourmenté d'idéal passe à côté du peintre attaché à l'humanité et à la terre.'
[99] From an article by Courbet in the *Précurseur d'Anvers* (2 Aug. 1861), 43–74, quoted Hautecœur, *Littérature et peinture*, 77.
[100] 'Extraits de divers auteurs', BMR, ms g 226³ 56. See ch. 6 for discussion of this *dossier*.

The 1860s and 1870s: Moreau

Moreau was the only contemporary painter to be welcomed with-
out reservation into the Flaubertian canon. His first reference to
Moreau comes in the letter to Chesneau. At this time, 1868,
Moreau was still relatively unknown, having produced so far, in
terms of major works, only *Œdipe et le Sphinx* (1864), *Jason* and
Le Jeune Homme et la mort (1865), *Diomède* (1866), and *Orphée*
(1866). Flaubert thanks Chesneau for giving due praise to Moreau:
'je vous remercie d'avoir rendu justice à Gustave Moreau, que
beaucoup de nos amis n'ont pas, selon moi, suffisamment admiré'
(*C3* 807).[101] Chesneau has no hesitation in proclaiming Moreau to
be a 'jeune maître' full of promise, the only successor to Delacroix
and Ingres (pp. 180, 207–8). He also tackles squarely the familiar
charge that Moreau was a 'literary' painter by insisting that Moreau's
painting is open to multiple interpretations—'bien des interpréta-
tions différentes et toutes également justes'—not tied to one mean-
ing, as in the case of a mere 'peintre à idées' (p. 187). Moreau is a
peintre-poète, not the literary painter he is often made out to be.
Moreau gives free rein to his imagination, and supplies a 'sentiment
moderne': 'Dira-t-on (et on l'a dit) que c'est là de la peinture à idées,
de la peinture littéraire faite seulement pour réjouir les lettrés et dicter
de subtiles analyses aux critiques?' (p. 201). This will explain why
Flaubert is drawn to Moreau—not because he was a 'peintre à idées',
as he was often presented as being, but because he was not.
Moreau's aim was just as much as Flaubert's to 'faire rêver'; and
his paintings evoked *poetic* ideas, allusively, as much through the
qualities of his medium as through any representative intention.[102]

Four years later, in 1872, we note a further strand in Flaubert's
admiration of Moreau, as, smarting still from the effects of the
Prussian occupation of France, Flaubert admires the painter's
ability to remain aloof, both literally and figuratively, creating his
own private world. Moreau's studio, in his home, filled with
images, corresponds to one of Flaubert's enduring fantasies, the

[101] On Moreau, cf. Chesneau, *Les Nations rivales*, 179–208. Gautier had noted
Moreau with approval as early as 1853 (cf. Guégan, 'Le Théatre idéal').
[102] Cf. Peter Cooke, 'Gustave Moreau, "painter poet"', D.Phil. thesis, University
of Oxford, 1995, which argues this point most persuasively. Cf. also the succinct
presentation of Cooke's argument in his article, 'Gustave Moreau from *Song of Songs*
(1853) to *Orpheus* (1866): The Making of a Symbolist Painter', *Apollo* (Sept.
1998), 37–45.

studio becoming the measure of the man's mind: he shares with Moreau an '*insupportation* de la foule. C'est une affection commune depuis "nos désastres", à ce qu'il paraît' (C4 561: 22 Aug. 1872). Four years later, Flaubert visits the 1876 *Salon*, which includes four paintings by Moreau, including his two *Salome* paintings, one the *Salome dansant*, an oil, the other *L'Apparition*, a water colour, at the very moment when he is in the process of planning *Hérodias*.[103] He makes no explicit mention of either, but *Hérodias* itself is sufficient comment.

Flaubert found echoes of his own position and his own aesthetic in Moreau. The fact that Moreau stood alone in his century was clearly part of his charm; many of Moreau's paintings (*Œdipe et le sphinx* and the *Salome* paintings, among others) are about the very act of looking, thus embodying one of Flaubert's own preoccupations; the combination of fantasy with minute attention to detail always exerted an irresistible appeal, as in the Brueghel;[104] and, finally, though not a literary painter in the accepted sense, Moreau combines sheer pictorial splendour with the graphic, most notably in an earlier version of the *Salome* painting where strange writing-like patterns inhabit Moreau's painting, though not with any intention of clarifying meaning, as is the case in cruder couplings of text and image.[105] This characteristic feature of Moreau's style enacts in reverse a strange sequence in one of Flaubert's earliest texts, *Bibliomanie*, where the protagonist lingers over the way an introductory capital letter gives rise to a series of arabesques and tiny figures, the pictorial inhabiting the writing as it were, and always ready to break through. Both Flaubert and Moreau are interested in tracing the limits of their art.

[103] This can hardly be coincidence, as Biasi points out: 'C'est beaucoup plus qu'une coïncidence. Le projet d'*Hérodias* était déjà acquis, mais il est clair que cette rencontre frappante le confirme dans son idée.' Cf. 15: 448 (20 Apr. 1876) and 2 May 1876 to Turgenev, where the reference to 'deux ou trois tableaux vantés qui m'exaspèrent' in this *Salon* is followed immediately by the information: 'Je crois que Jaokhanan (traduisez saint Jean-Baptiste) viendra'.

[104] This was one of the aspects of Moreau's paintings about which commentators were most appreciative: cf. an article in the *Illustration* (12 May 1866) which speaks of 'la curiosité d'exécution des détails' in Moreau's paintings, and the way this 's'allie [. . .] à un sentiment de vague rêverie'. The association of richness and austerity so characteristic of Moreau—as the critic and art-historian Charles Blanc put it, 'concilier le luxe des colorations romantiques avec l'austérité du style', *Le Temps* (27 Aug. 1867)—also reflects one of Flaubert's major aims in writing.

[105] On the entirely original relationship in Moreau between colour and writing-like arabesques, cf. M. Reid, 'Editor's Preface', *Yale French Studies*, 84 (1994).

Moreau was the only painter with whom Flaubert had a truly symbiotic relationship. *Salammbô* produced *Salome*, which in turn contributed to *Hérodias*. Each inspires and reinforces the other, but with no question of *illustration* on either side. When Zola asked Flaubert whether he would like Moreau to 'do him a Salome' ('Moreau vous fera une Salome'),[106] to illustrate *Hérodias*, Flaubert was adamant in his refusal: not even Moreau should illustrate him—*especially* not Moreau. Given Flaubert's views on the art of illustration, it would have been an act of pure philistinism.

The 1870s: Manet

Little is known of Flaubert's reactions to Manet and other Impressionists. In his *critique* of Chesneau's book of art criticism of 1868, the section on Manet is one of the few on which Flaubert does not comment. In 1879, responding to Zola's gift of his recently published volume of literary and art criticism, *Mes haines*, Flaubert is more aggressively non-committal: 'Quant à Manet, comme je ne comprends goutte à sa peinture, je me récuse' (16: 230: 4 July 1879).

The reasons for this muted hostility on Flaubert's part can be inferred, however. He equated Impressionism in painting with Naturalism in literature, and regarded them both as instances of crude materialism. In a well-known passage from a letter to Turgenev about Daudet's novel *Le Nabab* (which Flaubert liked a great deal less than Daudet's earlier novels, being more aware of its pretentions to mimesis than of the delicacy of its impressionistic style), Naturalists and Impressionists are seen as nothing more than old-style Realists reincarnated, as devoid as they were of imagination and vision:

[*Le Nabab*] est disparate. Il ne s'agit pas seulement de voir, il faut arranger et fondre ce que l'on a vu. La réalité, selon moi, ne doit être qu'un *tremplin*. Nos amis sont persuadés qu'à elle seule elle constitue tout l'état! Ce matérialisme m'indigne, et, presque tous les lundis, j'ai un accès d'irritation en lisant les feuilletons de ce brave Zola. Après les Réalistes, nous avons les Naturalistes et les Impressionnistes. Quel progrès! Tas de farceurs, qui veulent se faire accroire et nous faire accroire qu'ils ont découvert la Méditerrannée. (16: 24: 8 Dec. 1877)[107]

[106] Goncourts, *Journal*, ii. 827–8: 10 June 1879.
[107] Cf. also 16: 308 (3 Feb. 1880), where Flaubert makes the same point.

Flaubert is resistant to the kind of materialistic Naturalism which was promulgated by Zola at times when he was not giving due space to the artistic *tempérament* and imagination. His position is broadly identical with that of Chesneau and of Gautier, and not with that of those critics (such as Zola indeed) who, even in Flaubert's own time, could sense in this new generation of painters the ideal within the real, the subjective within the objective.[108] Flaubert simply could not recognize the presence of something akin to his own transforming vision in these new painters.

An isolated remark in a very late letter sums up Flaubert's position with regard to the Naturalism which he equated with Impressionism. Naturalism is simply a means of *copying* in a crudely materialistic manner, which results, paradoxically, not in a sense of 'le vrai', but in the fantastic, in the falling short, in other words, of Naturalism's avowed ideals: 'Admirer, dans le volume de Huysmans (*Marthe*) une illustration qui est un *comble*! Si c'est du naturalisme, où est le fantastique?' (16: 262: Oct. 1879). Forain is of course a special case, not to be confused with some vague category of 'Impressionists'. But the point is that what we see here, once more, is Flaubert's sensitivity not just to the form itself (which he seems nevertheless to find wanting) but also to the claims that are made for it. Words obstruct the painting for Flaubert: Courbet digs his own grave with his polemics and extravagant claims; Naturalist polemics obscure whatever Manet may otherwise have been able to bring him. We will see the same mechanism behind his reactions to photography.

[108] Chesneau's opinion is that Manet is deficient as a draughtsman (*Les Nations rivales*, 199) and that the Impressionists generally are resistant to poetry: 'Les facultés poétiques, les dons spéciaux de l'imagination, l'expression des passions, l'émotion du drame humain, les agitations de notre âme en ses douleurs, en ses joies, en ses troubles de toute sorte: tout cela leur paraît autant de subtilités absolument étrangères à la peinture, autant d'erreurs et de contre-sens anti-pittoresques mis à la mode par les raffinés, par les esprits littéraires' (p. 324). Cf. Gautier, 'Salon de 1869', in *Tableaux à la plume*, 284–5: Manet 'en sa qualité de réaliste, dédaigne l'imagination'. For the existence of different views, cf. R. Shiff, *Cézanne and the End of Impressionism* (1984), 5: 'For many contemporary artists and critics, impressionist painting seemed *both* objective and subjective. How this could be so is not adequately understood today.' Cf. L. Czyba, 'Flaubert et la peinture', *Littérales* (1994), 127 n. 4: Monet was pure eye for Cézanne ('mais quel œil') and so was Manet for Mallarmé (but an eye that was 'abstrait' 'vierge'). Courbet, too, was just an eye for Ingres (ibid.). Arguably, he would have found more favour with Flaubert if his mouth had not so often come in the way of it.

This small band of painters apart, Flaubert was less interested in contemporary painters and paintings than in what he could make of them. On the purely social level, he was not above leaning on various 'Establishment' painters—Boulanger, Breton, Cabanel, Émile Gut, Harpignies, and Puvis de Chavannes (this last known only 'indirectement')—for support in the matter of his niece's candidature for the 1879 *Salon* (16: 173, 223), or hobnobbing with the various painters in the circle of the princesse Mathilde (herself an enthusiastic amateur).[109] Quite a large number of painters were thrust upon him, so to speak, part and parcel of his daily life: his sister, then his niece;[110] the various painters who doubled as drawing masters in his early days (especially Dumée and Langlois, see below); local painters from Rouen (such as Joseph Court, who painted most of the Flaubert family, and Bellangé).[111] When Flaubert went out of his way to cultivate painters he usually did so less because of their painting than, as we shall shortly see, for other, related gifts. Praise for particular paintings by contemporary artists is so rare as to be almost non-existent.[112]

Popular Art and Bad Art

Flaubert was not alone in feeling that art of the mainstream in France had run itself out—Baudelaire, Fromentin, and Chesneau all agreed with him.[113] But Chesneau makes an exception for art in the popular domain, 'nos caricaturistes, Gavarni, Daumier' 'et dans les

[109] This circle included painters such as Giraud, who produced both a portrait and a caricature of Flaubert (cf. *Album Flaubert* (1972), 143, 144).

[110] On Flaubert's niece as painter and Flaubert's efforts on her behalf, see e.g. 15: 463, 16: 172, 186, 345–6. Beginning by painting 'dessus de portes' (C4 667) and copies of Ribera, among others, in the Musée des Beaux-Arts in Rouen (16: 85), Caroline Franklin Grout became a successful portrait painter (16: 175). Long after Flaubert's death, she produced some water-colour illustrations for the 1924 Fasquelle edition of *Par les champs et par les grèves*.

[111] Cf. *Album Flaubert* (1972), for portraits by Court. For Joseph-Louis-Hippolyte Bellangé (1800–66), cf. Fairlie's note, *Imagination and Language*, 374.

[112] Flaubert's approval of Bonnat's painting of Hugo in the *Salon* of 1879 seems unproblematic (16: 221), but his approval of Carolus-Duran's portrait of Mme Vandal (*Salon* 1879) is more perverse, in view of the fact that he finds it a poor likeness, thus flying in the face of one apparently fundamental requirement of the genre (16: 221).

[113] For Baudelaire, cf. article by Savy in *Regards d'écrivain*. For Fromentin cf. *Maîtres d'autrefois*, 152: 'l'art de peindre est depuis longtemps un secret perdu'. Flaubert singles out this passage for praise (15: 470).

publications périodiques';[114] and so does Baudelaire. Flaubert's turning away from mainstream to *non*-mainstream contemporary art also stemmed, like theirs, from the sense of a need for some way forward, out of the prevailing arthritic mode. The taste for popular art was not by any means a recognized taste, as Champfleury, who worked hard to promote it, pointed out. The general view was that popular art was barbaric, noisy, and vulgar: popular images were dismissed because of their 'colorations bruyantes': ' "Barbarie que ces colorations!" disent-ils'.[115] So Flaubert's attitude may be regarded as avant-garde.

Flaubert's attitude to popular art was dual. On the one hand, he was sensitive to any kind of art which might reveal what Owen Jones, in his discussion of the 'ornament of savage tribes', calls 'evidence of mind'.[116] On the other, he simply responded to the image, without bothering about its artistic intent. He had, therefore, a generous view of what constituted a popular art form. His early works are dotted with such examples of pictorial art as wallpaper and chair coverings, whose presence is never entirely accounted for by the narrative. He also notes posters for street shows (*Un parfum à sentir*, 11: 236), naïve and brightly coloured, and shop signs (*ES1* 8: 31), and of course images on tea caddies: 'Oh! que les boîtes à thé m'ont fait faire des voyages!' (*Nov* 11: 664). Flaubert anticipates Rimbaud and Proust, later in the century, with their enthusiasm for 'peintures idiotes', 'dessus de portes' and pictures on biscuit tins.[117] Recalled in later years, these images acquire added potency, as in the case of the 'devants de cheminées' which Flaubert recalls as having been in the house of the grandfather of his schoolfriend Ernest Chevalier: 'Henri IV chez la belle Gabrielle, un cheval qui ruait, etc etc.!' (*C3* 390). Such images as these are worked into the mature works too, with as little accompanying explanation as in the early works; we shall see many examples later.

Flaubert's early and continuing fascination with wallpaper, tea caddies, and the like grew to encompass such other popular art forms

[114] Chesneau, *Les Nations rivales*, 3–4.

[115] Champfleury, 'L'imagerie populaire', from *Histoire de l'imagerie populaire* (1869), in *Le Réalisme*, compiled by Geneviève and Jean Lacambre (1973), 215.

[116] Jones, *Grammar of Ornament*, 14.

[117] Cf. Rimbaud: 'J'aimais les peintures idiotes, dessus de portes, décors, toiles de saltimbanques, enseignes, enluminures populaires', 'Délires', ii. 'Alchimie du Verbe', *Œuvres* (Garnier, 1981), 228. For Proust on biscuit tins, cf. 'Journées de lecture', *Contre Sainte-Beuve* (Gallimard, Pléiade, 1971), 167.

as the *panorama*. An unexpected bonus during the travels in Egypt was a meeting on the Nile with 'le colonel Langlois', ex-painter and currently the director of famous and extremely well presented panoramas—Flaubert kept up the connection afterwards.[118] Baudelaire groups panoramas with theatre scenery, and writes about them in terms which echo Flaubert's feelings, in their dismissal of recognized contemporary artists and current conceptions of Realism:

Je désire être ramené vers les dioramas dont la magie brutale et énorme sait m'imposer une utile illusion. Je préfère contempler quelques décors de théâtre, où je trouve artistement exprimés et tragiquement concentrés mes rêves les plus chers. Ces choses, parce qu'elles sont fausses, sont infiniment plus près du vrai; tandis que la plupart de nos paysagistes sont des menteurs, justement parce qu'ils ont négligé de mentir.[119]

Theatre scenery was not considered to be art either, as the *Dictionnaire des idées reçues* makes clear: 'DÉCOR DE THÉATRE. N'est pas de la peinture: il suffit de jeter à vrac sur la toile un seau de couleurs; puis on l'étend avec un balai, et l'éloignement avec la lumière fait l'illusion.' But Flaubert loved it. Gautier loved theatre décor too, and Hugo, and Dumas; but they had to defend their taste against critics who felt it could not be accorded the status of art. Gautier's evocations of stage scenery emphasize the strange, stylized colours. No established contemporary painter paints pictures as Flaubert would like them to be—but he would find them in the theatre, and in his own descriptions: 'Le ciel, d'un bleu verdissant, est zébré de larges bandes blondes et fauves; de petits arbres fluets balancent sur le second plan leur feuillage clairsemé, couleur de rose sèche; les lointains [...] sont du plus beau vert-pomme.'[120] Gautier eventually

[118] Cf. C1 649, 651, 663, 693, 723—Flaubert was clearly enchanted with Langlois (cf. Du Camp's dismissive but penetrating remark that Flaubert could as well have enjoyed his travel impressions by means of a *panorama*). On Langlois, cf. also Du Camp, *Souvenirs littéraires*, 318–19: Langlois achieved 'le perfectionnement des panoramas', which were then raised 'à la hauteur de la grande peinture historique' (p. 319): 'Le colonel de Langlois faisait vraiment œuvre de magicien et créait la réalité' (p. 318). Cf. also B. Comment's study, *Le XIXᵉ siècle des panoramas* (1993). Delacroix too writes approvingly of Langlois (cf. ibid. 23).

[119] Baudelaire, 'Salon de 1859', *Critique d'Art*, 328. Cf. the extremely interesting article by H. Tuzet, 'Le Théâtre romantique français et ses peintres', in *Atti del quinto congresso internazionale di lingue e letterature moderne* (Florence: Valmartina, 1955), 363–74.

[120] Gautier, quoted Tuzet, ibid. 367, article of New Year 1839, 'Le théâtre tel que nous le rêvons'.

enjoyed the privilege of incorporating this kind of scene into his art with the productions of *Giselle* (1841) and *La Péri* (1843), whereas Flaubert never did. But he creates such scenes by proxy, in his travel notes, and in his fictional works.

Above all, like Félicité in *Un cœur simple*, Flaubert worships the *image d'Épinal*, the famous popular images created by Jean-Charles Pellerin in his factory at Épinal from 1800 onwards, and which will recur frequently in the course of this study. He even creates his own, spontaneously, as he notes himself: for example, when the Imperial prince is killed in battle in Zululand in 1879, the newspaper report conjures up just such an image in Flaubert's mind: 'La mort du Prince impérial [. . .] m'a frappé comme une image d'Épinal, tant elle est violente et sauvagesque' (16: 233). This is just one of many such images in Flaubert's writing. He was not the only artist of his time to draw inspiration from the *image d'Épinal*.[121]

Flaubert's conception of art was broader still, broader even than that of Champfleury, and indeed than that of most other nineteenth-century writers, except perhaps Baudelaire,[122] but Baudelaire's attachment to bad art was less joyous and *carnavalesque* than Flaubert's. The attraction to bad art was at first instinctive—'J'aime autant le clinquant que l'or' (*C1* 278), and Flaubert talks in the first *Éducation sentimentale* of 'ces prédilections niaises que nous avons malgré nous pour des œuvres médiocres' (*ES1* 8: 205)—but later he developed a series of theories in an attempt to account for his taste for it.

One of Flaubert's earliest recorded responses to a piece of bad art concerned an unidentified monstrosity in the Musée des

[121] Cf. P. Hamon, *La Description littéraire* (1991), 121: 'Le XIXe siècle post-romantique (Courbet, Rimbaud, Huysmans . . .) évoque volontiers—à titre de stimulant, de repoussoir, voire par provocation—les images naïves, enluminures, dessus de portes, enseignes, réclames de rues, images d'Épinal, etc., comme modèles pour ses exercices descriptifs. Ultimes avatars de l'*ekphrasis*, et mise en crise des grands modèles canoniques de la peinture.'

[122] Once again, Baudelaire's views are remarkably similar to those of Flaubert, cf. the 'Salon de 1846': 'Sans doute la distance est immense qui sépare *Le Départ pour l'île de Cythère* des misérables coloriages suspendus dans les chambres des filles, au-dessus d'un pot fêlé et d'une console branlante; mais dans un sujet aussi important [artistic revery] rien n'est à négliger. Et puis le génie sanctifie toutes choses', *Critique d'art*, 103. On bad art cf. J. Seznec, 'Flaubert and the Graphic Arts', *Journal of the Warburg and Courtauld Institutes*, 8 (1945), 175–90, and Fairlie, *Imagination and Language*, 355–78.

Beaux-Arts in Rouen. Flaubert had noted this painting at some point before 9 May 1843, when his sister Caroline sent him a little sketch she had made, lost, and found again—'Tu est un imbécile si ça ne te rappelle pas un agréable souvenir et si les larmes ne t'en viennent pas aux yeux' (*C1* 158). Baffled, Gustave responds two days later: 'Je n'ai jamais pu deviner le dessin.—J'y distingue un lit, un berceau ou une baignoire et puis des jambes de turc' (*C1* 159). Caroline's reply shows both that Gustave is known to possess a wonderfully retentive memory for works of art and that his response to this masterpiece was typical, in its mixture of delight and horror:

Mais que tu es bête, bonhomme! Et comment toi qui te vantes d'une merveilleuse mémoire pour tout objet d'art ne te rappelles-tu pas d'un [*sic*] certain tableau dans la Grande Galerie à Rouen qui représentait un enfant malade dans une baignoire, un thermomètre à droite, sa mère tenant une poupée à gauche, un lit au fond et une garde avec une bassinoire. Je te vois maintenant indigné contre toi-même en méditant le tableau. (*C1* 161)

However, that is apparently the end of it: the painting never resurfaces. Like other writers in their youth, Proust for example, Flaubert at first sidelines his interest in bad art. Though there is a great deal of bravado in the following statement from *Novembre*, there is also more than a hint that the young Gustave is unsure what to make of his apparent inability to admire the right things: 'il n'entendait rien à la peinture ni à la musique, je l'ai vu admirer des galettes authentiques et avoir la migraine en sortant de l'Opéra' (11: 665). The grotesque finds a place in the aesthetic of *ES1*, but bad art does not. It does not really come into its own till *Par les champs et par les grèves* (1848), and that was in part because a walking-tour in Brittany forced it on his attention. It was forced on his travelling companion's attention too, only whereas Du Camp either ignores it in the chapters for which he is responsible, or passes over it as quickly as possible, Flaubert gives it its head in a most exuberant manner, to Du Camp's dismay.[123] In *Par les champs*, for

[123] It fell to Du Camp, in theory, since he was assigned the even chapters in *Par les champs et par les grèves*, to write up the spectacle of the *jeunes phénomènes*, but he does not get far beyond the description of the advertising poster. However, his *Souvenirs littéraires* (pp. 254–5) includes a highly coloured account of Flaubert's reactions to this gruesome exhibition of 'living art', which Du Camp clearly could not fathom. Flaubert was delighted by this new art form (which consisted of a sheep and a cow joined together and exhibiting a supererogatory leg) and intrigued, surprised, and disappointed to find that the 'image' promoted by the impresarios both

the first time, Flaubert does more than simply relish bad art, he now begins to dwell on particular instances, to probe further, and seek to understand and put what he has understood into words.

Photography

Pellerin's final incarnation as a photographer has long been regarded as a sign of his having reached his nadir: 'l'industrie photographique était le refuge de tous les peintres manqués, trop mal doués ou trop paresseux pour achever leurs études'.[124] We have seen already how Flaubert equates photography with the artistic limitations of total visual recall. It is thus often assumed that Flaubert's view of photography is uncomplicatedly hostile, but this is not the case. Though he quickly developed an aversion to photography, he still had some uses for it; his attitude changed over the years; and photography itself changed.

Flaubert's hostility reflects in part the fact that he discovered it in the first few decades of its existence, when it was itself uncertain of its status, and when debates as to whether it was an art or a science generated considerable heat.[125] Flaubert himself was certainly not inclined to think of it as an art; early attempts at creativity on

verbally and pictorially turned out, despite all his expectations, to resemble reality. Humour today seems finally to have caught up with Flaubert, but at the time he stood alone. Gautier, Nerval, Baudelaire, and Mallarmé all made considerable poetic capital out of bad art, particularly in the form of freak shows such as this. There have been many critical works on the subject, but Flaubert's substantial contributions have mostly gone unnoticed.

[124] Baudelaire, 'Salon de 1859', *Critique d'Art*, 278. This was certainly the case for Daguerre, who moved from painting to the design of theatre scenery, the diorama, and then photography.

[125] The history of photography is by now thoroughly documented. Cf. esp. A. Rouillé, *La Photographie en France: Textes et controverses: Une anthologie 1816–1871* (1989): he emphasizes how photography developed and changed in France, from the daguerreotype in the 1840s through the beginnings of photography in the early 1850s, and then, after the 'impulsion de l'Exposition Universelle' of 1855, to its eventual triumph in the 1860s. Photography was admitted to the 1859 *Salon*, but cordoned off from the 'real' art. Cf. the manifesto of 1862 (Ingres, Flandrin, Isabey, *et al.*): photography cannot, '*en aucune circonstance*, être assimilée aux œuvres fruit de l'intelligence et de l'étude de l'art' (cited Rouillé, p. 399). Lamartine had at first condemned photography for its 'servilité' (1858) but changed his mind when he encountered the 'merveilleux portraits' of Adam Salomon; Delacroix, too, regarded the daguerreotype initially as no more than a 'dictionnaire', but later saw it as an art in itself. Others, like Flaubert, eventually found a use for it and/or adapted their own art accordingly (see end of Part II).

the part of photographers—experiments with views from odd angles, in the manner of earlier painters such as Valenciennes—might well have interested him, but they were few and far between, and he did not know them.[126]

Flaubert makes no reference to photography until the *Voyage en Orient* forced it upon him. His reactions to the new art are complicated by his experiences in the field, and by his reactions to Du Camp and Du Camp's complex of ambitions, of which photography formed a part. These were still early days for photography, and Du Camp was a pioneer. The photographs he published as a result of the *Voyage en Orient* were enormously successful and won him the *croix d'honneur*.[127] Du Camp sings the praises of photography in his poem 'La Vapeur' (*Les Chants modernes*, 1855). Here, Photography appears in the guise of an allegorical figure, celebrating its own powers, its mastery over the art of drawing ('Les dessins qu'on n'ose aborder | Ne me sont jamais indociles, | Et je n'ai qu'à les regarder!'). Photography was often regarded as competing with painting ('remplace la peinture', *DIR*), but what bothered Flaubert just as much was the threat it constituted to *writing*. Du Camp's stated reason for taking photographs, recorded years later in the *Souvenirs littéraires*, was, after all, to circumvent the need not only for drawings, but also for written descriptions:

Dans mes précédents voyages, j'avais remarqué que je perdais un temps précieux à dessiner les monuments ou les points de vue dont je voulais garder le souvenir; je dessinais lentement et d'une façon peu correcte; en outre, les notes que je prenais pour décrire soit un édifice, soit un paysage, me semblaient confuses lorsque je les relisais à distance, et j'avais compris qu'il me fallait un instrument de précision pour rapporter des images qui me permettraient des reconstitutions exactes.[128]

Photography strikes at the very core of Flaubert's existence as a writer, and we shall see later how Flaubert's descriptions in

[126] Cf. P. Galassi, *Before Photography* (1981), for the attempts of early photographers to imitate the selective, partial, odd-angled views of the sketches or water colours of Valenciennes and others.

[127] See Bibliography. Flaubert received his copy of Du Camp's album 19 June 1852 (C2 110). Du Camp was not the first person to take photographs in Egypt, cf. M. A. Stevens, *The Orientalists* (1984), 21: Horace Vernet was one of the first artists to use the daguerreotype on his trip to Egypt 1839 (cf. *Voyage daguerrienne*, 1841).

[128] Du Camp, *Souvenirs littéraires*, 286.

the *Voyage en Orient* were affected by his tussle with Du Camp's photographic activities. When Du Camp's photographs were published, Flaubert remarks himself how they swamp the text, both quantitatively and qualitatively—the text just consisting of bits and pieces cobbled together ('bâclé') from Champollion-Figeac and Lepsius (C2 370). He regards Du Camp and himself as being in competition, with Du Camp (temporarily) in the ascendant as a result of his recent facile achievements, of which photography is one. Commenting on Du Camp's elevation to the Legion of Honour (1853) in recognition of the achievement represented by these very photographs, Flaubert reflects bitterly on the topsy-turvy values of a society which honours a photographer and exiles a major poet (Hugo): 'Admirable époque [. . .] que celle où l'on décore les photographes et où l'on exile les poètes (vois-tu la quantité de bons tableaux qu'il faudrait avoir faits avant d'arriver à cette croix d'officier?' (C2 239). In an earlier letter to Louise Colet, Flaubert brings himself squarely into the equation, launching without transition from an account of his receipt of Du Camp's book of photographs into a fairly bitter bout of *self*-appraisal (C2 111).

Flaubert's objections to the new art are theoretical as well as instinctive, and spring in part from the same source as his objections to Realism and Naturalism. His first objection is formulated already in the *Voyage en Orient*: photography, as he has observed it countless times in action, is pure mechanics. There is no personal investment by the artist in the actual process of creating the picture: 'Lundi, re-estampage—le moyen mange le but—une bonne oisiveté au soleil est moins stérile que ces occupations où le cœur n'est pas' (*VE* 383).[129] 'Re-estampage': the process is repetitive (in all senses!); the means swamp the ends; and the mechanical noting of impressions destroys all life and poetry. 'Accuracy' here masquerades as truth, 'le réel' as 'le vrai'. Louise Colet's later offer of a photograph of herself turns out to be ill-advised: 'ne m'envoie pas ton portrait photographié. Je déteste les photographies à proportion que j'aime

[129] Flaubert's view of photography is remarkably similar in this respect to that of Barthes (who nevertheless was far more instinctively inclined, as most 20th-cent. viewers have been, to regard photography as art), cf. Barthes's 'Rhétorique de l'image', in *L'Obvie et l'obtus* (1982): drawing and photography differ in that drawing reflects a human investment, 'apprentissage', and style, whereas in photography the 'interventions de l'homme (cadrage, lumière etc) sont toutes en effet au plan de la connotation'; in photographs 'le *cela a été* bat en brèche le *c'est moi*' (pp. 35–6).

les originaux. Jamais je ne trouve cela *vrai* [. . .]. Ce procédé *mécanique* appliqué à toi surtout, m'irriterait plus qu'il ne me ferait plaisir' (C2 394: 14 Aug. 1853).[130] The eye itself cannot give us 'le réel', and the camera gives us even less than the eye: 'Je crois que généralement (et quoi qu'on en dise) le souvenir idéalise, c'est-à-dire choisit? Mais peut-être l'œil idéalise-t-il aussi? observez notre étonnement devant une épreuve photographique. Ce n'est jamais *ça* qu'on a vu' (C3 562: to Taine, ?20 Nov. 1866).[131]

But this criticism—'ce n'est jamais *ça* qu'on a vu'—is precisely the point which causes his attitude eventually to soften: just because photography often gives the viewer what he or she has never seen, it can have as powerful an effect as other kinds of art of which Flaubert approved. This occurred with one photograph in particular, which seems to have been of Flaubert himself. He was always extremely reluctant to have his image taken, both because of his preference, as a writer, to be present everywhere but visible nowhere, and no doubt through some instinctive fear of the image. This was the case with (painted) portraits—he was very proud of his refusal to be painted by Bonnat and Gleyre (16: 101)—and even more so in the case of photographs of his person. His reluctance to be photographed is expressed so vehemently that it suggests an underlying fear that photography might say, not too little, but too much. Thus, in August 1853, he swears to Louise Colet that *he* will never allow himself to be photographed (as *she* has just done). At least, he goes on to say, while it is true that he *had* in the past allowed

[130] She sent it regardless; and his expressions of gratitude are somewhat muted by his reiterating that, still, 'la photographie est une vilaine chose' (C2 398). Charles similarly thinks Emma will be delighted with a daguerreotype portrait of himself, *MB* 1: 152.

[131] Delacroix, too, makes a distinction between what the eye sees and what the camera sees: 'vous ne voyez que ce qui est intéressant, tandis que l'instrument aura tout mis', *Journal*, 366 (12 Oct. 1853); 'Malgré son étonnante réalité dans certaines parties, il [*the daguerreotype*] n'est encore qu'un reflet du réel, qu'une copie, fausse en quelque sorte à force d'être exacte', Delacroix, 'Revue des arts', *Revue des deux mondes* (Sept. 1850), 1139–46, extract quoted by Rouillé, *La Photographie*, 406. Cf. also Delacroix, *Journal*, 744 (1 Sept. 1859) on the way photography is redeemed by *failing* to capture all. Rodin too said painting and sculpture are superior to photography because photography 'rend les choses irréelles parce qu'elle les fixe' (quoted by Isabelle Daunais, *L'Art de la mesure* (1996), 56). Baudelaire disposes of the myth of accurate representation summarily: 'Puisque la photographie nous donne toutes les garanties désirables d'exactitude (ils croient cela, les insensés!)', 'Salon de 1859', *Critique d'art*, 277 (but Baudelaire too wavers, see below, n. 137).

this indecent act to occur, it had been only once, full-length, in dis-
guise, and at a distance: 'moi je ne consentirais jamais à ce que l'on
fît mon portrait en photographie. Max l'avait fait, mais j'étais en
costume nubien, en pied, et vu de très loin, dans un jardin' (C2 394:
14 Aug. 1853).[132]

Flaubert repeats on a later occasion his reluctance to have his
image taken, in no uncertain terms: having received a 'portrait' of
and from Mlle Leroyer de Chantepie, he is categorical: 'Je ne puis
malheureusement vous faire connaître ma figure par les mêmes
moyens, car jamais on ne m'a peint ni dessiné' (C2 700: 30 Mar.
1857). 'Pas d'illustrations', either to his text or of his person—there
is no doubt that as a matter of principle he vastly preferred indir-
ect or distorted representations, such as caricatures, or indeed the
painting of a bear which he thought could pass as a 'portrait de
Gustave Flaubert' (C1 238: 15 June 1845). Once again, it seems,
Flaubert is extremely hostile to the idea of undiluted transmission
of the image—it has to be devious or disguised or effaced, some-
how. Flaubert continually claimed that he was the subject of very
few portraits, photographic or otherwise.[133] But there were more
images of Flaubert in existence than he seemed to care to recog-
nize. Émile Bergerat tells an amusing story, which may be highly
coloured but which there is no reason to doubt, of his having dis-
covered three posed photographs of Flaubert by Carjat remaindered
in a junkshop and of Flaubert's evasiveness when confronted with
the evidence.[134]

Flaubert's response to photographs of himself was more power-
ful than his dismissive tone would lead one to believe. Photo-
graphs, like mirror-images, could produce something of the effect
of caricature (and hence of art)—akin to the sight of his own image
pulling faces in his shaving-mirror, which always set him laugh-
ing (C1 308). The mirror-image is not art, but it can ape the

[132] In fact, Flaubert posed for Maxime at least three times (see below, Ch. 4). For
this particular photograph, see Madeleine Cottin, 'Une image méconnue de Gustave
Flaubert: La Photographie prise en 1850 au Caire par son ami Maxime Du Camp',
Gazette des Beaux-Arts (Oct. 1965), 235–9. It is reproduced at *Album Flaubert*, 83.
Cf. C2 365, Flaubert notes that the only one of Du Camp's photographs that Du
Camp did *not* publish was this one: 'c'est une petite malice de sa part'. However, it
does appear in Du Camp's album under under the heading of *Le Kaire*, no. 3: 'Maison
et Jardin dans le quartier Frank'. How did Flaubert miss it?

[133] Cf. e.g. 15: 454 (17 June 1876).

[134] Bergerat, *Souvenirs d'un enfant de Paris* (1912), ii. 140.

effects of art. Flaubert's reactions to what must be one of the two photographs which he allowed either Carjat or Nadar to take of him[135] are both horrified and joyous: photography here has transcended itself, if only in the manner of Bouvard and Pécuchet's garden: 'Quant à la photographie, voilà vingt fois que je la regarde et vingt fois que je ris. Quelles pattes! et quelle bonne mine de bordel. Hénaurme! Je ne me lasse pas de la contempler' (*C3* 415: to J. Duplan, 24 Nov. 1864). The very fact that the photographic image, like some mirror-images, does not correspond with 'ce qu'on a vu' means its impact is tremendous. Photography triumphs through its very crudeness, reducing the viewer to the inarticulacy of pure contemplation—'Hénaurme!'—and of laughter, which replaces any kind of verbal response.

Indeed, by the end of his life, Flaubert has come to the point of conceding, albeit grudgingly, that photography might after all be considered as an art, on a level, in some respects, with oil painting: 'Il n'y a pas de vrai! Il n'y a que des manières de voir. Est-ce que la photographie est ressemblante? pas plus que la peinture à l'huile, ou tout autant' (16: 308: 3 Feb. 1880).[136] He had, anyhow, for some time, been quite prepared to regard the photograph as a perfectly serviceable accessory to the art of writing. 'Le daguerréotype est une insulte', we find him proclaiming to Maurice Schlesinger in 1857 (*C2* 681); and three weeks later asking for photos of Tunis for *Salammbô* (*C2* 689, 693).[137] Despite all the later criticism of Du Camp's photography, Flaubert acknowledges that the best idea of the Sphinx is to be obtained, not from any drawing Bouilhet might

[135] For Nadar's two photographs, see *Album Flaubert*, 124 and 133, and for the one taken by Carjat, also *c.* 1863, ibid. 134. Cf. also *C4* 12 (25 Jan. 1869) for Turgenev's reactions to the photograph of Flaubert which Flaubert has just sent him, 'bien militaire et bien peigné'; Turgenev wonders why Flaubert does not get a *better* one. Cf. also *C4* 32: Flaubert sends his 'portrait' to Mlle Leroyer de Chantepie.

[136] Heine's opinions developed in the same way, see S. Prawer, 'Heine and the Photographers', in S. Zantop (ed.), *Paintings on the Move* (1989), 75–90. Cf. esp. p. 76, quoting Heine 'some time in the 1840s': 'Daguerreotype—Zeugnis gegen die irrige Ansicht, dass die Kunst eine Nachahmung der Natur—die Natur hat selbst den Beweis geliefert, wie wenig sie von Kunst versteht, wie kläglich, wenn sie sich mit Kunst abgibt'. Prawer points out that Heine at first ignored the 'art' with which a photograph could be taken, but that by 1847 he experienced a slight change of heart (like Flaubert), allowing that photography can be more or less accurate and 'manchmal . . . poetisch'.

[137] Cf. Baudelaire, 'Salon de 1859', *Critique d'art*, 278: photography should be 'le secrétaire et le garde-note de quiconque a besoin dans sa profession d'une absolue exactitude matérielle'. This contradicts the view expressed above in n. 131.

have seen, but in one of Max's photographs: 'Aucun dessin que je connaisse n'en donne l'idée, si ce n'est une épreuve excellente que Max[ime] en a tiré[e] au photographe' (*C1* 570).[138] For all that, Flaubert does then go on to give his own very vivid evocation of the Sphinx, which includes elements which Du Camp's photograph, brilliant as it is, does not deliver:

Il a le nez mangé comme par un chancre, les oreilles écartées de la tête comme un nègre, on lui voit encore les yeux très expressifs et terrifiants; tout le corps est dans le sable; devant sa poitrine il y a un grand trou, reste des déblayements que l'on a essayés.—C'est là devant que nous avons arrêté nos chevaux, qui soufflaient bruyamment pendant que nous regardions d'un regard idiot. Puis la rage nous a rempoignés et nous sommes repartis à peu près du même train à travers les ruines des petites Pyramides qui parsèment le pied des grandes.

Flaubert's description provides the narrative context, the emphasis on the very experience of *looking*, both in the terrifying stare of the Sphinx itself and in their own idiotic goggling back at it, and their unreasoning, almost animal response, which sends them tearing off wildly back over the desert from which they had come 'au triple galop', in a state of holy terror at having dared to come so close to the most enigmatic image of them all.

PUTTING THE PICTORIAL IN ITS PLACE

Flaubert's 'cannibalism' rarely exerts itself on the great painters. In other cases, however, Flaubert's instinct is to minimize the pictorial, in favour of something else, usually connected with writing.

Thus, Gleyre, 'l'angélique Gleyre' (*C3* 168: 1 Aug. 1861) may be 'du plus grand talent' as a painter (16: 101),[139] but his greatest attraction for Flaubert was that he was a wonderful talker, a master word-spinner and evoker of images, a talent which he accords later to Pellerin in *L'Éducation sentimentale* and to Damis in the

[138] For this photograph, see *Album Flaubert*, 82.
[139] Cf. e.g. Boime, *French Painting*, 59 ff., on the real originality of Gleyre's painting, recognized but not understood by his contemporaries. Baudelaire was not impressed, see 'Salon de 1846', in *Critique d'art*, 32. Proust refers with affection to what he sees as Gleyre's 'œuvres naïvement incomplètes', which Marcel adored when he was too young to know better, cf. *A la recherche du temps perdu*, ed. J-Y Tadié (Gallimard Pléiade, 1987–9), i. 144.

Tentation. Flaubert seems to have preferred these verbally evoked images to the painted ones, thus responding to Gleyre as if he were an artist in his own field. Flaubert visited Gleyre in Lyon, on his way to the East (*C1* 520). Gleyre, having spent some time in Egypt, had devoted several paintings to a distinctly stylized evocation of Egyptian subjects, and talked to Flaubert a great deal about Egypt on this occasion. Flaubert gives a taste of his stories and evocations in the *Voyage en Orient* itself, and they are indeed extremely vivid (as retold by Flaubert), combining the ridiculous and the mythical in a way which always appealed to him:

> Il nous parle du Sennahar et nous monte la tête à l'endroit des singes qui viennent la nuit soulever le bas des tentes pour regarder les voyageurs. Le soir les pintades se mettent à nicher dans les grands arbres et les gazelles par troupeaux s'approchent des fontaines. Il y a là-bas des savanes de hautes herbes et avec des éléphants qui galopent sans qu'on puisse les atteindre [. . .] et toute la nuit nous rêvons Sennahar. (*VE* 147)

Flaubert's inviting Gleyre to the first reading of *Salammbô* is something of a return payment for these highly coloured, heady narratives, which were more worthy of being cited than his paintings.[140]

Similarly, paintings are often less interesting in themselves than for their associations. If Flaubert prefers Couture's portrait of George Sand to the portrait of her by Marchal, it is because he, Flaubert, is 'un vieux romantique' and Couture's portrait evokes the Sand he had read and loved (and imagined) in his youth (*C3* 535: 29 Sept. 1866). If he cites Boulanger's portrait of Adèle Hugo (shown at the *Salon* of 1839), it is because he is interested in the story of the anonymous young man of his acquaintance who fell in love with her, as a result of seeing the portrait (a foretaste of the association between love and art as portrayed later in *L'Éducation sentimentale*, *C2* 87). When Henriette Collier sends him a water-colour portrait of herself by a painter called Rossi, his letter of reply concentrates entirely on his memory of the circumstances of the

[140] Cf. Goncourts, *Journal*, i. 691 (6 May 1861) for the *Salammbô* reading. J.-M. Bailbé, 'Le Voyage en Egypte de Flaubert, illusion et poésie', *Flaubert et Maupassant* (1981), 71–89, considers some of Gleyre's 'Egyptian' paintings in relation to some of Flaubert's most painterly descriptions of Egypt in the *Voyage en Orient*. Camille Rogier (1810–96), 'de la même bande artistique' as Flaubert (*C1* 661), was another painter whose personality was more attractive to Flaubert than his painting. There are many references to Rogier in the *Correspondance*, cf. Bruneau's very full note *C1* 1105.

sittings, at one of which he was present: the picture itself makes way for memories of his love for her (unspoken) and an evocation of the subtle coincidences of image and text as he read *Atala* aloud to her while the painting was in progress: 'Quand M. Rossi vous a fait, je suis venu un jour chez vous. Et je vous lisais *Atala* pendant qu'il travaillait, vous en souvenez-vous? Je vous vois toujours ainsi couchée sur votre lit, tournant le dos à la cheminée et regardant les voitures qui passaient sur le Rond-Point' (*C2* 73). Flaubert substitutes a strong little memory-image of his own here for the actual portrait, a far more poignant one of the couch-bound invalid watching the carriages passing by (the latter detail being a persistent image in his writing). The water colour itself is just a trigger, an icon which he places alongside the bust of his sister and a 'vue d'Egypte'; when the Goncourts subsequently saw this water colour in Flaubert's collection, it did nothing to persuade them out of their conviction that Flaubert had no taste at all.[141] In all three paintings, then, the Couture, the Boulanger, and the Rossi, the painting itself is overlaid with *other* considerations, emotional and literary. This is typical of Flaubert's way with paintings; and love and art will become an extremely powerful association in all his works—we might note also that Flaubert's experiences of art in London will be all caught up with his relationship with his lover of many years' standing, Juliet Herbert.

Even the various drawing masters who figured in Flaubert's early life are as important for their role in a complex emotional network as for anything they taught him about the art of drawing. The two most important are Edmé Dumée and E.-H. Langlois.[142] Dumée became caught in a web of memories for Flaubert, of childhood, of his artistic sister who died so young, of 'Saint-Arnould' near Trouville where all three went on sketching expeditions, of the Schlesingers.[143] Langlois, too, has a permanent *niche* in Flaubert's

[141] For their reactions to this 'mauvaise aquarelle' see below. The portrait is now in the musée Picasso, Antibes, and is reproduced in the *Album Flaubert*, 43.

[142] Dumée (1793–1861) was stage designer at the Théâtre des Arts in Rouen (see Bruneau's note, *C1* 886). Langlois (1777–1837) was a pupil of David. Flaubert later compared the character Langibout in the Goncourt novel *Manette Salomon* to Langlois (*C3* 703). See *Album Flaubert* for Langlois's sketch of Flaubert as a boy.

[143] For 'Saint-Arnould', cf. *PCG* 727: 'j'y venais dessiner avec le père Dumée', and a contemporary reference to that period in a letter from Caroline (*C1* 121); the name 'Arnoux' is clearly a private reference to this complex of impressions. Drawing masters figure in most of Flaubert's later works, the final incarnation being in Pécuchet, with his ill-fated attempts to teach the new brother-and-sister couple, Victor and Victorine, to draw.

memory, associated in the *spirale* of his imagination with Don Quixote, and with his father's dissecting room, thus illustrating something of the darker connotations of images, which we shall have occasion to note so often: 'Les premières impressions ne s'effacent pas, tu le sais. Nous portons en nous notre passé [. . .]. Quand je m'analyse, je trouve en moi, encore fraîches et avec toutes leurs influences [. . .], la place du père Langlois, celle du père Mignot, celle [de] *don Quichotte* et de mes songeries d'enfant dans le jardin, à côté de la fenêtre de l'amphithéâtre' (*C1* 711–12). Langlois is also of course intimately connected with *Saint Julien l'Hospitalier*, since it was he who took the young Gustave to see the church at Caudebec with its stained-glass windows and statue of St Julien (1835)[144] and he who was the author of the *Essai sur la peinture sur verre*, which was the immediate textual source for *Saint Julien*. Thus, this painter-cum-writer was instrumental in more ways than one for the eventual emergence from the spiral of Flaubert's *conte*, which in itself was a better tribute to Langlois than the exhibition notes which Flaubert later declined to write.[145]

There is no doubt that, though these two talented artists, Dumée and Langlois, did not actually succeed in teaching Flaubert to *draw* with any skill (judging by the evidence of the few sketches we have, which are workmanlike but not artistic),[146] they did teach him the habit of assessing scenes and objects with a painterly eye;[147] and, indirectly, via associations and connotations, they became part of the spiral which was instrumental in helping him to *write*. Flaubert proceeds as if the works of art they produced were something of an accident. Like Balzac with Frenhofer, he is far more interested in the artistic *intention*, which does not necessarily express itself in the work of art, which itself is only a sign, an icon of the artist, a sign that he exists. It would perhaps not be fanciful, either, to include here the very obscure local Rouen painter called Melotte, to whom Flaubert took a particular shine, not, of course, because of his painting, but because of a habit he had of describing a particular arabesque in the air, like a double 's', every time he used the magic

[144] Cf. A. Raitt, *Flaubert: Trois contes* (1991), 35–6.

[145] See end of Part II for more on Langlois's exhibition, and the end of Ch. 8 for further discussion of the composite image of the stained-glass window and its relationship to *Saint Julien*.

[146] Cf. S. Hasumi, 'Les Dessins dans les mss de travail de Flaubert' (CNRS—ITEM, Séminaire Flaubert, 20 May 1995).

[147] Cf. e.g. *C1* 190, where Caroline judges the château of Veux to be a suitable subject for Dumée to draw.

word *artistique* (C4 724, 839; 16: 131). Melotte's *arabesque* became one of Flaubert's famous running jokes, which were opaque to everybody but himself. From his niece's point of view, Flaubert's reaction to Melotte's gesture was no doubt yet another manifestation of her uncle's intense enjoyment of his own gift for mimicry and satire; but for Flaubert himself, I am sure, Melotte's aerial arabesque was yet another example of verbal and visual fighting it out. However accomplished his art works were, Melotte's true artistic statement was embodied in that semi-scriptural, semi-figurative shape in the air, the kind of shape Flaubert wanted his art to produce, and which Mallarmé likened to the art of the dance.

FLAUBERT'S PRIVATE COLLECTION

Most of the points which have been made so far are illustrated by Flaubert's personal collection of art works. Opinions vary as to whether Flaubert owned any works of art at all. Some of Flaubert's contemporaries were convinced that he did not; others, that he did, but that those he had revealed either a very odd taste, or no taste at all. The Goncourts managed to occupy each of these positions at one time or another.

The Goncourts were convinced that Flaubert had very poor taste, and make the point repeatedly in their *Journal*—Flaubert responds, they fear, only to the vulgar and the barbaric: 'Flaubert, au fond, une grosse nature qu'attirent les choses plutôt grosses que délicates, qui n'est touché que par des qualités de grandeur, de grosseur, d'exagération, dont la perception de l'art est celle d'un sauvage. Il aime en un mot le peinturlurage, la verroterie, c'est une espèce d'Homère d'Otaïti.'[148] In an odd criticism, which presents Flaubert *both* as being sensitive only to what he *should* see in art *and* as being apt to get hold of the wrong end of the stick, the Goncourts accuse him of reading pictures no better than a 'sauvage': 'trouver le beau non désigné, non officiel d'une toile, d'un

[148] Goncourts, *Journal*, i. 817 (21 May 1862). Cf. also another contemporary critic, Saint-René Taillandier, quoted by Seznec, '*Madame Bovary* et la puissance de l'image', *Médecine de France*, 8 (1949), 36: 'Nulle préférence ne guide l'esprit de l'auteur, si ce n'est l'amour des images à dessiner, des couleurs à étaler', 'Une sotie au XIXᵉ siècle', *Revue des deux mondes* (1 May 1874). No Gauguin had yet appeared to make the idea of a Tahitian Homer acceptable.

dessin, d'une statue, saisir son angle aigu, pénétrant, sympathique, il en est absolument incapable. Il aime l'art comme les sauvages aiment un tableau: en le prenant à l'envers'. Not only has Flaubert no taste, he has no pictures: 'Flaubert n'a aucun sentiment artistique. Il n'a jamais acheté un objet d'art de vingt-cinq sous. Il n'a pas chez lui une statuette, un tableau, un bibelot quelconque. Il parle pourtant d'art avec fureur [. . .].'[149] The Goncourts contradict themselves however, when, just a few months before this entry, they note in their *Journal* that Flaubert owns a very beautiful reproduction of the Naples *Psyche* torso.[150]

None the less, the same vacuity is noted also by another contemporary of Flaubert's, Émile Bergerat, writing from memory in 1912, and what he says is supported, after a fashion, by Flaubert himself: 'pas un tableau, peint ou gravé, et de photographies moins encore. Je n'ai souvenance que d'une reproduction d'une toile de John Everett Millais, le préraphaëlite anglais, reléguée d'ailleurs dans l'antichambre; c'était un présent de sa chère nièce Caroline, ainsi le laissait-il là par tendresse pour elle mais il ne l'avait certainement jamais regardé.'[151] Bergerat then describes Flaubert's reactions on reading the account of an interview he had granted to a Rouen journalist, Pierre Giffard, in his apartment. The journalist had claimed that Flaubert's rooms were crammed with masterpieces, and Flaubert is furious at the very idea:

le journaliste, croyant plaire au maître, l'avait enrichi d'une collection de tableaux rothschildienne où les anciens disputaient aux modernes les centimètres de ses lambris. La fureur de Flaubert, à la lecture de l'article, était montée à la congestion.—Des tableaux chez moi! . . . Il en a vu! . . . Oh! le scélérat! . . . Et c'est un 'pays!' . . . La haine de la littérature! . . . M'accuser de galerie de peinture? Que lui-ai je fait?[152]

However exaggerated this account might be, the basic facts are confirmed more soberly by Flaubert himself in a letter of 1874, referring to recent 'chroniqueurs' who have irritated him by describing his Paris apartment as being stuffed with valuable art works: 'Or, il n'y a rien du tout sur mes murs' (C4 782). And it seems that,

[149] Goncourts, *Journal*, i. 910–11 (28 Dec. 1862).
[150] Ibid. i. 681 (7 Apr. 1861). The original statuette is in Naples, according to the *Journal*, i. 616 n. 1: 'un torse en marbre, trouvé à la fin du XVIIIᵉ siècle dans l'amphithéâtre de Capoue et représentant une femme à demi nue, de style pratixilien'.
[151] Bergerat, *Souvenirs*, ii. 138–9. [152] Ibid. 139.

even when he had, in earlier days, it was no more than a job lot of engravings, bought for him by Bouilhet, which Flaubert clearly regarded as so much wallpaper.[153]

However, all the preceding remarks refer to Flaubert in Paris, the public Flaubert. But Flaubert in Croisset was a different matter. His private collection was in Croisset, not Paris, precisely because it was private, not public. Croisset contains a shrine of images, an Aladdin's cave. When Flaubert speaks of resuscitating old family portraits from the attic at Croisset and hanging them (15: 529, 530 Jan. 1877), it is not because they are masterpieces, and they will not find favour with his niece, he knows; but their colour is cheering, and in their very naïvety they have the power to 'faire rêver' quite as well as the best art: 'Pourquoi méprises-tu les portraits de tes ancêtres? Ils s'abîment au grenier; je vais les accrocher dans le corridor. Premièrement, ça fera un peu de couleur, et puis ils sont si naïfs que ça vous entraîne dans des rêveries historiques, lesquelles ne manquent pas de charme' (15: 529).[154]

But the Goncourts did not share that view. When they were finally accorded the privilege of viewing Flaubert's collection of art works in Croisset they were as horrified by what they saw as they had been shocked to have seen almost nothing in his Paris apartment.[155] Unable to deny (this time) Flaubert's 'nature d'artiste' they were deeply unsettled by what was confirmed to them at the same time as a 'fond de barbare'. What they saw was akin to the 'bazar' of Félicité's room (4: 221): the 'pendule paternelle' in yellow marble and a bronze bust of Hippocrates, together with 'une mauvaise aquarelle, le portrait d'une petite Anglaise, langoureuse et maladive, qu'a connue Flaubert à Paris',[156] and, worst of all, box-tops, framed as if they were art works—'des dessus de boîtes à dessins indiens, encadrés comme des aquarelles'. All this was presented on a level, as it were, with examples of art work they could at least recognize as such, for example, Callot's engraving of the *Tentation de saint Antoine* (which Flaubert had acquired in 1846), and a bust of Flaubert's

[153] 'Je te laisse le choix. Je tiens plus à la quantité qu'*au fini*', C2 615.

[154] Sentimental reasons are in play, of course, as well; Flaubert speaks also of his intention to display in his apartment a miniature of his 'grand-père Fleuriot', and a photograph [*sic*] of his niece seen in profile, 'ton profil napoléonien que j'aime tant' (15: 530, 21 Jan. 1877).

[155] Goncourts, *Journal*, i. 1022–3 (29 Oct. 1863).

[156] Henriette Collier, by Rossi, see above, pp. 61–62.

sister by Pradier, 'figure pure et ferme qui semble une figure grecque retrouvée dans un keepsake'. On a table is 'une cassette de l'Inde à dessins coloriés', and the curtains too have an exotic air—'de façon ancienne et un peu orientale, à grandes fleurs rouges'—while the bed (like that in the Rouault house in *Madame Bovary*) is covered with an 'étoffe turque'; and the Goncourts feel that they have had an insight into the heart of Flaubert's artistic nature: 'Cet intérieur, c'est l'homme, ses goûts et son talent: sa vraie passion est celle de ce gros Orient, il y a un fond de barbare dans cette nature artiste.' Other art works and artefacts join the collection later, and are also often, like these, personal icons. The portrait of Saint Polycarpe Flaubert would finally have come to join them.[157]

Of course Flaubert collected art works, but with a complete disregard of received opinion. The 'chambre secrète', at Croisset, belies the public impression in Paris. Flaubert *is*, in part, a 'barbare', a 'sauvage', and he does indeed take an active pride in it, flaunting it, just as much as does his old adversary Barbey d'Aurevilly, the self-styled 'barbare à sensations'.[158] But that is not all he is. At home, Callot, Brueghel, and a delicate little Psyche rub shoulders with framed box-tops. If Flaubert is inclined to 'prendre l'art à l'envers', in the Goncourts' words, he knows that he is doing so and why.

On the other hand, Bergerat's statement that 'Flaubert avait l'horreur de la peinture' was based on Flaubert's own statements to him, and has some truth to it—but a more fundamental truth than Bergerat himself realized. While Flaubert's reactions to being 'accusé de galerie de peinture' are exaggerated, playing to his audience, this association between 'la haine de la littérature' and a gallery of paintings is entirely in line with Flaubert's more sober thinking on the subject. Moreover, it is very likely that Flaubert did utter the following statement, attributed to him by Bergerat: 'En fait de

[157] We could add to this list Flaubert's 'portraits de Japonaises' and some photographs (unspecified), cf. C4 664 (20 May 1873), and a drawing by Brueghel of another *Tentation de saint Antoine*, see G. Thibaudet, *Gustave Flaubert* (Gallimard, 1935), which includes a reproduction (facing p. 168): it depicts an enormous head penetrated by monsters, and is clearly closely related to Flaubert's obsession with this leitmotif (Flaubert notes its presence in Brueghel's *Temptation*). However, it is not certain that the print belonged to Flaubert. The only evidence is its stamp, which declares it to be the property of the museum of the *pavillon* of Croisset. Another portrait of Flaubert?

[158] Cf. Barbey d'Aurevilly, *Correspondance générale* (Les Belles Lettres, 1980–9), ii. 1060 (*Memorandum* of 1856), quoted by N. Dodille in G. Ponnau (ed.), *Fins de siècle* (1989).

paysages j'opère moi-meme, déclarait-il, et il ne se vantait pas, il faut en convenir.'[159] With a private gallery in his head, and some highly evocative icons in his secret chamber, he hardly needed pictures on his walls. Like the hero of Compton Mackenzie's *Sinister Street*: 'since pictures seldom could be found to provide what he sought in a picture, there were very few of them in his sitting room'.[160]

Flaubert's collection at Croisset, with its mixture of 'high' art and low, of 'good' and 'bad', of art for its own sake, and art for its connotations and connections, is a *mise en abyme* of his responses to the pictorial. A 'bazar hétéroclite', like Félicité's room in *Un cœur simple*, it is a mere stage on the way, a necessary preparation for the eventual apparition of the purely imagined (or God-given) image of the marvellous parrot, visual embodiment of the word.

[159] Bergerat, *Souvenirs*, ii. 139.
[160] *Sinister Street* (Harmondsworth: Penguin, 1961), 472.

Text and Image

'FAIRE VOIR': THE NATURE OF FLAUBERT'S PICTORIALISM

Flaubert was hailed as a practitioner of plastic writing by all his contemporaries. He was placed in the same category as Leconte de Lisle, as Gautier, and as Hugo (including by Leconte de Lisle himself). The prevailing view of Flaubert's writing is summed up by the Goncourts: *Madame Bovary* is painterly because it represents 'un côté très matériel de l'art de la pensée', whereby objects are accorded the same attention as 'plot' or 'character': 'Les accessoires y vivent autant et presque au même plan que les gens [. . .]. C'est une œuvre qui peint aux yeux, bien plus qu'elle ne parle à l'âme. La partie la plus noble et la plus forte de l'œuvre tient beaucoup plus de la peinture que de la littérature. C'est le stéréoscope poussé à sa dernière illusion.'[1]

Baudelaire too was sensitive to this aspect of Flaubert's writing, describing *Madame Bovary* as 'vraiment belle par la minutie et la vivacité des descriptions'.[2] Not all contemporary critics were so appreciative, however. *Salammbô* attracted the most comments on this score, and almost all were negative. The most vitriolic critic was Barbey d'Aurevilly. Having early in his career resigned himself to the fact that painting was too powerful a rival to writing and settled for what he called the mere 'crayon blanc' of prose,[3] Barbey d'Aurevilly was ill disposed to be indulgent to a writer who had not: Flaubert is a 'dessinateur à l'emporte-pièce', an 'enlumineur

[1] Goncourts, *Journal* (1989), i. 642 (10 Dec. 1860).

[2] Baudelaire, *Curiosités esthétiques*, ed. H. Lemaître (1962), 647.

[3] Cf. Barbey d'Aurevilly, *Memoranda* of 1837–8, on wishing to create various *portraits de femmes*: 'Alors les mots m'impatientent. Ils ne sont que du crayon blanc pour faire des chairs qui demanderaient les velours lumineux ou éteints des pastels', *Œuvres romanesques completes*, ed. J. Petit (1964–6), ii. 971. See also N. Dodille, 'Les "Sensations d'art" de Barbey d'Aurevilly', in *Fins de siècle* (1989), 183–94.

de cartes de géographie';[4] his writing is unbearable in the intensity of its visual detail:

Venu après son ami M. Théophile Gautier, le lapidaire des *Émaux et camées*, qui, lui aussi, grave sur pierre et peint sur caillou, M. Flaubert a été un Théophile Gautier prosaïque, descriptif jusqu'à la minutie, découpant tout et empâtant la couleur sur tout, pour que tout se voie, bombant l'atome et pointillant l'éléphant, et finissant par donner aux yeux de l'esprit la sensation, insupportable pour ceux du corps, que donne une tôle brillant au soleil; car ses paysages si vantés, ces paysages sans nuances flottantes, sans tons fondus, et sans transparence, ont la solidité et l'éclat brusque d'un métal.[5]

Flaubert's writing is plasticity itself, he is 'matérialiste dans la forme, comme personne, avant lui, ne s'était peut-être jamais révélé'. He is in the business of selling pictures: 'il cloue et soude des tableaux à d'autres tableaux. Son livre, c'est la boutique de son sieur Arnoux, qui, lui aussi, vend des tableaux.'[6] *L'Éducation sentimentale* is but a succession of magic-lantern images.[7] The *Tentation* receives the same kind of criticisms from Barbey d'Aurevilly, though other contemporaries were more at ease with these particular brilliant flickerings, possibly because they did not strike them as being particularly out of place in a genre which, unlike *Salammbô*, escaped all known definitions. But Barbey d'Aurevilly

[4] Barbey d'Aurevilly, 'Flaubert: *L'Éducation sentimentale*' (*Le Constitutionnel*, 29 Nov. 1869), in *Le XIXᵉ siècle* (1964), ii. 157. The Goncourts criticized *Salammbô* in the same terms, *Journal*, i. 692, 'roulant dans l'emphase, la grosse couleur, presque l'enluminure'. Courbet and Manet were both also accused of *enluminure*, cf. P. Hamon in S. Michaud *et al.* (eds.) *Usages de l'image au XIXᵉ siècle* (1992), 240.

[5] Ibid. The art critic Théophile Silvestre also emphasizes heaviness and solidity when speaking of Flaubert's artistic vision: Flaubert's eyes (which Silvestre had evidently found disturbing) are 'yeux d'objectif, pleins de mots et d'images': 'Impossible de mieux porter son style dans le regard, un style visqueux et batracien', *Figaro* (8 Jan. 1863), quoted C3 1229.

[6] Barbey d'Aurevilly, *Le XIXᵉ siècle*, ii. 161.

[7] Ibid. 161–2: 'cette suite de tableaux à la file, tous pareils à une lanterne magique'. Optical instruments are often invoked in connection with Flaubert's style, especially the stereoscope (the Goncourts, quoted above, and Dusolier, at 2: 406) and the camera (Gautier, 2: 453, 454). Analogies are now often made with the cinema, cf. e.g. 4: 194, CT 427, 799 and esp. Biasi in his edn. of *Trois contes* (Seuil, 1993), 267: 'Le cinéma est une référence anachronique, mais pertinente au sens où Flaubert était réellement obsédé par la question de la mobilité visuelle: ses carnets attestent d'ailleurs de tentatives (maladroites, mais significatives) pour imaginer une technique de projection d'images mouvantes sur écran (ombres chinoises, lanternes magiques, etc.).' Cf. on stained glass pp. 19 ff.

writes with unabated loathing of the *Tentation*'s 'peintures qui
ressembent à l'imagerie'; Flaubert is 'un industriel en culs-de-lampe',
'un enlumineur qui peint des verres coloriés pour les lanternes
magiques [. . .] ce n'est pas seulement son livre qui est une
lanterne magique. C'est même son cerveau.'[8]

Barbey d'Aurevilly was of course an extremely acerbic critic, despite
and because of his understanding of Flaubert. But his view is
supported by a far more kindly critic, and one who actually *talked*
with Flaubert, Taine. One of the fundamental points of difference
between Taine and Flaubert was the question of whether writing
should or should not be visually evocative. This difference surfaced
from the moment of what must have been their very first meeting,
in 1862. Taine's note describing the circumstances of that meeting
censures Flaubert's writing as being 'de la littérature dégénérée, tirée
hors de son domaine, traînée de force dans celui de la science et des
arts du dessin': 'Ma thèse est toujours que son état d'esprit, la vision
du détail physique, n'est point transmissible par l'écriture, mais seule-
ment par la peinture. Sa réponse est que c'est là son état d'esprit,
et l'état d'esprit moderne.'[9] Further discussion over the years that
followed did nothing to weaken their respective positions, as Taine
himself tells Paul Bourget in a letter of 1881: 'Mon principe est qu'un
écrivain est un psychologue, non un peintre ou un musicien, qu'il
est un transmetteur d'idées et de sentiments, non de sensations. Nos
deux esthétiques diffèrent; cela ne m'empêche pas d'estimer la
vôtre à toute sa valeur qui est très haute. Le pauvre Flaubert avait
tout à fait les mêmes idées que vous là-dessus.'[10]

Flaubert himself was the first to note that the point of writing,
for him, was 'faire voir'. The idea that writing is a *sorcellerie
évocatoire* surfaces as early as the *Souvenirs, notes et pensées
intimes*: 'Quand on écrit [. . .] on se compose des tableaux qu'on
voit [. . .]; j'ai composé dès que j'ai su écrire, je me suis composé
exprès pour moi de ravissants tableaux' (pp. 66–7). Flaubert was
attracted all his life to writing which was closely related to the visual
arts—theatre, opera, *féeries*, and puppet shows. How is it then that
his pronouncements on the subject of associations between liter-
ature and the visual arts are almost unfailingly hostile?

[8] Barbey d'Aurevilly, 'Flaubert: *La Tentation de saint Antoine*' (*Le Constitu-
tionnel*, 20 Apr. 1874: xviii. 111 ff.), in Barbey d'Aurevilly, *Le XIXᵉ siècle*, ii. 236.
[9] *Taine, sa vie et sa correspondance*, 4 vols. (1902–7), ii. 233, 235.
[10] Ibid. iv. 114, letter to Paul Bourget, 9–10 May 1881.

'UT PICTURA POESIS'?

What was conventionally understood as coming under the banner of the idea of *ut pictura poesis* was anathema to Flaubert. The idea is an old one, whose history has been often retold, and retold with apologies for the further retelling—of its origins in the misinterpretation of a phrase in Horace (who himself had inherited it), its overriding importance in France until the eighteenth century (the pockets of resistance in La Fontaine, Locke, Du Bos, and others having done little to undermine its power), in the domain of painting at first rather than for literature, until Delille and others made a determined effort to imbue literature with the pictorial in the genre of descriptive poetry.[11] The idea that literature and painting should aspire to resemble each other was dominant until Lessing dealt it what seemed to be a decisive blow in his *Laokoon* (1776). While allowing that the two arts are similar in their principles, and that both are concerned with mimesis, Lessing insisted on the differences of medium, literature employing conventional signs and developing its effects through time, painting employing natural signs and developing its effects in space. In the nineteenth century, in France, Lessing's lesson still held firm. The 'sister arts' were now as often perceived as rivals, and Flaubert was not the only writer to feel that each had a tendency to encroach on the other's domain.[12]

[11] See bibliography for studies by, esp., Abel, Gamboni, W. J. T. Mitchell, Hatzfeld, Lee, Praz, Scott, and Steiner 1982. One of the best overviews is by D. C. Miller (ed.), 'Afterword', in *American Iconology* (1993). Entire journals are now devoted to the question of the relationship between word and image, and more individual studies than this note could encompass. Recent theorists and philosphers (Goodman, J. Hyman, W. J. T. Mitchell, Lyotard, Marin) have worked hard to dispel the 'soft air of whimsy' which A. Fowler rightly says pervades this subject ('Periodization and Interart Analogies', *New Literary History*, 3 (1972), 498). It has inevitably become enmeshed in the study of description: cf. Barthes, *S/Z*, which equates realism and pictorial reference and see bibliography for studies by Hamon and Debray Genette.
[12] The language in which the debate about the relationship between literature and the visual arts is conducted is often that of battle, or war between the sexes (with literature usually playing the man), e.g. W. J. T. Mitchell in J. A. W. Heffernan (ed.), *Space, Time, Image, Sign* (1987), 1–11. Cf. also Mitchell, *Picture Theory* (1994), 114–15 on the English Romantics' resistance to anything that smacked of mere 'picture language' (Coleridge) and on Burke's famous distinction between the Sublime and the Beautiful. The sense of rivalry continues in 19th-cent. France, cf. Hamon, 'Le Musée et le texte', *Revue d'histoire littéraire de la France* (1995): the novel of this period exhibits 'un savoir-faire stylistique qui passe par la fabrication

While Flaubert did not deign to engage in debate on this issue, his sympathies, as he tells Louise Colet (*C1* 339), were with Cousin, who was opposed, after Lessing, to the idea of *ut pictura poesis*, believing that each art was constrained by its own formal requirements.[13] The only way in which literature should ape painting (and vice versa) is by staying within its own domain.

It is certain that Flaubert was highly dubious about what was usually understood in his time to be pictorialist writing, whether in the form of the *transposition d'art*, as practised by Hugo, Gautier, and others, and to which Huysmans, later, remained faithful, or in the form of highly descriptive, Parnassian writing. Flaubert was particularly critical of the latter, and remarked of Leconte de Lisle that, for all the latter's plasticity, crucially 'il lui manque la faculté de *faire voir*' (*C2* 298). Flaubert shares with certain other writers, not only Symbolists but others too (Diderot, Stendhal, Turgenev), the sense that exhaustive description is not necessarily the most effective way to evoke an object.[14] Flaubert's description of Charles's

d' "images" (à lire) destinées à concurrencer les images à voir du musée' (p. 11); 'La tonalité souvent ironique ou parodique des diverses mises en scènes de divers "musées" dans les textes littéraires constitue certainement le signal que ces questions sont "vives" ', p. 12. Cf. also Hamon in Michaud *et al.* (eds.), *Usages de l'image* (1992), 246: ' "Prose blanche" (c'est le sous-titre que Laforgue donne à sa *Grande complainte de la ville de Paris*), prose grise (Flaubert, à propos de sa Bovary), "painted plates" (Rimbaud) ou "Images d'un sou" [. . .] ainsi se formule une unique question: que faire de l'image (à lire comme à voir) au XIXe siècle?'

[13] Cf. e.g. V. Cousin, *du vrai, du beau et du bien* (1836), 196: 'Depuis le Laocoon, il n'est plus permis de répéter sans de grandes réserves l'axiome fameux: Ut pictura poesis.' Though Flaubert did at some time read the *Laokoon* and take notes on it, for *Bouvard et Pécuchet*, the file is now empty. See Ch. 6 for discussion of this *dossier*.

[14] Cf. Stendhal, who, faced with a view near Grenoble, so beautiful as to resist description, imagines a form of evocation which would be as light as a sailor's song: 'Mais comment décrire ces choses-là? Il faudrait dix pages, prendre le ton épique et emphatique que j'ai en horreur; et le résultat de tant de travail ne serait peut-être que de l'ennui pour le lecteur. J'ai remarqué que les belles descriptions de Mme Radcliffe ne décrivent rien; c'est le chant d'un matelot qui fait rêver', *Mémoires d'un touriste*, in *Voyages en France* (Pléiade, 1992), 378; and Champfleury, *Le Réalisme* (1857), 100 ff., which makes the point (in an interesting and vivid way) that description is only one way to evoke vivid images. Later, Banville associates literature and painting in a new lightness and indirectness of evocation: 'Ce n'est pas en décrivant les objets sous leurs aspects divers et dans leurs moindres détails que le vers les fait voir [. . .]; mais IL SUSCITE dans leur esprit [= *des auditeurs*] ces images ou ces idées, et pour les susciter il lui suffit en effet d'un mot. De même, au moyen d'une touche juste, le peintre suscite dans la pensée du spectateur l'idée du feuillage de hêtre ou du feuillage de chêne: cependant vous pouvez vous approcher du tableau et le scruter attentivement, le peintre n'a représenté en effet ni le contour ni la structure des feuilles de hêtre ou de chêne; c'est dans notre esprit que se peint

hat is all too famous and the cause of much debate, but it has to be invoked here because one thing it undeniably does is parody the idea of plastic evocation. The whole process of exhaustive description is mocked in this description which would seem to aspire to the evocation of a clear image but which fails to do so.[15] Flaubert's aversion to the idea of pictorialist writing as usually understood is clear from his judgement of his own style during the writing of *Madame Bovary*: 'par-ci, par-là, certains chics pittoresques inutiles; manie de peindre quand même, qui coupe le mouvement et quelquefois la description elle-même' (C2 333: 26 May 1853).

Later, during the writing of *Salammbô*, Flaubert's constant desire to *faire voir* raised before him the bogey of the meticulous finish and attention to detail of the painter Gérôme and the neo-Pompeian school: 'j'ai peur que ce ne soit poncif et rococo en diable' (C2 782). He can 'see' his subject but knows that there can be no simple correspondence between text and image: 'Je commence, je crois, à voir clair dans mon sacré roman [. . .]. J'ai introduit ma petite femme au milieu des soldats. A force de lui fourrer sur le corps des pierres précieuses et de la pourpre, on ne la voit plus du tout [. . .]. Il faudrait traiter ce sujet d'une manière simple, enlevée [. . .]. Mais comment *faire voir* les choses au bourgeois avec ce procédé?' (C2 768–9).[16] Flaubert's well-known dislike of the art of illustration stems similarly from his resistance, instinctive

cette image, parce que le peintre l'a voulu. Ainsi le poëte' *Petit Traité de poésie française* (1871; Alphonse Lemerre, 1891), 54–5. Cf. also P. Bourget's account of a conversation with Turgenev, *Essais de psychologie contemporaine* (1883; Plon, 1916), ii. 209 ff., quoted in P. Hamon *La Description littéraire* (1991), 164: Turgenev wants the 'détail évocateur' ('il voulait que la description fût toujours indirecte, et *suggérée* plutôt que *montrée*'), and cites a passage in Tolstoy where a whole night scene is evoked via one simple detail, 'une chauve-souris s'envole'. Cf. of course and finally Mallarmé, *Œuvres complètes* (Gallimard, Pléiade, 1945), 869: 'les Parnassiens, eux, prennent la chose entièrement et la montrent: par là ils manquent de mystère'.

[15] The topos of Charles's hat is now a staple of the undergraduate seminar, cf. Dorothy Kelly, 'Teaching *Madame Bovary* through the Lens of Poststructuralism', in L. M. Porter and E. F. Gray (eds.), *Approaches to Teaching Flaubert's Madame Bovary* (New York: The Modern Language Association of America, 1995), 90–7 at pp. 91–2.

[16] Being able to 'see' his subject is an essential stage in the writing process for Flaubert: 'Quand on a son modèle net, devant les yeux, on écrit toujours bien', C2 377; cf. also C3 55: '*Carthage* ne va pas trop mal [. . .], au moins je *vois*, maintenant'; 15: 485: '*Hérodias* se présente et *je vois* (nettement, comme *je vois* la Seine) la surface de la mer Morte scintiller au soleil. Hérode et sa femme sont sur un balcon d'où l'on découvre les tuiles dorées du Temple.' For further discussion of Flaubert's strategies for controlling pictorialism in *Salammbô*, see Ch. 7.

as well as intellectual, to this idea of fixity, of a one-to-one corres-
pondence between text and image.

FLAUBERT AND THE ART OF ILLUSTRATION

Flaubert did not object to being an inspiration for painters (he
was surprised when his *Tentation* pleased musicians rather than
painters, C4 793); and he actively encouraged the idea of turning
the inherently operatic *Salammbô* into an opera—especially if
Verdi would take it on;[17] and he even gave his permission for
costumes to be designed after the text of *Salammbô* for fancy-dress
balls (though he should have been more wary—the results, accord-
ing to Du Camp, were farcical). Inspiration, or development of inher-
ently pictorial potential, to these he had no objection. But he was
unflaggingly hostile to the idea of his texts being *illustrated*.[18]
Illustration differed from both fancy dress and opera in being asso-
ciated in his mind with fixity, as is clear from his reactions to Lévy's
idea of publishing an illustrated edition of *Salammbô*:

Jamais, moi vivant, on ne m'illustrera, parce que la plus belle description
littéraire est dévorée par le plus piètre dessin. Du moment qu'un type est
fixé par le crayon, il perd ce caractère de généralité, cette concordance avec
mille objets connus qui font dire au lecteur: 'J'ai vu cela' ou 'Cela doit être'.
Une femme dessinée ressemble à une femme, voilà tout. L'idée est dès lors

[17] For a thorough review of Flaubert's relationship with the theatre, see A. Raitt,
'Flaubert Off-Stage and On Stage', *Essays in Memory of Michael Parkinson and Janine
Dakyns, Norwich Papers*, iv (1996), 107–12, and *Flaubert et le théâtre* (1998). Flaubert
consistently refused requests to adapt the essentially *non*-operatic *Madame Bovary*
for the stage ('c'était une tocade universelle': C2 797), though he seems to have been
tempted at one point, cf. C3 79: 'je te garde une gratitude éternelle pour m'avoir
empêché de consentir à ce qu'on fît une pièce avec la *Bovary*'. Point made by Raitt,
'Flaubert Off-Stage', n. 12.

[18] Cf. Du Camp, *Souvenirs littéraires*, (1882; Aubier, 1994), 532: 'Les dessina-
teurs se mirent à la torture pour reconstituer, d'après la description de Flaubert, le
vêtement et la coiffure de Salammbô. Le résultat fut d'une bouffonnerie dont ils ne
se doutèrent pas. Le costume de Salammbô est celui que Cléopâtre-Isis porte sur la
façade occidentale du temple de Kalabischeh en Nubie.' Du Camp's identification
of the source for Salammbô's costume does not coincide with that given by
Flaubert, cf. C3 302. For the costumes designed by H. Valentin and reproduced in
the *Illustrateur des dames*, see *Album Flaubert*, 131-2. Cf. also C3 152, 301, 302.
Only Mallarmé took such an uncompromising line as Flaubert: 'Je suis pour—aucune
illustration', (*Œuvres complètes*, 878). Flaubert knew that the wish to illustrate was
a compliment, however, cf. C2 240 to Louise Colet: the sign of the value of her short
story *La Paysanne* is that 'on en fera des illustrations'.

fermée, complète, et toutes les phrases sont inutiles, tandis qu'une femme écrite fait rêver à mille femmes. Donc, ceci étant une question d'esthétique, je refuse formellement toute espèce d'illustration. (C3 221–2)

Quant aux illustrations, m'offrirait-on cent mille francs, je te jure qu'il n'en paraîtra pas *une*. Ainsi il est inutile de revenir là-dessus. Cette idée seule me fait entrer en *phrénésie*. Je trouve cela *stupide*, surtout à propos de *Carthage*.—Jamais, jamais! Plutôt rengainer le manuscrit indéfiniment au fond de mon tiroir. Donc voilà une question vuidée [. . .]. Mais la persistance que Lévy met à demander des illustrations me fout dans une fureur *impossible à décrire*. Ah! qu'on me le montre, le coco qui me fera le portrait d'Hannibal.—Et le dessin d'un fauteuil carthaginois! Il me rendra grand service. Ce n'était guère la peine d'employer tant d'art à laisser tout dans le vague, pour qu'un pignouf vienne démolir mon rêve par sa précision inepte. (C3 226)[19]

Flaubert was, in the end, successful in his attempts to prevent *Salammbô* being illustrated, but he was powerless to prevent other illustrated editions of his works, among others an illustrated edition of *Madame Bovary* (Lemerre, 1874), about which he remarked dryly in 1879 that 'les dessins concernent le livre à peu près comme la lune' (16: 286).[20]

Flaubert's one major attempt at parody of the idea of a one-to-one correspondence between text and image was his planned *féerie*, the *Île des Locutions*. The whole point of the *féerie* was to illustrate by means of flesh and blood characters and concrete situations the dangers of literalism, of a too close correspondence between word and image. The basic idea, which was astonishingly innovatory, was for the words spoken on stage actually to produce the images seen on stage. Du Camp explains how it would have worked, in his *Souvenirs littéraires*:

C'était l'image même contenue dans le dialogue qui devenait visible et se formulait matériellement aux yeux des spectateurs. Ainsi, un père cherche son fils, le trouve dans un café, buvant et fumant; il s'irrite et lui dit: 'Tu

[19] The subject will not lie down: cf. C3 227: '*pas d'illustrations*'. Lévy finally gives up, C3 240.
[20] The illustrations to this edn. of *Madame Bovary* were by Émile Boilvin; cf. note to 16: 286. Charpentier had already pestered Flaubert in the same year of 1879 for permission to produce a further illustrated edn. of *Madame Bovary*, and another of *La Légende de saint Julien l'Hospitalier*, 16: 222 (13 June 1879).

n'es qu'un pilier d'estaminet'; à l'instant le jeune homme devient un pilier et forme un des linteaux de la porte.[21]

It was an ambitious and expensive project. Du Camp adds a rider to the effect that 'la mise en scène eût ruiné la direction': 'L'idée en elle-même était ingénieuse, mais elle bouleversait tellement les habitudes théâtrales [. . .] qu'elle devait être considérée comme une innovation trop coûteuse et par conséquent inadmissible.'

Flaubert's experiences with the illustrations to the *féerie* he did actually complete exacerbated his loathing of the simple, non-parodic duplication of text by image. *Le Château des cœurs* began as a collaborative venture with D'Osmoy and Louis Bouilhet, but Flaubert finished it alone, and the piece became eventually very much his own. When it became clear that it would never be performed,[22] Flaubert consented, *faute de mieux*, to having it published serially in *La Vie moderne*, with illustrations by Daniel Vierge. He should have known better. Vierge's illustrations fulfilled all Flaubert's worst fears—the human figures were both ridiculous and intrusive: 'on coupe ma prose avec de petits bonshommes imbéciles, je *rage* contre Bergerat!' (16: 319).[23] The next instalment of *La Vie moderne* twists the knife in the wound—Flaubert complains bitterly to Charpentier, the publisher, of '[son] peu d'enthousiasme' for the way his text has been presented: not only are the figures stupid but they colonize the space:

Le numéro d'hier ne change pas mon opinion. Ces petits bonshommes sont imbéciles et leurs physionomies absolument contraires à l'esprit du texte! Deux pages de texte en tout! de sorte qu'un *seul* tableau demandera

[21] Du Camp, *Souvenirs littéraires*, 569. As Raitt points out, *Flaubert et le théâtre*, 96, Du Camp confuses this *féerie* with *Le Château des cœurs*. For the draft of the *Île des Locutions*, cf. Flaubert, *CT* 260.

[22] For an excellent discussion of *Le Château des cœurs*, see Raitt, *Flaubert et le théâtre*, 92–115.

[23] Cf. 16: 229 (3 July 1879)—'je me résigne à publier *Le Château des cœurs* avec une petite préface et douze dessins, un par tableau'—and CHH 16: 230: 'nous la publierons *avec illustrations*!!! [*sic*]. Il y a douze tableaux; on peut faire douze dessins de décors.' The preface was by Émile Bergerat, one of the directors of the journal. Cf. *Album Flaubert*, 200, for a reproduction of the cover page of *La Vie moderne* (21 Jan. 1880), and the 'Premier Tableau' by Vierge. Cf. A. Lombard, *Flaubert et saint Antoine* (1934), 99–100: 'On sait que, Flaubert ne pouvant arriver à faire représenter sa féerie, l'éditeur Charpentier chercha à lui offrir une compensation en la publiant dans sa revue avec une illustration très abondante. Les planches hors texte et le croquis, suivant et comme jouant la pièce de scène en scène, tenaient lieu ainsi d'une représentation.'

plusieurs numéros. Et encore, si ce n'était pas coupé par d'autres dessins,
n'ayant aucun rapport avec l'œuvre! ...
 O illustration! invention moderne faite pour déshonorer toute littérature!
(16: 322)

Almost the last letter Flaubert ever writes in his life is about the
battle between image and his text. Things have gone from bad to
worse. A later episode of the *féerie* has been interrupted not only
by an 'article de sport' but by a view of the Pont-Neuf—this is image
encroaching on text with a vengeance (16: 359–60: 15 Feb. 1880).

 The fact that Flaubert would have loved to see *Le Château des
cœurs* in the visual form for which he had *intended* it, with living
and breathing figures, on stage, was a further rubbing of salt into
the wound: 'Cela est un de mes chagrins littéraires (est-ce un
chagrin?) ne pas voir sur les planches le tableau du "cabaret" et
celui du "Pot-au-Feu!" ' (16: 233). The illustrations were intended
to compensate for the missing stage spectacle, but in the event they
did not even do that.

 It must be said that no illustrator could have done justice to the
surrealist visions evoked in the two *tableaux* to which Flaubert refers,
of the 'cabaret' and the 'Pot-au-Feu'. Probably, no stage produc-
tion could do so either, as Du Camp pointed out—Flaubert's vision
here is so fantastic that it would require the resources of the
cinema or computer graphics to realise it adequately.[24] Indeed,
Flaubert's phrase: 'est-ce un chagrin?' may well express some
doubt on his part as to whether any producer could have done any-
thing but spoil whatever Flaubert was intending in this strangest of
visual confections. The gap between image and reality could have
been as great, and the effects as *unintentionally* comic as Bouvard
and Pécuchet's embodying of Phèdre and Hippolyte.

 The only time Flaubert positively *wished* to include an illustra-
tion in any of his works, he did so out of pure perversity. Though
he refused to allow Charpentier to produce an illustrated edition
of *Saint Julien*, in the normal way, he did initially try to persuade
him to reproduce a 'lithochromie' (a particularly gaudy art form)
of the St Julian window to accompany the text, but to no avail
—Charpentier, perhaps smelling a rat, refuses.[25] Later, having

[24] Lombard (p. 97) makes this point.
[25] 15: 565: 'Pensez-vous à l'édition de luxe pour *Saint Julien*, avec polychromie?'
Cf. also 16: 102 (Flaubert had got as far as bringing Charpentier a drawing of the
stained-glass window, but in vain) and 16: 125 (Charpentier had promised to include

abandoned the attempt to persuade Charpentier, Flaubert explains to him why he had been so keen on the idea:

Je désirais mettre à la suite de *Saint Julien* le vitrail de la cathédrale de Rouen. Il s'agissait de colorer la planche qui se trouve dans le livre de Langlois, rien de plus. Et cette illustration me plaisait *précisément* parce que ce n'était pas une illustration, mais un document historique! En comparant l'image au texte on se serait dit: 'Je n'y comprends rien. Comment a-t-il tiré ceci de cela?'

Toute illustration en général m'exaspère, à plus forte raison quand il s'agit de mes œuvres, et de mon vivant on n'en fera pas. *Dixi*! (16: 146: 16 Feb. 1879)

'Comment a-t-il tiré ceci de cela?' is a question which could be asked about the relationship between image and text in *all* Flaubert's works, not just *Saint Julien*. We shall see, in Chapter 8, that the window is indeed a source, but more deviously symbolic than the reader would expect.

Flaubert's intransigence was not complete however, even here. The illustrations to Feydeau's *Quatre saisons*, for example, find favour with him: 'Bien que je n'aime pas les illustrations, celles-là sont fort gentilles' (*C3* 91, 8 May 1860). He was also much taken with Maurice Sand's intelligent, comic little cartoon figures of monsters for the *Tentation*.[26] But these are exceptions.[27]

Painted images in Flaubert play the role of the ultimate *tentation* so often, either too good or too bad, either invading the text or distracting from it, that one wonders whether, had he lived to see them, his reactions to Redon's illustrations of the *Tentation* (three series, dating from 1888 to 1896) would have been any more benevolent, despite Redon's own resistance to the 'statisme' which Flaubert abhorred.[28]

So, in light of the contradictions we have noted so far, what exactly is Flaubert's position in relation to the question of connections

the illustration as early as Sept. 1878 but had subsequently backed off from the expense of such an 'édition de luxe').

[26] Cf. Ch. 7.

[27] Cf. also Flaubert's reactions (above, Ch. 1) to the illustrations to Mme Régnier's *Princesse Méduse* (16: 272).

[28] Cf. Redon's desire to be 'tout le temps dans l'équivoque', quoted Seznec, 'Odilon Redon and literature', in U. Finke, *French Nineteenth-Century Painting and Literature* (1972), 280–98.

between literature and the visual arts? An answer may be found in the formulation Flaubert himself gives in *Bouvard et Pécuchet*, as the culmination of his protagonists' exhaustive study of aesthetics. It is suitably tentative, flexible, and open-ended: 'Puisqu'une idée ne peut se traduire par toutes les formes, nous devons reconnaître des limites entre les arts, et, dans chacun des arts, plusieurs genres; mais des combinaisons surgissent où le style de l'un entrera dans l'autre, sous peine de dévier du but, de ne pas être vrai' (*BP* 5: 149). Boundaries should be respected, then; but somehow, in practice, 'des combinaisons surgissent', and the boundaries are necessarily transgressed—unfortunately. Flaubert's position, then, would betray the same ambivalence as that of both Gautier and Baudelaire, Gautier dismissing the familiar idea of *ut pictura poesis* as a 'vieille bêtise', yet searching continually for *real* and original connections between the arts, Baudelaire bemoaning the fact that 'cette nécessité de trouver à tout prix des pendants et des analogues dans les différents arts amène souvent d'étranges bévues'—yet still seeking 'les parties concordantes de tous les arts et les ressemblances dans leurs méthodes'.[29]

Flaubert's practice is consistent with the flexible position adopted finally by Bouvard and Pécuchet. The critics who praise or blame him for the plasticity of his writing are not wrong. Flaubert may wish to censor 'les chics pittoresques' but in effect he often yields to the 'manie de peindre quand même', as he noted himself. However, he does not indulge in picturesque writing for its own sake (as, say, Gautier does). His contemporaries, while recognizing the plasticity of his descriptions, were not by any means so sensitive to the various narrative strategies by which it is controlled and which will be examined in Chapter 7.

[29] Gautier, 'Chronique des Beaux-arts', *Le Figaro* (11 Nov. 1836), quoted D. Scott, *Pictoralist Poetics* (1987), 5 (*'L'ut pictura poesis* est une vieille bêtise qui pour avoir tantôt deux mille ans, n'est guère plus respectable pour cela. La peinture et la poésie sont des choses diamétralement opposées'). The same sentiments are expressed in Gautier's *Salon* of 1839 (*La Presse* (21 Mar. 1839), quoted D. Scott, *Pictorialist Poetics*, 177). For Baudelaire, cf. 'Salon de 1846', *Critique d'Art*, 9 and 'Salon de 1859', *Critique d'Art*, 287. In 'L'Œuvre et la vie d'Eugène Delacroix' (1863), Baudelaire continues to envisage a kind of union: the two arts can learn from each other and work together, 'se prêter réciproquement des forces nouvelles'; but Lessing's lesson should not be forgotten—they are not interchangeable: 'C'est [. . .] un des diagnostics de l'état spirituel de notre siècle que les arts aspirent, sinon à se suppléer l'un l'autre, du moins à se prêter réciproquement des forces nouvelles', *Critique d'art*, 404. Even Cousin did not entirely exclude the possibility that connections could be made: his phrase 'sans de grandes réserves' (see n. 13 above) keeps a certain number of options open.

But Flaubert's idea of what constitutes a proper relationship between image and text also transcends plastic writing of the Parnassian kind. In Flaubert, the relationship between text and image is often indirect. Reading a letter from his mother, for instance, Flaubert evokes a very precise visual image, which is as remote from what the words themselves actually mean as the 'lys' of Mallarmé's 'Prose pour des Esseintes' is to the original 'grimoire': 'Quand je relis tes lettres comme tout à l'heure tes deux dernières, je vois ta bonne mine penchée sur ton secrétaire et écrivant, en puisant de l'encre dans [un] de tes vastes encriers qui ont toujours trop de coton et pas assez d'encre' (*C1* 586). Flaubert lends this experience to Emma Bovary. Reading a letter from her father evokes in her a powerful visual memory of life on the farm, which is only tangentially related to what her father has actually written. Her vivid image of the kitchen and farmyard arises somehow from a combination of her father's ideas struggling through the thicket of his style, 'qui caquetait tout au travers comme une poule à demi cachée dans une haie d'aubépine' (*MB* 1: 204), and the ash from the fire which he has used to dry the ink.

In the following example, the process is more complex. Here, reality and writing combine to create an imaginary picture. A visual perception leads to a memory of a text, which in turn evokes (somehow) a related but different image in Flaubert's imagination. Flaubert sees a basket of tulips, remembers one of Bouilhet's poems, and produces his own extremely vivid image of Bouilhet as a child, an image whose resemblance to the modes of eighteenth-century painting is entirely appropriate:

Tantôt, après dîner, en regardant une bannette de tulipes, j'ai songé à ta pièce sur les tulipes de ton grand-père, et j'ai vu, nettement, un bonhomme en culotte courte et poudré, arrangeant des tulipes pareilles dans un jardin vague, au soleil, le matin.—Il y avait à côté un môme de quatre à cinq ans (dont la petite culotte était boutonnée à la veste), joufflu, tranquille, et les yeux écarquillés devant les fleurs, c'était toi. Tu étais habillé d'une espèce de couleur chocolat [. . .] (*C2* 573–4)

The best writers, for Flaubert, are those who can evoke images in this way, images which 'font rêver'. Reading Turgenev, hc says, 'on voit et on rêve' (*C3* 309). Flaubert evokes Turgenev's 'puissance d'images' by proxy, in a letter to George Sand, at the same time indulging in a very appealing 'sorcellerie évocatoire' of his own: Turgenev 'a une telle puissance d'images, même dans la conversation,

qu'il *m'a montré* G. Sand, accoudée sur un balcon dans le château de Mme Viardot, à Rosay. Il y avait sous la tourelle un fossé, dans le fossé un bateau et Tourgueneff, assis sur le banc de cette barque, vous regardait d'en bas, le soleil couchant frappait sur vos cheveux noirs . . .' (C4 34: 31 Mar. 1869). This process of evocation should not be regarded just as a happy accident, but should be programmed into the very act of writing: 'Il faut qu'on voie la foule gueuler', says Flaubert of the *comices agricoles* (C2 444), demonstrating, in this strange phrase alone, how pictorialism for him is no simple matter.

Flaubert's sense of pictorialism in writing reflects and also anticipates changes in nineteenth-century thinking, concerning what is to be understood by the terms *pictura* and *poesis*. If 'literary' means discursive/philosophical, then literature at this time is becoming less literary. If 'literary' means becoming more conscious of its own medium, then literature is becoming *more* literary. The sense of *pictura* is also changing: painting is moving away from literary influences (that is, away from history painting, narrative painting, text-based painting, and the like), but does so at the exact moment when literature itself is changing, and moving closer to what used to be understood as painting's domain.[30] Baudelaire sums up the position admirably in the *Salon* of 1846. Painting and literature can resemble each other only if each is defined in a certain way: 'La peinture n'est intéressante que par la couleur et par la forme; elle ne ressemble à la poésie qu'autant que celle-ci éveille dans le lecteur des idées de peinture.'[31]

[30] R. G. de Saisselin, '*Ut pictura poesis*', *Journal of Aesthetics and Art Criticism* (1961), 149, quotes Du Bos in praise of Poussin for communicating so much in his painting *La Mort de Germanicus* which an epic poet could not, 'sans s'embarrasser en des descriptions qui rendraient son récit ennuyeux': 'The implications of this attitude towards the visual are important for the development of poetry and in a sense we might argue that this attitude will change the nature of the poetic, though this will appear fully only in the nineteenth century.' Cf. also Mitchell in Heffernan, *Space, Time, Image, Sign*, 2: '(1) there is no *essential* difference between poetry and painting [. . .]; (2) there are always a number of differences *in place* in a culture which allow it to sort out the distinctive qualities of its ensemble of signs and symbols'; and Miller, *American Iconology*: 'our very experience of the visual or verbal, far from being fixed for all time, is subject to continual reformulation and redefinition right up to the present day', 'Afterword', 284.

[31] 'Salon de 1846', *Critique d'Art*, 134. Cf. also Proust, 'Préface du traducteur', *La Bible d'Amiens*, 57: 'la peinture ne peut atteindre la réalité nue des choses, et rivaliser par là avec la littérature, qu'à condition de ne pas être littéraire'. In the enormous mass of attempts to define the relative domains of the visual and the

Baudelaire's concept of pictorialist writing does not at all re-
semble the 'statisme pictural' instanced by Debray Genette and
resisted by Flaubert with such passion. 'Le statisme pictural' would
describe, rather, the kind of writing Baudelaire had in mind when
he called Hugo, dismissively, a 'peintre en poésie', with Delacroix
the painter being the real poet.[32] Not only that, but the 'idées de
peinture' which Baudelaire has in mind are best evoked, in his
view, not by Hugo but by Malherbe. Later, in 'L'Œuvre et la vie
d'Eugène Delacroix', he explains what he means: he refers to an
anonymous 'poète' (himself, no doubt), who is sent into raptures
by the musical pictorialism of a line of Malherbe: 'Je connais un
poète, d'une nature toujours orageuse et vibrante, qu'un vers de
Malherbe, symétrique et carré de mélodie, jette dans de longues
extases.'[33] That, as Baudelaire's editor Henri Lemaître astutely
remarks, is to exemplify the concept of *ut pictura poesis* in a way
in which Horace never envisaged it![34] It is also Flaubert's way.
Flaubert too was sensitive to this kind of plasticity in writing, only
in his case the model was Montesquieu not Malherbe (15: 431).

When Flaubert said that he loved 'dans la peinture, la Peinture'
he did not mean by 'Peinture' anything resembling what is usually
meant by 'statisme pictural', but something far more ambiguous
and fluid. Paintings he liked drew him in by their overall tonality,
colouring, and atmosphere, and the concept of *stasis* has very
little to do with any of these. Flaubert's explanations of what he
wants his writing to be frequently have strong visual, pictorialist
connotations but these connotations are of an extremely abstract
nature: 'fixer un mirage' for example (of *Salammbô*, C3 276), where

verbal, Plato's stands out, as being itself remarkably vivid, and applicable to Flau-
bert's attitude to both painting and words: 'for the creatures of painting stand like
living beings, but if one asks them a question, they preserve a solemn silence. And
so it is with words; you might think that they spoke as if they had intelligence . . .
but . . . they always say one and the same thing.' *Phaedrus*, 275 D.

[32] 'Trop matériel, trop attentif aux superficies de la nature, M. Victor Hugo
est devenu un peintre en poésie; Delacroix, toujours respectueux de son idéal, est
souvent, à son insu, un poète en peinture', 'Salon de 1846', *Critique d'Art*, 92.

[33] *Critique d'Art*, 414.

[34] 'Donc *ut pictura poesis*, et réciproquement, mais en un autre sens, certes, que
celui où l'entendait Horace!', Baudelaire, *Curiosités esthétiques*, 328 n. 1. Once again,
there is a marked resemblance between Flaubert and Delacroix, cf. Baudelaire,
'L'Œuvre et la vie d'Eugène Delacroix', in *Critique d'Art*, 415: Delacroix had 'une
sympathie très prononcée pour les écrivains concis et concentrés, ceux dont la prose
peu chargée d'ornements a l'air d'imiter les mouvements rapides de la pensée, et dont
la phrase ressemble à un geste, Montesquieu, par exemple'.

the visual is simultaneously invoked and called into question. When
he writes about what he wants his writing to be, he does so, cer-
tainly, often in the light of a pictorialist ideal, but one which is
both abstract and elusive. In Flaubert's writing, as in many of the
paintings which drew his attention the most powerfully, we find
the art of 'rendre marginalement l'indisable', in Sartre's words.[35] To
wish writing to evoke certain colours as Flaubert famously did is
to invoke a pictorialist ideal of a sort, but not one which has
anything to do with any conventional idea of what constitutes 'a
picture'.[36] Again, Flaubert's yearning to evoke 'de grandes histoires
à pic, et peintes du haut en bas' (C2 416), 'des livres à grandes mur-
ailles et peintes du haut en bas' (C2 428) is a desire not to reflect
or evoke particular pictures but to create an overall effect. Indeed,
towards the end of his life, Flaubert evokes the even more radical
idea of the 'mur d'Acropole', the 'mur tout nu', where the idea of
a picture is finally erased (15: 446: 3 Apr. 1876).

Flaubert's idea of painterly writing is close to Barthes's defini-
tion of the pictorial, as adapted and applied to Flaubert by Biasi.[37]
According to Barthes's definition, painterly writing is a writing of
desire, or, even more elusively, of the desire for desire. Painting
represents the open-endedness which characterizes what literature
essentially is: 'la littérature est forclose au moment même où il
n'y a plus de peinture'.[38] Biasi draws a parallel between Barthes's
own texts on painting and Flaubert's writing: 'Reste, bien sûr, à se
demander par quel miracle, c'est-à-dire par quel travail flaubertien
de l'écriture, le texte a pu s'approcher à ce point de la mélodie
charnelle de la parole, de ce "grain de la voix" par lequel devient
sensible le grain du trait, de la couleur, de la toile et du papier.'[39]

[35] *L'Idiot de la famille*, ii. 1981. Cf. Henry James, in *The Painter's Eye*, ed.
J. Sweeney (1956), 118: 'the unsayable—the better half, we think, of all that
belongs to a work of art'.

[36] Cf. Goncourts, *Journal*, i. 673–4 (17 Mar. 1861) on Flaubert's desire to evoke
colours; Flaubert had envisaged something of the kind long before cf. *C1* 416 (1846):
'les querelles de peuple à peuple, de canton à arrondissement, d'homme à homme,
m'intéressent peu et ne m'amusent que lorsque ça fait de grands tableaux avec des
fonds rouges'.

[37] Cf. Barthes, 'Requichot et son corps', in *L'Obvie et l'obtus* (1982), 189–214,
and Biasi, 'Barthes et la peinture: Le Désir de l'illisible', *Magazine littéraire* (Oct.
1993), 68–70; and 'Le Tableau, terre inconnue', *Diogène* (Jan.–Mar. 1995), 88–99.

[38] Barthes, *L'Obvie et l'obtus*, 212–13.

[39] 'Barthes et la peinture', 70. Cf. Biasi, 'Le Tableau, terre inconnue', 98: 'il y a
bien conflit entre la peinture et la langue, mais cette confrontation est celle du désir

But painterly beauty represented only part of what Flaubert wanted writing to be. His 'livre sur rien' was, after all, never written. But Sartre recognized that Flaubert's writing resembles the painting of his contemporaries in so far as it transcends its ostensible theme to anticipate the more abstract kind of painting to come: 'Flaubert ressemble aux peintres de son époque qui avaient besoin d'un "sujet"—fût-ce une simple nature morte—pour enflammer leurs couleurs mais dont le but principal était à travers la signification (le thème traité) de révéler un être plastique et non signifiant, une certaine chose qui est une combinaison de couleurs et de tons.'[40]

Flaubert often uses painterly vocabulary to refer to his writing. When he does so, it is often in a spirit of mockery and self-mockery, between inverted commas, as it were.[41] But the irony is a smokescreen; he does indeed write in the light of an ideal he recognizes as painterly, even if it differs from the contemporary received view, and even if contemporary interpretations of the term prevented him from using it.

FLAUBERT AND THE ART OF ART CRITICISM

Art criticism for Flaubert is a further example of an unhealthy relationship between literature and the visual arts. He couples it with illustration as a peculiarly modern contagion. Flaubert was unusual in this attitude. Writers in general flocked to try their hand

et de la séduction. La littérature, l'écriture vivante coïncide avec l'émergence du désir de dire: c'est la textualisation de cette pulsion. De même, la peinture n'apparaît que dans le désir de former une énigme offerte à la langue qui l'interprétera.'

[40] Sartre, quoted F. Gaillard, *Revue d'histoire littéraire de la France* (1980), 996. Cf. C. Rosen and H. Zerner, *Romanticism and Realism* (1984), 155: 'A work of avant-garde Realism proclaims itself first as a solid, material art object, and only then allows us access to the contemporary world it portrays'; ibid. 157: 'To Flaubert, art is both representational and at the same time in itself pure and abstractly beautiful.'

[41] There are many examples, some unsurprising ('ton', 'couleur', 'contour', 'premier plan', 'deuxième plan', 'relief', 'tableau'), some more technical and specific: e.g. 'faire la pyramide' (*C3* 318 and 16: 258), and 'La littérature est l'art des sacrifices' (15: 464: 8 Aug. 1876). Cf. J. Bruneau, 'Les Deux Voyages de G. Flaubert en Italie', in *Connaissances de l'étranger* (1964) on Flaubert's use of painters' vocabulary. Flaubert mocks himself for this tendency: 'Me voilà arrivé à peu près à la fin de ma seconde partie. Je viens, ce soir, de bâcler les huit dernières pages. Il me reste à y mettre le *"grainé fin"*; la *ligne* est faite; quant au *trait de force*? . . .' (*C3* 725). Cf. also under DESSIN (*DIR*) for 'le grainé fin' (and in the relevant section of *BP* itself).

at this currently very popular genre. Instituted in its modern form by Diderot, art criticism was a convenient sideline for most of the major writers of this period in France. According to the malicious Goncourt brothers, both Taine and Sainte-Beuve desperately tried to 'bone up' on the new genre, in order to be up to the mark and be seen to be modern.[42]

A great deal of the art criticism of the time was primarily descriptive, partly because readers would not normally have access to either originals or reproductions, partly because no more was expected or required, partly because art critics had little or no technical expertise. Only Gautier and the Goncourts had such expertise, but they still remained faithful to the mixture of descriptive, narrative, and thematic modes of presentation, established by Diderot. Baudelaire was the only mid-century literary art critic in France to question the genre or break the mould.

Art criticism was regarded as an excellent *début* for a writer: 'SALON (FAIRE LE): début littéraire qui pose très bien son homme' (*Dictionnaire des idées reçues*). Flaubert may mock, but Baudelaire, Fromentin and Zola benefited enormously from beginning their literary careers in this way.

Flaubert himself gave three reasons for his dislike of art criticism. The first was the lack of technical knowledge of most writers who practised it, and the second was his dislike of criticism *tout court*. Invited to cover the 1875 *Salon*, he declined, on precisely these grounds: '*Paul Meurice* est venu il y a huit jours me proposer "de faire le Salon" dans *Le Rappel*. J'ai dénié l'honneur, car je n'admets pas que l'on fasse la critique d'un art dont on ignore la technique! et puis, à quoi bon tant de critique!' (C4 917: 27 Mar. 1875).[43]

The third reason stems from the very heart of his aesthetic. He calls into question not only art criticism but *any* attempt to evoke

[42] 'Taine [. . .] nous demande à regarder des gravures. Nous lui faisons défiler deux cartons. Il les regarde et nous voyons qu'il ne les voit pas. Cependant, comme il faut paraître voir et que l'art commence à passer pour quelque chose d'où l'on peut tirer des idées [. . .]': Goncourts, *Journal*, i. 952 (29 Mar. 1863); 'La préoccupation de l'art, dans laquelle nous vivons, le trouble, l'inquiète, le tente. Assez intelligent pour comprendre tout ce que ce nouvel élément, inconnu jusqu'ici à l'histoire, a apporté de couleurs et de richesses au romancier et à l'historien, [Sainte-Beuve] veut se mettre au courant [. . .]. Il ne sait pas et il voudrait bien savoir . . . [*sic*]': *Journal*, i. 915 (3 Jan. 1863).
[43] For similar sentiments, cf. C3 472: Dec. 1865 ('Étant un pauvre connaisseur en peinture') and 15: 470 (to Fromentin), 'je ne suis pas du bâtiment'.

paintings in words. Even if the argument had been put to Flaubert that the possibility of language is 'written in' to painting, and they are part of the same sign-system, he would still have maintained that verbal description of a painting is necessarily *de trop*.[44] Invited to provide a critical biography and commentary for the catalogue of an exhibition of drawings and engravings by his old friend 'le père Langlois', he declines:

1° Je [...] suis [...] l'ennemi né des textes qui expliquent des dessins et des dessins qui expliquent les textes, ma conviction est là-dessus radicale et fait partie de mon esthétique.

Je vous *défie* de me citer parmi les Modernes dont c'est la manie (car pour les Anciens, ils se sont abstenus de ce sacrilège) un bon exemple en faveur du contraire. L'explication d'une forme artistique par une autre forme d'une autre espèce est une monstruosité. Vous ne trouverez pas dans tous les musées du monde un bon tableau qui ait besoin d'un commentaire. Regardez les livrets d'exposition. Plus il y a de lignes, plus la peinture est mauvaise. (C3 718: 1867–8)[45]

In adhering to this belief, he had more in common with painters than with other writers: 'Painters always have a great distrust of those who write about pictures', said that great unrepentant art critic, Henry James.[46] Flaubert's views are identical to those of Delacroix, who was suspicious of all art critics, even Gautier and Baudelaire.[47]

Whenever art critics submitted their works to Flaubert, as frequently happened, he tended to rewrite them, subtly, and pull their arguments his way. He also emphasizes over and over again the

[44] Many commentators (such as Goodman) have followed Wittgenstein's line here: *Philosophical Investigations*, 481(e), quoted in Heffernan, *Space, Time, Image, Sign*, 74: 'A *picture* held us captive. And we could not get outside it, for it lay in our language and language seemed to repeat it to us inexorably.'

[45] Cf. C2 417: 'j'aurais bien défié Voltaire de faire la description seulement d'un de ces tableaux de Raphaël dont il se moque [*in Candide*]'.

[46] James *The Painter's Eye*, 35.

[47] Cf. Delacroix, *Journal*, 515–16 (17 June 1855), 606 (5 Jan. 1857), and *Correspondance générale* (1936), ii. 310. For the relationship between Delacroix and Baudelaire, cf. *inter alia* Armand Moss, *Baudelaire and Delacroix* (1973). Other painters were of the same view, cf. esp. Degas, quoted by Valéry, *Œuvres*, ii. 1308: 'il arrivait infailliblement à cet apologue: que les Muses font leur besogne chacune pour soi et à l'écart des autres, qu'elles ne se parlent jamais de leurs affaires, la journée finie, point de disputes, point de comparaisons de leurs industries respectives. "*Elles dansent*" criait-il.' Cf. also Pissarro on Huysmans, *Lettres à son fils Lucien* (Albin Michel, 1950), 44 (13 May 1883), the Goncourts, *Journal*, ii. 1179 (1 Sept. 1885) and Sainte-Beuve (despite his eagerness to join this new élite), 'Théophile Gautier', *Nouveaux lundis*, 6 (Lévy 1883), 315.

need for knowledge of technique, whether he is reminding Ernest Chesneau in an apparent aside how much he values the presence of 'le Praticien sous l'Esthéticien' (*C3* 808), or somewhat disingenuously reminding his correspondent of his own lack of professional expertise.

We are not surprised, in light of what has already been said, that Flaubert disliked Diderot's art criticism on the grounds that it was 'anti-peintre',[48] and that it was on the same grounds that he objected also to Thoré, Proudhon, Ruskin, Laverdant, and the obscure abbé Gaume.[49] These critics are worse than Diderot in Flaubert's eyes, because they are *committed*.

Among those of whom he disapproved less are Ernest Chesneau, whose book, *Peinture—Sculpture: Les Nations rivales dans l'art* (1868), is received with polite approval and encouragement (*C3* 806–8), and Fromentin, whose *Maîtres d'autrefois* (1876) is met with a measure of deference as befitting one who is at least 'du bâtiment' (15: 469–70).[50] But Flaubert's wholehearted approval seems to have gone only to Joseph Milsand, who was himself writing a mostly negative *critique* of Ruskin! Flaubert refers in passing to Milsand in his letter to Ernest Chesneau (*C3* 807) and made notes on Milsand's study of Ruskin, *L'Esthétique anglaise*, probably with *Bouvard et Pécuchet* in mind. Milsand's criticisms of Ruskin's art criticism could be Flaubert's.[51] Ruskin, according to Milsand, is too preoccupied with *ideas* in painting. He is obsessed with reading in symbols (Flaubert's own readings of pictures are resolutely anti-symbolic) yet at the same time is a devotee of the kind of realism

[48] Quoted in the dossier 'L'Esthétique', BMR, ms g 226¹ 155ʳ.

[49] For Thoré, cf. *C1* 470: 17 Sept. 1847; for Proudhon, *C3* 454: 'Chaque phrase est une ordure. Le tout à la gloire de Courbet! et pour la démolition du romantisme!' For Proudhon, Laverdant, and l'abbé Gaume's *Le Ver rongeur*, see BMR, g 226³ 48–64. Critics of earlier generations aroused less ire in Flaubert, cf. e.g. Vasari (*C2* 396), Hegel's *Cours d'esthétique* (*C1* 390, *PCG* 113), Jouffroy (BMR, ms g 226³ 60ʳ: 'La littérature doit être matérielle et non métaphysique'), Winckelmann's *Histoire de l'art chez les anciens* (BMR, g 226¹ 124ʳ–136ᵛ), Lessing and Cousin (for both of which see earlier in this chapter).

[50] For a discussion of the exchange of letters between Flaubert and Chesneau, cf. Fairlie, *Imagination and Language*, 357–64. Flaubert also received sections of *L'Art du XVIIIᵉ siècle* from the Goncourts (14: 419, *C3* 509)—and a copy of Zola's *Mes haines* (16: 230). Cf. also Philippe Burty (1830–90), critic, painter, writer, and engraver, friend of the Goncourts and the Impressionists, of whom Flaubert seems not to have disapproved and who designed the title-page of *Trois contes* (15: 555).

[51] For the transcription of these notes (BMR, ms g 226¹ 165ʳ⁻ᵛ), see Appendix C.

which we know Flaubert abhorred (Flaubert underlines the phrase citing Ruskin's view that 'l'art ne doit être qu'un compte rendu'). The following phrases, which are a paraphrase of Milsand himself, speaking in his own right, carry Flaubert's full approval, insisting as they do on the resistance of painting to recuperation by writing:

Les lettrés sont incapables d'apprécier les qualités en qque sorte musicales qui distinguent les tableaux des œuvres peintes. [*It is significant that Flaubert writes 'peintes' for 'écrites'*.] [. . .]

La théorie de Ruskin, en dernier terme, aboutit à ravaler l'élément plastique.

Les Penseurs qui s'occupent des artistes les engagent sous prétexte de se relever à se dégrader.

L'intérêt humain, pathétique, moral, philosophique sont [precip] précisément ce [que la] que cherche & aime dans un tableau la foule ignorante & les lettrés qui lui demandent les mérites d'un récit ou d'un roman [. . .].

Milsand escapes Flaubert's ire in part because he is writing about writing (Ruskin) and not directly about painting; and moreover doubting the validity of writing about painting at all. But Flaubert's most fruitful encounter with an art critic is with Taine.

FLAUBERT AND TAINE

Flaubert's responses to the various volumes of art criticism sent to him by Taine are very revealing. While Flaubert clearly did not pore over every word ('flicking through' is the phrase that comes to mind), his judgements are telling, not only as a *critique* of Taine's ideas and practice but as an indirect expression of his own. On the subject of art criticism, as on the subject of pictorialist writing in general, Taine and Flaubert did not agree. As we follow their debates over the years, recorded primarily in letters, we see Flaubert trying and seeming partly to convince an unwilling Taine to value his own writing, for its own sake, not as the servant of some other art.

Taine sent Flaubert three volumes of art criticism in three consecutive years. The first was the second volume of Taine's *Voyage en Italie* subtitled *Florence et Venise* (1866). The second and third were based on lectures given while Taine was Professor of Aesthetics at the Collège de France: *De l'idéal dans l'art* (1867), and *Philosophie de l'art dans les Pays-Bas* (1868). Flaubert responded in a series of four letters: C3 547–9 (5 Nov. 1866); 561–3 (20 Nov.

1866); 654–5 (14 June 1867); 821–3 (10 Nov. 1868). At the same
time, Taine was working on *De l'intelligence*, his book on artistic
vision, with Flaubert as one of its points of reference. All the
letters which pass between Flaubert and Taine in these years
(1866–8), then, deal with painting, aesthetics, and/or the related
subjects of artistic vision and hallucination. It hardly matters that
Taine's side of the correspondence has not survived[52]—his views
are amply represented by his books which owe a great deal to
Flaubert's ideas.[53] Flaubert's input was invaluable, not only with
regard to *De l'intelligence* but also in so far as it helped to refine
Taine's writing about art in the other volumes.

Most of Flaubert's comments are addressed in some manner to
Taine's reluctance to deal with form. For Taine the art work was
document rather than *monument* (Wind's distinction), an expres-
sion primarily of the basic principle of *la race, le milieu et le
moment*, of which Flaubert was extremely dubious. Flaubert's very
first letter to Taine grasps this nettle: 'Encore une fois (et c'est là
mon sujet de dissentiment entre nous) vous ne tenez pas assez
compte de l'*Art en soi*' (C3 548).[54] In Taine's subsequent offering,
De l'idéal dans l'art, he has made some moves in the right direc-
tion, for which Flaubert congratulates him: 'Voilà la première fois
que je vois de l'esthétique pratique, ou plutôt de praticien' (C3 654).
Taine has not moved far—'Je regrette que vous ne vous soyez pas
plus étendu sur ce que c'est que le style', adds Flaubert—but he
is closer to Flaubert's ideal than he was: 'Un mot de vous m'avait
autrefois révolté: à savoir qu'une œuvre n'avait d'importance que
comme document historique. Il me semble qu'ici au contraire vous
faites grand cas de l'art en soi?'. Flaubert seems almost content with
Taine's third offering, *Pays-Bas*. But his rather pointed praise of 'tout
ce qui a trait à la peinture même' (C3 822) is in fact a preamble to
a more subtle point, and one which is even closer to Flaubert's heart.
He singles out for particular praise two passages which are not only
'des choses parfaitement originales (je crois)' but, what is more

[52] See Bruneau's note, C3 1232.
[53] This debt is surely acknowledged in the fact that Taine dedicated *Pays-Bas* to
Flaubert. Cf. Flaubert's earlier double-edged remark to Taine on *De l'idéal dans l'art*:
'Ces idées sont les miennes' (C3 654).
[54] Cf. 14: 467 to Turgenev (2 Feb. 1869): 'Sainte-Beuve et Taine [. . .] ne tien-
nent pas suffisamment compte de l'*Art*, de l'œuvre en soi, de la composition, du style,
bref de ce qui fait le Beau.'

crucial, 'supérieurement exprimées'. The first passage, in particular, on the *école allemande*, is a forceful reminder of the fact that form is all-important. Taine makes a distinction between German and English painting, on the one hand, and Dutch and Flemish on the other, showing that the former are preoccupied with ideas rather than form, the latter with form for its own sake;[55] and Taine now states as firmly as Flaubert might have wished that painting is primarily for the *eye*: 'Pour comprendre et aimer la peinture, il faut que l'œil soit sensible aux formes et aux couleurs' (p. 48). Taine's language, here, becomes positively sensual. The viewer of paintings must 'être capable de s'oublier devant la riche consonnance d'un rouge et d'un vert [. . .], devant les nuances d'une soie ou d'un satin qui, selon ses cassures, ses enfoncements et ses distances, prend des reflets d'opale, de vagues miroitements lumineux, d'imperceptibles teintes bleuâtres'. He ends with the triumphant statement, with which Flaubert would have been firmly in accordance, that 'l'œil est un gourmet comme la bouche' (pp. 48–9).

Now, an important corollary of Flaubert's insistence on the need to attend to form in painting is his equal insistence on the need for Taine to attend to his own style; hence the rider to his phrase praising the originality of Taine's ideas—they are also 'supérieurement exprimées'. The message is clear. If Taine would only attend to form in painting, it would follow, as day follows night, that he would attend to form in his own writing. Taine must be a (painterly) writer as much as, or more than, a writer about painting. Meeting the first condition is the best way, even the *only* way of meeting the second. The question, 'How should you write about painting?' leads to the question 'shouldn't you be doing something else?' And the 'something else' which Taine should be doing is something Taine does not theoretically much want to do.

Right from Flaubert's first letter, in response to the second volume of Taine's *Voyage en Italie*, Flaubert focuses on the question

[55] Dürer is 'un esprit à qui la forme ne suffit pas [. . .]; Cornélius et les maîtres de Munich considèrent l'idée comme principale et l'exécution comme secondaire' (p. 49). The English too (Constable, Turner, Gainsborough, Reynolds) are preoccupied with producing *meaning*: 'même dans le paysage, c'est l'âme qu'ils peignent; les choses corporelles ne sont pour eux qu'un indice et une *suggestion*'; 'Aujourd'hui enfin, leur coloris est d'une brutalité choquante, et leur dessin d'une minutie littérale.—Seuls, les Flamands et les Hollandais ont aimé les formes et les couleurs pour elles-mêmes' (*Pays-Bas*, 50–1).

of the proper balance between text and pictorial image. Though
Flaubert insists that he is not, of course, one of those philistines who
find 'qu'il est trop question de peintures dans votre ouvrage' (C3
547), he regrets 'le petit nombre de paysages' in Taine's own hand
to counterbalance the considerable quantity of painted ones. To
illustrate his point, Flaubert then singles out an interesting little
image from Taine's text, for praise: 'Dès la page 5 je suis empoigné
par l'effet de nuit, avec ce postillon "qui sautille éternellement
dans la clarté jaune"[. . .]'. This is Taine's text: 'Ce qui achève le
cauchemar, c'est le lugubre postillon, en vieille cape déguenillée, qui
sautille éternellement dans la clarté jaunâtre.'[56] This strange little
image, incidental but somehow seeming to comment, could easily
be one of Flaubert's own. Intensely visual, haunting, eerie, and enig-
matic, it is nevertheless unmistakably *literary*: its final phrase is
Flaubertian, with its phonetic echoes, its abstraction, and (if only
the adverb were moved to the end) its rhythm.

Flaubert returns to the attack later in the same letter, again
praising in order to encourage. He states how greatly he admires
Taine's solution to the problem of 'covering' the paintings in the
Uffizi, when so many have done so before him. Taine's solution is
that of a 'grand raffiné', in that it throws all the weight onto the
quality of his own writing. Taine's attitude here is one of cultivated
ignorance, rather like that of Jules in Italy: 'Ce qu'il y a de plus
simple, c'est de laisser là l'étude et de se promener pour son plaisir'
(p. 158). Flaubert's praise implies that the way to write best 'about'
pictures is simply to create writing of the highest calibre: 'La page
202 est adorable'. This is how it begins: 'On entre [dans les Uffizi]
dans le détachement et la douceur de la vie abstraite; la volonté se
détend, le tumulte intérieur s'apaise; on se sent devenir moine,
moine moderne [. . .]' (p. 159). Taine evokes the gallery of the Uffizi
exactly as Flaubert evokes the musée Calvet in Avignon in 1845 (see
below, Chapter 3). The way to write best 'about' pictures, then, is,
like Taine (here), and Flaubert himself, to write something *else*.

Flaubert makes substantially the same point in his assessment of
Taine's evocation of Venice, which Flaubert declares to be 'un
chef-d'œuvre ni plus ni moins', especially the 'couchers de soleil'
and descriptions of gondola rides.[57] In the course of this evocation,

[56] Taine, *Voyage en Italie* (1921), ii. 4–5.
[57] A *coucher de soleil* is the opening set-piece (p. 251–2), a *journée en gondole* is
the second (pp. 252–64).

Taine actually evokes pictorial art as being in competition with his own: 'Cela ne peut pas se decrire; il faut voir des estampes, et encore qu'est-ce que des estampes sans couleur?' (p. 254). Taine's word-painting of the lagoon also invokes the names of Veronese and Titian (p. 261). Finally, Taine's paragraph on the inadequacy of language to express a painting, on which Flaubert does not comment, must have all his approval, as it leads implicitly to the idea that the best tribute to painting is indirect:

Avec quoi montrer l'harmonie d'une draperie bleue sur une jupe jaune, ou d'un bras dont la moitié est dans l'ombre et l'autre sous le soleil? Et pourtant presque toute la puissance de la peinture est là dans l'effet d'un ton près d'un ton, comme celle de la musique dans l'effet d'une note sur une note; l'œil jouit corporellement, comme l'ouïe, et l'écriture qui arrive à l'esprit n'atteint pas jusqu'aux nerfs. (pp. 259–60)

In all these examples, paintings are evoked by Taine as models, foils, or haunting presence, and that, for Flaubert, is enough.

In Flaubert's response to Taine's third offering, *Philosophie de l'art dans les Pays-Bas*, once more, the qualities of Taine's own writing are emphasized as being of equal importance with the formal qualities of painting: 'Quel écrivain et quel peintre vous faites!' he says, encouragingly (C3 822). Passages Flaubert singles out for praise here continue to be those which echo features of his own style, descriptions where reality seems like art: towns depicted as stage-sets or suburban villages which 'semblent des décors d'opéra-comique' (*Pays-Bas*, 42), or stables 'dont le sol est un parquet', or pavements tiled with blue pottery (p. 43), and so on.

One passage, in particular, includes what Flaubert calls a 'merveilleuse phrase'. Here is the whole sequence, with the phrase referred to by Flaubert emphasized:

Si vous regardez les paysages de van der Neer, vous aurez une idée de ces vastes fleuves paresseux qui, aux approches de la mer, sont larges d'une lieue; *ils dorment vautrés dans leur lit comme un énorme poisson visqueux et plat, et luisent blafards, vaseux, avec des tons d'écaille terne; souvent la plaine est plus basse qu'eux et ne se défend que par des levées de terre; on les sent qui vont déborder; de leur dos transpire une vapeur incessante, et la nuit, sous la lune, le brouillard épais enveloppe toute la campagne de son humidité bleuâtre.* (p. 25)

Once more, the passage is introduced with reference to painting— the landscapes of Van der Neer. But the passage itself is resolutely

literary. It is a marvellous evocation, almost worthy of Flaubert himself, with its indeterminacy of content, simply adumbrated in the 'vastes fleuves paresseux [. . .] larges d'une lieue' and the attenuated colours, 'blafards' 'bleuâtre', the mist shading off all hard lines being emphasized in insistent synonyms ('vapeur', 'brouillard', 'humidité'), the unusual but appropriately overdetermined metonymic image of the fish, together with the music of the words, the sheer pleasure of their sounds, a gourmet feast, 'larges d'une lieue', 'visqueux . . . vaseux'.

Another passage singled out for praise by Flaubert is not so concretely visual, and Flaubert says he cannot say why he likes it so much: 'En voici une autre qui me *va au cœur* (je ne sais pourquoi). "Les chênes déracinés qui tombaient dans les fleuves faisaient des radeaux comme aujourd'hui sur le Mississippi et venaient choquer les flottes romaines".' (p. 26). The charm of this sentence is clearly akin to that of the line of Malherbe which sent Baudelaire's poet into 'de longues extases', or the sentences in Montesquieu which held Flaubert entranced—concrete but not mimetic, sculpted but not sculptural. It is an example of a new conception of plastic writing, and one of which Flaubert seems surprised to find Taine capable. Taine is slipping here into a kind of plastic writing which lies beyond description. Patricia Lombardo remarks, rightly, of Taine, that even his best descriptive prose is inferior to 'l'art de Baudelaire, qui ne décrit pas'.[58] Here, Taine penetrates, briefly, into that more subtle mode of evocation.

However, such feats of evocation are rare. More usually, Taine resigns himself to conventionally descriptive writing when he feels he must, though he does not really like it, or feel that it is as successful as painting.[59] The result is that such description, for Taine, is a dead end, a product simply of what he himself calls his holiday self, the '*moi* sentant des vacances'.[60] Flaubert, on the other hand, makes what he would agree is potentially a blind alley a way through to broader vistas. Flaubert stopped writing about pictures in the conventional sense but never stopped writing in the light of

[58] Patricia Lombardo, 'Hippolyte Taine ou la critique sans l'art', *Cahiers de l'Association Internationale des Études françaises*, 37 (1985), 191.
[59] Cf. *Voyage en Italie*, 259–60, already quoted, and p. 254: 'Cela ne peut pas se décrire; il faut voir des estampes, et encore qu'est-ce que des estampes sans couleur?'
[60] Taine, 25 Oct. 1855, quoted by A.-L. Lepschy, 'Taine and Venetian Painting', *Saggi e memorie di storia dell'arte*, 5 (1966), 137–52, at p. 152.

a pictorialist ideal of writing. Taine said that the great choice in his life was between two role-models, Flaubert and Renan, and that he had taken Renan's path but always regretted not having chosen Flaubert's. Flaubert himself never wavered: 'c'est mon état d'esprit, et c'est l'état d'esprit moderne'.

This is the nub of Flaubert's attitude to art criticism. If undertaken at all, it is still only, ever, something to be left behind and transcended. His impulse, always, when writing to art critics, was to remind them that they were first and foremost writers. The Goncourts never forget: Flaubert refers approvingly to their 'façon de parler peinture—qui elle-même peint' (14: 419)—and Fromentin also receives praise on this score (15: 469–70). Others needed encouraging and reminding, and Taine is one of them.

Flaubert's deep-seated resistance as a matter of principle not only to art criticism but even to art commentaries or simple descriptions of paintings should not obscure the fact that he not only read it with interest, when obliged to, and managed to adapt it to sustain many of his own cherished notions, but also wrote it himself. If he was Jules, he was also Henry. He writes art commentaries. Only his art commentaries are not like Henry's. They are, however, very like those of Delacroix.

Delacroix's evocations of his paintings for exhibition catalogues are succinct to the point of curtness, a *degré zéro* of writing. Just after remarking on Delacroix's liking for Montesquieu's style (which Flaubert shares), Baudelaire draws an interesting comparison between the style of the established art critic Paul de Saint-Victor and that of Delacroix himself, writing about his own paintings. Saint-Victor is encyclopaedic and exhaustive, 'rien n'est oublié', and his style is charming, 'aussi spirituel que coloré'; but what remains in the reader's memory is just 'un spectre diffus'. In contrast, Delacroix's style is concise, even terse. In Delacroix, 'le lecteur sera obligé de deviner beaucoup, de collaborer, pour ainsi dire, avec le rédacteur de la note', but Delacroix's exhibition notes are incomparably more evocative, *regardless of whether he was evoking a real or an imaginary painting*: 'Comparez ce vaste morceau [*Saint-Victor*] aux quelques lignes suivantes, bien plus énergiques, selon moi, et bien plus aptes à *faire tableau*, en supposant même que le tableau qu'elles résument n'existe pas.'[61] Flaubert's art commentaries are like

[61] Baudelaire, 'L'Œuvre et la vie d'Eugène Delacroix', *Critique d'art*, 415–16.

those of Delacroix, because they stem, like Delacroix's, from a deep mistrust of art criticism as usually practised. But Flaubert's art commentaries remain unpublished, *aides-mémoire* for the most part, verbal indicators. He writes them, but then he abandons the form of the art commentaries entirely, and turns instead to the more indirect tribute to painting which is its transcendence in his own writing. Thus, once again, we see the pattern: pictures are vital, but must, in the end, give way to the writer's own art.

II

A Pictorial Education: Flaubert's Travel Years, 1840–1851

II

A Provincial Education: Flaubert's
Travel Years, 1840–1851

3

Art Commentaries (i): 1840–1848

Flaubert's travel writing plays a major role in his literary develop-
ment, and the same is true of the art commentaries contained
within it.[1] Description of paintings and other art forms has been
associated with travel writing from the days of early religious
pilgrimages. In nineteenth-century travel writing, the emphasis had
simply shifted to art for its own sake, but the sense of duty re-
mained. The great public and private collections began to open
their doors more liberally to the travelling public. Flaubert cites
the 'musée' as a 'must', at least as important as details of breakfast
and the meditations on ruins, which were a staple feature of travel
accounts of the first decades of the century:[2]

Le voyageur est tenu de dire tout ce qu'il a vu, son grand talent est de ra-
conter dans l'ordre chronologique: déjeuner au café et au lait, montée en
fiacre, station au coin de la borne, musée, bibliothèque, cabinet d'histoire
naturelle, le tout assaisonné d'émotions et de réflexions sur les ruines; je
m'y conformerai donc autant qu'il sera possible. (*PC* 10: 289)

Art commentaries, directed at specific paintings (as opposed to the
global impressions of collections familiar from earlier days), began
to play an important role in travel writing from about 1840 (with
Stendhal as an isolated forerunner).[3] Gautier's *Tra los montes*
(1840) was the first of this particular generation of artistic travellers;
Flaubert, the Goncourt brothers, Taine, and Fromentin followed
Gautier's lead, Flaubert figuring along with the Goncourts and
Fromentin as one of the first 'pèlerins de l'art' in the modern sense.[4]

[1] See *PCG*, ed. Tooke (1987), introduction, and bibliography for studies of
Flaubert's travel writing by Block, Bruneau, Carré, Castellani, Jaffe, and Parvi.

[2] On the theme of ruins in early 19th-cent. literature, cf. esp. Roland Mortier, *La
Poétique des ruines en France* (1974).

[3] See bibliography for relevant travel works by Stendhal and Gautier. Nerval and
Dumas did not include art commentaries in their travel writing.

[4] Cf. J. Bruneau, 'Les Deux Voyages de G. Flaubert en Italie', in *Connaissances
de l'étranger* (1964), 180.

Flaubert disliked travel writing and art commentaries in equal measure: travel impressions, like impressions of paintings, should feed into the writer's art by indirect means. The travel account and the art commentary are, in his view, not ends in themselves, nor are they 'art'. Yet the fact remains that, for all his complaints and reservations, Flaubert did actually produce both travel accounts and art commentaries, primarily out of a sense of self-discipline. But neither label, however, 'travel writing' or 'art commentary', is adequate to describe the complexity of his actual practice and the intensity of his personal investment, as a writer, in both. Flaubert progressively finds a voice for writing about paintings and the pictorial arts in general. His response remains personal throughout, but a growing sophistication is evident, with aesthetic considerations tending to dominate as time goes on. The style of art commentary also varies: the notes intended for Flaubert's private use (*Italie et Suisse* and the *Voyage en Orient*) are terse, and often simply an *aide-mémoire*, whereas the full-blown *récit de voyage* (*Par les champs et par les grèves*) experiments with different kinds of techniques.

Most importantly, we trace a process of gradual emancipation from the art commentary as well, developing side by side with the growing confidence in approaches to painting. Flaubert's commentaries always have a dual purpose. On the one hand, he attends to art for its own sake (the aesthetic of the painting, and what that aesthetic contributes to his own art). In this respect he is, as Bruneau says, 'passé maître'.[5] On the other, we see Flaubert already transcending the paintings about which he writes, on the way to his own master works, always keeping them in mind, as a presence more or less detectable in his text, but beginning already to exhibit signs of his 'style cannibale' (*C3* 43), or what Jean-Pierre Richard terms his 'sadisme formel'.[6]

ITALIE ET SUISSE, 1845

Italie et Suisse was the first of Flaubert's travel accounts to incorporate descriptions of paintings. While we know that pictures had

[5] Ibid. 179: 'Flaubert doit à ses visites dans les musées et à la critique d'art à laquelle il s'est initié et où il est passé maître [. . .] le perfectionnement de sa technique de romancier [. . .]; l'analyse des chefs-d'œuvre de la peinture italienne l'a aidé à prendre conscience des problèmes de composition; il a pu étudier les solutions que leur apportaient les grands artistes de la Renaissance et de l'époque baroque'.

[6] 'La Création de la forme chez Flaubert', in *Littérature et sensation* (Seuil, 1970), 195.

the power to move Flaubert greatly, they had figured only rarely in his *first* travel account, *Pyrénées et Corse* (1840): it is as if, at this early stage, there are two separate categories of pictorial art for Flaubert: the 'great works', on which he has as yet no purchase; and the popular forms—tea caddies, sofa patterns, *dessus de porte*, and the like—which have already caught his attention, but which remain private or are simply noted, without much development, in his early prose narratives. *Pyrénées et Corse* taught him a great deal in the way of nature but not much in the way of direct experience of the visual arts.

By the time of his second trip, to Italy and Switzerland (2 April to 7 June 1845), Flaubert has an aesthetic system in place, the one which he had recently set out in the first *Éducation sentimentale*, completed in January 1845. The *Éducation sentimentale* ends with Jules setting off for the Orient, having 'found himself' emotionally and intellectually, and being ready now to roam as the fancy takes him (though armed with his Homer). Flaubert too now sets off; but only to experience a certain degree of disappointment— a combination of honeymoon and family outing, with Flaubert under constant supervision for fear of further nervous attacks, does not quite fit with his ideal of travel as a 'travail sérieux': 'Voilà deux fois [. . .] que je vois la Méditerranée en épicier! [. . .] Si tu savais tout ce qu'involontairement on fait avorter en moi [. . .]' (*CI* 223, 226). Being alone was a rare pleasure.[7] He has almost no time to enjoy, Jules-like, the pleasures of colour and form in the smoke spiralling from his cigar: 'O! O! arrachement, comme à Fréjus! Il a fallu rentrer! toujours la même histoire! Vivre à Oneglia et passer ses heures à dormir sur le galet! N'y avoir rien qu'un cigare et ne contempler que le bleu de la mer, le blanc des vagues et les spirales bleues du tabac!' (10: 364). Despite these drawbacks, we see in the notes of *Italie et Suisse* a tentative but none the less selective and personal taste beginning to assert itself.

Italie et Suisse contains notes of visits to provincial collections in Dijon, Lyon, Avignon, Marseilles, and Toulon, as well as to the great *palazzi* of Genoa, the museum of Turin ('nul' unfortunately), the Brera and the Ambrosiana in Milan, and, on the way home, to Mme de Staël's house at Coppet, the Musée des Beaux-Arts in Geneva,

[7] 'Le lendemain matin, seul' (10: 356); 'Promenade seul' (358); 'Je suis sorti seul le soir' (361).

and Voltaire's house at Ferney.[8] Throughout, as always in his travel writing, Flaubert relies more on his own impressions than on guidebooks, or indeed background material in general. As far as guides to painting are concerned, internal evidence suggests that he used Murray's *Handbook* more than anything else; but Murray is very succinct, and could have served as little more than a pointer to particular paintings, not as a guide to interpretation.[9] Flaubert also took occasional guided tours, but seems to have been more attentive to the style of these tours than to their content; thus, he is far more interested in the lively narrative style of his guide to the Château des Papes than in whatever it was that she told him. Already, in this small example, we see how Flaubert's interest transcends the art which he has ostensibly come to see.

Paintings occupy about a sixth of the text, with the most substantial commentaries being those on Brueghel's *Temptation* and Veronese's *Giuditta e Oloferno*. Dutch and Flemish painters figure prominently: Brueghel, of course, but also Rubens and Van Dyck, these last being a major feature of Genoa. Velvet Brueghel, too, whom Flaubert confuses with his uncle who painted the *Temptation of Saint Anthony* and thus refers to as 'mon Brueghel', makes a first discreet appearance in the Ambrosiana in Milan, with two of his four *Elements*, the *Allegory of Fire* and the *Allegory of*

[8] The 1845 notes have been given little attention to date. Opinions differ as to their value, cf. G. Faure, *Pèlerinages passionnés* (1919), 133: 'J'admire [. . .] la précision, la netteté, la spontanéité des notations de Flaubert que ne guidait alors aucun de ces manuels qui dirigent les visites et les jugements de nos contemporains', against Bruneau: 'ses goûts se révèlent peu originaux, et ses connaissances d'histoire de l'art bien insuffisantes', 'Les Deux Voyages', 173. Nevertheless, Bruneau does not consider Flaubert's youthful lack of expertise to detract from the importance of these notes.

[9] Cf. Bruneau, 'Les Deux Voyages', 170, on Flaubert's use of Murray in Genoa: they cover the *palazzi* in the same order; both attribute Veronese's *Judith* to Titian (though Flaubert later changes his mind); the wording is similar in one instance, cf. Flaubert: 'Elle vient de tuer', and Murray: 'She has just taken it off [*i.e. the head*]', etc. Conclusion: 'Il est assez vraisemblable que Flaubert a utilisé à Gênes le guide Murray, ou un ouvrage imité par Murray ou inspiré de lui.' It would have been the English version, as it had not been translated into French by 1845. Flaubert would also have used written guides provided on the spot, cf. Baedeker's *North Italy* (1879), which mentions the 'Catalogue for the use of visitors' at the palazzo Rosso in Genoa (p. 87). Flaubert cites only three background books, one a history, the others concerned primarily with history and architecture: Vincent's *Histoire de la République de Gênes* (1842) (10: 362 and C1 218); Millin's *Voyage dans les départements de la France* (1807–11) (10: 356); and Mérimée's *Notes d'un voyage dans le midi de la France* (1835) (C1 218).

Water.[10] Flaubert's affection for Velvet Brueghel was to endure; later, he devotes considerable space to describing four wonderful paintings in the palazzo Doria-Pamphilj in Rome, all joyful paintings, depicting sinless paradises in glorious colour. Flaubert also gives space to painters habitually disregarded at the time—to Memling and Cranach (or to painters believed at the time to be Memling and Cranach).

Already the Venetian School begins to exert a powerful appeal—apart from Veronese's *Judith*, Flaubert notes paintings by Titian and Tintoretto. Leonardo's sketches and caricatures, and Raphael's great cartoon for the *School of Athens* are also given prominence. Perhaps more unexpectedly for a young viewer with little expertise, he also notes two paintings by Guercino. For the rest, we have a mixture: two Holbeins (not now believed to be Holbeins), a little Spanish,[11] including for the first time a painter who will become one of the stars in Flaubert's constellation, Murillo, and a handful of contemporary painters—Gérard, Devéria, the Vernets, and Prudhon—though these last with no significant degree of real interest or commitment. And, as we might expect, there are almost no landscapes.

Flaubert is by no means an impartial viewer. Indeed, Du Camp censures him for being altogether too personally involved in what he saw. In a letter of 29 October 1851, a letter full of 'duretés' intended to be bracing, Du Camp accuses Flaubert of being completely self-absorbed, and of seeing nothing except what would send back a mirror-image of himself: 'Tu as beau regarder autour de toi, tu ne vois que toi, et dans toutes tes œuvres, tu n'as jamais fait que toi' (C2 865). But this is to simplify. Flaubert had himself already considered the position long before Du Camp did. In 1845, in *Italie et Suisse*, he records how he was so moved by Canova's statue of *Amor e Psyche* at the Villa Carlotta on Lake Como that he took advantage of a momentary absence of the *gardien* to kiss Psyche's armpit. He then muses on the frailty of the conventional distinction between sensuality and aestheticism, between 'femme' and 'forme':

[10] The confusion between uncle and nephew was common at the time, cf. e.g. *Murray's Handbook for Travellers in N. Italy* (1877), who attributes the *Temptation* to 'Jan Breughel'.

[11] Cf. Gautier's initiation of the French public to Spanish art in his *Tra los montes* and Louis-Philippe's great Spanish collection brought to France by Baron Taylor and deposited till 1848 in the musée du Luxembourg.

je n'ai rien regardé du reste de la galerie; j'y suis revenu à plusieurs reprises, et à la dernière j'ai embrassé sous l'aisselle la femme pâmée qui tend vers l'Amour ses deux longs bras de marbre. Et le pied! et la tête! le profil! Qu'on me le pardonne, ç'a été depuis longtemps mon seul baiser sensuel; il était quelque chose de plus encore, j'embrassais la beauté elle-même, c'est au génie que je vouais mon ardent enthousiasme. Je me suis rué sur la forme, sans presque songer à ce qu'elle disait. Définissez-moi-la, faiseurs d'esthétiques, classez-la, étiquetez-la, essuyez bien le verre de vos lunettes, et dites-moi pourquoi cela m'enchante. (10: 377)

The fusion of 'femme' and 'forme', so important in the second *Éducation sentimentale*,[12] is apparent also in Flaubert's attitude to another female icon to which he was particularly drawn: Judith. According to the Goncourts, the appeal of such figures to Flaubert was simply erotic: 'Il y a une grossièreté de nature dans Flaubert qui se plaît à ces femmes terribles de sens et d'emportement d'âme, qui éreintent l'amour à force de transports, de colères, d'ivresses brutales ou spirituelles.'[13] But once again it is the form which Flaubert loves as much as the figure. The Veronese Judith which he sees in Genoa is the third so far, and prompts a brief art-historical disquisition comparing and contrasting this one with those by Horace Vernet and by Steuben.[14] Each of these paintings deals with a different stage of the narrative: Vernet's precedes the killing, Steuben's depicts the act itself, while Veronese shows us the aftermath, when Judith is putting Holophernes' head into the sack. Flaubert prefers the homely detail of the latter, with Veronese daring to eschew the obviously erotic, the obviously dramatic, and to humanize the heroine. He prefers the post-climactic moment, the idea of life going on, 'toute bête' as it is:

la plus jolie, comme joli, c'est celle de Steuben; celle que l'on aimerait le mieux à foutre, c'est celle de Vernet; celle que l'on admire le plus c'est celle

[12] Frédéric's feelings for Mme Arnoux are just such a fusion of the erotic and the aesthetic (see Ch. 8, where this point is developed). For this particular incident, cf. *ES2* 3: 314: Frédéric is moved to a feeling of 'concupiscence rétrospective' by a portrait of Diane de Poitiers (3: 314).

[13] Goncourts, *Journal* (1989), i. 774 (21 Feb. 1862).

[14] Flaubert is referring here to Vernet's first *Judith* (painted in 1829, and on show in the musée du Luxembourg). The *Judith* subsequently shown at the 1847 *Salon* was a second version, cf. Du Camp, *Souvenirs littéraires* (1994), 240, on this *Salon*: 'Les "bourgeois" s'extasiaient devant la *Judith* d'Horace Vernet . . .'. The Steuben *Judith* was to have hung in Guillaumin's living room (*MB nv* 583). In the end, Guillaumin is given an *Esmeralda* instead, which Flaubert was also fond of in 1845 (*IS* 10: 371). This may or may not be an implied comment on Flaubert's early tastes.

de Véronèse: c'est peut-être la supérieure, en tout cas c'est la conception la plus hardie des trois. La manière toute bête dont elle met la tête d'Holopherne dans le sac n'est pas sortie d'un artiste vulgaire qui eût voulu faire de l'inspiré, de l'animé, du mouvementé, comme au premier abord le sujet d'un tel fait semble le demander. (10: 366–7)

Flaubert 'collects' Judiths. In 1851, he adds two more to the list, both of which stress this homely, realistic side. The first is the Allori, in two versions, one large and one small, in the Uffizi and the Pitti, respectively, and is both magnificently colourist and almost comic, as Holofernes' gruesome green sawn-off head replaces the finely wrought purse we might have expected to see swinging almost casually from her hand. The second is also in two versions, one attributed to Caravaggio (Naples, Capodimonte), and the other attributed to 'Artémise Lomi' (the female painter known also as Artemisia Gentileschi) in the Uffizi—Flaubert himself makes the connection ('C'est le même tableau qui est à Naples sous le nom du Caravaggio', p. 165).[15] Both are now attributed to Gentileschi. Interestingly, the 1844 guide to the Uffizi (which Flaubert himself used in 1851)[16] declares that its *Judith* is 'trop fort pour être l'ouvrage d'une femme' (Pl. 1). The main interest for Flaubert in these two paintings, however, is less in questions of authorship than in the alliance of such a violent subject with such matter-of-fact precision—Flaubert himself remarks that Judith is attacking the business of sawing off Holofernes' head as if he were a particularly tough chicken: 'Elle l'égorge comme un poulet, lui coupant le col avec son glaive; elle est calme et fronce seulement le sourcil, de la peine qu'elle a.' The Gentileschi Judith is depicted in the throes of the act itself, butchering Holofernes as if he were so much dead meat, reducing the whole scene to the traditionally feminine domain of the kitchen, but subverting its traditional connotations of domesticity and peace.

Between the two series of painted Judiths, that is, between 1845 and 1851, there will be a real-life equivalent, which will come to join the *spirale* of images. Lying with Kuchuk-Hanem, after they have made love, Flaubert steps through the frame and enters the

[15] Cf. J. Seznec's notes on 'Flaubert and art' in the Taylor Institution, Oxford, section 3 (see Bibliography), on Flaubert's *Judith* paintings: the Allori Judith is the model for Josépha in *La Cousine Bette*, while the Gentileschi derives from a lost Rubens, at whose audacity Diderot marvelled.

[16] Cf. Appendix A, Florence.

picture as the weaker partner: 'j'ai pensé à Judith et à Holophernes couchés ensemble' (*VE* 287), and that memory of the dark room in Esneh with the weak shimmer of the light and the play of reminiscences of other women in other rooms ('des intensités nerveuses pleines de réminiscences'), he with his finger passed through the chain around her neck as if afraid she will leave him ('comme pour la retenir si elle s'éveillait'), becomes associated with the paintings—and no doubt many others—to culminate finally in the chapter of *Salammbô* entitled 'Sous la tente'.[17] Here, Mâtho, like Holofernes, loses Salammbô through the very act that has won her, while Flaubert's own magnificent chiaroscuro word-painting acts as a kind of tribute to these real paintings which showed him the way. While these Judith figures cannot fail to have focused Flaubert's own sexual desires and fears,[18] more than sexuality is at stake, and to attribute the sequence 'Sous la tente' only to Horace Vernet, as Hourticq does, is to ignore more earthy contributions from other paintings. Salammbô is ornamental, certainly, but once Mâtho has been metaphorically beheaded and the chain between her ankles literally broken, she shows her mettle. Then the carefully cultivated art work, object of men's desire, turns into a female person, albeit briefly, as she demonstrates that a pretty icon can tuck up her skirts and run (compare Flaubert's similar demystifying of the Salome figure in *Hérodias*).

Flaubert certainly concentrates on the human interest in painting, even in religious and mythological subjects: in Domenichino's fresco of the battle of the centaurs and lapiths, Flaubert notes the purely incidental figure of a man seen shouting his head off: 'on lui voit tout le palais, les dents' (10: 368); in Guercino's *Abraham and Agar* (10: 376) he notes how 'Ismaël se cache les yeux avec ses poings'; in Guido Reni's painting of St Jerome, he notes the loving depiction of the saint's toes with their 'ongles crochus' (p. 366). In paintings, as in life, Flaubert pursues the good face ('j'ai cette manie de bâtir de suite des livres sur les figures que je rencontre': *VE* 145). More than a third of the paintings in *Italie et Suisse* are

[17] The connection between Judith and Salammbô is an obvious one, underlined if need be by this note in one of Flaubert's scenarios for *Salammbô*: 'la jeune fille prend, après mille luttes, la résolution de sauver la ville, en reprenant le voile' (2: 285).

[18] For other paintings depicting beheadings, cf. the Salomes of the *Cambio* in Perugia, and of Moreau and Dolci (England 1865), and Domenichino's *David and Goliath* (10: 384), etc.

portraits (though Flaubert was fully aware of the drawbacks of the genre—its popularity, its mimetic function, the *bêtise* of specialist portrait painters). He is particularly interested in depictions of artists, the singer Annibali painted by Mengs, Mengs himself painted by Knoller (10: 375), a self-portrait attributed to Titian where Flaubert's own personal interest in the act of looking and its importance for the artist is underlined by the way Titian paints his own gaze: 'Dans les figures des grands artistes tout se concentre dans l'œil, parce qu'ils ne sont peut-être que cela, que des contemplateurs, comme disait Boileau en parlant de Molière. Regard un peu oblique et fixe' (10: 368).

Flaubert is also interested in the extent to which painting may be a more *devious* form of self-expression, with the artist being, in his own words, 'présent partout et visible nulle part' (C2 204). Thus, Van Dyck paints portraits of all kinds of people; and Flaubert sees Van Dyck himself in all he paints: 'C'était un homme intense que ce Van Dyck' (10: 368). Even an apparently impersonal market-scene by Bassano is a form of self-expression: 'toujours confus, sale de couleur et singulièrement bousculé; il y a pourtant là quelque chose. Bassano devait être un homme malheureux.' Years later, Flaubert will make a similar comment about himself: 'Peu de gens devineront combien il a fallu être triste pour entreprendre de ressusciter Carthage!' (C3 59).

Flaubert also registers paintings which reflect and confirm aspects of his newly created aesthetic system: Brueghel, of course, but other paintings too where a 'living' art of movement and dissonance is depicted, such as Bassano's *Mercato* ('bousculé', 10: 348), Rubens's '*Amours*' ('beaux d'expression, de mouvement et de chaleur', 10: 367–8), or Domenichino's frieze depicting the battle of the centaurs and the lapiths ('vigoureuse et mouvementée', 10: 368). The two Velvet Brueghels and, in more boisterous mode, Rubens's *Silenus*, are a celebration of the natural world. Flaubert's interest in monsters is reflected in the attention he gives to the caricatures of Leonardo in Milan,[19] and his delight in collapsing conventional distinctions is reawakened by Domenichino's centaurs and lapiths,

[19] NB, not 'Léandre' as in all editions to date. The appeal of Leonardo's caricatures for Flaubert is obvious. Cf. Gautier, *Critique artistique et littéraire* (1929), 27, on these caricatures: 'On dirait que l'artiste a voulu faire une espèce de cours de tératologie entendu dans le sens large de Geoffroy Saint-Hilaire et prouver la beauté par la laideur, la *norme* par le désordre [. . .]'.

which deconstruct the conventional antithesis between civilization and barbarism (a central theme of *Salammbô*, and of enduring interest to Flaubert) and by paintings of saints with strong animal connections—Saint Anthony, and Guido Reni's *Saint Jerome* (10: 366). But the most important painting of all in 1845 was without a doubt Brueghel's *Temptation of Saint Anthony*, which went to the heart of several of Flaubert's most enduring preoccupations, not least concerning the relationship between text and image.

Brueghel: 'The Temptation of Saint Anthony'

Flaubert's description of this painting is his first real art commentary. It did not come easily. When he first sees the painting in Genoa he simply alludes to it, not attempting to describe it ('il a effacé pour moi toute la galerie où il est, je ne me souviens déjà plus du reste': 10: 373). He does not get round to writing a commentary until he is in Milan. He then takes the trouble to draw attention to the time-gap, as if to signal its necessity, by writing 'Milan' at the end of his text (though all editions omit this detail).

Brueghel's *Temptation* has long been recognized as playing a major role in Flaubert's development, not least by Flaubert himself: 'C'est l'œuvre de toute ma vie, puisque la première idée m'en est venue en 1845, à Gênes, devant un tableau de Breughel et depuis ce temps-là je n'ai cessé d'y songer et de faire des lectures afférentes' (C4 531: 5 June 1872). Seznec pointed out long ago that the painting crystallized Flaubert's emotional position.[20] It certainly exerted a tremendous pull: the saint beset by images of a horrifying strangeness and intensity is a mirror-image of Flaubert himself (his first nervous attacks had occurred only recently): 'Saint Antoine, c'est moi' (C2 127). Anthony is both seduced and terrorized by images. They make him feel as if his very being is exploding into the thousand pieces of a firework display ('mes pensées [. . .] s'échappent de moi', says Antoine already in the first version of Flaubert's text,

[20] Seznec, *Nouvelles études sur la Tentation de saint Antoine* (1949), 86. Cf. also L. Czyba, 'Flaubert et la peinture', *Littérales* (1994), 129: 'Ce qui bouleverse ici Flaubert, c'est le sentiment brutal, immédiat, d'une analogie, d'une sorte de parenté profonde entre la sensibilité du peintre et la sienne.' The Brueghel *Temptation* is now in private hands. For a reproduction of it, see the cover of Flaubert's *Tentation de saint Antoine*, ed. Jacques Suffel (Garner-Flammarion, 1967).

9: 55). Images haunt not just the *Tentation* itself but Flaubert's writing as a whole, erupting into his work from time to time, either volcanically, as in the *Tentation*, or elsewhere detectable as a subterranean presence, discreetly conditioning some of his writing's most subtle effects.

But more than a question of shared 'sensibilité' is in question. When Seznec said that the painting crystallized Flaubert's position, he was thinking primarily of the idea of being beset by images. But that position must include the question of where *words* stand in relation to images. As the eye of the viewer scans the picture, it moves from the images, which dominate, to the seemingly marginalized figure of the saint with his book (Bible or missal). In the face of that teeming mass of images, the saint averts his eyes and takes refuge in the sacred text. In other words, the Brueghel relates directly to the connection between image and writing. The book may not even be a refuge at all, as Foucault points out—in a further horrifying twist, it seems as if the book itself may be helping to *evoke* those very images, or at least doing very little to dispel them.[21] That idea is confirmed by a detail noted in another painting which Flaubert saw in Naples, in 1851. In this *Crucifixion* by Joos van Cleve, a woman is praying, with her missal open beside her. Lurking by the missal, hovering over the words, is a chuckling little demon, with the most brilliantly coloured insides to his ears, which Flaubert also notes: 'A côté de la femme, agenouillée sur un prie-Dieu et un livre à la main, paraît la figure monstrueuse du diable-dragon, qui rit; il a l'intérieur des oreilles coloriées comme si on y avait figuré des fleurs' (11: 118).[22] Whether this bright little demon is being kept at bay or conjured up by the woman's book is impossible to say. Flaubert's *Tentation*, like Brueghel's and the van Cleve, plays on that central question of whether the text is any refuge at all, as the

[21] Foucault is one of the few commentators to have made this point, and he makes it brilliantly, see 'La Bibliothèque fantastique', in R. Debray-Genette (ed.), *Flaubert* (Librairie Marcel Didier, 1970), 177. The saint of the painting is buried in his book, blind to the tumult: 'Il ne voit rien, à moins qu'il ne perçoive, en diagonale, le grand charivari. A moins que le balbutiement qui épèle les signes écrits n'évoque toutes ces pauvres figures informes, qui n'ont reçu aucun vocable dans aucune langue, qu'aucun livre n'accueille jamais [. . .]. Plus fécond que le sommeil de la raison, le livre engendre peut-être l'infini des monstres.'

[22] For this detail, see cover. Flaubert frequently notes the presence of books in paintings, perhaps because of the sense it gives of the intrusion of the other art.

images that besiege Flaubert's Antoine very often come from the very Bible in which he tries to take comfort.[23]

The whole of Flaubert's *œuvre* is a magnified version of the saint's gesture of turning away from image to text. The saint's gesture is a re-enactment of the central episode in the first *Éducation sentimentale*, where Jules meets the monstrous dog. It was this monstrous image, with its crude juxtapositions of yellow water and blood-red sun and sky (*ES1* 8: 199), which precipitated Jules's act of turning definitively to writing; and 'depuis, il se corrigea de ses peurs superstitieuses'.[24] But whereas this comment suggests that Jules has nothing more to fear, Flaubert's sight of the Brueghel throws everything into the air once more, and suggests that the ghost of the dog has not after all been laid and that images retain their power to subvert and disturb.

Baudelaire's description of Flaubert's *Tentation* as the 'chambre secrète de son esprit' is perfectly apt.[25] The *Tentation* is, in every sense, *about* image, and in that respect is a *mise en abyme* of Flaubert's writing generally. The effect of the Brueghel is all the more devastating in that it is parodic. It is not simply a mirror-image, as it is usually described, but a mirror-image distorted, 'ricanant' (10: 373), like the image Flaubert sees of himself in his shaving mirror. With its bright colours and its visual jokes, it takes the age-old theme of the tussle between God and all the demons of life and its pleasures, and mocks it, turning it into a subject for comedy, exactly as the famous puppet-show of the *foire Saint-Romain* did. Irony makes the drama somehow worse, as if the greatest tragedy of all in the human condition were that its dramas are enacted on the level of a marionette show or huge joke, 'grotesque' but 'triste' (*C1* 307), 'le comique qui ne fait pas rire, le lyrisme dans la blague' (*C2* 52).[26] Doggedly pursuing his 'ligne droite' despite the hordes of grotesque, grimacing images seething maniacally around, the saint is

[23] See especially the first section of the *Tentation*, where the images of the banquet (4: 50), of riches (4: 50–2), the massacre at Alexandria (4: 53–4), Nebuchadnezzar (4: 56), and the Queen of Sheba (4: 57–62) spring from the various Bible texts read by Antoine earlier in the chapter (4: 44–5).

[24] Cf. R. Griffin, *Rape of the Lock* (1988), 145, and all those who have speculated on the 'episode of the dog'. The episode seems to be based on a similar episode in Rousseau, *Rêveries* ('deuxième promenade'), the *accident de Menilmontant*: Rousseau was knocked over by a dog, and this changed his life.

[25] Baudelaire, 'Madame Bovary', *Curiosités esthétiques*, 651.

[26] Cf. Baudelaire's perspicacious remark about the way Flaubert's writing turns characters into puppets, ibid. 649.

tragic but a figure of fun too, and sends back a parodic echo to Flaubert of his own position at this time, poised in a precarious state of balance, product of an entirely closed system, as he later defines it for the benefit of Louise Colet: 'je marchais avec la rectitude d'un système particulier fait pour un cas spécial' (*C1* 281: 8–9 Aug. 1846).[27]

Other elements of Flaubert's position are parodied too, notably the aesthetic of 1845. It was Brueghel's 'désordre très ordonné', as Huysmans put it,[28] that attracted Flaubert, just as much as it repelled his contemporaries. 'Fourmillant, grouillant' (10: 373), the painting is full of life and apparent disharmonies. It plays with metamorphoses, it blurs the borderline between 'natural' and 'monstrous', 'man' and 'animal', just as the aesthetic does. Once again, the mirror sends back a distorted image. The splendid pantheistic emotion of Flaubert's aesthetic is parodied in the painting. Infinite flexibility becomes nightmarish flux, and the painting suggests, in glorious colour, that personal identity can be destroyed by it. Colour is now an abomination, appearing in the form of the 'mets coloriés' offered by the figure of Gluttony.

But Brueghel's *Temptation* is not just a nightmarish embodiment of Flaubert's central dilemma, it also, more prosaically, poses questions about form, to which Flaubert has not yet paid much attention in painting. Immediately after noting particular figures in the painting, Flaubert passes without transition to questions of presentation:

[. . .] tout semble sur le même plan. Ensemble fourmillant, grouillant et ricanant d'une façon grotesque et emportée, sous la bonhomie de chaque détail. Ce tableau paraît d'abord confus, puis il devient étrange pour la plupart, drôle pour quelques-uns, quelque chose de plus pour d'autres; il a effacé pour moi toute la galerie où il est, je ne me souviens déjà plus du reste. (10: 373)

The accusation of lack of structure—'tout sur le même plan'—was one of those commonly levelled at Flaubert, from *Salammbô* onwards.[29] In the case of *Salammbô*, the criticism was unfounded;

[27] Louise disturbs his calm, as had the Brueghel: 'Tu es venue du bout de ton doigt remuer tout cela. La vieille lie a rebouilli, le lac de mon cœur a tressailli.'

[28] Huysmans, *Trois églises et trois primitifs* (1908), 183–4.

[29] Cf. e.g. Sainte-Beuve (2: 440) and Goncourts, *Journal*, i. 692 of *Salammbô*: 'les tableaux, dont tous les plans sont au même plan'.

Flaubert does not in fact risk constructing his narratives in this way until *L'Éducation sentimentale*. Even then, looking back on the *Éducation* from a distance of ten years, he adds his voice to that of those such as Barbey d'Aurevilly who accused his novel of failing to 'faire la pyramide'.[30] On the other hand, he still wonders whether this very incorrectness of form was not after all the novel's greatest strength:

Pourquoi ce livre-là n-a-t-il pas eu le succès que j'en attendais? Robin en a peut-être découvert la raison. C'est trop vrai et, esthétiquement parlant, il y manque *la fausseté de la perspective*. A force d'avoir bien combiné le plan, le plan disparaît. Toute œuvre d'art doit avoir un point, un sommet, faire la pyramide, ou bien la lumière doit frapper sur un point de la boule. Or rien de tout cela dans la vie. Mais l'Art n'est pas la Nature! N'importe! je crois que personne n'a poussé la probité plus loin. (16: 258: 8 Oct. 1879)

'Personne n'a poussé la probité plus loin'; Zola realized, and Huysmans, and Proust, that Flaubert (like Brueghel) was pushing structure to its limits.[31]

Yet another reason for the painting's attraction for Flaubert is that it appeals to his sense of the enigmatic, so much so that he cannot find words to express it: the painting is 'confus [...] étrange [...] quelque chose de plus'. For Baudelaire, writing twelve years later, Brueghel's attraction for the modern observer consists precisely in this resistance to meaning. His 'allégories presque indéchiffrables aujourd'hui' are among the most attractive and disturbing features of Brueghel's art: 'des maisons dont les fenêtres sont des yeux, des moulins dont les ailes sont des bras, et mille compositions

[30] Cf. Barbey d'Aurevilly, 'Flaubert: *L'Éducation sentimentale*', in *Le XIXᵉ siècle* (1964), ii. 162. Cf. Flaubert's comment 14: 536 (7 Dec. 1869): 'Les plus indulgents trouvent que je n'ai fait que des tableaux, et que la composition, le dessin manquent absolument.' In Apr. 1863, Flaubert had made the same point, before the critics did: 'Ça ne fait pas la pyramide' (C3 318).

[31] Cf. Zola in *Le Messager de l'Europe* (Nov. 1875): 'Gustave Flaubert refusait toute affabulation romanesque et centrale. Il voulait la vie au jour le jour, telle qu'elle se présente, avec sa suite continue de petits incidents vulgaires, qui finissent par en faire un drame compliqué et redoutable [...] l'apparent décousu des faits, le train-train ordinaire des événements [...]: rien que des figures de passant se bousculant sur un trottoir.' For Huysmans, cf. preface to *A Rebours* (1903). For Proust on the 'Trottoir roulant' of Flaubert's style, see 'A propos du "style" de Flaubert', *Contre Sainte-Beuve* (Gallimard, Plériade, 1971), 566 ff. Cf. also Flaubert's reply to Zola, 16: 277: 'comme vous y allez! Comme vous me vengez! Mon opinion secrète est que vous avez raison; c'est un livre *honnête*. Mais n'ai-je pas voulu faire dire au roman plus qu'il ne comporte?' Cf. also P. Hamon in S. Michaud *et al.* (eds.), *Usages de l'image* (1992), 245: Flaubert's metonymic comparisons (e.g. Charles's hat) give the effect of being all 'sur le même plan'.

effrayantes où la nature est incessamment transformée en logo-griphe'.[32] Brueghel's paintings are a conundrum for the modern observer, an allegory whose meaning is hidden, a cryptogram whose code is lost. The *Temptation* is only the first of many paintings to catch Flaubert's attention for its enigmatic power. It satisfies one of Flaubert's highest criteria for art: it makes the viewer 'rêver à l'insaisissable' and it enacts one of his profoundest *tentations*: 'Ma vie s'est passée à vouloir saisir des chimères' (16: 58, 878). But here again the Brueghel takes this most essential and valued of Flaubert's artistic criteria and pushes it to excess and flaunts it in his face.

The actual material input from Brueghel's painting to Flaubert's *Tentation de saint Antoine* is minimal. But its influence on Flaubert's work as a whole was as enormous as it was indirect.

Brueghel aside, form is not particularly to the fore as yet, though Flaubert does have an eye already for the odd discordant detail, and for strange angles. Despite the confident assertions of the aesthetic of 1845, Flaubert was never entirely happy with anything that suggested an irresolution of figure and ground, as we have seen already in his responses to the Brueghel. There are other examples. For example, in Guercino's *Gesù scaccia i mercanti*, which he finds 'peu agréable' in general effect, he notes as 'beau' the potentially disruptive detail of the back of a man running away: 'beau dessin du dos de l'homme qu'il pousse et qui s'enfuit naïvement avec lâcheté' (10: 366); he also notes the detail of the 'tapis trop colorié' in *Esther et Ahasverus*, which distracts the eye (10: 376); in Raphael's cartoon for the *School of Athens*, he registers that the mathematician is just head, 'on ne lui voit que le haut de la tête' (10: 374), that another philosopher is depicted from behind. Emphasis on such features will become almost commonplace by the time of the *Voyage en Orient*.

Beyond Painting

In all that has preceded, emphasis has been on the paintings them-selves, though from a very personal angle. Flaubert tests his own feelings and ideas on them, and learns from them. Elsewhere,

[32] 'Quelques caricaturistes étrangers', *Critique d'art*, 233 (article first published in 1857).

however, he subsumes paintings into a more general impression, or makes use of them for his own purposes. But he rarely turns paintings into narrative, as both Diderot and Stendhal do. More usually, he absorbs them into a general atmosphere: 'Palais Palaviccini: superbe comme ornement, comme ameublement, comme chic, comme ensemble. Je ne me souviens plus des tableaux' (10: 369). One of the most interesting instances of Flaubert subsuming paintings in this way occurs in his notes on the musée Calvet in Avignon, which Flaubert describes as the museum which gave him the most pleasure of all. The paintings are there, hanging on the walls, but he leaves them hanging as little unexplored icons and creates an evocation of his own which contains but transcends them. Stendhal, too, was struck by something magical about this museum, something in the general atmosphere that made the individual paintings irrelevant, but in which the paintings played their part.[33]

Flaubert's very atmospheric evocation combines elements of the verbal (the antique inscriptions), the pictorial (various Vernets—Karl's sketches, Joseph's marines, and Horace's *Mazeppa*), everyday reality (the guide and her child), and impressions of nature (the trees and the garden). The original art works blend harmoniously with the other, natural impressions of the trees, the garden, and the two people. Art and nature come together in a complex and delicate association, in line with the principles of Flaubert's aesthetic, and writing is there too, in the 'inscriptions', to keep the balance:

Musée jardin nat, <les arbres se balanç, le vent frémissait> inscriptions grecques et latines de la grande pièce au rez-de-chaussée, presque tous [*illegible word*] au bas de l'escalier, deux portiques qui sont dessinés dans Millin.—C'est le musée où j'ai le plus joui, j'étais seul où je commençais une série d'émotions qui s'annonçaient joyeuses—la femme qui me le montrait, avec son marmot. Croquis de Karl Vernet; marines de Joseph Vernet le *Mazeppa* de H V—Il faisait un calme exquis dans ce musée. (10: 356)

The impression of the musée Calvet, barely 'written up' as it is, was powerful enough to come back to Flaubert when he passed through Avignon once more, four years later, on his way to the East.

[33] Cf. Stendhal, *Mémoires d'un touriste, Voyages en France* (1992), 157: 'Les tableaux sont placés d'une manière charmante, dans de grandes salles qui donnent sur un jardin solitaire, lequel a de grands arbres. Il règne en ce lieu une tranquillité profonde qui m'a rappelé les belles églises d'Italie: l'âme [. . .] est disposée à sentir la beauté sublime.' The musée Calvet has, however, only recently been restored, so the effect may have been lost.

He recalls 'son charmant musée, où l'on est tout seul, lisant les inscriptions antiques sur les stèles de marbre, au bruit des arbres du jardin qui se penchent contre les carreaux' (*VE* 148). The Vernets have melted away.

This is Flaubert's first attempt at descriptions of this kind, where a painting or paintings are present but overlaid with other impressions. Here, in this description, Flaubert begins the process of writing out paintings, rather than writing them in. We will see other versions in *Par les champs* and the *Voyage en Orient*.

Flaubert is also preoccupied with paintings which have become faded with time to the point of being all but effaced. Paintings like this figure already in *Pyrénées et Corse*, but there he simply notes them without comment. Some 'vieilles peintures moisies' in a church near Pau simply figure in a footnote, literally marginalized (the CHH edition omits them altogether);[34] a sculpture at Carcassonne, so old it is 'illisible', lets only a few features glimmer through—'une vieille sculpture illisible où l'on ne voyait que confusément des cavaliers, une tour, un assaut' (*PC* 10: 312); further examples of 'vieilles peintures dégradées' in *Italie et Suisse* are also simply noted (10: 374). There is one example also outside the travel accounts, in *Quidquid Volueris*: an eighteenth-century pastoral scene, depicted on a 'dessus de porte', old, faded, and dusty. But it too is simply described and then left:

[. . .] sur les dessus de la cheminée, on voyait, à demi effacée par la poussière, une scène pastorale: c'était une bergère bien poudrée, couverte de mouches, avec des paniers, au milieu de ses blancs moutons; l'Amour volait au-dessus d'elle, et un joli carlin était étendu à ses pieds, assis sur un tapis brodé où l'on voyait un bouquet de roses lié par un fil d'or. (11: 312)[35]

But it is in *Italie et Suisse* that Flaubert first makes something of this preoccupation with old faded paintings, connecting them with the layering effect of memory. Every step of his journey so far has evoked a memory of his first journey to the Midi in 1840. Time

[34] They appear in the 'Intégrale' edition of the *Œuvres complètes* (1964), ii. 432.

[35] Nothing in the text explains the great personal significance of this painting (but cf. *MF* 11: 488: 'Il y a des choses insignifiantes qui m'ont frappé fortement et que je garderai toujours comme l'empreinte d'un fer rouge, quoiqu'elles soient banales et niaises'). A letter subsequently reveals that the château of *Quidquid Volueris* is the château de Mauny, where Flaubert stayed as a very small child (cf. *C1* 574 and Bruneau's note ibid. 1075), and which counted among his 'plus vieux souvenirs'.

has added a lustre to that first encounter, 'comme dans les vieux tableaux', so that a new, more complex reality is created, so elusive that it can be expressed only in terms of music (one of those lingering airs which haunt Flaubert's writing):

Partout, jusqu'à Toulon, j'ai été obsédé, surtout quand j'y repense, par les souvenirs de mon premier voyage; la distance qui les sépare s'efface, ils se posent toujours en parallèle et se mettent au même niveau, si bien que déjà ils me semblent presque à même éloignement. Au bout d'un certain temps, les ombres et les lumières se mêlent, tout prend même teinte, comme dans les vieux tableaux: les jours tristes se colorent des jours gais, les jours heureux s'alanguissent un peu de la mélancolie des autres. Voilà pourquoi on aime à revenir sur son passé. Il est triste et charmant cependant, c'est comme les airs qui font mal à entendre et qu'on est poussé à écouter toujours et le plus longtemps possible. (10: 359–60)

Ruins, old uniforms, old paintings: all acquire an artistic patina, and should never be restored.[36]

The best paintings are those which are half effaced to the point of being a collection of traces. This gives them a feeling of magic or mystery. Thus, for example, in the *Voyage en Orient*, a landscape impinges on Flaubert because it recalls ancient prints or paintings, dark with time, hidden in corners, only ever half seen and then half forgotten, merged with others in an obscure oneiric recall: 'on a vu cela dans d'anciennes gravures, dans des tableaux noirs qui étaient dans des angles, à la place la moins visible de l'appartement' (*VO* 11: 107). And here once more we see the process of effacement of painting at work, in a new context.

Time is not the only creator of new effects. Light performs the same function, transforming a mere canvas into a new, more successful work of art. Rosanette's portrait at the end of *L'Éducation sentimentale* is transformed by the light sufficiently to pass (almost) for the *vieille peinture italienne*, which Pellerin on his own had been unable to make it, though this had been his aim. Time and light come together in a passage in *Madame Bovary* as the time-darkened portraits at the château of la Vaubyessard are picked out in a network of golden lines by the effect of the light on the 'craquelures' which are gradually destroying the canvas itself (1: 89);

[36] Cf. 10: 318: 'Il y a plus de poésie dans la casaque trouée d'un vieux troupier que sur l'uniforme le plus doré d'un général; les drapeaux ne sont beaux que lorsqu'ils sont a moitié déchirés et noirs de poudre.'

the portrait of Bouvard's father is transformed into something hideously impressive through a combination of light and mould. This is an effect which Flaubert was already exploring in *Italie et Suisse*, and largely because he saw light and time as being analogous to the artist's transforming vision.

Thus, the right light would transform the 'vieilles peintures dégradées' of the cathedral of Monza—'de vieilles peintures dégradées qui demanderaient les rayons d'aplomb d'un soleil couchant pour être encore vues et avoir de l'expression' (10: 374). Light and memory fuse in Flaubert's retrospective evocation of Gérard's portrait of Madame de Staël, which he saw in 1845 but does not actually describe till *Par les champs*, where he evokes from memory how the June sun that day two years ago had picked out the mouth in a heavy, winy red and made the nostrils seem to flare and breathe:

Mme Deshoulières, debout [. . .] m'a remis en mémoire, à l'occasion de la bouche qui est grosse, avancée, charnue et charnelle, la brutalité du portrait de Mme de Staël, par Gérard. Quand je le vis, il y a deux ans, à Coppet, (la fenêtre était ouverte, le soleil l'éclairait de face) je ne pus m'empêcher d'être frappé par ces lèvres rouges et vineuses, par ces narines larges, reniflantes et aspirantes. (*PCG* 119–20)

It is as if Flaubert's memory and the June sun were performing the same operation.

Flaubert likes to submit art works to the effects of nature, shade off their edges, and remind us of the value of incompletion. And he tends always to colonize the painting, to make it entirely his own, by various and sometimes devious means.

PAR LES CHAMPS ET PAR LES GRÈVES, 1848

Par les champs et par les grèves is the account of a walking-tour in Brittany, Touraine, and Normandy. The most artistically accomplished of Flaubert's early works, it was by his own account the first to confront him with 'les affres du style'. *Par les champs* is Flaubert's only true *récit de voyage*, intended originally for publication. Flaubert and Du Camp divided the twelve chapters between them, Flaubert writing the odd chapters, Du Camp the even. Flaubert made notes for all twelve chapters, however, and these are

preserved in his *Carnets de voyage*.[37] The notes in the *Carnets* are as succinct and allusive as those in *Italie et Suisse*; but in the final text, in *Par les champs* itself, Flaubert was obliged to alter his manner considerably. Wishing to avoid the disjointed effects of the typical travel account, Flaubert wanted to make a *récit* out of what was fundamentally no more than a series of descriptions, 'faire un tout d'une foule de choses disparates' (C2 66: 3 Apr. 1852).[38] Art commentaries thus become part of narrative in *Par les champs*, and the perceived obligation to narrate forces Flaubert to 'cannibalize' paintings more than he does when he is writing in note form.

Though Flaubert was at last free to go his own way, free of family pressures, Brittany imposed its own limitations. Stone statuary and churches there were in abundance (so many indeed that they began to pall), but paintings of any quality were few in number, and mostly outside Brittany itself. Aside from the odd masterpiece tucked away in a church (such as a Philippe de Champaigne in Saumur, chapter 2), Flaubert's experience of the masters in *Par les champs* was restricted to three important provincial collections: the château of Chenonceau, which owned a collection of distinguished portraits, now dispersed (*PCG* 116 ff.), and the Musées des Beaux-Arts of Nantes (172 ff.) and Caen (653 ff., 723–4), where Flaubert noted mostly portraits. Fortunately, Flaubert was able to compensate for this shortage of everything but portraits by extending his acquaintance with bad art.

By this stage and because of the constraints of this particular text, Flaubert is far more interested in what he can *do* with paintings than in simply admiring and exploring them, or finding new illustrations of qualities he already enjoys. There are examples of the latter, however. When chance, at the Musée des Beaux-Arts in Nantes, provides another *Adoration des Mages*, it reminds him of Brueghel's *Temptation* (the same liveliness, humour, and clashing colours, also perhaps the inherent unreadability), and he concludes that in the last resort it escapes the net of language:

Nous sommes restés longtemps devant un tableau dans la vieille manière allemande, représentant une *Adoration des Mages*; le dessin en est d'une naïveté presque ironique: un mage, vêtu d'une sorte de manteau d'évêque, se prosterne aux pieds du Christ avec un air si stupide et un front si déprimé

[37] See Bibliography, section 1. [38] See *PCG*, ed. Tooke, introduction.

qu'on croirait volontiers que c'est une malice du peintre; il y a des nègres singuliers, ajustés dans des caleçons rouges et couverts de colliers de corail; à une fenêtre, des femmes et des hommes passent la tête et montrent une mine ébahie. Tout cela est vivant et drôle, heurté en tons rouges et verts (un peu comme la *Tentation de saint Antoine* de Breughel), intense d'expression, amusant de détail, original d'ensemble et d'un effet impossible à faire comprendre quand on ne l'a pas vu. (*PCG* 173–4)

The fact that this painting incorporates onlookers is a new element. Whatever their function may be in terms of pictorial intent—they may contribute to compositional unity, or supply a suggestion of further depth, an invitation to 'faire rêver'—for Flaubert, internal spectators seem to draw attention above all to the very act of looking, foregrounding the essential pleasure of painting. Two more examples of the same motif follow in quick succession, in a carnival scene by Lancret and his *Camargo dansant*.[39] Flaubert's notes for these paintings in his *Carnets* emphasize the act of looking: 'on regarde autour' (*CV* 681: *Carnaval*); 'une femme qui regarde' (*Camargo*). Flaubert borrows this device also in paintings of his own creation, as, later, in the tiny *vignette* of the stud-farm, which includes himself and Du Camp as onlookers (*PCG* 714).

 The figure of the onlooker is also related to questions of interpretation and its limitations, another feature which will become dominant later in the *Voyage en Orient*. The road to Brest was made hideous for Flaubert and Du Camp by the presence of a man called Monsieur Genès, a forerunner of Monsieur Homais, only more seedy. Forced to turn his mind to the calvary of Plougastel because the two travelling 'amants du pittoresque' wished to do so, Genès misreads the scene, which depicts the Last Supper, and turns it into a game of cards: 'il prit les plats pour des cartes, les coupes pour des dés, et il dit fort ébahi: "ils jouent; c'est farce"' (*PCG* 490). On the surface, this is just another sign of Genès's *bêtise*. On another level, however, it is an echo in reverse of a new element in Flaubert's presentation of pictures, which surfaces for the first time in *Par les champs*, and which is a kind of programmed *bêtise*, a refusal to read according to the artist's apparent intention, a willingness to be guided by form alone. 'De la forme naît l'idée.'[40] Flaubert knows perfectly

[39] It is not certain that the *Carnaval* painting is by Lancret, see note *PCG* 174.
[40] Phrase attributed to Flaubert by Gautier, cf. Goncourts, *Journal*, i. 228 (3 Jan. 1857).

well that one of the communicants in the representation of a com-
munion scene is not being sick into her hands but the form tells him
otherwise, and so she 'a l'air de degueuler dans ses mains' (PCG
688). What begins here as a joke becomes a perfectly serious way
of looking at paintings in the Voyage en Orient.

Portraits figure as before, with some favourite female icons
appearing at Chenonceau and Nantes (Gabrielle d'Estrées, Isabeau
de Bavière, Mme Dupin, and Elizabeth I), and artists (Rabelais
and the poet Mme Deshoulières), or unknowns with good faces at
Caen (the Marquis d'Argenson and the Magistrat de Tournières).
He delivers a broadside at the modern portrait, at Girodet and
others of the previous generation, all 'chevelure et manteau au vent',
and at the current 'rage de se reproduire' (PCG 109), which man-
ifests itself especially in the form of family portraits, which multiply
the art of copying to the nth degree, and are the leprosy of paint-
ing (PCG 613), and the institutionalized royal portraits of the gen-
eration of Louis-Philippe, with stereotyped poses and plenty of bright
colours to please the people (PCG 109–10). But Par les champs also
provides a new dimension, extending the theme already initiated
in Italie et Suisse of the lure of 'vieux tableaux', and focusing it
further onto, specifically, old portraits. The named individual gives
way to the idea of the anonymous job lot, with a powerful poetic
charge. These are the 'vieux portraits muets' (PCG 99), whose
principal function is to 'faire rêver' ('Comme cela fait rêver, les
vieux portraits!', C3 16). These portraits are neither 'histoire' nor
'poème'[41] but purely and simply a springboard for the imagination:

N'y a-t-il pas d'ailleurs partout de bons vieux portraits à vous faire passer
de longues heures en se figurant le temps où en vivaient les modèles, et les
ballets où tournoyaient les vertugadins de ces belles dames roses, et les bons
coups d'épées que ces gentilshommes s'allongeaient avec leurs rapières. Voilà
une des tentations de l'histoire. On voudrait savoir si ces gens-là ont aimé
comme nous, et les différences qu'il y avait entre leurs passions et les nôtres;
on voudrait que leurs lèvres s'ouvrissent pour nous dire les récits de leur
cœur, ce qu'ils ont fait autrefois, même de futile; quelles furent leurs
angoisses, leurs voluptés: c'est une curiosité irritante et séductrice comme
on en a pour le passé inconnu d'une maîtresse, afin d'être initié à tous les

[41] Cf. Baudelaire's famous distinction, 'Salon de 1846', Critique d'Art, 124: 'Il y
a deux manières de comprendre le portrait,—l'histoire et le roman [. . .]. La sec-
onde méthode, celle particulière aux coloristes, est de faire du portrait un tableau,
un poème avec ses accessoires, plein d'espace et de rêverie.'

jours qu'elle a vécu sans vous, et d'en avoir sa part; puis, quand les mites auront picoté leur toile, quand leur cadre sera pourri et qu'ils seront tombés en poussière, on rêvera à notre tour devant nos propres images, en se demandant ce qu'on faisait dans ce temps-là, de quelle couleur était la vie, si elle n'était pas plus chaude. (*PCG* 116)[42]

Seen from this angle, portraits are but spaces for the imagination to fill. At Blois, the guide points to the place where the blood of the murdered duc de Guise fell in 1588. The bloodstain itself has long disappeared, but the travellers continue to peer fixedly at the empty spot: 'vainement l'œil le cherche encore sur le plancher [. . .]. On ne voit plus rien, et cependant on regarde' (p. 98). Blank spaces, ancient walls, empty tombs, and 'vieux portraits' are all equivalent, all equally silent and vacant, all seeming to promise a meaning they never in fact deliver:

Le sang a été lavé, le bruit des sarabandes et des menuets s'est évanoui avec le rire des pages et le frôlement des robes à queue. Que reste-t-il de ce que l'histoire en sait? et de tout ce qu'elle ne sait pas! Ce qui est plus tentant à connaître, et ce qu'on s'en va demandant aux vieux lambris, aux vieux portraits muets qui vous regardent, aux tombeaux vides qui bâillent: secret qu'ils gardent pour eux seuls, et qu'ils se murmurent dans leur solitude. (*PCG* 99)

Other portraits—of the *ducs de Beauvillier* and of the *Camargo* —retain their names but little else, as Flaubert hones down the original painting, creating a very indirect evocation of it which emphasizes the literary over the visual. After a gesture towards ekphrasis in a summary description of the portraits of the ducs de Beauvillier at Chenonceau (*PCG* 117), Flaubert adumbrates an alternative image of his own, a *mise en abyme* of seventeenth-century château life, with all the paraphernalia of hunts in mystical forests and the obligatory 'son du cor au fond des bois'. Impressionistic and elusive, the passage is a perfect evocation of a feeling which is akin to a half-memory:[43] 'Il vous revient là devant comme un souvenir des carrousels de Louis XV, et des grandes chasses à courre, avec des

[42] Cf. *Nov* ii: 669: 'Il se promenait dans les musées, il contemplait tous ces personnages factices, immobiles et toujours jeunes dans leur vie idéale, que l'on va voir, et qui voient passer devant eux la foule, sans déranger leur tête, sans ôter la main de dessus leur épée, et dont les yeux brilleront encore quand nos petit-fils seront ensevelis.'

[43] Flaubert's evocation *is* of course as a matter of fact composed entirely from memory, cf. his perfunctory note in the *Carnet*, *PCG* 672.

lévriers jaunes à taches blanches, une nuée de piqueurs en livrée, des meutes aboyantes, et les grandes trompes passées autour du corps, sonnant dans les clairières des hallalis prolongés.' A visual image is evoked but is blurred by the poetic plurals; Flaubert makes sound as important as the visual. Flaubert was pleased enough with this passage to transpose it to the Fontainebleau episode in *L'Éducation sentimentale* (3: 313 ff.).

The second example also replaces ekphrasis with a more indirect and decidedly *literary* evocation. This is Flaubert's evocation of Lancret's *Camargo dansant* (Nantes). Once again, the place occupied by the original painting in Flaubert's evocation is very small. The trigger for the description is not the painting at all but its *title*, as Flaubert takes care to point out—'la Camargo! quel nom!':

Elle danse—en plein vent—sur l'herbe, en robe de satin blanc, avec des rubans bleus et des guirlandes de roses. A sa droite, un tambour remue ses baguettes, un fifre enfle ses joues; à gauche, un violon, un basson et une femme qui regarde. La Camargo! quel nom! Est-ce qu'il n'est pas tout résonnant de grelots vermeils? Est-ce qu'il ne nous envoie pas comme dans une ritournelle folâtre, avec le vent chaud d'une jupe qui tourne, une odeur de poudre d'iris ou de jasmin d'Espagne, et des aperçus de rotules blanches qui se raidissent sur des édredons de soie jaune, dans un boudoir plein de porcelaines de Saxe, et tout couvert de pastels? (*PCG* 174–5)

Flaubert's evocation makes only the slightest of allusions to the painting, and rests on the lightest and most intangible of *non-visual* impressions—the wind of her skirt as she turns, and an *imagined* perfume. When visual impressions are evoked, it is only in the form of fleeting glimpses, and these glimpses are of scenes not in the painting—'des aperçus de rotules blanches qui se raidissent'. Pictorial art does return at the end of Flaubert's evocation, but not in the shape of the Lancret itself. It returns in the form of mere furniture, as little unspecified icons left unexplored—a set of anonymous pastels, redolent somehow of the eighteenth century and of desirable women: 'dans un boudoir plein de porcelaine de Saxe et tout couvert de pastels'. Pictorial art has the last word, then, literally, but is more or less submerged in verbal poetics. The final sequence is defiantly musical, with marked phonetic echoes and the near-anagram of 'odeur' and 'poudre'. Not only is there now no reference at all to the painting which inspires the description, but the impression given, though still visual, is both plural and undefined, and so, like the last one, hauntingly elusive. The process

of occlusion of the painting—from source to submersion and only oneiric recall in the tangential reference to the undefined pastels —mirrors once more the evolution of the status of painting in Flaubert's writing.

This, then, is Flaubert measuring his own art against what painting can do.

The other major preoccupation in *Par les champs*, bad art, was an irritant, playing the role of sand to the oyster. In *Pyrénées et Corse*, bad art hardly figures: a job lot of paintings in the church of St Jean in Toulouse is simply noted as 'mauvaises peintures d'auberge' (10: 310); a bad engraving of the figure of *Europe*, seen in Irun, is simply mentioned (10: 298) and left to fester (whereas in later years Flaubert will make much of it). No bad art is recorded for *Italie et Suisse*. But in *Par les champs* it emerges at last, centre stage, to the extent that, as Seznec says, it 's'affirme avec la régularité d'une manie'.[44] That is mainly because, in accordance with the principles of the aesthetic of the first *Éducation sentimentale*, Flaubert is trying to recuperate this new monster. Indeed he keeps trying to do this, all through his life; he is haunted by bad art, and keeps trying different modes of approach to it. It is a severe test for his inherent relativism. He remarks that notions of what constitutes 'good' and 'bad' taste change with time (*PCG* 199); or that good taste constricts the spirit ('Il y a une chose qui nous perd, vois-tu, une chose stupide qui nous entrave, c'est le goût, le bon goût [. . .]. La terreur du mauvais nous envahit comme un brouillard', *C1* 676), or creates inflexibility ('Le goût est comme la voix. Souvent il perd en justesse et en ductilité ce qu'il gagne en hauteur' (*Carnet de lecture*, 2 (1859–78?), *CT* 215) or perversity ('Quand le goût se raffine, il se pervertit' (ibid.). Bad taste is always preferable to the simply clever ('l'*ingénieux*, l'esprit'), for it may be a 'bonne qualité dévoyée' (*C2* 385): 'Car pour avoir ce qui s'appelle du mauvais goût, il faut avoir de la poésie dans la cervelle.' Good intentions count; and, after all, 'Tout le monde ne peut pas être pape' (*C1* 772). On the other hand, intentions, method, models, all can be wrong and yet still produce huge effects, like the garden created by Bouvard and Pécuchet. Better a laughing stock than an uninspired success: 'Je garde toute ma haine et tout mon dédain pour les gens qui font

[44] Cf. Seznec, notes on 'Flaubert and art', Taylor Institution, Oxford, section 5.

des choses *convenables* et réussies [. . .]. Il n'est pas donné à tout le monde d'être ridicule' (*C3* 186). 'Le Beau' may not be the last word—a bas-relief of St Hubert at Amboise may be 'un peu lourd, et d'une plastique qui n'est pas rigoureuse; mais il y a tant de vie et de mouvement [. . .], de [. . .] gentillesse et de bonne foi dans les détails [. . .]' (*PCG* 108–9); a Breton calvary is 'sculpté si mal que ça en a du caractère' (*PCG* 688).[45] For Flaubert, part of the reason for the tremendous effect of the *Last Judgement* in the Camposanto lies, precisely, in its perceived incorrectness of form: 'c'est parce que ces formes sont incorrectes qu'elles font tant d'effet' (*C2* 397).[46] It may captivate through its propensity to linger in the memory ('malgré le laid de l'exécution [. . .] et le mauvais goût de tout cela il y a là qq chose qui frappe et qu'on se rappelle', *PCG* 674). Bad art may even attain beauty through excess (the Armenian church in Jerusalem is 'surprenante de richesse, le mauvais goût atteint là presqu'à la majesté. Suffit-il donc qu'une chose soit exagérée pour qu'elle arrive à être belle?' (10 564). Flaubert was not dogmatic. He knew, anyway, that anything can be made sacred: in the *Tentation*, blocks of wood (the Greek *xoana*) are revered as gods; the formless 'grosses pierres' of Carnac are magic symbols to some; a dead parrot can represent the Holy Ghost. The spectator can, in Hawthorne's words, 'transfigure the Transfiguration itself',[47] and distinctions are invidious. Bad art manages very well, and that is why it haunts Flaubert, just as the linguistic cliché haunted him. The cliché can be as moving, dynamic, expressive, effective, and persistent as poetry; and the best artistic efforts may resemble the worst: 'nous battons des mélodies à faire danser les ours, quand on voudrait attendrir les étoiles' (*MB* 1: 220).

The two most substantial examples of bad art in *Par les champs* are the *images de Cancale* (596–8, 601–2) and a painting depicting the death of a bishop in Quimperlé (361–4). In both cases, Flaubert's descriptions end on the recognition that *somebody* loves them:

[45] Champfleury makes the same kind of point, *Le Réalisme* (1973), 215: 'Telle maladresse artistique est plus rapprochée de l'œuvre des hommes de génie que ces compositions entre-deux.' Cf. also Gautier on Chinese art (which he found misshapen and ugly): 'De telles figures, en dehors de tout art, peuvent cependant faire rêver [. . .]' Gautier, 'Collection chinoise', *Les Beaux-Arts en Europe* (1855), 134.

[46] Cf. Taine, who also read Orcagna as 'incorrect'. But where Flaubert was 'ravagé', Taine was left cold: 'c'est de l'imagerie qui veut devenir et ne devient pas de la peinture', *Voyage en Italie* (1921), 73.

[47] Cf. Hawthorne, *The Marble Faun* (New York: Pocket Library, 1958), 10, quoted W. Steiner, *Pictures of Romance* (1988), 115.

Mais c'est la servante, j'imagine, qui doit s'y plaire et s'en nourrir. Il est probable qu'elle convoite d'abord la bijouterie qui s'y trouve, et qu'elle rêve là-dessus à des bonheurs de reine, à quelqu'existence sensuelle et cossue, toute chatoyante de la couleur des cachemires, et sucrée comme du sirop, avec un bel amant bien habillé et des pâmoisons amoureuses dans de la toile de Hollande. (*PCG* 602)

En contemplant cette épouvantable toile, et en songeant que beaucoup l'ont pu regarder sans rire; qu'à d'autres, sans doute, elle a semblé belle; que d'autres enfin se sont agenouillés devant, et y ont puisé peut-être des inspirations suprêmes, nous avons été pris malgré nous d'une mélancolie chagrine. Mais qu'y a-t-il donc dans le cœur de l'homme pour que toujours et sans cesse il le jette sur toutes choses, et se cramponne avec une ardeur pareille au laid comme au beau, au mesquin comme au sublime? hélas! hélas! rappelons-nous pour excuser celui qui a fait cela, et encore plus ceux qui l'admirent, nos prédilections maladives et nos extases imbéciles; évoquons dans notre passé tout ce que nous avons eu jadis d'amour naïf pour quelque femme laide, de candide enthousiasme pour un niais, ou d'amitié dévouée pour un lâche. (*PCG* 364)

The *images de Cancale* are five separate images, which combine to form a narrative, depicting all the stages of marriage from the formal proposal through the wedding, the wedding celebrations, the wedding night, and the morning after. Though the images in themselves would be more than sufficient to tell the story, they are reinforced, uselessly, by a series of redundant and flowery *légendes*. Everything is fixed. It is a perfect example of 'le statisme pictural'. Not only is each picture a collection of clichés but their accompanying captions are an attempt to fix the meaning even further.[48] The result is the kind of doubling that Flaubert continually satirizes (in his insistence on 'ses deux yeux', 'ses deux bras', and so on). The words are entirely redundant, a verbal equivalent to an image which is itself already a stereotype of an activity which is itself the most banal and cliché-ridden: a copy of a copy of a copy. Flaubert includes a similar set of images in *Bouvard et Pécuchet*. There once more pictures reinforce their moral intent with captions. But here

[48] Cf. Baudelaire, 'Salon de 1859', *Critique d'art*, 274: 'Chercher a étonner par des moyens d'étonnement étrangers à l'art en question [*i.e.* "titres", "légendes"] est la grande ressource des gens qui ne sont pas *naturellement* peintres'; and 'De quelques caricaturistes français', *Critique d'art*, 219, on the difference between Daumier and Gavarni: 'Daumier est un génie franc et direct. Ôtez-lui la légende, le dessin reste une belle et claire chose. Il n'en est pas ainsi de Gavarni; celui-ci est double; il y a le dessin, plus la légende.' But cf. Goncourts, *Journal*, i. 84 for a different view: Gavarni's *légendes* grew gradually out of his image as he worked.

the process misfires, because Victor reads against the grain and takes the 'wrong' but more exciting image as role model instead of the captions. It is yet another proof that 'de la forme naît l'idée':

[. . .] des images exposant la vie du bon sujet et du mauvais sujet.

Le premier, Adolphe, embrassait sa mère, étudiait l'allemand, secourait un aveugle et était reçu à l'École polytechnique.

Le mauvais, Eugène, commençait par désobéir à son père, avait une querelle dans un café, battait son épouse, tombait ivre-mort, fracturait une armoire, et un dernier tableau le représentait au bagne, où un monsieur, accompagné d'un jeune garçon, disait en le montrant:

'Tu vois, mon fils, les dangers de l'inconduite'.' (*BP* 5: 259)

It is the crude juxtaposition of image and text which Flaubert dislikes. He is very happy, on the other hand, with representations which blur the difference between one and the other, as in the lines incised on the Druidic stones of the island of Gavrinis (*PCG* 687), and which, as he says, could equally well be figural or graphic— 'du reste il faudrait avoir bonne volonté pr y voir la reproduction de quoi que ce soit'. The images of Cancale on the other hand are fixed, both in themselves and further by their texts, and in this they resemble the gardens of La Garenne, an early version of a theme park in Nantes, where picturesque boulders and other significant beauty spots are firmly signalled as such by having relevant texts from Delille posted up and attached to them. As if to drive the message home here, in the case of Cancale, the whole series is nailed firmly to the wall. These images are a frozen mockery of qualities he loves, and a mockery of his belief that bad art is simply a matter of 'bonnes qualités dévoyées'. Flaubert's love of colour is derided, as all the primary colours are present, framed in black, on white ('cinq cadres de bois noirs accrochés aux murs, et dans ces cadres du rouge, du bleu, du jaune, une mosaïque de grosses couleurs qui tranche comme une tache bigarrée sur la blancheur du mur de plâtre'), and his interest in accessory everyday detail is mocked by the incidental detail of the maid in image 5 thrusting stained sheets into a cupboard.

The painting of the dying bishop is so bad that it almost reduces the author to silence, reminding him of certain frescos in Nort which he had decided would best be described by the Sterne-like device of leaving half a blank page (*PCG* 161). The bishop is on his deathbed (*PCG* 361–4). Dying, he still keeps his red cap on, 'pour qu'on

voie bien qu'il est évêque jusqu'au bout'. A priest and a servant
figure in poses suited to priests and servants. Meanwhile a *Last
Judgement* is enacted in glorious colour: an angel whispers good
advice to the bishop, who manifestly 'hésite un peu', because a green
devil with crow's beak and flaccid dugs 'essaie de le fasciner par
ses contorsions'; the forces of good are lined up against all the forces
of evil, the former as nauseatingly sweet as the latter are loathsome,
all squirming, writhing, and drooling. The effect is of a pantomine
or *guignol*: will the bishop go to hell or won't he? 'Ira-t-il? n'ira-t-
il pas?' Luckily God is there, perched at the top of the picture, 'habillé
en pape', and cohorts of angels advance towards the bishop in pretty
pink and blue shoes. If Brueghel's *Temptation* was a parody of
Flaubert's position, the painting of the bishop, by a further twist,
is a parody of Brueghel's *Temptation*. There is the same emphasis
on colour—the bishop's red hat, the green devil with the 'bouffées
noires' issuing from his mouth—and on detail—the yellow soles of
the choirboy's hobnail boots, realism rampant as every nail in
those soles is depicted in loving detail. The choirboy, moreover, is
depicted at an odd angle, just as Flaubert likes, so that he appears
to be a new life-form, with feet growing out of his back:

Tout près du moribond, à genoux, vu de dos, au premier plan, se tient un
enfant de chœur, qui porte un cierge. La semelle jaune de ses robustes souliers
est garnie de clous aussi formidables que les dents des diables, et se
présente devant vous avec une naïveté qui fait plaisir; d'autant plus qu'un
raccourci de jambes bien entendu les lui remonte jusqu'au milieu des reins.
(PCG 362)

The only response to such artefacts, it seems, is ekphrasis:
'copier'. That is what Flaubert does. But he also provides a coun-
terbalance to these two dreadful art works in two descriptions of
his own. The description of the *images de Cancale* is presented in
two halves, interrupted by a wonderful evocation of the beach of
Cancale, at low tide and then at high tide. The description of the
other painting, of the dying bishop, is followed immediately by a
reference to his having emerged from the church into the streets of
Quimperlé with the feeling that 'Dieu est là et pas ailleurs' (p. 364);
and the streets of Quimperlé then provide an opportunity for
another evocation of living art from Flaubert, in another exemplary
word-painting, of a beautiful boy.

4

Art Commentaries (ii): The 'Voyage en Orient', 1849–1851

The *Voyage en Orient* introduced Flaubert to a wide range of new forms of pictorial art—new worlds of colour and strange iconography in Egypt, Rhodes, and Asia Minor, new forms of bad art in the churches of the Holy Land, new forms of realism in Persian illuminated manuscripts, new forms of stylization in early Christian mosaics in the churches of Rome.

Had Flaubert pursued his original intention of finishing and publishing his *Voyage*, it would have been a masterpiece, adding something entirely new to the genre. Some idea of what it might have been can be gleaned from the only surviving remnant of his original intention, 'La Cange'. He had intended to write up his journey as a series of *petits poèmes en prose*: 'J'avais l'intention d'écrire ainsi mon voyage par paragraphes, en forme de petits chapitres. Au fur et à mesure, quand j'aurais le temps [. . .]' (*VE* 128).[1] In the event, Flaubert simply wrote up his notes when he got home and left it at that.[2] The section known as 'La Cange' remains as a brilliant example of the kind of indirect evocation we have seen already in *Par les champs*, being in this case a perfect illustration of how to evoke *x* (Egypt) by evoking *y* (Normandy).

We still do not have a satisfactory text of the *Voyage en Orient*, and questions remain concerning the status of the extant manuscripts. Flaubert's original notes in the *Carnets de voyage* (4–9) are complete;[3] but we still do not know whether Flaubert completed the *mise au net*, as it is still, in part, inaccessible. Successive editions have simply produced a combination of *mise au net* and *Carnets*, according to their lights. Thus, today, a considerable proportion of

[1] He had gone so far as to promise some articles to Lavallée for the *Revue d'Orient*: 'Il s'en passera, malgré mes promesses . . .' (*C1* 564: 15 Jan. 1850).

[2] Cf. Flaubert's note: 'Fini de copier ces notes le samedi soir, minuit sonnant, 19 Juillet 1851' (11: 39).

[3] See Bibliography, section 1.

the *Carnets* remains unpublished. Half of the *mise au net* (the 'Egypt' section) has at last become available and has been presented in an excellent recent edition by P.-M. de Biasi. Biasi suggests that Flaubert may not in fact have taken the *mise au net* further than the sections dealing with Egypt, Rhodes, and Asia Minor.[4] However, the Venice section, the last one of all, which has never been published in any form, certainly existed in a form suitable for loan in 1859—Flaubert lent it to his friend and literary collaborator Charles d'Osmoy (*C3* 893). The version of Venice in the *Carnets* is an editor's nightmare, and Flaubert is highly unlikely to have imposed that on his friend. Possibly d'Osmoy never returned it.

There thus remain elements of uncertainty about the text of the *Voyage en Orient*. The discussion which follows centres on the Egyptian and Italian sections of the *Voyage*, for which I use Biasi's edition (*Voyage en Egypte (mise au net)* and a combination of the CHH edition (vols. 10 and 11) and the *Carnets de voyage*, 8–9). The *Carnets* are not identical with the *mise au net*, even allowing for errors in the published editions.

EGYPT

Flaubert and Du Camp prepared for their journey with background reading. We know which books Du Camp used because his notes are extant.[5] But there are unfortunately no notes for Flaubert, who may simply have relied on Du Camp's notes and the books he (Flaubert) mentions as having taken with him, and which he cites *en route*.[6] Whatever he read, reading still does not seem to have entirely prepared him for the shock of what he saw.

[4] Cf. Biasi, *VE* 14–18, for details of the *mise au net* and its history. The *mise au net* covers Egypt (22 Oct. 1849–18 July 1850), Rhodes (8–14 Oct. 1850), and part of Asia Minor (14 Oct.–12 Nov. 1850), up to the arrival at Constantinople. It excludes Palestine and the Lebanon, Constantinople, Athens, and Italy.

[5] See Antoine-Youssef Naaman, *Les Lettres d'Égypte de Gustave Flaubert* (Nizet, 1965), for details.

[6] There are references in the course of the *Voyage en Orient* to Champollion (*VE* 343, 359, 390) and, in the correspondence, to Champollion and Lepsius (*C2* 366, 370): see Bibliography for details. Flaubert also recommends to his mother that she consult the monumental *Description de l'Égypte*, 3 vols. (1809–13), which may well be the 'deux volumes d'Orient' which he takes in his luggage, cf. *CV* 4 81ʳ). At some point, Flaubert acquired some notes on Winckelmann's *Histoire de l'art chez les anciens*, which deals in part with Egypt (see Bibliography), but this was probably much later, as the notes form part of the dossier for *Bouvard et Pécuchet*.

Though the *mise au net* was written up at home, several months after the experiences recorded, Flaubert tends not to let hindsight alter the freshness of the first impressions, so the reader can follow the development of his responses and gradual dawning of appreciation of the strange new art of Egypt.

Flaubert's appreciation of Egyptian wall-paintings took some time to grow. At first, he could not see them as art. This applies particularly to depictions of the human form, which, as Winckelmann had pointed out, could never be realistic because they were so often used as representations of the gods.[7] Flaubert seems to have worked this out for himself, for later, in Italy, musing on medieval depictions of the Christ child (static, stylized, symbolic) as opposed to Renaissance depictions (mobile, life-like, *vraisemblable*), he suggests that art increases as the religious impulse wanes: 'Le sens profondément religieux de l'Enfant-Dieu assis dans les bras de sa mère, sans bouger, comme vérité éternelle, fait place ici au sentiment de la vie et du vrai humain; la religion perd, l'art empiète' (11: 171-2).

Therefore, at first, Flaubert is unable to see any beauty in Egyptian representations of the human form at all. That he is looking through a distinctly modern and personal grid is evident in the endearing reference to his own knock-knees: 'comme plastique, l'ensemble du dessin de toutes ces représentations est généralement lourd, mastoc, décadent—les genoux, au lieu d'être perpendiculaires à la jambe, sont rentrés en dedans, comme les miens, ce qui est laid' (*VE* 291). However, this remark dates from relatively early in his journey up the Nile (the temple of Esneh, 7 Mar. 1850). A few weeks later, at the temple of Philae (13-15 Apr. 1850), he is relieved and delighted to see naturalism breaking through stylization. He notes the gesture of a woman in despair, in some otherwise entirely conventional embalming scenes: 'dans le coin à droite, femme ployée sur les genoux, avec des bras désespérés lamentants—l'observation artistique perce ici à travers le rituel de la forme convenue' (*VE* 348). Later, at El-Cab, not far from Esneh, he enjoys the scenes of daily life depicted in the tomb-paintings of the necropolis: 'Rien n'est amusant comme ces peintures qui sortent de la rigidité impitoyable de l'art égyptien' (*VE* 360). Once Flaubert arrives at the Valley of the Kings and the underground tombs of the Theban necropolis, he finds examples of

[7] This point is included in Flaubert's notes on Winckelmann, cf. BMR, ms g 226¹ 126ᵛ.

such realism everywhere: 'C'est incontestablement ce qu'il y a de plus curieux comme *art* en Égypte' (*VE* 390). Flaubert is beguiled by the grace and charm of these depictions of everyday life, for example, the Chinese-like forms of the man picking lotuses in a boat with the detail of the bending branch, the stork, and a bush: 'un homme nu peint en rouge, qui est dans une barque et qui cueille des lotus—au-dessus de sa tête une branche s'incline—une cigogne se tient sur l'arbrisseau. chose charmante pleine de grâce et d'originalité' (*VE* 390).

There is a further stage in the development of his appreciation. In time, the ritualistic representations too come to fascinate and please. In this instance, it is the Valley of the Kings that opens the door. In the tomb of Sethos I, for example, are some exquisite representations of gods: 'Il y avait, au milieu de cette admirable chambre, deux piliers: l'un fut renversé par le Dr Lepsius—sur le deuxième, d'un travail exquis et peint sur les quatre faces, dieux à visage vert, les poings près l'un de l'autre sur la poitrine, les coudes écartés, et tenant dans leur mains le sceptre et le fouet' (*VE* 395).

Whether depicting everyday subjects or grander, mythological iconography, these tombs were certainly the high spot of Flaubert's experience of Egyptian art. There were many strands to his response, but undoubtedly the shock of the colours was one of the things which impressed him most (and even modern coloured reproductions cannot prepare the viewer for the impact of their brilliance). Hidden under the desert, needing to be actively sought out, often through tunnels and stairways, these tombs are made to appeal to a writer with a 'chambre secrète' of his own, and whose protagonist in *Hérodias*, Herod Antipas, conceals beautiful, brightly coloured horses, white with blue manes, stored away carefully underground. Flaubert writes to his mother about the stupendous effect of these great tombs, with their walls 'peintes du haut en bas' (a phrase he was later to use in connection with his own writing), their colours, and their strange symbols, which feed his taste for enigma:

C'est une *merveille*. Figure-toi une vallée entière coupée dans une montagne où il n'y a pas plus de végétation que sur une table de marbre et, des deux côtés, des carrières; ce sont autant de tombeaux. On descend dans chacun par une série d'escaliers les uns au bout des autres et qui n'en finissent [plus]. Puis l'on entre dans de grandes salles, peintes du haut en bas et au plafond. On y voyage, le mot est littéral. Figure-toi des grottes de Caumont, dont les murs seraient poncés et couverts de peintures d'or, d'azur, etc.

Ce sont des représentations fantastiques ou symboliques, des serpents à plusieurs têtes qui marchent sur des pieds humains, des têtes décapitées qui naviguent, des singes qui traînent des navires, des rois sur leurs trônes avec des visages verts et des attributs étranges.—Les peintures sont fraîches comme si elles venaient d'être faites et s'enlèvent sous le pouce. Ailleurs ce sont des joueurs de harpe, des danseuses, des gens qui mangent . . . on en casse-pète. (*C1* 621)[8]

Colour in secret places, with associations of death, are an irresistible combination for Flaubert, as we have already seen to some extent. To borrow his own image: he himself is a pyramid, and inside this great grey monument are marvels of strange colours, strange forms, and enigmatic icons whose presence no one suspects. In 1868, he recalls the 'fresques de Medinet-Abou' with nostalgia and pleasure (*C3* 725), and pays them a final tribute in the final version of the *Tentation de saint Antoine*.[9]

On the other hand, Flaubert has no difficulty coming to terms with lack of realism with respect to colour. He seems delighted with green faces (above), or red faces and blue hair (*VE* 393) or black beards and green hair (*VE* 396), or with the fact that Osiris is entirely blue (*VE* 385). Nor is he anything but pleased at the strange iconography. The *Temptation of Saint Anthony* lives again: composite beings with bodies of lizards and heads of monkeys or snakes; a birdman ('espèce d'oiseau à figure d'homme étrangement coiffé' *VE* 341); red snakes with black spots and harps coming from liquid from their mouths (*VE* 394); needlessly complex arms, forked from the elbow 'et ayant deux mains élevées, suppliantes vers une boule d'où part un jet qui va rejoindre une autre boule—sous l'arc du jet, un personnage tout rouge, debout—barbu, coiffé du bonnet en pointe à bouton' (*VE* 397). Hands encircle a human body, and appear, foreshortened, to be feet (*VE* 311). Flaubert notes strange,

[8] Cf. *C1* 634, to Bouilhet: 'Quelque chose de bougrement magnifique, ce sont les tombeaux des rois. Figure-toi des carrières de Caumont, dans lesquelles on descend par des escaliers successifs, tout cela peint et doré du haut en bas et représentant des scènes funèbres, des morts que l'on embaume, des rois sur leurs trônes avec tous leurs attributs et des fantaisies terribles et singulières, des serpents qui marchent sur des jambes humaines, des têtes décapitées portées sur des dos de crocodiles, et puis des joueurs d'instruments de musique et des forêts de lotus. Nous avons vécu là trois jours.'

[9] Cf. *TSA3* 4: 117, on wall-paintings such as these: 'et leurs formes m'entraînèrent vers d'autres mondes'; 4: 134, 'des salles où étaient reproduites les joies des bons, les tortures des méchants, tout ce qui a lieu dans le troisième monde invisible. Rangés le long des murs, les morts dans des cercueils peints attendaient leur tour [. . .]'.

complicated hairstyles, with urns and birds. In the small temple at
Abou-Simbel (*VE* 327) and elsewhere (*VE* 360), he notes figures
resembling wigs on wooden mushrooms. This is iconography as a
puzzle beyond his wildest dreams. Flaubert's notes are punctuated
with questions. He takes pleasure in naming the nilometer, the
pschent, the uraeus, as all good tourists do, but mysteries still
remain. Flaubert lingers over certain forms, hesitating as to how to
name them: is it a bird? is it a hare (*VE* 290–1)?; '*Qu'était-ce que
la boule qui est toujours sur le garrot des chevaux?*' (Flaubert's
emphasis, *VE* 386). Nothing is too obscure to be noted—he regis-
ters 'deux signes méconnaissables pour moi' (*VE* 394); other
figures, headless and bound, were presumably not just prisoners but
'avaient sans doute un sens symbolique plus élevé' (*VE* 397). These
are not the questions and reflections of a writer who is imposing
any kind of preformed grid on what he sees.

Not all the paintings and pictorial representations attain the
clarity and brilliance of those in the Valley of the Kings, of course.
But when they do not, they offer an alternative charm, to which
Flaubert has already shown himself to be sensible. Often, not only
are the representations undecipherable in themselves, they are also
half-effaced, thus adding mystery to mystery. Colours have faded
sometimes to the point where only lines are still visible, so that paint-
ing seems to turn into writing, representation to signifying. But the
result is still a conundrum, and Flaubert pores over it as he had
already in the presence of ancient inscriptions in Brittany, suscep-
tible as ever to the lure of artefacts that only appear to be offering
meaning: wavy lines scratched on a wall (a representation? a sign?
random scratchings?); the imprint of a foot which occurs several
times in and around Egyptian temples (e.g. *VE* 360). All these feed
his continual interest in traces and signs which offer but no longer
deliver meaning.

At a more basic level still, Flaubert sometimes simply concentrates
on shapes and colours, uncaring about the picture as a whole.
Sometimes he focuses on tiny details of a garment as depicted in a
wall-painting:

une longue robe [. . .] dont le dessin est: des petites bandes blanches oblique-
ment croisées, formant par leur intersection des losanges de couleur viol-
ette, au milieu desquels est une petite rondelle blanche ayant à son centre
un pois rouge; au point d'intersection des bandes sont aussi des pois
rouges se trouvant sur la même ligne que ceux des rondelles. (*VE* 342)

This occurs not only in Egypt, of course. Later, in Bethlehem (10: 568), he notes as meticulously the 'superfétation d'ornement' on the figure of a Byzantine Madonna—the peacock feather on her crown is already 'superfétation' enough, but there is more. The feather itself is filled with blue and white eyes. Then the artist has removed some of the whites of the eyes and replaced them with cherubs' heads, and that is to go delightfully too far. In this we see a major feature of Flaubert's later art commentaries, the tendency to concentrate on pattern, as if pictures were no more than arrangements of shapes and colour.

ITALY

'Ne te fous pas de moi de vouloir voir l'Italie. Que les épiciers s'y amusent aussi, tant mieux pour eux. Il y a là-bas de vieux pans de murs, le long desquels je veux aller. J'ai besoin de voir Caprée et de regarder couler l'eau du Tibre' (C1 732, to Bouilhet).

Flaubert spent three days living in a 'petite chambre' in the palace of Karnak, with a sky-blue ceiling, and queens and kings painted on the walls (C1 620). Italy was the same experience writ large. Flaubert's first impression of Rome was 'defavorable' (C1 772), because he was expecting 'la Rome de Néron' and found only 'celle de Sixte-Quint'. But this less ancient Rome soon became a source of great pleasure. In Rome, he was steeped in art, every day: 'On peut s'y faire une atmosphère complètement idéale et vivre à part, dans les tableaux et les marbres' (C1 779). Rome is one great 'chambre secrète', with frescos on every wall. The Vatican is the quintessence of travel, the home of the *ailleurs*: 'Je donnerais tous les glaciers pour le musée du Vatican. C'est là qu'on rêve' (15: 317–18: 3 July 1874).

As in 1845, family pressures made themselves felt.[10] Flaubert spent only four months in Italy in all, from February to June 1851: five weeks in Naples, five in Rome, ten days in Florence (with brief visits to Perugia and Pisa on the way) and a meagre four days in Venice, with a trip to the villa Valmarana near Vicenza. Also, Flaubert

[10] See C1 699 to his mother on their projected itinerary; a more definite rendez-vous is proposed C1 739; she will join him in Rome C1 765; Gustave is forced to curtail his stay in Venice C1 782–3 ('je suis exaspéré').

was afraid that he had not made adequate preparations for Italy. Writing to Bouilhet, he defends his decision to go ahead and fit it in all the same: 'Crois-tu que comme toi je ne sente pas bien la fétid-ité d'un voyage exécuté sans préparations et qui durera peut-être six mois tout au plus? N'importe, j'en prendrai ce que je pourrai [. . .]' (*C1* 725–6: 19 Dec. 1850). Lack of preparation does not seem in the event to have proved a major drawback however. Internal evidence suggests that he used for Naples a catalogue of 1844 by Bernard Quaranta (in French)—Flaubert's numbering is ident-ical with Quaranta's, and that is not the case for comparable cata-logues for other years, and there are also small textual echoes from Quaranta to Flaubert—and one of the current Murray Guides: a high proportion of the paintings on which he comments appears in Murray, often among those Murray especially recommends.[11] Rome is less straightforward. Internal evidence, once again, suggests Murray as the primary source, but Flaubert is also highly likely to have used the catalogues which were provided for the use of visitors in various museums and galleries. Flaubert himself refers to one such catalogue in the Vatican (11: 159) and another in the Uffizi (11: 169), and Murray's guide to Rome for both 1843 and 1858 lists such catalogues as being provided in both the palazzo Borghese and the palazzo Corsini.[12] For Florence, it seems almost certain that Flaubert used the Catalogue of 1844 (in French) for the Uffizi. He was clearly guided by it in his selection of paintings (though he ignores certain stars of the Catalogue, such as the *Fornarina*, and gives great prominence to Rubens's *Baccanalia*, to which the Catalogue does not pay particular attention) and communication of certain basic facts (such as that the Raphael *John the Baptist* was an example of his third manner, or that the Uffizi Judith is the same as the Naples Judith) or the most superficial of value judgements, such as that a certain painting is 'beau' or 'vrai'. But all his *inter-esting* comments are entirely his own; for example, the Catalogue simply notes that the Allori *Abraham and Isaac* is 'un des plus beaux ouvrages d'Allori', where Flaubert gets lost in the intricacies of its composition; the Catalogue says of Vasari's portrait of *Lorenzo dei Medici* simply that it is 'très-intéressant pour le sujet' and for the 'perfection du dessein', whereas Flaubert notes such things as bone

[11] See Bibliography for details of Quaranta, Murray, etc.
[12] Cf. Murray's *Rome* (1843), 439 (Borghese) and 1858 (palazzo Corsini).

structure and the form of the hands; the Catalogue draws attention to the male nudes in the background to the Michelangelo *Holy Family*, but only Flaubert highlights the incongruity and the humour, and so on.

In Naples, Flaubert spent much of his time in what was then the Real Museo Borbonico, which housed both antiquities and paintings. While at first he concentrated on antiquities (*C1* 756, 758, 761), a great deal of time was subsequently devoted also to paintings.[13] Flaubert is explicit about certain of his reactions. A letter to the painter Camille Rogier (*C1* 761–2) cites paintings by Salvator Rosa, and the Rembrandt self-portrait (actually a copy). Other paintings which figure prominently in the notes are a *Crucifixion* and a *Magi*, both presumed at the time to be by Lucas van Leyden (but now attributed to Joos van Cleve), a Ribera *Silenus*, and a *Nativity*, presumed to be by Dürer (= van Oostsanen), on which Flaubert claimed there would be 'tout un livre à faire'.

In Rome as in Naples Flaubert began with the art of antiquity: 'Le Vatican et le Capitole nous occupent entièrement' (*C1* 769).[14] But the Cinquecento was an unexpectedly magnificent discovery: 'comme tableaux, comme statues, comme XVIᵉ siècle, Rome est le plus splendide musée qu'il y ait au monde' (*C1* 772). 'Quant à la Rome du XVIᵉ siècle, elle est flambante. La quantité des chefs-d'œuvre est une chose aussi surprenante que leur qualité! Quels tableaux! quels tableaux! J'ai pris des notes sur quelques-uns' (*C1* 779). It was in Rome also that Flaubert discovered a taste, rare at the time, for early mosaics.[15]

Flaubert identifies his favourite works of art in Rome as being the Vatican *Torso*, the *Last Judgement*, Veronese's *Europa*, and the Murillo *Madonna* (*C1* 770, 772). Only the Murillo figures in the notes (ii: 152–3). The others left him quite properly at a loss for words. A letter refers to his having enjoyed 'douze *bonnes* toiles dans

[13] The antiquities are now housed at the Museo Archeologico Nazionale, the paintings in the Museo Capodimonte. For further details, see Appendix A. Of the thirty-five paintings noted by Flaubert (not including murals and bas-reliefs from Herculaneum and Pompeii), thirty-three appear in the published version of the *mise au net* (but not in *Carnet* 8) and two in *Carnet* 8 (but not in the *mise au net*).

[14] The published version of the *mise au net* includes quite substantial notes on exhibits in these museums, and on exhibits then in the Collegio Romano; the *Carnets* have remarkably little.

[15] See Ch. 1 above. A considerable proportion of the 'Rome' notes is unpublished. See Appendix A.

différentes galeries' (C1 780), and these probably include, as well as the *Europa* and the *Madonna*, Titian's *Sacred and Profane Love*, which is given a great deal of space in the notes (the text in the published versions is truncated) and Velvet Brueghel's beautiful paintings of the *Paradiso terrestre* and the four elements (the notes for which paintings remain entirely unpublished).

Perugia was a very brief visit, but Flaubert had time to note the Signorelli in the cathedral, and the frescos by Perugino in the Collegio del Cambio, including the story of the beheading of John the Baptist. There is no mention of Pisa in the published version, and only a very terse note in *Carnet* 8 (30ᵛ). Once more, we note that silence is Flaubert's response to works which affected him too deeply: the *Last Judgement* in the Camposanto in Pisa which 'ravaged' him passes unnoticed in the notes. Flaubert's comments on it are all retrospective.

Since Flaubert had at his disposal only ten days for Florence, it is understandable that his notes are devoted entirely to paintings in the Uffizi (twenty-eight paintings in all) and the Pitti (nineteen paintings in all). Internal evidence suggests a particular interest in the Rubens *Baccanalia*—'tableau dont on ne peut se détacher et qui attire à soi chaque fois qu'on veut sortir de la salle' (11: 167)—and the three Fiesoles depicting scenes in the life of the Virgin (11: 164),[16] an *Abraham and Isaac* by A. Allori (11: 166), and a *Lazarus* by N. Frumenti (11: 168).[17]

Most of what Flaubert managed to see in the tiny space of time at his disposal in Venice was in the collection of the palazzo Manfrin. This was dispersed in 1855 (some but by no means all of it going to the Accademia). But the *Carnet* contains quite clear notes on visits to the palazzo Labia, with its lovely Tiepolo frescos of Antony and Cleopatra, the palazzo Pisani (Veronese's *Family of Darius before Alexander*, now in London), the San Marco mosaics, the tiny church of San Sebastiano with its luminous Veroneses hidden away inside, and, above all, the Frari for the grand *finale*, the painting which impressed Flaubert above and beyond all the rest, and left him once again at a loss for words: Titian's *Assumption*, mentioned only in the correspondence (C1 783).

[16] Fra Angelico returns as a model for Emma Bovary during her religious crisis, *MB nv* 78, 89 ('visions de Fiesole. Sentiments de sirops et de mièvreries religieuses'), 91, 95.

[17] Flaubert's interest in Lazarus figures would repay further study.

Flaubert's notes, then, range from the tersest of notations to quite long developments, and some of his greatest excitements are not even included. Titian, Veronese, Velvet Brueghel, Rubens, and Rembrandt continue to dominate, alongside some new painters, including Perugino and Fra Angelico. The largest genre by far remains the portrait, and there continue to be next to no 'genre' painting or landscapes.

In the Italian notes, Flaubert is not interested in submitting paintings to experiments in writing, as he was in *Par les champs*. Here they are an object of serious study. The rest of this chapter will focus on certain paintings as indicators of particular aspects of Flaubert's response, aesthetic and otherwise. We begin with three paintings which elicit a powerful emotional response, and can be said to be to his 'taste'. The others are interesting primarily with respect to points of form.

(i) The Murillo Madonna (Rome, palazzo Corsini) and (ii) the Frari Madonna (Venice)

The initial impetus for interest in paintings of the Madonna is clear from an early reference, in *Mémoires d'un fou* (1838): 'Maria' (Mme Schlesinger) appears in the guise of a 'Vierge au long col', breast-feeding her child and singing, appropriately, something in Italian: 'cette gorge palpitante, ce long cou gracieux et cette tête penchée, avec ses cheveux noirs en papillottes, vers cette enfant qui tétait, et qu'elle berçait lentement, sur ses genoux, en fredonnant un air italien' (11: 493). Having made a quiet first appearance in *Italie et Suisse*, Madonnas proliferate in *Par les champs*, usually in the form of gaudy statues, the one spot of beauty and colour in an otherwise quiet and sombre church, a focus for desire (*PCG* 407–9). 'Femme' and 'forme' are once again united. When St Antoine falls in love with an image of the Madonna (*TSA1*), he is half in love with the woman, half in love with the form, with the paint itself, the 'peinture qui attire mes lèvres'. In Egypt, the net extends to include representations of other divine mother–son relationships: Flaubert notes many depictions of Isis suckling an often life-sized Horus (*VE* 341, 348, 357, etc.); and Madonnas dominate in the Italian notes of 1851, constituting something over 20 per cent of the total

number of paintings, and culminating in the two masterpieces, which elicited two contrasting responses from Flaubert. The Murillo provokes one of his most expansive and tender descriptions.[18] His letter on the Frari *Madonna* makes something of his feelings clear, as he muses on what the effects of Venice might have been on him, had he come twelve years earlier (that is, at the time of the *Mémoires d'un fou*) (C1 770).

Gautier shrewdly characterizes the Titian Madonna as a very terrestrial 'housewife and mother' figure.[19] She is then an embodiment of Mme Schlesinger and a foretaste of Mme Arnoux, and Flaubert is associating 'femme' and 'forme' just like St Antoine with *his* image of the Madonna. But Flaubert's response goes beyond that. In both of these Madonnas, love itself is the subject, and not just the love of mother for child (to which we might have expected the fixated Flaubert to respond) but, in the Murillo, the love of *both* mother and son for the viewer, at whom both are looking (the eyes of the Murillo Madonna 'descendent en vous' (11: 152) and remain in the memory as 'deux lanternes dansantes' for ever) and, in the Titian, the love of God the Father who is poised over the tired and ageing woman, rather, one might say, like an enormous parrot. What these two pictures bequeath to Flaubert above all is entirely ideal: a memory of two magnificent depictions of love, and of two dancing lanterns which pursue him 'comme une hallucination perpétuelle' (C1 772), which are *also* the eyes of the Muse and the best kind of love. Art and love come together, as they will later in *L'Éducation sentimentale*. Gautier also makes the excellent point that the Titian is an expression of love by the painter, too, and that Titian is there in his entirety in his painting, 'présent partout', we might say, in the very quality of the paint.[20]

[18] Seznec makes the connection between this painting and the ultimately deleted sequence in Flaubert's first *Tentation* when Antoine falls in love with the painted image of the Virgin Mary, cf. Seznec, *Nouvelles études sur la Tentation de saint Antoine* (1949), 90–2: 'Flaubert devant la Vierge, c'est Antoine "suivant les contours qui dessinent son image, comptant tous les coups de pinceau qui la colorent [. . .]": la vision de saint Antoine avait préfiguré celle de Flaubert'. In fact, though, other Madonnas had already prepared the ground.

[19] Cf. Gautier, *Voyage en Italie* (1894), 211 ff.: the BVM is 'd'une beauté solide' (p. 213) with 'ses larges flancs'.

[20] Cf. ibid. 214: 'La Vierge de l'*Assunta*, grande, forte, colorée, avec sa grâce robuste et saine, son beau port, sa beauté simple et naturelle, n'est-elle pas la peinture du Titien avec toutes ses qualités?'

(iii) Titian, Sacred and Profane Love
(Rome, palazzo Borghese)

This painting, too, is a tribute to love, and infused with generosity and warmth (Pl. 2). As a great wall of colour, it is entirely to Flaubert's taste, and so is the theme. But Flaubert wisely leaves his personal responses as read, and lets the form of his commentary speak for itself. It is one of Flaubert's longest commentaries. This is not apparent from the text as it has been published to date. What follows is the full text as it appears in *Carnet* 9 (the unpublished section begins at the asterisk):

Borghèse

Dixième chambre.23. L'Amour sacré et l'amour profane Titien. Deux femmes assises sur un sarcophage antique. La sacrée à gauche robe de satin blanc, gris perle au bras, robe rouge de dessous, tient des fleurs noires— gants gris de fer un peu lâches, chevelure rousse, cheveux sur l'épaule gauche, le coude gauche en arrière, la main appuyée sur un vase rond—entre les 2 femmes, penché sur le sarcophage (plein d'eau), un amour y plonge le bras droit *—à droite femme nue appuyée un peu sur la fesse & la main droite, tenant de la gauche une petit urne noire d'où s'échappe une fumée légère; draperie rouge lourde tombant & s'échappant du bras gauche—le pied droit est caché par la jambe gauche en dehors—elle n'est pas tout à fait de [côté] profil, on voit un peu de son œil droit—draperie blanche sur le haut des cuisses à la motte—délicieux œil, (gauche) bleu foncé, 2 plis sous chaque aisselle—l'eau coule du sarcophage par un goulot. Sur le bord du sarcophage un plat creux [à g] et une rose—sur le sarcoph sculptés: un cheval, un homme qui en frappe un autre à terre—3 hommes debout dont l'un porte un bâton. fonds: à gauche terre, moutons bruns, 2 lapins, un cavalier, une ville avec une tour, arbres grêles derrière l'Amour qui puise et la femme sérieuse de face, feuillages bruns. A droite terrains plats, 2 cavaliers, 2 lévriers et un lièvre, berger qui garde ses moutons. Forêts—derrière les cavaliers bleus d'eau—église—la mer bleue—ciel froid à grande bande jaune. Nuage blanc déchiqueté plaqué. (CV9 11v–12v)[21]

Current opinion on the iconography differs from the nineteenth-century view. In the first place, 'sacred' and 'profane' have changed places, an inversion which would have delighted Flaubert, as an

[21] I have expanded Flaubert's own shorthand to some extent, to give an intelligible text. Here and in following quotations, square brackets indicate words crossed through by Flaubert, angled brackets indicate insertions.

illustration of his belief that these categories are purely conventional.[22] Like other nineteenth-century viewers, Flaubert believed the woman representing the 'sacred' to be the one on the left:[23] she is dressed, while the woman on the right is naked except for the scarlet drape, interpreted as a sign of prostitution. However, it has been pointed out that the inverse interpretation is equally valid: nakedness is a sign of purity; and the icon of the church in the background outweighs the scarlet drape. Moreover, discussion about which is sacred and which is profane is now regarded as redundant. Current opinion abandons the idea of *contrast*: the simplistic division between 'sacred' on the one hand and 'profane' on the other, suggested by the (erroneous) title, is quite foreign to Titian's way of thinking.[24]

That the same is true for Flaubert is evident if only in the way he describes the two figures, with equal attention and equal tenderness (they are probably the same woman).[25] For, contrary to what the published version of the commentary would lead one to suppose, Flaubert describes *all* parts of the painting, and that in itself is significant. His description traces out the different parts of the painting, systematically, beginning with the foreground and moving from left to right: dressed figure, Cupid, naked figure; then moving to the sarcophagus, lower foreground, centre; from there to the background, again moving from left to right. Exactly in the manner of Delacroix describing his paintings, Flaubert makes no attempt whatever at interpretation. This may have several causes, including inability or natural caution. Another possibility is suggested by what Taine says about this painting in his *Voyage en Italie*. According to Taine, no interpretation should be attempted: 'tout est pour le plaisir des yeux, rien pour celui de la faculté raisonnante'.[26] Accordingly, Taine does not himself attempt an interpretation. Like Flaubert, Taine describes the whole painting, foreground and background—it is in fact apropos the background that he reiterates his essential point about the great Venetian colourists ('Ils aiment

[22] For Flaubert's views on the interchangeability of these two concepts, see e.g. C2 378, C3 16.

[23] The words 'la sacrée' which begin Flaubert's third sentence are omitted from the published version.

[24] See E. Wind, *Pagan Mysteries in the Renaissance* (1967), 141 ff.

[25] Elsewhere, Flaubert notes that Cranach's *Eve* (Florence) is the same woman as his *Venus* (Rome, Borghese)—another small link between sacred and profane.

[26] Taine, *Voyage en Italie* (1921), i. 267.

les paysages réels qu'ils voient tous les jours, et les mettent dans leurs tableaux sans s'inquiéter de la ressemblance').

Flaubert's commentary also focuses on the two little background scenes of everyday life going on—a perfect example of what Flaubert elsewhere called 'art bonhomme'—which may or may not be iconographically relevant to the main subject. (We shall see other examples of this kind of transference of attention from foreground to background later on.) But where Taine, with the mania of the scholar, comments on the significance of the background, if only to say that it is there precisely *not* to signify, Flaubert simply notes its presence. More significantly, Taine makes no mention at all of a still greater distraction in the painting, which is the enigmatic but *possibly* relevant scene on the sarcophagus, and which nobody has yet been able fully to explain.[27] Flaubert, on the other hand, gives it all due attention. Resonances may suggest themselves between this grey space at the heart of the painting and certain areas of Flaubert's own writing where full meaning is denied.

Finally, Flaubert (again unlike Taine) includes the detail of the 'ciel froid à grande bande jaune' which links all the disparate elements of the painting together. This detail of the streak of light in the sky—yellow or red—is far from being neutral for Flaubert. It is one of many, never explained (as it is not explained here), which recur throughout his work. It appears several times in various texts, notably in the second *Éducation sentimentale*, when Mme Dambreuse and Frédéric make love for the first time (3: 350).[28] Flaubert here is responding to the presence of one of his own images, and he is as silent as to what the image signifies as he is about the meaning of the painting itself.

To compare Flaubert's commentary on this painting with that of Taine is to see once more how art commentaries for Flaubert are essentially a set of potential growing-points, while those of Taine are a dutiful dead end.

[27] Cf. E. Panofsky, *Iconology* (1962), 152 n. 79.

[28] Cf. *ES2* 3: 350: 'Mme Dambreuse ferma les yeux, et il fut surpris par la facil-ité de sa victoire. Les grands arbres du jardin qui frissonnaient mollement s'arrêtèrent. Des nuages immobiles rayaient le ciel de longues bandes rouges, et il y eut comme une suspension universelle des choses. Alors, des soirs semblables, avec des silences pareils, revinrent dans son esprit, confusément. Où était-ce?' The drafts show that Flaubert toyed with the idea of being more explicit, cf. *Scénarios*, ed. Williams (1992), 302: 'ce crépuscule en rappelle vaguement à Frédéric un autre où il est sorti au bras de Me Arnoux [mais] cette idée [glisse] disparaît comme un mirage'. The vaguer oneirism of the definitive version reflects Flaubert's own palimpsest of memories; for the same detail, cf. *PCG* 90 n. 1, 276, 299; *VE* 355; *CHH* 10: 581, etc.

(iv) Early Christian mosaics
(Rome, S. Prassede, S. Maria Maggiore)

These were a major discovery for Flaubert. He had had no pre-
paration in advance, since scholars had only recently begun to
turn their attention to this new domain, as we saw in Chapter 1.
Flaubert's own perception, indeed, was that, faced with this art form,
he was entirely on his own ('qui est-ce qui a étudié le byzantin?',
VO 11: 151) and was free to see with fresh eyes. The emotional
impact was considerable. Flaubert registers something of the same
shock of pleasure as he experienced on seeing the best Egyptian tomb-
paintings in the Valley of the Kings. In the dark interiors, the
mosaics spring into sudden life as the torch illuminates them, their
crude whites and reds bursting out of the darkness in the same entirely
unexpected way: 'Expression presque effrayante de portraits plus
grands [. . .] avec leurs grands yeux ouverts, blancs. Aux joues, pour
imiter la couleur des pommettes, le mosaïque tranche en rouge sur
la pâleur, comme du sang, et la rehausse' (11: 151). But the mosaics
were more than frightening icons, all eyes and blood. Their attraction
for Flaubert seems to have lain also in their non-representational
sign system and in the way figuration so often gives way to pattern.
Louis Hautecœur gives a good working description of the art of mean-
ing in Byzantine art, which would chime with the sort of thing
Flaubert singles out to comment on: 'Les détails sont signifiés, plus
que représentés: un arbre, c'est un tronc muni de quelques branches,
où sont attachées quelques feuilles; une montagne, c'est une ondula-
tion ou un simple rocher. Les couleurs sont conventionnelles. L'art
est un langage.'[29]

If art was a language, Flaubert particularly liked it when he did
not understand what it was saying. One mosaic which particularly
fascinated him (and which provoked him into drawing a little
sketch in order to try to understand it better), is one of those to be
found in the apse of the church of S. Prassede (Pl. 3). His commentary
lingers in particular on the mysterious objects which surround the
figure of Christ. Though in fact he has worked out to his own
satisfaction what these are ('ce sont évidemment des nuages'
(waves, rather?)), he keeps that realization in reserve, and proceeds
as if he does not know what they are:

[29] L. Hautecœur, *Littérature et peinture en France* (1942), 6.

Tout autour du Christ, de chaque côté, montent à partir de ses pieds jusqu'à ses épaules quantité de choses (pains? poissons? nuages?), rangés les uns sur les autres et alternativement rouges et verts. Au-dessus de Jésus, ces espèces de saumons de couleur se représentent: là, ce sont évidemment des nuages; une main en sort tenant une couronne. (11: 151)

He closes his eyes to reason and, like Elstir, notes what he sees. Representation gives way to an ambiguous sign.

The mosaic of the apse of S. Maria Maggiore presents a similar kind of phenomenon (Pl. 4). Here, trees 'take off' and evolve into other forms. 'Arbres' become 'arbres-candélabres' (CV8 25ʳ): 'De chaque côté de la mosaïque, dans les angles, un grand arbre, candélabre à arabesques régulières au lieu de branches, et sur ces arabesques ou rinceaux sont perchés de grands oiseaux, paons, aigles, poule, un perroquet(?)' (11: 151–2). Figure becomes pattern. Flaubert had already registered the same mechanism at work in a detail of a *Nativity* by van Oostsanen, which he had seen in Naples. Here, he focuses on the way one particular cherub is depicted. The others are depicted realistically, but the body of this one becomes a sign, a shape echoing that of the censor. As in the mosaics, representation gives way to signification—the cherub *signifies* incense:

Le Chérubin qui encense a un mouvement de jambe pareil à son encensoir: l'encensoir revient, et le Chérubin, suspendu en l'air, a les jambes qui s'en vont en arrière, en une courbe analogue, il encense de tout son corps et de tout son encensoir, le corps suit l'encensoir, les deux ne font qu'un. Le Chérubin lui-même est-il autre chose? (11: 120)

Representation becomes pattern or symbol, as in Flaubert's own art.[30]

(v) Pietro Testa (attr.), Cimone ed Ifigenia (Rome, galleria Colonna)

This is another example of a painting which is difficult to read (Pl. 5). In Flaubert's day no reading was attempted. The painting was attributed at the time he saw it to Poussin, and the subject was

[30] On this subject, cf. Owen Jones, *The Grammar of Ornament* (1856). Jones is primarily interested in decoration, and in how it sits with architectural style, and less in the transition from figurative art to pattern, which is Flaubert's main interest. However, Jones does consider this transition to some extent in relation to Egyptian art.

assumed to be a bucolic scene, reflected in the suitably vague title, *Sommeil des bergers*. The painting certainly creates a strange effect, rather like a Symbolist painting. Once again, Flaubert's description (only recorded in note form in the *Carnet*) makes no attempt at interpretation:

> Sommeil des Bergers—Poussin .
>
> A gauche berger debout sur sa houlette, épaule & bras droit découverts. Draperie rousse et à lumière lie de vin—appuyé sur la jambe droite le corps est porté sur le pied gauche et les doigts du pied [droit] gauche sur le bord externe du pied droit, le talon étant levé. Assise & se réveillant <la main droite> appuyée par terre une femme blonde & rosée, chemise blanche, draperie sur [les genoux] cuisses, genou et jambe blancs gris, elle le regarde —devant elle au premier plan de dos toute courbée et le bras droit plié sur le gauche allongée une femme draperie couleur argent qui l'enveloppe jusqu'au milieu du dos—position très naturelle des pieds, écartés, quand on est couché sur le flanc—au troisième plan, assise et penchée sur la droite femme endormie sur une draperie verte—quatrième plan homme assis endormi, d'un sens opposé. Amour très en vol, et lève une flèche sur le berger endormi, lumière qui arrive sur son bras gauche—dans le fond fontaine à dauphin, terrains bruns, ciel à grande bande rouge—à gauche et servant de fond aux personnes grands arbres bruns largement faits—les bras & les mains un peu traités à la vénitienne. Délicieuse figure de la femme [de *illegible word*] qui se réveille—un petit filet de perles sur ses cheveux roux— (CV9 8ᵛ–9ʳ)

The riddle of the subject of this painting is now resolved. It is now attributed, tentatively, to Pietro Testa, and is believed to illustrate an episode of Boccaccio's *Decameron* (Fifth Day, first story). It has consequently acquired a new title: *Cimone ed Ifigenia*. For modern viewers, then, the enigma is dispelled. But for Flaubert the painting was principally little more than an arrangement of forms and colour, with a beautiful woman once more as focus, but as a whole suggesting a meaning never stated, and including once again, as if to underline its own enigmatic quality, a 'ciel à grande bande rouge'.

 Thus, whatever their meaning, both the Titian and the Testa appear in Flaubert's description as primarily an arrangement of form and colours. Questions of meaning do not trouble him, so long as they are offered and not resolved. On the contrary their lack of detectable meaning is what makes these paintings incomplete and therefore attractive.

(vi) Bronzino, Sacrificio di Isacco *(Florence, Uffizi)*

The subject alone was sufficient to catch Flaubert's interest (Pl. 6). He had already noted a painting on the same theme in Bethlehem (10: 568). However, once again, all his comments bear on the *form*:

> *Alexandre Allori. Le Sacrifice d'Isaac.* Curieux pour la composition. D'abord, en commençant par la gauche, on voit dans le fond une maisonnette. Scène rustique: 1° Isaac et Abraham se mettent en marche; 2° plus près de nous, Isaac fait le paquet de bois, l'âne est là; 3° au premier plan, nous voyons l'âne chargé des provisions, un chien qui fouille dans un panier à terre et deux hommes qui dorment sur l'herbe; 4° Isaac et Abraham sont en marche.
>
> (Comme dimension, nous sommes ici au sujet principal de la toile, Isaac porte le bois et Abraham un brandon allumé. Belle draperie rouge et jaune d'Abraham, étude d'anatomie et de couleur, surtout dans les bras nus.)
>
> 5° Au haut de la montagne, Isaac sur le bûcher, et l'ange qui arrive; 6° même motif répété plus loin dans le fond à droite, mais il n'y a dans la pensée de l'auteur évidemment de principal que la montée et le bûcher.
>
> Tout ce qui précède est sur un plan plus reculé, comme un lointain au sujet, comme un précédent à l'action; mais pourquoi avoir répété deux fois la scène du bûcher avec l'ange qui arrive? (11: 166)

It was not the first time Flaubert had seen a narrative painting where the principal subject is repeated several times at different points of the narrative—the first *Abraham and Isaac* which he had seen in Bethlehem was also a narrative painting (10: 568).[31] But in this painting what seems to have interested him most is the fact that what emerges structurally as the 'sujet principal de la toile' is in fact an accessory incident, Isaac carrying his wood and Abraham 'un brandon allumé'; whereas the climax of the drama is tucked away in the background. Not only that, it is depicted twice.

Some unease is apparent, as always when Flaubert is dealing with a painting which seems to overstep the limits in terms of composition. He ends his commentary on a criticism, which is rare for him: 'Quelque chose de gêné dans l'exécution de tout ce tableau, cet art n'est pas encore arrivé à la liberté de sa forme.'

[31] For others, see e.g. 10: 568 (a painting of the Virgin), 11: 118 (a Nativity with Judas's arrival imminent). This kind of narrative painting was not common after 1500: cf. W. Steiner, *Pictures of Romance* (1988).

(vii) Michelangelo, Sacra Famiglia *(Florence, Uffizi)*

Flaubert was invariably drawn to Michelangelo, as we have seen, admiring not only his power but his anti-naturalism. However, in this commentary, no mention is made of either. Here, what dominates once more is the matter of composition. After describing the main group of the Holy Family (Pl. 7), Flaubert's eye is drawn to the background, where seemingly incongruous groups of men are lounging about naked: 'Dans le fond, académies d'hommes tout nus, inutiles, appuyés sur une sorte de parapet; on dirait qu'ils sortent du bain, un groupe de deux à gauche, de trois à droite' (11: 173).

The attention to incidental detail is also evident in Flaubert's notes on the *Nozze di Alessandro* by Il Sodoma in the villa Farnesina in Rome (11: 154), where distracting Cupids cavort about, one in particular wrapping the bed-hanging around his head, pretending it is a hood. Elsewhere, in the *Testa di Medusa* attributed at that time to Leonardo, Flaubert notes the incidental detail of two carefully depicted little toads (11: 165), or in Albertinelli gorgeous *Visitation*, tiny details of flowers (11: 166). In Salvator Rosa's *Cristo fra i dottori* (Naples) Jesus seems to be of only incidental interest—the focus is rather on an area of yellow paint (a 'pan de mur jaune'): 'C'est dans le clair-obscur, Jésus est vu de profil et même moins que de profil; il est, à coup sûr, moins important là que le dos jaune d'un docteur en turban blanc, couleur magnifique. Tête chauve d'un homme qui est en face de Jésus. Admirable couleur qui passe sur tout' (11: 121).

(viii) Perspectival Wall-Painting, Pompeii
(Naples, Museo Archeologico Nazionale)

Strange perspectives and odd angles continually attract Flaubert's attention, whether in reality (see Chapter 5) or in art (as in the Marinelli *Visitation* just mentioned, where the two female figures fill the whole space of the painting). In this Pompeian wall-painting, the scene is viewed from below. Thus, it would have delighted Degas, who noted that contemporary artists did not yet paint from this angle: 'on n'a jamais fait encore les monuments ou les maisons, d'en bas,

en dessous, de près, comme on les voit en passant dans les rues.'[32] It also illustrates several other of the qualities which appealed to Flaubert in painting: a *trompe-l'œil* effect, so that nature and art seem to overlap (as prescribed in the aesthetic of 1845); odd framing, which communicates a strong sense of the incomplete, of the *non-finito*, along with the half-open door which suggests some kind of further vista, not itself represented.

(ix) Herculaneum Dancers, Naples

This is another illustration of the incomplete ('ce qui fait le charme de ces figures, c'est leur peu de fini'), and they are as coloured, vague, and light as a dream, a kind of mirage, or *zaïmph*: 'Rien au monde de plus *rêveur* que ces figures en *vol* sur leur fond noir; elles ont le caractère d'un songe, vagues, aériennes, colorées. Ce qui fait le charme de ces figures, c'est leur peu de fini [. . .] faites pour être vues de loin' (11: 126). 'Faites pour être vues de loin'—as if already half caught up in Flaubert's spiral.

[32] Cf. L. Nochlin, *Realism* (1971), 19, for the sketch by Degas of a building seen from below (c.1874–83) with accompanying note. These odd angles came to be mocked very soon as a cliché of modernist style, cf. D. Riout, *Les Écrivains devant l'impressionnisme* (1989), 129, for reproductions and discussion of Bec's 'Coup d'œil sur les indépendants', in *Le Monde parisien* (17 May 1879), 6–7: a series of cartoon parodies of Caillebotte paintings with captions, very funny, including two rowers, one with no feet, another with no head; and a blue young man on a sofa with only one, very large hand.

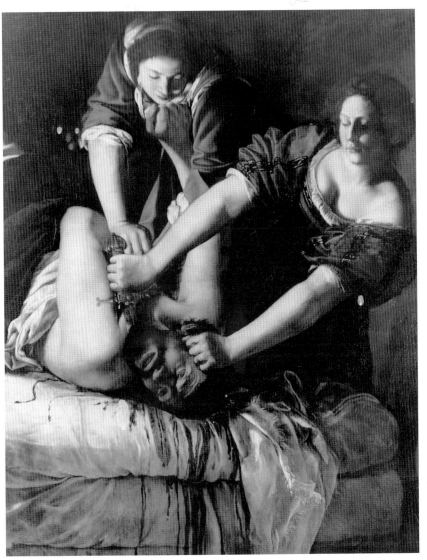

Pl. 1. Artemisa Gentileschi, *Giuditta e Holoferno*, Naples, Museo di Capodimonte

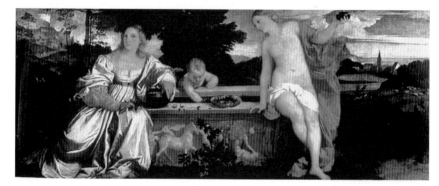

Pl. 2. Titian, *Amor sacro e profano*, Rome, Villa Borghese

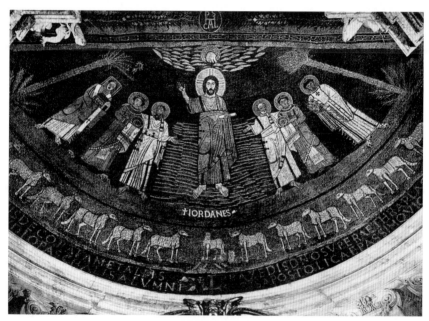

Pl. 3. Mosaic, church of S. Prassede, Rome (Istituto Poligrafico e Zecca dello Stato)

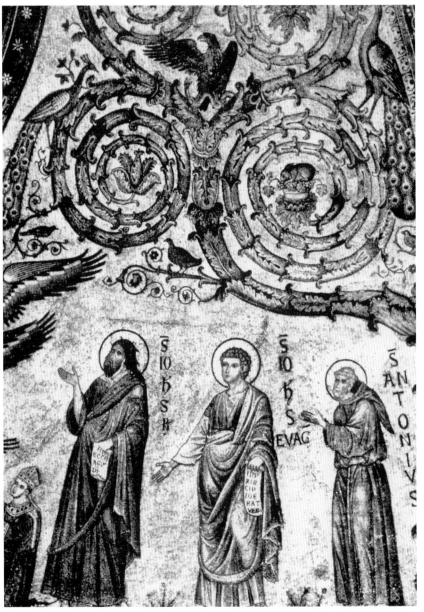

Pl. 4. Mosaic, apse of S. Maria Maggiore, Rome (Istituto Poligrafico e Zecca dello Stato)

Pl. 5. Pietro Testa (attr.), *Cimone ed Ifigenia*, Rome, Galleria Colonna (photo: Alinari)

Pl. 6. Alessandro Allori, *Sacrificio d'Isacco*, Florence, Galleria degli Uffizi

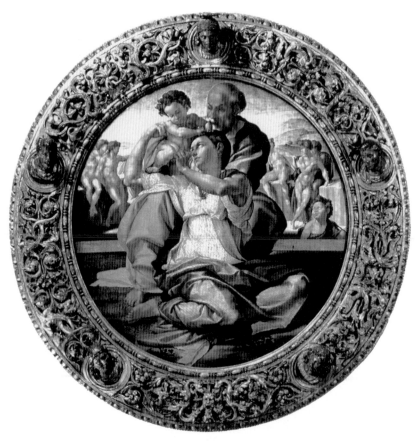

Pl. 7. Michelangelo, *Sacra famiglia*, Florence, Galleria degli Uffizi

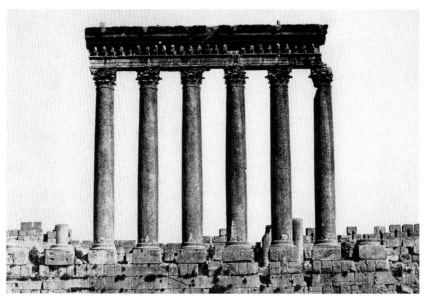

Pl. 8. Maxime du Camp, *Baalbek*, from *Égypte, Nubie, Palestine et Syrie, dessins photographiques recueillis pendant les années 1849, 1850 et 1851* (Gide et Baudry, 1852–3)

Pl. 9. Maxime du Camp, *Doums*, from *Égypte, Nubie, Palestine et Syrie, dessins photographiques recueillis pendant les années 1849, 1850 et 1851* (Gide et Baudry, 1852–3)

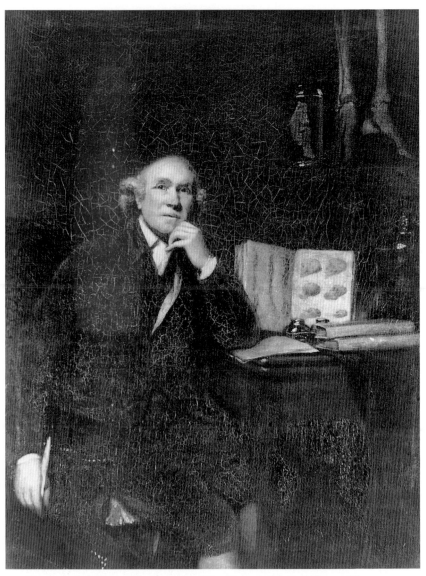

Pl. 10. Joshua Reynolds, *Portrait of Dr Hunter*, Royal College of Surgeons,
St Bartholomew's Hospital, London (the Courtauld Gallery, London)

5

Nature into Art:
Travel Descriptions and
Pictorialist Models

Description is the distinguishing feature of the travel account, according to Flaubert. When he writes to dissuade the young Ernest Feydeau from writing one, he does so on the grounds that Feydeau no longer needed to prove his descriptive talents.[1] Flaubert found travel to be a constant test for his descriptive techniques. His text is haunted by silence, to an extent that goes beyond the conventional rhetorical mode of preterition.[2] Certain landscapes reduce Flaubert to silence, just as we have seen that he is silenced by certain paintings: 'on ne saurait dire ce qui se passe en vous à de pareils spectacles' (*PC* 10: 336). The view from the Simplon pass in *Italie et Suisse* is only adumbrated, and then yields to a simple expression of the inability to express, which is no doubt expressive enough: 'Indescriptible! il faut rêver et se souvenir' (10: 379). In Palestine, in 1850, words fail him when he tries to communicate the exact colour of some rocks: 'Les notes ne peuvent, hélas! rien dire quant à la couleur des terrains qui souvent, quoique voisins et pareils, sont de couleurs toutes différentes; ainsi une montagne bleue, et une noire à côté, et pourtant ce n'est ni du bleu, ni du noir!' (10: 596).

[1] 'Je repousse absolument l'idée que tu as d'écrire ton voyage: 1° parce que c'est facile; 2° parce qu'un roman vaut mieux. As-tu besoin de prouver que tu sais faire des descriptions?' (*C3* 96). On Flaubert's descriptive technique in his travel accounts, see Bibliography for works by Bart, Parvi, and Daunais (1996). On the art of description in general, see P. Hamon's invaluable *La Description littéraire* (1991); and on the sociological implications of modes of description cf. T. Mitchell, *Colonizing Egypt* (Cambridge: CUP, 1988) and D. Gregory, 'Between the Book and the Lamp', *Trans. British Geographers* (1995). While Mitchell's negative view of Flaubert's attitude to Egypt is valid for the most conventional pictorialist descriptions in the *Voyage en Orient*, it hardly does justice to Flaubert's willingness to confront landscapes and scenes which are more resistant to the Western tradition, as I hope to show in this chapter.

[2] See Hamon, *Description*, 140–3 on the subject.

There are many other examples, some of them comic, as when Flaubert tries and fails to capture the best sunset he had ever seen, from the gates of Smyrna, and is reduced to something of the 'zut zut zut' of Proust's Marcel: 'les montagnes sont blondes de tous les blonds possibles, puis roses, rouges . . . O mon Dieu! mon Dieu! . . . !!! . . . ???' (11: 37). Somewhere between Megara and Corinth, the landscape arranges itself into something that strikes him as essentially 'antique', which makes him want both to make love to someone and to pray, 'mais dans quelle langue et par quelle formule?' (11: 92). Here the image defies description: 'ça restera pour moi comme des instants de soleil de ma vie. Pauvre chose que la plume, rien même que pour se rappeler cela!' (11: 93).

Description is even taboo. In *Pyrénées et Corse*, Flaubert embarks on what seems to be a perfectly neutral description of a ride through the forest of Marmano, and then stops short, as if forbidden to continue: 'Nous avons monté depuis le matin et nous entrons dans la forêt de Marmano. Le chemin est raide et va en zigzag à travers les sapins, dont le tronc a des lueurs du soleil qui pénètre à travers les branches supérieures et éclaire tout le pied de la forêt; l'air embaume de l'odeur du bois vert. Il ne faut pas écrire tout cela' (10: 335).

So description is impossible and description is taboo. But between the interdiction ('il ne faut pas', 10: 335) and the inability ('on ne saurait', 336) comes a magnificent evocation of the Tirrhenian sea, complete with a bemused spectator, struck dumb, gazing at the great white line on the horizon that signifies 'Italy': 'je suis resté une demi-heure sans remuer, et regardant comme un idiot la grande ligne blanche qui s'étendait à l'horizon' (10: 336).

This chapter will examine the various strategies by which Flaubert succeeds in turning nature into art. He does so, in the end, by a process of cannibalization, transforming nature into art before our very eyes, and, what is more, often into the most manifestly artificial of forms.

FLAUBERT AND THE PICTURESQUE

Flaubert's ambivalence with regard to the picturesque is evident from the first page of his first travel account, where he promises not to use the word *pittoresque* more than *six* times per page—a joke, but

suggesting unease: 'je ne me permettrai que six fois par page le mot *pittoresque* et une douzaine de fois celui d'*admirable*. Les voyageurs disent le premier à tous les tas de cailloux et le second à tous les bornes' (*PC* 10: 285). Flaubert in fact loathes the *pittoresque*, at any rate the kind of picturesque popularized in the travel writing and nature descriptions of the early years of the nineteenth century, and in particular in the immensely popular *Voyages pittoresques* produced (illustrated!) over many years by Nodier and Taylor. Later, in *Pyrénées et Corse*, a different but related target emerges. Unmoved by the picturesque beauty of the *canal du Midi*, Flaubert is moved to think of 'poésie descriptive': 'Il y a des gens qui trouvent cela superbe et qui se pâment en sensation pittoresque, cela m'ennuie comme la poésie descriptive' (10: 309). The maestro of descriptive poetry is Delille,[3] who will crop up in *Par les champs et par les grèves* as the butt of Flaubert's satire, for he is an important feature—literally!—in the landscaped garden of La Garenne in Nantes. Dating from 1798, this Romantic park is an illustration of what Flaubert calls the 'genre noble', with its temple of Vesta, its temple to friendship, and several artificial ruins and brooding rocks dotted about in strategic positions. The creator of the garden was a 'peintre de l'Empire' called Lemot, so the garden is an embodiment in three dimensions of the kind of landscape he paints. Nature, painting, and literature come together in this garden in a most contrived and literal-minded way, as the rocks, arranged as in a painting, are tagged with selected lines from the poetry of Delille, attached to the stone, as *légendes* were affixed to the *images de Cancale*. In La Garenne, the picturesque is packaged with the express intent to 'faire rêver' and inspire poetic descriptions: 'RUINES. Font rêver, et donnent de la poésie à un paysage' (*DIR*); 'SITE: Endroit pour faire des vers' (*DIR*).[4] Flaubert's horror of stasis and fixity is summed up in the concept of a 'site' such as this, set in stone, waiting to be admired, and transferred *tel quel* to the traveller's 'album' (such as is carried later by Frédéric Moreau), and finally fixed.

[3] See esp. Delille, *Les Jardins* (1780). See Hamon, *Description*, 63, on Delille as the main point of reference in discussions of the role of description. Elsewhere, Flaubert associates Delille with Gérôme, whom he also regarded as over-detailed, and whose painting he did not wish *Salammbô* to evoke (*C2* 749).

[4] Cf. *C1* 707—Constantinople turns out to be, despite all expectations, a *genuine* 'site'. Cf. also *BP*—Pécuchet and the children go off to 'chercher un site', complete with 'fixatifs'.

Flaubert also mocks the landscape painter, ever in search of the perfect *site*: 'Tu n'imagines pas la beauté de ce pays [. . .]. C'est à faire exprès le voyage. Que de sujets pour un pitre-paiysagête [. . .]. Les bords de l'Orne [. . .] sont on ne peut plus . . . *pittoresques*! (pardon du mot)' (C4 816). None the less, all the mocking and jokes do not prevent this particular 'pitre-paiysagête' from producing many remarkable 'paysages' of his own, and any number of ideas for others. Flaubert is a collector of landscapes, returning from the East with 'beaucoup de paysages de plus *dedans*' (C1 719). He is certainly no Delille, but great 'set-piece' landscapes do occur throughout the whole of his travel writing. He aims for variety. Thus, in *Pyrénées et Corse* there is at least one example each of lake scenery (p. 301), seascapes (one at midday (p. 323), the other at night (p. 344)), mountainscapes (pp. 306–7), a landscape in the evening light (p. 327), another by moonlight (pp. 334–5), and so on. *Par les champs* is written under the sign of the Barbizon school, which determines the persona adopted by Flaubert and Du Camp from the very first lines: the two travellers set out, as the new breed of landscape painters do, 'sac au dos, souliers ferrés aux pieds, gourdin en main, fumée aux lèvres et fantaisie en tête' (p. 82).[5] So successful is their disguise that they are in fact taken for landscape painters by a local policeman, as Du Camp relates— this is the origin of Flaubert's 'pitre-paiysagête':

Aux approches de Crozon, un gendarme bienveillant, après avoir lu nos passeports, nous dit: 'Je sais ce que vous faites; j'ai déjà vu un monsieur qui voyageait comme vous avec le sac sur le dos et un grand parapluie; il tirait en portrait les grottes de Morgat; j'ai voulu savoir quel était son métier; je lui ai demandé ses papiers, et j'ai vu qu'il était "pénitre passagète [*sic*]".'[6]

Par les champs too boasts a great many 'set-piece' landscapes, experimenting now also with descriptions of the same landscape seen at different times, in different conditions. This too was fairly common practice at the time, and was to become a favourite technique with the Impressionists. One of the most successful demonstrations occurs in *Par les champs*, in the evocation of the beach at Cancale, which contrasts all the languor of low tide with the exhilarating

[5] Cf. Zola: 'Nos paysagistes partent dès l'aube, la boîte sur le dos [. . .] choisissant à peine leurs motifs', *Salons* (1959), 134.

[6] *Souvenirs littéraires* (1994), 253–4.

briskness of the same scene at high water (and sets both off triumphantly against the awfulness of the *images de Cancale: PCG* 596–602).

Another well-tried technique is to name painters as models for particular landscapes. Flaubert rarely does this. When he does, it serves to add a dimension to the scene, or provide what Brooks calls an 'aesthetic guarantor', or, sometimes, to make a joke or point up some incongruity.[7] However, Flaubert does frequently present landscapes and views within a frame, and this too is a time-honoured tradition. We witness him registering the usefulness of a frame for the first time in 1845, in *Italie et Suisse*. Flaubert notes the careful engineering of painting-like views framed in greenery, as a feature of the beautifully landscaped garden of the villa Serbelloni by Lake Como: 'Grotte d'où l'on voit deux points de vue divers encadrés dans la verdure' (10: 378).[8] Thereafter Flaubert reproduces this device frequently, presenting scenes framed through a bridge, a window, or vegetation. The frame adds pleasure and depth, as he explains himself: 'Rien n'est joli comme la campagne vue dans l'encadrement d'une arche d'un de ces ponts ou d'un aqueduc, surtout quand passent dessous des chameaux ou des mulets' (10: 556). A letter from Flaubert to his mother makes the point explicitly that this is a *picture* ('tableau') and that that is precisely the source of the pleasure: 'Il y a de temps à autre des ponts bossus, jetés sur des ravins desséchés, qui font mon bonheur, surtout quand une bande de voyageurs, chameaux et Bédouins, arrive à passer dessous,—ça fait un grand tableau de verdure dans un petit cadre de pierre' (*C1* 662).[9] Sometimes the frame surrounds a more or less conventional picturesque view, as in this particularly well organized if rather empty

[7] Cf. *PC* 10: 287: bullock drays resemble a Léopold Robert. A landscape looks like a Salvator Rosa (*IS* 10: 357) or a Poussin (*IS* 10: 370); a woman listening to a concert has a 'profil à l'Esméralda' (10: 371); a woman selling bearskins in a shop in Geneva resembles an engraving from Flaubert's copy of the marquis de Sade, 'sauf l'animation toutefois' (10: 384); in *PCG* 281–2, 308, a ragged postman on a horse evokes the names of Callot and of Bellangé; elsewhere, a scene on a boat resembles a Veronese (*C1* 694); a woman drawing water from a well resembles a Mignard (*VO* 10: 581); a landscape is 'comme dans les tableaux de Poussin, pays vraiment fait pour la peinture et qui semble même fait d'après elle' (*VO* 10: 607); the woman who is the subject of 'Rencontre' evokes the paintings of Ingres and Lehmann (11: 157); a sunset is 'un vrai Claude Lorrain' (15: 408).

[8] See also the 'paradis terrestre' of Isola Madre, slightly later: 'deux percées encadrées de verdure et voyant le lac' (10: 378).

[9] For other examples, see *PCG* 477; *VE* 267–8, 307; *VO* 11: 27.

view from the Elephantine Island: 'une grande prairie verte s'étendait devant nous, entre des dattiers qui l'encadraient, et au loin le Nil brillait dans la découpure inégale des rochers de granit qu'il traverse' (*C1* 598). At other times, both the frame and the view are more original, as in the tiny 'snapshot' image which Flaubert captures as he leaves the Mont Saint-Michel, looking through the little rear window of his cab: 'j'ai appliqué mon œil à la petite lucarne qui est au fond des voitures, et j'ai dit adieu au Mont Saint-Michel' (*PCG* 617). Flaubert subverts normal practice entirely, however, when he makes his frame capture pure absence, empty sky framed in a window. This is to capture 'l'infini dans le fini', as Baudelaire put it.[10] The empty rectangle draws the eye away, a *tentation* as powerful as can be provided by any horizon, path, vehicle, or touch of blue sea: 'des baies carrées de grandeur et d'alignement inégales, laissaient éclater à travers leurs barreaux croisés, le bleu vif du ciel qui tirait l'œil' (*PCG* 188). It is a motif which occurs again and again.

Flaubert also favours the metaphysical landscape, which of course was immensely popular at that time. He loves horizons ('Laissez s'en aller mes yeux vers tous les horizons', *PCG* 296). The desert, the sea, or the sky often figure in Flaubert's landscapes as the sign of the *ailleurs*. In a strange phrase in the following example, the desert 'vous persécute dans les horizons' and mocks the neatly laid out gardens in the foreground, with their little yearning Madame Bovary figure:

ces jardins sont d'un aspect atrocement triste, on y crève d'ennui—le désert est là derrière, ça semble vouloir le nier et il vous persécute dans les horizons—au jardin d'Abbas-pacha, colonnes au pavillon—premier plan: verdure, le désert au bout. C'est bien là le jardin d'où, dans son pavillon, la sultane voit venir au loin un dromadaire qui galope à toutes jambes, elle jette un regard triste sur l'horizon sans bornes . . . (*VE* 447)[11]

[10] Baudelaire, 'Salon de 1859', *Critique d'art* (1992), 296. Baudelaire regards this technique of framing of the infinite as a new effect in painting, cf. 'Salon de 1845', *Critique d'art*, 52; but the Goncourts see it already in Watteau: 'Watteau a fait une nature plus belle que la nature [. . .]. Watteau la doit, cette victoire, au poète dont est doublé le peintre. Regardez, dans tous ces dessous de bois, ces berceaux, ces bocages, dans toute cette ombre feuillue, regardez les trous, les jours, les percées, qui mènent toujours l'œil à du ciel, à des perspectives, à des horizons, à du lointain, à de l'infini, à de l'espace lumineux et vide qui fait rêver [. . .] c'est la poésie du peintre-poète, poésie avec laquelle il *surnaturalise*, pour ainsi dire, le coin de terre que son pinceau peint', *L'Art du XVIIIᵉ siècle*, 1st ser. [1881], 62–3.

[11] Cf. M. Praz, *Mnemosyne* (1970), 159, citing Zeitler on the dualistic nature of early 19th-cent. paintings which combine an everyday subject in the foreground with

One of the great pre-Impressionist landscapes of *Par les champs* gives a view of hills and cornfields picked out in patches of colour, and above them, through the mist, in the sky, just a blue arabesque as the sign of the sea:

Dans l'écartement de deux vallons, elle [la campagne] développait sa verte étendue sillonnée en balafres noires par les lignes capricieuses des haies, tachée çà et là par le massif d'un bois, enluminée par des bouquets d'ajoncs, ou blanchie par quelque champ cultivé au bord des prairies qui remontaient lentement vers les collines et se perdaient dans l'horizon. Au-dessus d'elles, bien loin à travers la brume, dans un trou du ciel, apparaissait un méandre bleu, c'était la mer. (*PCG* 389)

Flaubert adapts the metaphysical landscape to incorporate more everyday motifs. Everyday objects such as vehicles (the 'Hirondelle' for Emma), sails, or paths take the eye and are a focus for desire. A view of the Loire adapts the conventionally picturesque to poetico-metaphysical ends, with the final touch of two brilliant sails connoting movement towards some other place: 'deux voiles éclatant de blancheur au soleil'.[12]

Not all of Flaubert's traditional landscapes are 'finished', of course. There are also any number of ideas for landscapes, sketched in quickly as in a painter's notebook. His evocation of the harbour of Cannes (10: 362) is beautiful in its concision, consisting of just a few lines and shapes: 'Port de mer exquis, en demi-lune allongée; voilure triangulaire, le grand mat, simple, mis de côté'. The *Corniche* is reduced to two simple colours, white on blue ('pif paf', as Pellerin would say, 3: 144): 'Sur le chemin, deux teintes: les rochers blancs, presque à pic, et la mer toute bleue qui brille au soleil' (10: 364).

In the early days particularly, landscape is quite an orderly affair, all transitions gracefully managed, a delicate balance of contrasts and similarities which bears a remarkable resemblance to the idea behind the aesthetic of the first *Éducation sentimentale*: 'A gauche, en sortant, grande montagne, prairies au bas, puis au milieu neige et rochers, nue au sommet. C'est un spécimen de l'art du grand artiste. Comme tous les tons sont fondus et comme toutes

a glimpse of something mysterious in the background: 'A foreground formed by everyday circumstances [. . .] serves as a runway for a yearning, a dream, which is projected into a distance full of mystery, a magical beyond' (such as the sight of a faraway ship, or a view through a window).

[12] For tracks performing the same function, see *PCG* 389 and *VE* 407.

les transitions sont ménagées, rien de disparate quoique rien de pareil' (*IS* 10: 380). Landscapes come ready-made, not through the awkward randomness of the 'open window', but at certain moments, when the conditions are right. Nature gathers itself together into a perfect shape, just for a moment ('composition toute faite, moment juste'). This kind of landscape persists through to the *Voyage en Orient* and beyond: 'Le moulin, chameaux, bouquets, odeur, bruit de l'eau, premiers plans et horizons (composition toute faite, moment juste) et, sous une avancée de toit, une femme que je vois de loin . . .' (*VO* 10: 596, Palestine). The pictorial reference is even more explicit in the following example: 'bouquets de palmiers entourés de petits murs circulaires, au pied d'un desquels fumaient deux Turcs—c'était comme une gravure une vue de l'Orient dans un livre' (*VE* 303).[13]

But already in *Pyrénées et Corse* there is a sense of Flaubert's impatience with the old models, however brilliantly he could produce them and ring the changes. The desire to carve out an original territory for himself and his descriptions is already apparent.

First, Flaubert's pictorial models are not by any means only the obvious ones, such as Poussin or Salvator Rosa. Some scenes resemble illustrations from books: boats on Lake Como 'freeze' into a keepsake illustration and thus become even more attractively elusive (10: 377); a particular landscape is charming because it is a 'paysage de romans de chevaliers' (11: 29); the Seraglio garden in Constantinople looks so much like 'gravures anciennes' of oriental gardens that it must surely have been created by some early ambassador (11: 42). Trees growing by the Erdre similarly evoke a seventeenth-century engraving; no actual trees are ever actually *described*, whether real or painted; they are named and then simply evoked through pictorial associations ('non le bois intrinsèque et

[13] Cf. also 10: 602 (the cedars of Lebanon): 'comme bouquet et imprévu dans la composition, ils sont là d'un bel effet'. Cf. also P. Danger on this effect: 'c'est la nature qui d'elle-même s'arrange et s'équilibre en œuvre d'art, effet particulièrement rare [. . .], le propre de la nature étant justement de n'être pas "cadrée" mais infinie et de ne répondre, généralement, à aucune cohérence perceptible au regard humain' (*Sensations et objets dans le roman de Flaubert* (A. Colin, 1973), 112–13). In Flaubert, however, the effect is less rare than Danger says. Cf. Gautier, quoted J. Roos, in *Atti del quinto congresso* (1951), 391: 'J'ai éprouvé assez souvent une sensation singulière en face de la réalité, le paysage véritable m'a paru peint et n'être, apres tout, qu'une imitation maladroite de Cabat ou de Ruysdael.'

dense des arbres', as Mallarmé was to say[14]): 'de jolis aspects des arbres dans le goût des vieilles gravures XVIIe siècle où on voit un homme pêcher à la ligne en culotte courte, en chemise bouffante au nombril tandis qu'à côté de lui une bergère arrange des fleurs dans son tablier et qu'un chien est couché à plat ventre sur le foin' (*PCG* 680). This is the art of the stage set. It is often evoked. The next example shows Flaubert erasing all overt pictorial reference, leaving only an aura of the pictorial behind, in the language of his text.[15] The original note, however, makes the pictorial reference explicit—these trees are 'arbres de théâtre': 'une allée de vieux ormeaux à tronc large, à branches diffuses, ces vrais arbres 18e siècle arbres de théâtre sous lesquels les fillettes dansent au son du violon' (*Carnet de voyage*, *PCG* 669). In the final version, the reader senses artifice, painting, and theatricality indirectly, through a certain stylization in the writing:

vrais ormeaux XVIIIe siècle; poussés larges pour qu'on danse dessous au son du violon du ménétrier, qui monté sur une barrique, bat la mesure de son pied sonore, pendant que les cottes volent au vent, que les boucles poudrées se dénouent, et que les garçons prennent la taille aux fillettes qui en rient d'effroi, et s'en pâment de plaisir. (*PCG* 90)[16]

The two previous examples are characteristic of Flaubert's way with paintings—he likes them to recede by some means or other until they become just remnants of a dream. In another passage still, Flaubert attributes the charm of certain scenes to their obscure oneirism—they seem to recall pictures but pictures seen a long time ago, 'dont on a oublié les noms', and which have left behind them only a 'lambeau de songe':

Nous apercevons bientôt le village de Topolia, à mi-côte; devant lui, un rocher vert, à petits carrés longitudinaux, comme de grandes marqueteries; un bois d'oliviers dominé par les hautes pentes des montagnes. Tout

[14] Mallarmé, *Œuvres complètes* (Pléiade, 1945), 365–6.

[15] R. Debray Genette (*Métamorphoses du récit* (1988), 243–4) contrasts Du Camp's unsubtle evocation of the painting of Metsu at Morlaix (ch. 10), 'ce tableau resssemble à Morlaix', with Flaubert's infinitely more subtle procedures, which throw all the weight on to the writing. Debray Genette's point, that in the case of Flaubert 'c'est l'écriture qui fait advenir la peinture [. . .] l'aquatique suscite l'aquarelle' is valid, but her conclusion—that Flaubert's writing is not pictorialist—is too sweeping.

[16] This scene reappears in *MB nv* 527 as the subject of an old print in the hotel room where Emma and Léon have their meetings.

cela a quelque chose de déjà vu, on le retrouve, il vous semble qu'on se rappelle de très vieux souvenirs. Sont-ce ceux de tableaux dont on a oublié les noms et que l'on aurait vus dans son enfance, ayant à peine les yeux ouverts [. . .]. C'est comme un lambeau de songe qui vous repasse dans l'esprit. (*VO* 11: 69)

Elsewhere, Flaubert does all he can to disrupt conventional pictorial models. Potentially static landscapes become dynamic and active, for example. He counteracts the conventional descriptive emphasis on the visual by supplying sound, often of a quite disruptive, discordant kind,[17] and will also frequently shroud a scene in layers of mist and vapours.[18] One of his earliest techniques was to make the 'view' implicate the viewer and draw him into the frame: a picturesque waterfall drenches its admirers in a penetrating 'poussière d'eau' (10: 302), blinding white walls of snow light their way (p. 302), rocks cut like knives (p. 307). Sometimes, the landscape seems to come alive and move;[19] or successive changes of viewpoint make 'le même tableau' open out to become three-dimensional (this is the art of the 'stéréoscope' to which Flaubert's writing was often compared by contemporaries): 'La route [. . .] suit toutes les ondulations et fait souvent des coudes sur les flancs du maquis, de sorte que la vue change sans cesse et que le même tableau montre graduellement toutes ses parties et se déploie avec toutes ses couleurs, ses nuances de ton et tous les caprices de son terrain accidenté' (10: 322).[20] Stasis is frequently traded for 'kinema' in this way.[21] The mark of the 'vraie beauté' of the château de Clisson (in *Par les champs*), as opposed to the fixed beauties of La Garenne, is the way it draws the spectator in, 'on s'avance, on s'en va . . .'.

[17] Cf. *PCG* 188 (windmill), 610 (loom), *ES2* 3: 318 (creaking chain). Cf. Goncourts, *Journal*, ii. 1080 (8 June 1884): where Gautier's descriptions were purely visual, Fromentin incorporated auditive effects, and Zola and Loti supplied the olfactory as well. But Flaubert was first in fact.

[18] This happens frequently in *PC*, *passim*. For later instances, cf. *VE* 365–6, *VO* 10: 575. For one of the strangest cf. *VE* 216–17: 'les premiers plans sont tout violets, les cailloux brillent, baignés littéralement dans de la couleur violette: on dirait que c'est une de ces eaux si transparentes qu'on ne les voit pas, et les cailloux entourés de cette lumière glacée, sur elle ont l'air métallique et brillent'.

[19] Cf. e.g. 11: 63: 'On monte encore, et voici que s'ouvre devant vous un grand flot de terrain qui se courbe avec rapidité, se relève devant vous un peu sur la droite, et va s'écouler tout à fait à droite [. . .]. A gauche, mouvement grandiose [. . .]; larges pelouses qui descendent'.

[20] Cf. *C1* 74: 9 Oct. 1840, 'le paysage change comme un tableau à vue'.

[21] Cf. T. Brownlow, *John Clare and Picturesque Landscape* (1983), 228, on the poetry of landscapes which depend on movement, 'kinema'.

Description thereby becomes, in Gracq's term, *chemin*, a starting-point for narrative.[22] As his descriptive techniques develop, Flaubert is more and more inclined to break up the view—presenting it through gaps in fences is one of his favourite techniques, and, in a delightful passage in *Par les champs*, he presents the view from a moving cab as a series of disjunctive 'frames' as the hood of the ancient, disreputable vehicle closes and opens, closes and opens of its own accord (*PCG* 404).

The grand landscape, the great set-piece, begins to yield, also, to the more approachable *image d'Épinal*. A visit to a stud-farm is a 'tableau tout fait', a little cartoon-image with splashes of red, incorporating himself and Du Camp as internal viewers: 'Haras—effet de l'homme à côté des animaux [. . .]—vestes rouges des garçons—l'agent comptable les paysans—nous autres. c'était un tableau tout fait. Mais où n'y a-t-il pas de tableaux tout faits. il s'agit de les voir' (*PCG* 714). These little images become more and more frequent in Flaubert's text, and are often very charming. In Egypt, out shooting by moonlight (unsuccessfully), the two travellers become a cartoon-image, two incongruous faces in a great waste of desert: 'Le soir nous passons de l'autre côté du Nil pour aller tuer des spatules, que nous manquons—immense étendue de sable plate—la lune dessus—nos deux balles côte à côte' (*VE* 366).

It is the *Voyage en Orient*, however, that is the real test for Flaubert's pictorialist techniques. Flaubert was confronted with exactly the same difficulties as painters of his time: how to find a form to accommodate the landscapes of the Near East and could they even be called 'landscapes' as such? Colours and light seemed absolutely new; and notions of the picturesque were quite out of place in the desert.[23] As Flaubert drifted down the Nile in the dreamy way that so irritated Du Camp, images floated past him in a very *un*-pictorialist way, in the form of fragments only, mixed with

[22] 'Tout grand paysage est une invitation à le posséder par la marche', Julien Gracq, *En lisant, en écrivant* (José Corti, 1980), 13–15, quoted Hamon, *Description*, 181. Daunais, *L'Art de la mesure*, argues the same point, cf. e.g. p. 61 on 'l'expansion de l'image dans le récit'.

[23] Cf. M. A. Stevens (ed.), *The Orientalists* (1984), 19: 'many painters faced the need to modify their artistic conventions, which they brought with them from Europe, such as the Picturesque approach to landscape and the established means for notating light and colour'. See also Fromentin on how European ideas of landscape painting were challenged in the Near East (*Une année dans le Sahel* (1858; 1981), 174–5, 177).

sounds: 'On vit dans une torpeur parfumée, dans une sorte d'état somnolent, où il vous passe sous les yeux des changements de décors, et à l'oreille des mélodies subites, bruits du vent, roulement des torrents, clochettes des troupeaux' (*C1* 741).[24] Flaubert had tried his hand at the evocation of mists and vapours before, many times; but how to handle the *mirage*, which no painter had yet attempted?[25]

Landscapes now are not just dynamic or uncomfortable but can induce a state of holy terror, like this one at Delphi:

Avoir choisi Delphes pour y mettre la Pythie est un coup de génie. C'est un paysage à terreurs religieuses, vallée étroite entre deux montagnes presque à pic, le fond plein d'oliviers noirs, les montagnes rouges et vertes, le tout garni de précipices, avec la mer au fond et un horizon de montagnes couvertes de neige. (*C1* 751)

This is not an example of the pathetic fallacy at work. Nature in Flaubert is often frightening, precisely because humans do not count for anything. In the following example, of sunset in the desert, stasis and silence are pushed to the limits of the tolerable, and the few human and animal figures do nothing to break the tension:

Des nuages d'or, semblables à des divans de satin—le ciel est plein de teintes bleuâtres gorge-de-pigeon—le soleil se couche dans le désert—à gauche, la chaîne arabique avec ses échancrures—elle est plate par son sommet, c'est un plateau—au premier plan, des palmiers, et ce premier plan est baigné dans la teinte noire. Au deuxième plan, au-delà des palmiers, des chameaux qui passent—deux ou trois Arabes vont sur des ânes—quel silence!—pas un bruit—de grandes grèves et du soleil! le paysage ainsi peut arriver à devenir terrible—le Sphinx a quelque chose de cet effet. (*VE* 258)

At such a pitch of intensity, content and colour empty out: 'Je reviens à la tente tout seul, par le désert et derrière les montagnes—silence —silence—silence—la lumière tombe d'aplomb—elle a une trans-parence noire—je marche sur les petits cailloux, la tête baissée—le soleil me mord le crâne' (*VE* 320).

There are no pictorialist models now. Even a conventional group is problematic in this light and in this place: 'quel charmant groupe

[24] See Emma's fantasies of travel, 1: 223.
[25] Guillaumet did actually paint a mirage in 'Le Désert', shown at the *Salon* of 1857, see reproduction in Stevens, *Orientalists*, no. 67.

un peintre eût fait avec ces deux têtes et le paysage à l'entour! mais où trouver le peintre? et comment composer le groupe?' (*VE* 435). Painters are timorous creatures. Flaubert's own vision takes him far beyond what contemporary painters dare to paint. He makes the point explicitly when he writes about the ruins of Baalbek:

La couleur des ruines de Baalbeck est magnifique, quelques colonnes sont devenues presque rouges; tantôt à midi, en arrivant, une partie de frise, couronnant les six grandes colonnes debout, m'a semblé un lingot d'or ciselé. Voilà un paysage historique comme aucun peintre que je sache n'en a encore fait; rien n'y manque, ni la ruine, ni les montagnes, ni le pâtre, ni l'eau qui coule et dont j'entends le bruit maintenant. (*VO* 10: 597)

Writing to his mother, he reduces this impression to the minimum, isolating the columns and the light (which is now the light of his memory too), but bringing in other, non-visual details to create an extremely atmospheric description (Pl. 8):

Quant au temple de Baalbek, je ne croyais pas qu'on pût être amoureux d'une colonnade: c'est pourtant vrai. Il faut dire que cette colonnade a l'air d'être en vermeil ciselé, à cause de la couleur des pierres et du soleil. De temps à autre, un grand oiseau qui passe en battant dans l'air bleu ses ailes silencieuses; l'ombre de son corps ovale se dessine un instant sur les pierres et glisse dessus; puis rien, du vent, et le silence. Çà et là, dans l'air, quelques mèches de coton arrachées aux grands chardons des ruines, et qui voltigent comme du vent. (*C1* 696)[26]

Colours escape definition, as in this landscape on the way to the Dead Sea: 'au fond, les montagnes passant, suivant que la lumière marche, par toutes les teintes possibles de ce que je ne peux appeler autrement que du bleu' (*VO* 10: 574). No painter would dare to paint the colours of the surface of the Red Sea, for fear of appearing to exaggerate:

Jamais je n'oublierai cette matinée là. J'en ai été remué comme d'une aventure. Le fond de l'eau était plus varié de couleurs, à cause de toutes ses coquilles, coquillages, madrépores, coraux, etc., que ne l'est au printemps une prairie couverte de primevères. Quant à la couleur de la surface de la mer, toutes les teintes possibles y passaient, y chatoyaient, se dégradaient de l'une sur l'autre, s'y fondaient ensemble depuis le chocolat jusqu'à l'améthyste, depuis le rose jusqu'au lapis-lazuli et au vert le plus pâle. C'était

[26] Something of the beauty and simplicity of this colonnade is caught in Du Camp's photograph 121, 'colonnade du temple du Soleil' (Pl. 8).

inouï, et si j'avais été peintre, j'aurais été rudement embêté en songeant com-
bien la reproduction de cette vérité (en admettant que ce fût possible) paraî-
trait fausse. (*C1* 637)

Flaubert mockingly thrusts the marvellously coloured heap of
rotting entrails at the slaughter-house in Jerusalem in the faces of
all colourists everywhere: an 'arsenal de tons chauds à l'usage des
coloristes' (*C1* 665). At the leper colony in Damascus, training his
lorgnon in order to try to decide whether the green shreds hanging
from a man's arms are rags or hands, Flaubert reflects once more
on the pusillanimity of painters: 'O coloristes, où êtes-vous donc?
quels imbéciles que les peintres!' (*C1* 683)

Flaubert constantly sees nature in the East as being already like
art, but an art unlike any other, or, at least, unlike the institution-
alized art of his time. If he continually evokes stage scenery, it is
because of the boldness of its colours and its fragility (the sense of
a precarious, special moment) and also the sense of expectancy which
a stage set generates, the feeling that something is about to happen,
some mystery or ritual. One of Flaubert's best moments in Egypt
was when the evening light transformed nature and turned it into
a stage set, with himself and Du Camp becoming, briefly, part of
this strange other world, 'une autre nature' (Pl. 9). He tells the story
twice:

Comme Nature, ce que j'ai encore vu de mieux, ce sont les environs de
Thèbes [. . .]. Un soir, dans les environs de Denderah, nous avons fait une
promenade sous les dooms (= palmier de Thèbes); les montagnes étaient
lie de vin, le Nil bleu, le ciel outre-mer et les verdures d'un vert livide; tout
était immobile; ça avait l'air d'un paysage peint, d'un immense décor de
théâtre fait exprès pour nous. Quelques bons Turcs fumaient au pied des
arbres avec leurs turbans et leurs longues pipes.—Nous marchions entre
les arbres. (*C1* 608: 13 Mar. 1850)

palmiers doums: cet arbre fait penser à un arbre peint—petit bois à tourn-
ure avec des hommes en robe bleue assis au pied fumant leurs pipes—au
coucher du soleil la verdure devient archi-verte (on entre dans une autre
nature—le caractère agricole de l'Égypte disparaît)—la chaîne arabique est
lie-de-vin, tout le paysage énorme. (*VE* 269–70)[27]

At other times, nature produces effects stranger than any known
art form has produced, institutional or otherwise, and here we see

[27] Cf. also *VO* 11: 68—a room in an inn in Delphi is compared to a stage set for
a 'drame allemand'.

the truth of Flaubert's claim that 'en fait de paysages, j'opère moi-même'. He chooses to describe strange effects of light from very early.[28] The first example comes in *Pyrénées et Corse*. At the highest point of the mountains at the port de Venasque, the clouds from the gorges below are blown up towards the travellers by the wind, and the sunlight filtering through these clouds gives each of the people present a kind of halo: 'et quand ils nous ont entourés, le soleil qui les traversait comme à travers un tamis blanc fit à chacun de nous une auréole qui couronnait notre ombre et marchait à nos côtés' (10: 307). Light penetrates substances ('la lumière liquide paraît pénétrer la surface des choses et entrer dedans', *VE* 201), or becomes substance itself, a mass of fine snow: 'Entre les gorges une poussière de lumière comme de la neige éthérée qui se tiendrait en l'air immobile et en serait pénétrée' (*VO* 10: 552). Light, like Flaubert's writing, transforms nature into a wonderfully strange work of art: 'je ne sais comment la lumière s'arrangeait, mais, frappant sur les parois blanchâtres de la route, ça faisait du rose, de grandes nappes indistinctes, plus vives à la base, et qui allaient s'apâlissant à mesure qu'elles montaient sur la roche. Il y a eu un moment où tout m'a semblé palpiter dans une atmosphère rose' (*VO* 10: 573).

Light turns nature into what, for Flaubert, it already really is— an artist's studio: 'La lumière tranquille, tombant d'aplomb et d'en haut comme celle d'un atelier, donnait aux rochers et à tout le paysage quelque chose de la statuaire, sourire éternel analogue à celui des statues' (11: 63).[29] The light from the setting sun turns trees into pillars (11: 39). Light creates new forms, a heightened reality, as at the beginning of a nervous attack, casting a weird light on Flaubert's companions, who seem to be standing against a black background, every detail crystal clear, and pouring a soft blue liquid over the green of the grass: 'La lumière, tombant de ma droite

[28] Cf. Stevens, *Orientalists*, 20, on the painter Belly's 'concern with capturing strange light'.

[29] Cf. *VE* 219: 'promenade au coucher du soleil dans les bois de palmiers, leur ombre s'étend sur l'herbe verte comme les colonnes devaient faire autrefois sur les grandes dalles disparues—le palmier, arbre architectural—tout en Égypte semble fait pour l'architecture: plans des terrains, végétations, anatomies humaines, lignes de l'horizon'; *C1* 728: 'Jamais je n'oublierai ces vieilles montagnes de Bithynie, toutes blanches, et la lumière qui les éclairait, si froide et si immobile qu'elle semblait factice'; *C1* 751 (Gulf of Corinth): 'La nature avait tout fait pour ces gens-là, langue, paysage, anatomies et soleils, jusqu'à la forme des montagnes, qui est comme sculptée et a des lignes architecturales plus que partout ailleurs.'

et presque d'aplomb, éclaire étrangement François et Max à ma gauche, qui se détachent sur un fond noir; je vois chaque petit détail de leur figure très nettement; elle tombe sur l'herbe verte et a l'air d'épancher sur elle un fluide doux et reposé, de couleur bleue distillée' (11: 95). Falling onto an already strange image, light makes it even stranger: 'Dans la petite pièce du fond après le couloir de droite, trou dans l'angle droit—un large rayon de soleil passait, dans lequel tournoyait de la poussière—la lumière allait frapper un œil surmonté d'un vase et éclairait les figures bleues et rouges' (*VE* 311). Like the artistic vision, light can invert, subvert, turn black into white and overturn received ways of seeing:

de loin un rocher noir, brillant au soleil, me fait l'effet d'un Nubien en chemise blanche, posté en vigie, ou d'un morceau de linge blanc qui sèche—comment ce qui est noir peut-il ainsi arriver à paraître blanc? c'est quand le soleil éclaire le tranchant d'un angle—j'ai plusieurs fois observé ce même effet, et Gibert m'a dit, à Rome, l'avoir remarqué également. (*VE* 319)[30]

Even the ancient literary and pictorial topos of sunsets acquires a new status in Flaubert's hands. In the following example, the setting sun creates a Rimbaud-like vision of pale green lakes in the sky, with white palm trees spraying out like fountains, and pink mountains. Flaubert ends this astonishing evocation by wondering what life would be like if palm trees were 'really' as white as bunches of ostrich plumes (one imagines the answer would be that it would be rather like a stage set for *Le Château des cœurs*):

hommes en silhouette, au milieu des gazis et des palmiers—grandes bandes vermillon dans le ciel—des lacs vert pâle se fondent dans le bleu du ciel—les palmiers s'irradient par gerbes, comme des fontaines—à mesure que vient la nuit, ils foncent de ton—quelques voiles sur le Nil—les montagnes basses du côté du Levant sont roses.

Que serait une forêt où les palmiers seraient blancs comme des bouquets de plumes d'autruches? (*VE* 354–5)

Colour is half in the object, half in the seeing subject, as Flaubert said. Flaubert's way of seeing is unique. It anticipates the strange,

[30] Cf. *VE* 320: 'la lumière tombe d'aplomb—elle a une transparence noire'. Biasi's note, *VE* 319, calls this process a 'métamorphose sensorielle' and regards it as a *mise en abyme* of Flaubert's artistic vision, which reverses the usual order of things ('Le sujet mériterait une étude approfondie et systématique sur la totalité du corpus'). Cf. also J.-P. Richard, cited by Biasi, who in turn cites the Goncourts citing Flaubert: 'Ce marbre est blanc, trop blanc, s'écrie Flaubert enthousiasmé, il est noir comme de l'ébène.'

bright visions of Rimbaud, and recalls both the weirdly coloured images he created from the illustrations in his childhood books and the images he received through the stained-glass vision of his adolescence. Flaubert's obsession with colour creates many new and unusual images. Many landscapes consist simply of blocks of crude colour juxtaposed.[31] In the following example, pink sky is juxtaposed to black earth, and a blue and pink river carries a boat which is made strange by foreshortening and is all black: 'au soleil couchant le Nil est tout plat, le ciel rose, la terre noire—sur le bleu du fleuve, une teinte rosée, reflet du ciel—devant nous, en plein raccourci, arrive une cange—les marins rament en chantant—toute noire dans la lumière qui l'entoure—elle aborde près de nous' (*VE* 263). One of the most haunting images of all resembles a scene from one of the many wall-paintings Flaubert had been seeing—the little green lake by Karnak in the evening sun, with its golden boat and golden men and the figure of Maxime to bring it nearer home: 'petite mare verte où toutes les nuits navigue une cange d'or avec des hommes d'or—le bord est piqué de joncs pointus, piquants—Maxime s'y baigne—aspect de son corps nu, debout—sur les bords' (*VE* 382).

While in terms of structure and composition Flaubert's landscapes do often conform to the typical European landscape, their content is often very strange, as in the following example. Flaubert's mechanical logging of the various elements of the landscape should not obscure the fact that something very bizarre is actually being logged: palm trees are jets of green liquid, there is a lawn of 'very green' barley, houses look like rocks which have fallen from the mountains, and there is the final focus on the tiny detail of the red leaves of the cotton, with the cotton balls just beginning to open:

Entre ces grands palmiers, qui sont au premier plan, et un bouquet d'autres palmiers plus petits et dont les branches retombaient en courbes molles, comme eussent fait des jets de liquides verts, on voyait le Nil—après

[31] Cf. e.g. *VE* 308: 'Au coucher du soleil, le ciel s'est divisé en deux parties. Ce qui touchait à l'horizon était bleu pâle, bleu tendre, tandis qu'au-dessus de nos têtes [et] dans toute sa largeur, c'était un immense rideau pourpre à trois plis—un, deux, trois—derrière moi et sur les côtés, le ciel était comme balayé par de petits nuages blancs, allongés en forme de grèves—il avait eu cet aspect toute la journée—la rive à ma gauche était toute noire. Le grand rideau vermeil s'est décomposé en petits monticules d'or ou moutonnés—c'était comme tamponné par petites masses régulières —le Nil, rougi par la réflexion du ciel, est devenu couleur sirop de groseille. Puis, comme si le vent eût poussé tout cela, la couleur du ciel s'est retirée à gauche, du côté de l'Occident, et les ténèbres sont descendues.

le Nil, qui entrait là dans les terres, au troisième plan, s'avançait une demi-lune de grands palmiers—après eux, une grande pelouse d'orge, très verte, qui allait jusqu'à la montagne au pied de laquelle est le village. Ses maisons grises confondent avec elle leur ton, et comme ces maisons sont carrées, il semble que ce ne soit que quelques grosses pierres des assises inférieures de la montagne. Entre les premiers palmiers et le Nil (entre le premier et le second plan) il y avait deux petits carrés de cotonniers dont les feuilles sont rouges—rouillées par place—des coques de coton commençaient à s'ouvrir. (*VE* 305–6)

Some landscapes look as if they are made out of a combination of minerals—gold dust, ebony, and ink. Sunset produces a crop of mineralizations, as in the following example, where trees are drawn in black crayon, hills are heaps of gold dust, black streaks in the sand are made of ebony, and the gold is the gold of old coins: 'Au coucher du soleil, les arbres ont l'air faits au crayon noir et les collines de sable semblent être de poudre d'or. De place en place elles ont des raies noires minces (traînées de terre, ou plis du vent) qui font des lignes d'ébène sur ce fond d'or—or comme celui des vieux sequins' (*VE* 293). Some landscapes are geometric shapes in metal (10: 574); an evening sky is vermilion with clouds like fishbones and sand made of ink, while the Nile is molten steel (*VE* 179–80). Some are like tiny artefacts or a child's toy: striations in a mountain are reduced to the scale of stones cut in half (*VE* 273); rocks are like lumps of coal (*VE* 301, 317). Knowing Flaubert's tastes, Du Camp makes him a landscape in yoghurt (*VE* 399). It is this miniaturizing effect that Flaubert himself creates in his little *images d'Épinal*, when he suddenly takes a long view, as of the stud-farm in *Par les champs* or of himself and Du Camp hunting by the Nile. In all cases, we witness a sudden focusing, a freezing into a tiny 'tableau tout fait', an effect which is frequently echoed in the depiction of various artefacts in the mature works—the little figures on the wedding cake in *Madame Bovary*, or on the barrel organ, or on Emma's lightshade.

Flaubert approaches certain landscapes with the same attitude of programmed *bêtise* with which he approaches certain pictures. In these landscapes, impression is more important than cognition. The valley of the Nile is like a sea (*C1* 568); the desert is another sea ('un autre océan'); the early morning fog is like great sheets of gauze; the fields are like carpets, with the Nile as a fringe; the sky is old vermilion; the sails of a boat are like the wings of a

foreshortened swallow. Elsewhere, a cab is a crab (*PCG* 607), a rock is a tortoise (*PCG* 525), sun is redcurrant jam (*C2* 388). No wonder Frédéric and Rosanette at Fontainebleau have a moment of panic when the famous rocks with their animal shapes seem to come alive (3: 317).

Flaubert responded to odd angles and perspectives in reality as he did in painting. Again, this began early; there is an isolated example in *Pyrénées et Corse*, where heads surmount stalks of ferns: 'nous allons dans des sentiers à travers de hautes fougères, et chacun voit la tête de celui qui le précède passer rapidement, en mille détours, le long de leur tige' (10: 339–40). By the time of the *Voyage en Orient*, such details are almost commonplace. Foreshortening is one of Flaubert's favourite distorting devices. A conventional enough 'tableau', signposted as such by Flaubert himself, incorporates three of his devices: minimalism, foreshortening, uncertain vision: 'tableau: un chameau qui s'avance, de face, en raccourci, l'homme par derrière, de côté, et deux palmiers du même côté, au troisième plan. Au fond le désert qui remonte—premier effet du mirage' (*VE* 176–7).[32] Vertical perspectives also attract Flaubert. Noting one example in Egypt, Flaubert himself refers back to the first instance he had noted in *Pyrénées et Corse* (a sign of how much it meant to him): 'Les arbres des bouquets de village [. . .] semblent dans le ciel même, car toute la perspective se trouve perpendiculaire, comme je l'ai vue une fois du port de la Picade dans les Pyrénées' (*VE* 210).[33] He notes the same effect in pictorial art, in Luxor, where an apparent 'défaut de perspective' in the representation of a battle scene makes the soldiers look as if they are piled up vertically (*VE* 375).[34] Earlier, he had noted a similar oddness of perspective in the figure of 'Victory' on the Parthenon, whose head is on a level with the head of the horse rearing up behind her: 'cette invraisemblance ne choque nullement' (11: 82). The view from below, which he had observed in Pompeian wall-paintings, he reproduces himself in his description of his first sight of Kuchuk-Hanem: 'Sur

[32] Cf. *VE* 407–8—two wonderful views of advancing camels, one group surrounded by the dust of the *khamsin*, the other gradually defining itself and its strange foreshortening effect. Flaubert drew on such impressions for the famous mirage sequence in *Salammbô*.

[33] Cf. *PC* 10: 307 on the view of the distant plains of France 'comme des immenses tableaux suspendus' .

[34] See Ch. 7 for Emma's drawing of a cat and a landscape by Pécuchet. Rimbaud also liked perpendicular perspectives.

l'escalier, en face de nous, la lumière l'entourant, et se détachant sur le fond bleu du ciel, une femme debout, en pantalons roses, n'ayant autour du torse qu'une gaze d'un violet foncé' (*VE* 280–1).

If Flaubert was so fascinated by camels in the East, it is in part because they help to create such strange images. They metamorphose readily, into turkeys and swans—'cet étrange animal qui sautille comme un dindon, et balance son cul [*cou?*] comme un cygne' (*C1* 539)—or ostriches: 'Les chameaux des caravanes vont quelquefois les uns à la file des autres, d'autres fois tous de front. Alors, quand on aperçoit de loin à l'horizon, en raccourci, toutes ces têtes se dandinant qui viennent vers vous, on dirait d'une émigration d'autruches qui avance lentement, lentement, et se rapproche' (*C1* 636). They also, for some reason, lend themselves to strange perspectives: 'Un chameau va au haut de la montée, en face de moi; il montait lentement. Vu en raccourci, je ne voyais que son train de derrière, l'air passait entre ses jambes allant pas à pas, se découpant sur le bleu; il avait l'air de monter dans le ciel' (*VO* 10: 573).[35]

Nature as described by Flaubert falls readily into patterns, as is frequently the case in the art that he likes. One delightful example among many is this one, of the pattern of light and shade created by a roof of palm leaves in a khan at Aswan: 'Le dessus, fait de nattes de palmier, était pénétré de soleil—il pendait en déchirures épaisses, losangées, etc.—toiles d'araignées qui pendaient dans les coins—la poussière unissait le ton varié des fils des nattes—le bleu du ciel, féroce, passait à travers les trous de formes différentes' (*VE* 293–4).

All these are instances of the 'style cannibale', which replaces the natural world with a strange world of Flaubert's own making, and which he transforms into the textual world of his novels.

THE ART OF THE GLIMPSE

Where Flaubert comes closest to modern forms of *reportage* is when he evokes indirectly, by suggestion, with a few light touches. The

[35] Cf. *VO* 10: 569 a line of camels: 'Le bleu du ciel cru passait entre leurs jambes raides aux mouvements lents'; Félicité's sudden vision of horses swinging in the sky, *CS* 4: 211.

non-finito of the note form is perfectly suited to this kind of swift evocation.[36] 'Il est des choses dont il ne faut garder qu'une vision' (*PC* 10: 346). A monk passes by with a particular gesture, noted but not described: 'Un moine a passé, dans la lumière, maigre, à plis flottants, tout blanc, allant vite.—Mouvement pour tourner dans l'escalier' (*IS* 375); an old muleteer grabs hold of a prostitute—'Je n'oublierai jamais le mouvement brutal' (*VE* 242); boys climb out of a river glistening like bronze statues, but unlike statues they come and go in a flash and a glimmer, the memory retaining just a 'lambeau de songe' (*VE* 301). Figures pass by in an instant:

A une lieue environ d'Alexandrie il passe à côté de nous à droite deux chameaux montés par un nègre et un arabe. Ils sont sans charge—les cordes sont entrecroisées à la selle et pendent sur leurs hanches. Les hommes montés dessus, se tiennent debout et les battent à grands coups de bâton de palmier en riant d'une voix rauque [c'est une des choses les plus féroces que j'aie vues] les chameaux trottinent comme des dindes—ils ont passé vite. (*VE* 183–4)

Many of these glimpses are of women, thus playing on all the senses of 'curiosité', sensual and otherwise. Two women enter a church, reduced to not much more than a gesture and a perfume and a small visual detail which lingers in the memory: 'à cette heure je vois passer devant moi un bas d'étoffe rose bouffante et le bout d'un pied dans une pantoufle jaune pointue' (*VE* 247).[37] Certain descriptions attain a degree of minimalism which can barely be called 'pictorial' at all, despite the fact that the visual image evoked is vivid: 'il fait clair de lune—deux chiens sur un mur' (*VE* 264). Moonlight makes a composition out of a leg and a bit of sock: 'Dans la position où j'étais, elle éclairait ma jambe droite et la partie de ma chaussette blanche comprise entre mon pantalon et mon soulier' (*VE* 320).

Indirect evocation is as efficient as unmediated description. In 'La Cange', Flaubert gives the 'feel' of Egypt through an alternative description of Normandy. Flaubert may feel unable to describe the Simplon, but he evokes something of its cold, threatening grandeur by evoking its opposite, the beautiful, balmy shores of Lake Como and the 'paradis terrestre' of its villas, and by following this with

[36] See Daunais, *L'Art de la mesure* 55, on the suitability for Flaubert's purposes in the *Voyage en Orient* of 'l'écriture elliptique et "inachevée" de la note'.

[37] Cf. already *PC* a swift 'apparition moresque' of two girls; 10: 296 another girl (etc.).

the simple notation '*Écrit au Simplon.—Fumée du poêle*'. These two simple phrases are like a caption, supplying a context and a perspective: only then do we realize that Lake Como is a memory, recalled in the shelter of a smoky mountain refuge. They draw attention to the act of writing, as a dark but necessary context to the image, Mallarmé's 'grimoire'. Indirect evocation is again in play in the following example, which is Flaubert's attempt to describe the view from his window in the Lebanon. After the briefest of thumbnail sketches, or rather caricatures (the mountains come complete with tie and wig), comes the familiar protest that description is inadequate. But this is then followed by what is in practice a magnificent evocation of part at least of what the Orient means to him in an extremely precise, very personal and highly visual detail, as his arms mineralize to emeralds and his feet turn to ivory in the water:

J'ai la mer sous mes fenêtres, un peu plus loin Beyrouth entouré de mûriers et à ma droite le Liban qui a une cravate de nuages et une perruque de neige; et quand je pense qu'il y a des gens qui ont assez de toupet pour *faire des descriptions* de tout ça! Savez-vous, cher ami, quel sera quant à moi le résultat de mon voyage d'Orient? ce sera de m'empêcher d'écrire jamais une seule ligne sur l'Orient. Nom d'un nom! la mer casse-pète de bleu (ah, ne vous moquez pas du *bleu*, mon cher, c'est une crâne couleur). Hier je m'y suis baigné, à travers la transparence de l'eau je voyais mes bras colorés d'une teinte pâle d'émeraude, et quand je marchais sur les cailloux et sur les herbes, mes pieds plus blancs que de l'ivoire. (*C1* 652)

WRITING, PHOTOGRAPHY, AND PAINTING

Flaubert's fear of being reduced to silence is more than rhetorical coquetry on his part, particularly in the *Voyage en Orient*. Flaubert has just been devastated by his friends' reactions to the first *Tentation de saint Antoine*, and now he is faced with a barrage of images which challenge his ability to write anything at all. The frequently quoted statement that 'il vaut mieux être œil' has a pessimistic ring when seen in its context: 'Les premiers jours je m'étais mis à écrire un peu, mais j'en ai, Dieu merci, bien vite reconnu l'ineptie. Il vaut mieux être œil, tout bonnement' (*C1* 602). It is all very well to note forms and colours 'à faire pâmer tous les peintres'; what is he to do about 'cette vieille littérature'? In a slightly later letter, Flaubert's

transition from the subject of images and painting to that of writing and his own sense of inadequacy is revealing:

Une chose merveilleuse, c'est la lumière, elle fait briller tout. Dans les villes, cela nous éblouit toujours, comme ferait le papillotage de couleurs d'un immense bal costumé. Ces vêtements blancs, tout jaunes, ou azur se détachent dans l'atmosphère transparente avec des crudités de ton à faire pâmer tous les peintres.—Pour moi, je rêvasse de cette vieille littérature, je tâche d'empoigner tout ça. Je voudrais bien imaginer quelque chose, mais [. . .] je ne sais quoi. Il me semble que je deviens bête comme un pot.

Nous lisons dans les temples les noms des voyageurs; cela nous paraît bien grêle et bien vain.—Nous n'avons mis les nôtres nulle part. (*C1* 615)

In the East, Flaubert very often feels 'très vide et très stérile' (*C1* 637), too given to dissemination and reverie, too caught up in the visual.[38]

Flaubert was already conscious enough of the need to assert the power of writing against painting. In the course of the *Voyage en Orient* he discovers a new rival: photography.[39] There is no doubt that he perceived photography as constituting a real threat.

Flaubert's first extant reference to photography occurs in the *Voyage en Orient*. Waiting more or less impatiently in the desert for Du Camp to complete the lengthy process that constituted the taking of photographs in 1850, Flaubert had ample time to develop and formulate his objections to this new art form. Not only

[38] Already, on the boat to Alexandria from Marseilles, looking is equated with basic animality and wordlessness: 'Accoudé sur le bastingage je contemplais les flots au clair de lune, en m'efforçant de penser à tous les souvenirs historiques qui devaient m'arriver, et ne m'arrivaient pas, tandis que mon œil, stupide comme celui d'un bœuf, regardait l'eau, tout bonnement' (*C1* 539).

[39] Cf. e.g. Valéry's view (cited in Hamon, *Description*, 171–4) that photography, for literature, was a 'réactif nouveau'. Cf. also C. Bustarret in S. Michaud *et al.* (eds.) *Usages de l'image* (1992), 129–41, on the way engravers adapted their art to outdo photography by aiming at effects which photography could not achieve; and cf. P. Martino, in *Atti del quinto congresso* (1951), 404—some writers (e.g. Champfleury) tried to use photography as a model for a while, but 'pour la majorité au contraire et pour presque tous les peintres cette concurrence parut odieuse: elle les a poussés certainement à demander autre chose que la reproduction plate ou brutale de la réalité [. . .] on peut dire que le daguerréotype aide à ouvrir des chemins vers un certain surréalisme'. On the effects of photography on writing style, cf. also Walter Benjamin, 'The Work of Art in the Age of Mechanical Reproduction', *Illuminations*, ed. H. Arendt (1970). For details of the processes involved in taking photographs at the time, see Du Camp, *Souvenirs littéraires* (1993), 287. Du Camp's photographs were *calotypes*. Cf. A. Rouillé, *La Photographie en France* (1989), 118: the daguerreotype was mechanically exact, but in the case of the *calotype*, 'la ressemblance n'était pas surbordonnée à la précision'.

did photography take a great deal of time, it necessitated a great
mass of equipment, which the two travellers were obliged to drag
around with them until they finally disposed of it in Beirut, after a
year of travelling, in exchange for two gorgeous divans 'comme les
rois n'en ont pas' (*C1* 697: 7 Oct. 1850)—and on which Flaubert
could no doubt lie and view imaginary panoramas. It is amusing
to watch Flaubert's exasperation grow. At first, he simply notes,
without comment. The first references to Maxime's activities are
neutral[40] or approving—Max 'réussit' (*C1* 560: 5 Jan. 1850), 'réussit
parfaitement' (*C1* 613: 15 Apr. 1850). At this stage, Flaubert asso-
ciates himself with Max's success: 'nous aurons, je crois, un album
assez gentil' (*C1* 609). He even poses for photographs at least three
times, once in a hotel garden in Cairo, once on a Pyramid, and once
at the top of a mosque.[41] However, this benign neutrality does not
last. Complaints begin to surface, at first indirectly and cautiously,
then with more vigour and precision. Photography and activities
attendant upon it are associated by Flaubert with negative things:
cold or rainy weather;[42] his role as dogsbody and general overseer;[43]
hard work—many of the 'travaux de déblaiement' they undertook
(e.g. *VE* 327) were necessary because Du Camp wanted to get a
good photograph—and dirty work;[44] and trouble with the local
sheik.[45] Flaubert's criticisms become progressively more focused.
Maxime is in the grip of a mania: 'La photographie absorbe et con-
sume les jours de Max[ime]. Il réussit, mais se désespère chaque fois
que rate une épreuve ou qu'un plateau est mal nettoyé. Vraiment

[40] Cf. e.g. *VE* 327 ('essais d'estampage'), 328 ('Maxime faisait une épreuve de la
forteresse'), 335 ('Maxime travaille son épreuve'), 381 (Maxime improvises a dark-
room, the 'petite chambre pour la photographie').
[41] For the photograph in the Cairo hotel garden, see Ch. 1 above and for the
others, cf. *VE* 215, 'Dimanche, matinée froide passée à la photographie. Je pose en
haut de la Pyramide qui est à l'angle S.-E. de la grande', and *VE* 346, 'pour poser,
je monte au haut de la mosquée de *Keleel-Rasoun-Saba*'. Neither of the last two
photographs is reproduced by Du Camp.
[42] Cf. above *VE* 215 and 227, 'A partir de lundi 17 toute la semaine il a plu—le
temps a été employé à l'analyse des notes de Bekir-Bey et à la photographie'.
[43] Cf. *VE* 367, 'Photographie.—Je cure les plateaux'; *VE* 382, 'surveillé les
estampages dans le palais—quand cette besogne stupide fut achevée, promenade autour
de Karnac'; *C1* 620: '3 jours, Max photographiant et moi estampant, ou pour mieux
dire faisant estamper'.
[44] Cf. *C1* 618–19: 'j'ai tous les doigts noircis de nitrate d'argent, pour avoir aidé
mon associé, hier, à Herment, dans ses travaux photographiques'.
[45] *VE* 381, 'Affaire du sheik à propos de nos estampages dans le petit tombeau
de Gournah [. . .], visite au gouverneur pour l'affaire du sheik de Gournah'.

s'il ne se calme il en crèvera. Il a du reste obtenu des résultats superbes' (*C1* 560).[46] Maxime wears himself out while Gustave grows fat: 'Je ne sais comment Maxime ne se fait pas crever avec la rage photographique qu'il déploie. Du reste il réussit parfaitement. Quant à moi, qui ne fais que contempler la nature, fumer des chicheks et me promener au soleil, j'engraisse . . .' (*C1* 613). Max keeps himself busy while Flaubert simply sits, being visited by flies and lascivious thoughts and guilt at his own lack of productivity: 'le jeune Du Camp est parti faire une épreuve; il réussit assez bien; nous aurons, je crois, un album assez gentil [. . .] je deviens cochon [. . .]. Si le cerveau baisse, la pine se relève.—Ce n'est pas pourtant que je n'aie recueilli quelques comparaisons. *J'ai eu des mouvements.* Mais comment les employer et où?' (*C1* 609). Eventually, on 16 May 1850, he spells out exactly why photography is a 'besogne stupide' and why it repels him so: 'Lundi, re-estampage—le moyen mange le but—une bonne oisiveté au soleil est moins stérile que ces occupations où le cœur n'est pas' (*VE* 383).

From the very first, photography is set against writing or narrative: in Alexandria, while Du Camp 'photographise', Flaubert writes an account of his journey so far to his mother (*C1* 526): 'Max[ime] photographise avec Sassetti, je suis seul dans ma chambre qui donne sur la grande place d'Alexandrie. Les volets sont fermés. Personne ne passe [. . .] je commence [. . .]'. Maxime works away on his print while Flaubert listens to their guide's narrative of his childhood: 'Pendant que Maxime travaille son épreuve, Joseph, assis à côté de moi sur le sable, me parle de son enfance [. . .]' (*VE* 335). Flaubert is made aware of all that photography cannot capture. Photography requires immobility:[47] Du Camp can only photograph waterfalls, he cannot photograph this more fugitive glimpse, he can only tell Flaubert about it: 'en allant ce matin photographier à la cataracte, Max a vu de loin un chameau qui courait, avec quelque chose de noir qui le suivait en bas: c'était un esclave des gellabs qui s'était enfui et que l'on ramenait ainsi attaché au chameau' (*VE* 325).

Flaubert's own sense that he cannot write is then crucial: 'Qu'est-ce que je vais faire une fois rentré au gîte, publierais-je, ne

[46] Cf. also *C1* 599, 'Maxime va recommencer ses rages photographiques'.
[47] Cf. Du Camp, *Souvenirs littéraires*, 287: 'il fallait au moins deux minutes de pose pour obtenir une image'. Cf. Rouillé, *La Photographie*, 79 ff.: human subjects moving would simply not figure in the photographic image.

publierais-je? qu'écrirai-je? et même écrirai-je? l'histoire de *Saint Antoine* m'a porté un coup grave, je ne le cache pas [. . .]' (*Cı* 601). However, that is not his last word. Not only does he finally break through the block, but he writes defiantly in the face of what photography can do. His account of Abou Simbel alternates references to photography with demonstrations of what writing can achieve. Flaubert begins on his own terrain, evoking in turn the tremendous colossi and the bats, colossi and bats becoming associated in his mind as he sits in a semi-stupor. Finally, the sound of the bats squeaking 'comme le battement lointain d'une horloge de campagne' evokes two alternative but related images, first, of Normandy farmsteads on hot afternoons, second, of the legend of the guilty, hopeless love of King Mycerinus. Both narratives are left trailing suggestively and poetically, before giving way to the prosaic 'essais d'estampages':

Les chauves-souris font entendre leur petit cri aigu—pendant un moment, l'une d'elles criait régulièrement et cela faisait comme le battement lointain d'une horloge de campagne—j'ai pensé aux fermes normandes, en été, quand tout le monde est aux champs, vers trois heures de l'après-midi . . . et au roi Mycérinus se promenant un soir, en char, faisant le tour du lac Moeris avec un prêtre assis à côté de lui—il lui parle de son amour pour sa fille—c'est un soir de moisson . . . les buffles rentrent . . . Essais d'estampage. (*VE* 326–7)[48]

The second example comes from Flaubert's account of the temple of Medinet-Abou (*VE* 384–8). It begins with a conscientious, well-ordered description of the temple, culminating in the description of the pictorial representations in the courtyards (which Du Camp photographs). This process is clearly a verbal equivalent to Du Camp's photographic activity. The sequence ends with a reference to Max's departure for the 'cange' to prepare some more photographic paper. At this point Flaubert is alone—'je monte à cheval et je vais me promener seul' (*VE* 388). There follows an encounter with a fox, which moves Flaubert, and which he develops later and includes in a letter to Bouilhet, prefacing his narrative with a reference to Maxime's photography, as if simultaneously to highlight a difference between Maxime's mechanistic activities and this more intimate confrontation of subject with object, and suggest some kind

[48] Cf. *Cı* 601 on Flaubert's attempts to write a *conte oriental* about Mycerinus and his daughter.

of comparison—he takes a kind of snapshot through his own lens, the *lorgnon*; and wishes he had brought his gun (so that he could bring home the pelt, at least, of the animal):

un jour que je me promenais à cheval tout seul et sans armes du côté des hypogées, pendant que Max[ime] photographiait de son côté, je montais lentement et le nez baissé sur ma poitrine, me laissant aller au mouvement du cheval, quand tout à coup j'entends un bruit de pierres qui déroulent: je lève la tête et je vois sortant d'une caverne, à 10 pas en face de moi, quelque chose qui monte la roche, à pic, comme un serpent. C'était un gros renard; il s'arrête, s'assoit sur le train de derrière et me regarde. Je prends mon lorgnon et nous restons ainsi à nous contempler réciproquement pendant trois minutes, nous livrant sans doute à part nous-mêmes à des réflexions différentes. Comme je m'en retournais tranquillement, maudissant la sottise que j'avais faite de n'avoir pas emporté mon fusil [. . .] (*C1* 634)[49]

Flaubert may have been inhibited from writing up and publishing his *Voyage en Orient* in part because he feared that Du Camp's photographs would make such predominantly descriptive activity redundant. Once he resorted to the kind of narrative we see in the above example, there was no reason for staying within the genre of the travel account, and so he did not. Flaubert himself notes a turning-point in his attitude: 'Il se prépare en moi quelque chose de nouveau, une seconde manière peut-être' (*C1* 704), where both photography and description can cease to loom large and can take their proper place.

Flaubert's attitude to painting is more forgiving, and a happy union seems here to be possible.

The sequence devoted to the temple of Hamada (*VE* 309–12) illustrates many of the aspects of Flaubert's responses to pictorial representations which we have seen so far. First, Flaubert provides a methodical description of the temple as a whole, simply noting what is there. Among the various pictorial art works which he includes are figures in a *bari* (a funeral boat), painted on the back wall of the temple, two of them seated on thrones, and the third standing. Flaubert then evokes other details, incidental to the temple and to tourism's usual 'sights', namely, four women collecting goat

[49] The relevance of this sequence to *La Légende de saint Julien* hardly needs emphasizing.

droppings. The description ends with two views. The first is a panoramic vista from the steps at the entrance to the temple, looking out onto the Nile and the grey mountains beyond. This is a fairly conventional view. The second is the view from the back of the temple, and that view is more unusual.[50] As a final poetic note, Flaubert returns to the three painted gods on the back wall in their *cange*, animates them, and fuses with them—they share his view, from the back of the temple, river-gazing (as was his habit). Clearly, even gods need to dream; and the people who painted them may have thought that too when they gave them this wonderful view. Flaubert's evocation animates these figures. From their painted boat, hieratically immobile, they gaze at boats which unlike them have the power of movement. They themselves are fixed, but they can gaze at what they cannot have:

Quand on est monté sur les dalles extérieures du temple, on a derrière soi: le désert avec ses sables jaunes, en face le Nil, et au-delà les montagnes grises mamelonnées. Entre le Nil et les montagnes, ligne de verdure des palmiers et des champs d'orge. La rive du Nil est ornée de place en place de sakiehs—à droite le Nil fait un coude et l'horizon s'aplatit.

Du fond du temple on voit le Nil compris entre le sable qui dévale vers l'entrée du temple et le grès du plafond et des piliers du pronaos—les Dieux peints sur la bari pouvaient voir les canges passer. (*VE* 312)

Boats, sails, passing cabs;—the poignancy of the feelings of the non-traveller is expressed in this sequence, entirely by suggestion. It was a feeling Flaubert himself knew very well, and which he wove on many occasions into his later writing.[51] Flaubert's writing can be observed once more here bringing images to life and creating in the process a haunting poetic detail. Once again, he is paying homage to his sister art through indirect means, evoking by not describing.

[50] Note that Gardner Wilkinson (who wrote the first Murray's guide to Egypt) sketched a similar view, see S. Flynn, *Sir John Gardner Wilkinson* (1997), 15, item 32.
[51] Bouilhet works this quintessentially Flaubertian leitmotif into a poem about Kuchuk-Hanem, written while Flaubert was still in Egypt and inspired by Flaubert's account of her, cf. *C1* 1139 for the final two lines: 'Et tu penches la tête, écoutant . . . écoutant I Passer le bruit lointain des canges sur le fleuve!' Cf. also *TSA3* 4: 117: 'Quand j'habitais le temple d'Héliopolis, j'ai souvent considéré tout ce qu'il y a sur les murailles: vautours portant des sceptres, crocodiles pinçant des lyres, figures d'hommes avec des corps de serpent, femmes à tête de vache prosternées devant des dieux ithyphalliques; et leurs formes surnaturelles m'entraînaient vers d'autres mondes. *J'aurais voulu savoir ce que regardent ces yeux tranquilles.*' (My emphasis.)

POSTSCRIPT: LONDON AND CARTHAGE

A few weeks after his return to France after the *Voyage en Orient*, Flaubert took another trip, this time to London, to see the Great Exhibition of 1851.[52] The Exhibition itself was concentrated in different venues, including the British Museum and the Crystal Palace. Flaubert was particularly interested in the specimens of Indian art and, above all, in 'the celebrated Chinese collection now exhibiting Albert Gate, Hyde Park'. Pictures were only part of what was on show, of course, but there is still some interesting material in Flaubert's notes on the subject of pictorial art, with pictorial depictions on screens and shawls particularly catching his attention.[53] Stunning as this unfamiliar art form was, it did not in a sense tell Flaubert anything he did not already know. We would expect Flaubert to be attracted by these 'peintures étincelantes d'or et d'argent, où passent des personnages magnifiques', by the stylization ('aucune intention d'imiter la nature' in these specimens of Chinese art),[54] by its displays of exuberance in the creation of grotesques, and by the bestowing of the illusion of reality on what is manifestly invention.[55] Flaubert's personal idiosyncracies also find an echo in the art of China: he notes new instances of strange marriages of art with nature, as in the screen which comes complete with real hair and beards, or the sculpture which builds on the natural features of wood.[56]

In the course of the second London visit of 1865, Flaubert was introduced to British art, and widened his acquaintance with Dutch and Flemish painting.[57] In the space of about a week, Flaubert visited the South Kensington Museum (British art), the Bridgewater Collection, Grosvenor House, Hampton Court, and the National Gallery, noting, very briefly, about fifty paintings.[58] Portraits remain Flaubert's dominant interest. He continues to show little interest in

[52] Cf. J. Seznec, *Flaubert à l'exposition de 1851* (Oxford: Clarendon Press, 1951).

[53] See ibid. 36–9. Cf. C3 58: 24 Nov. 1859, China is the 'pays des paravents et du nankin'.

[54] Seznec, *Flaubert à l'exposition*, 37, of a shawl.

[55] Ibid. 36. [56] Ibid. 37.

[57] See CV 13, 32ᵛ–36ᵛ; 49ᵛ–63ᶠ, transcribed in CT 362–7, 348–57. See the excellent commentary and chronology in H. Oliver, *Flaubert and an English Governess* (1980), 79–88.

[58] See Oliver, *Governess*, 81–5, for details of these collections.

genre paintings and still life, though there are some animal paint-
ings. Flaubert is still averse to realism of the kind he regards as
unpoetic: 'quelle absence radicale de poésie et d'effet' he says of a
Teniers (*CT* 352), and remarks on the 'réalisme horripilant' of a
Kitchen by Slingelandt (*CT* 351). Rubens and Rembrandt remain
major interests. The 'chef-d'œuvre' of the Bridgewater Collection
is Titian's painting *The Three Ages of Man*.[59] Flaubert also lingers
over the play of light and dark in the atmospheric painting of the
Air Pump, by Wright of Derby (now at the Tate) (*CT* 350).

These visits to England are the only art-tourism Flaubert undertook
after 1851, apart from what was incidental to local excursions under-
taken for specific purposes for his writing (such as Fontainebleau
for *L'Éducation sentimentale*). His visit to Algeria and Tunisia in
1858, recorded in *Voyage à Carthage*, was undertaken with the
specific intention of injecting some enthusiasm and confidence into
his writing of *Salammbô*, which was currently in the doldrums (*C2*
795). He was absorbed by the natural environment above all. His
notes resemble a painter's notebook, as Biasi has pointed out, but
they contain no record of pictorial art at all, with just one excep-
tion, and that exception is in many ways the best art commentary
that Flaubert ever wrote.

 The subject is a Roman mosaic in the garden of a M. de Nobelly,
in the town of Philippeville:[60]

Visité le jardin de M. Nobels [*sic*], en vue de la mer. Rosiers en fleurs embau-
ment. Une mosaïque, trouvée sur place, représente deux femmes, l'une assise
et conduisant un monstre marin à bec d'aigle; une autre assise et conduisant
un cheval, des iris entre les oreilles font des flammes rouges; une troisième
danseuse, avec des anneaux aux chevilles, pieds et jambes remarquables de
forme et de mouvement, la droite sur la gauche; le champ est semé de pois-
sons. Le nègre jardinier qui m'a conduit va m'emplir un arrosoir et asperge

[59] Now in the National Gallery of Scotland, Edinburgh.
[60] See Fanny Besson, 'Le Séjour de Flaubert en Algérie', *Amis de Flaubert* (May
1968), 4–52. For the mosaic, cf. pp. 26–7. It is reproduced facing p. 34 (from another
reproduction in the *Album Delamarre* (1845), M. de Nobelly having discovered it
in his garden a few years earlier). Besson quotes Charles Vars, *Rusicade et Stora*
(1896), 63–5, who admires it greatly, emphasizing the *finesse* of its detail and the
subtlety of its execution: 'Mais ce qui excite particulièrement l'admiration, c'est l'ex-
iguïté presque infinitésimal des matériaux mis en œuvre par l'artiste. Il s'est servi de
petits cubes à peine palpables, qui donnent à sa composition la finesse d'une tapis-
serie.' Later Stéphane Gsell 'reconnaît la richesse et l'harmonie des couleurs'.

la mosaïque pour me la faire voir. Je suis pris de tendresse dans ce jardin! Le temps est brumeux, les soldats de la terrasse en face jouent des fanfares. (11: 182)

This experience was significant enough for Flaubert to send an alternative version of this passage in a letter to Bouilhet. This version turns its back on the ekphrasis of the travel notes, and brings out the poetry of the experience more strongly:

J'ai vu à Philippeville, dans un jardin tout plein de rosiers en fleurs, sur le bord de la mer, une belle mosaïque romaine représentant deux femmes, l'une assise sur un cheval et l'autre sur un monstre marin. Il faisait un silence exquis dans ce jardin. On n'entendait que le bruit de la mer. Le jardinier, qui était un nègre, a été prendre de l'eau dans un vieil arrosoir et il l'a répandue devant moi pour faire revivre les belles couleurs de la mosaïque.—Et puis je me suis en allé. (C2 808)

This evocation sums up the role of the pictorial arts for Flaubert. Images are fragile, needing to be brought to life, by water from the gardener's hose, or by the imagination. As in Avignon, in 1845, an image is only part of the beauty of a scene, though an essential part. Ekphrastic description gives way to an indirect tribute to the mosaic in the simple, subtle poetry of Flaubert's phrases. Prosaically, the image is a source (for *Salammbô*). 'Et puis je me suis en allé'—Flaubert leaves it behind, and a sense of closure gives way to a new beginning.

III

The Mature Years: The Role of the Pictorial in Flaubert's Major Works of Fiction

DESCRIPTIONS: il y en a toujours trop dans les romans.

(*Dictionnaire des idées reçues*)

These years of exposure to the pictorial arts left a considerable legacy in the works of Flaubert's maturity. What remains to be traced is the process of repression of the pictorial in Flaubert's major works of fiction and the significant residue which the pictorial left behind. Pictorial art remains in Flaubert's *œuvre* as a touchstone and a foil, its presence carefully monitored and controlled. Flaubert never gave pictorialism its head, as Gautier, for example, did. But art and the art world remain as important themes; pictorialist sources and models continue to play a vital role; and images retain all their power to move and disturb. Part III begins with a discovery of unexpected richness—a dossier of notes on painters taken by Flaubert for a chapter of *Bouvard et Pécuchet* which he did not in the end write.

6

Bouvard et Pécuchet: 'Peinture', the Missing Chapter

The *contemporary* art world is a major theme of *L'Éducation sentimentale*. What is not generally known, however, is that Flaubert considered taking up the subject again in *Bouvard et Pécuchet*, only this time focusing on artists of the past rather than the present. Amidst the mass of preparatory material collected in the *dossiers* for *Bouvard et Pécuchet* is a substantial file headed *L'Esthétique*, which contains, among other things, a separate dossier entitled *Peinture*. Though the existence of this *dossier* has been noted, it has not hitherto been examined, nor have its contents been identified. The text is transcribed in full in Appendix B, for ease of reference for what follows in this chapter.[1]

Flaubert himself does not identify his source for these notes. However, it turns out on examination to be Charles Blanc's *Histoire des peintres*, the first comprehensive encyclopaedia of art to be published in France (1861–76) and a landmark for contemporary literature.[2] The date of 1876 suggests that Flaubert's notes were intended for *Bouvard et Pécuchet*, not for the earlier *L'Éducation sentimentale*. Only traces of Flaubert's original project remain,

[1] For the complete set of dossiers, cf. Bibliothèque Municipale de Rouen, ms g 226[1-8]. For their contents, see Bibliography, section 1. For the notes on painting, see specifically g 226[5] 333–55. Some of the material in these dossiers was intended for *ES*, some for *BP*. Cf. A. Cento, *Bouvard et Pécuchet* (1964), pp. lxiii–lxiv and *Il realismo* (1967), 73 ff. and C. Gothot-Mersch, 'Le Roman interminable', in *Flaubert et le comble de l'art* (1981), 14. Cf. also A. Fairlie, in *Imagination and Language* (1981), 364–71, 375–6, and Irma B. Jaffe, 'Flaubert: The Novelist as Art Critic', *Gazette des Beaux-Arts* (May–June 1970), 335–70, which includes facsimiles of selected pages. See Appendix B for the transcription of the 'Peinture' file.

[2] The importance of this work for 19th-cent. writing is reflected in the fact that it appears in Manet's portrait of Zola. (I am indebted to Professor Robert Lethbridge for this information.) See Bibliography for details of publication; the work appeared first in a series of short separate instalments, beginning in 1849, and was subsequently published in several volumes between 1861 and 1876. Some of the entries were co-authored (by Paul Mantz, Henri Delaborde, Philarète Chasles, and others).

in the visits made by Bouvard and Pécuchet in the early sections of the novel to 'toutes les collections publiques' of Paris, and also in the medley of entries in the *Dictionnaire des idées reçues* relating to the pictorial arts.[3] No doubt, as has been suggested, the important role of Pellerin in *L'Éducation sentimentale* accounts for the eventual absence of painting as a subject from *Bouvard et Pécuchet*.[4] The other indication that this file is intended for *Bouvard et Pécuchet* is that the painters selected are exactly the mixture of 'good' and 'bad', famous and less famous, that we would expect from the protagonists' characteristically erratic aim.[5]

As is the case for *Bouvard et Pécuchet* as a whole, the reader is in a state of more or less continual uncertainty as to the relationship between Flaubert's text and its source. Flaubert focuses almost entirely on Blanc's text, rarely on its accompanying illustrations. Sometimes, he quotes Blanc *verbatim*. More often, his notes are succinct paraphrases. This is of course the way with notes; but, as is usual in *Bouvard et Pécuchet*, the result is a *reductio ad absurdum* which produces comic effects.

Reading these notes, one senses that mockery is all-pervasive: mockery of Bouvard and Pécuchet, of the painters they study, of Blanc and his co-authors, self-mockery. But, as in *Bouvard et Pécuchet* as a whole, mockery is not all there is; along with all the jokes, Flaubert is still fascinated by painters and painting, still recognizing echoes and still 'milking' them, just as he always did. It is often impossible to tell at whom we should laugh, if at all.

THE PROTAGONISTS

It is easy to imagine Bouvard and Pécuchet desperately playing off one painter against another, one theory against another, one aesthetic system against another, in an attempt to arrive at some

[3] Cf. e.g. *clair-obscur* ('On ne sait pas ce que c'est'), *dessin*, *Fornarina*, *Fresque* ('On n'en fait plus'), *hémicycle*, *mosaïques* ('Le secret en est perdu', same remark as for *Émail* and *Peinture sur verre*), and *Paysages* ('toujours des plats d'épinards').
[4] Cf. C. Gothot-Mersch, *L'Éducation sentimentale* (Garnier Flammarion, 1985), 514–15 n. 33.
[5] The largest single group of painters consists of French painters of the 17th/18th cents. (19/60). Italian painters are also well represented (18) and *L'École hollandaise* (11). Spanish (5), English (2), Scottish (1), Flemish (1), and German (1) bring up the rear.

sort of standard or criterion: 'La touche de Metsu est presque l'opposé de celle de Mieris et de Gérard Dow. Celle de Mieris est fondue et sent la peine, celle de Metsu facile, vive, large et hardie. Gérard Dow touche à la minutie. Metsu est pimpant et décidé' (352ʳ).[6] They would have dazzled their friends and neighbours with confident formulations, which do of course lose all their power to persuade when plucked from the passages of consecutive prose in which they are embedded—'la couleur générale d'un vert légèrement bistré n'est pas sans charme quoiqu'elle sente la convention', 345ʳ—or with their grasp of the basic paradigm of the paintings of Gabriel Metsu: 'Souvent des tête à tête le 3ᵉ personnage s'il y en a un est insignifiant la dame a souvent un chien', 352ʳ, or with their knowledge of the fact that the detail of the apostles lying down in Poussin's *Last Supper* is an innovation (340ʳ). Flaubert copies out seductively neat formulations, such as that Wilkie is 'le Hogarth de l'Écosse' (335ᵛ). Certain facts, similarly cruelly isolated by Flaubert, lodge themselves for ever in the memory—such as that St Hugues, the subject of a painting by Zurbarán, changed food on the dinner-table to tortoises (339ʳ), or that Murillo's Madonnas never show their feet (339ʳ).

Bouvard and Pécuchet were also to have become mesmerized by details incidental to the art works themselves, thus reflecting Flaubert's own often repeated complaint that contemporary critics paid attention to anything but form. The question of changing economic values becomes a recurring preoccupation, as do questions of influence, of who was whose pupil, and statistics: we learn that Dow takes ages over a painting (five days to paint a hand, three for a broomhandle, 335ʳ), whereas Mignard works very fast (just three hours for a portrait of Louis XIV, 336ᵛ), while Giordano's father urged him to work faster ('fa presto', 348ʳ). We learn about the artists' personal habits: Terburg 'avait l'habitude de chanter en peignant', and Bauer 's'échauffait tellement qu'il parlait à son modèle même inanimé', while 'le Bamboche s'interrompait à chaque minute pour retrousser sa moustache' (355ʳ), and Maratti took great pains over the wigs he wore (348ʳ). We learn that Dürer suffered from the mange, and that Maratti told his students: 'si vous voulez vivre longtemps,

[6] Here, as in the transcription of these notes in Appendix B, I supply accents. I expand Flaubert's use of 'qq' and 'qques' to 'quoique' and 'quelques' etc., in this chapter but not in Appendix B. Flaubert's text here is a shortened paraphrase of Blanc's. One (rare) misreading: 'pimpant' for 'piquant'.

soyez sobre' (348ʳ). Bouvard and Pécuchet were also to have be-
come obsessed with biography. But many of their potential subjects
(like the duc d'Angoulême, whose biography they *did* in fact decide
to write in chapter 4) have no life to speak of: Casanova's brother
(344ᵛ), for example, and Pater: 'La vie de Pater n'eut rien de sail-
lant' (Blanc, p. 1); or their life is a nightmare. As we begin to smile,
either at the expense of the poor tormented painters—Domenichino,
'horriblement malheureux dans son ménage, a peur d'être empoi-
sonné par sa femme' (346ᵛ); Dürer, locked up and frightened by his
wife (351ʳ); Wilkie, dogged by Scottish ideas of decency which pro-
hibited the use of nude models (335ᵛ)—or at Bouvard and Pécuchet
for their obsession with domestic miseries, we also begin to detect
a serious side: the contrast of the determined cultivation of artistic
peace and harmony with the nightmare of daily existence, showing
how art can rise above circumstance. Dürer, once more: 'Sur sa
fin, au lieu de chercher l'abondance des détails, songeait à la sim-
plicité, l'harmonie.—c'est alors qu'il fit les *Apôtres* de Munich—si
malheureux à cause de sa femme qu'il en était quelquefois presque
fou' (351ʳ). For of course Bouvard and Pécuchet would have
unearthed things of value, facts that 'font rêver' in among the
nonsense; and we see already how impossible it is to disentangle
laughing at them from laughing at their object of study—the
painters themselves—or their source material.

THE PAINTERS

Flaubert's own fascination with the bad is both expressed and
mocked in the way Bouvard and Pécuchet focus less on the great
and good than on their less illustrious brothers, nephews, or
uncles. The Coypel Flaubert selects from Blanc is not the great
Antoine but his brother, Noël-Nicholas; Flaubert's Casanova, like-
wise, is brother to the one we all know; Flaubert includes not only
the famous Adriaen van Ostade but also Isaac his brother, 'éclipsé
par la gloire de son frère' (355ʳ). His Allori is C. Allori, son of the
more famous Alessandro (whose *Judith* Flaubert had liked so
much in Naples), his Mieris is Guillaume, son of the more famous
Franz (355ʳ). Some of the artists Flaubert selects are no doubt
chosen because Blanc himself presents them (somewhat shockingly
to our eyes) as being second-rate, such as Dolci, Cortona, and

Maratti;[7] and there are others who were (and are) far from being household words—Pierre, Demarne, Feti, the Moucherons père et fils, Stella, Pater: 'Qui connaîtrait Pater?', as Blanc himself asks. The most unfortunate of these neglected painters must be Largillière's father-in-law, Jean Forest, whose 'peintures ont tellement poussé au noir qu'elles n'existent plus' (342[r])[8]—just the thing to 'faire rêver' and a wonderful parody of Flaubert's own taste for the almost invisible. Painters who are presented by Blanc or his co-authors as the last of a line also figure prominently. With C. Allori (346[r-v]), 'on devine que Florence s'en va' (Blanc, p. 4). Panini too (348[v]) is a dead end, representing 'la décadence de l'école romaine' (Mantz, p. 1): 'L'école romaine finit par lui qui ne s'occupa que de la réalité la plus superficielle' (Flaubert, 348[v]).

But even if we feel confident in smiling at the protagonists' choices, we may be less sure what to think about the plethora of what we may feel are unambiguously 'good' painters who nevertheless are less than perfect in the way they regard their art. Should this matter? Flaubert targets quite a large group of Hussonnet-like figures, of widely varying status, who were sidetracked into management or other power games. Brun is one illustrious example (336[r]). Another is the all-but-forgotten Pierre, whose first act when he succeeded Boucher as *premier peintre du roi* was to suppress a prestiqious Academy (334[r]). Some painters, great as they are, have something of Pellerin about them, hard-nosed businessmen, operators, and careerists, attuning their painting to the tastes of the time. (Giordano's father, for example, was so successful in urging his son to yet more speed, that Giordano could produce a saint in a day and a half: 's'efforce de s'assimiler toutes les manières. fait des imitations et les vend "Fa presto" lui dit son père. fait pour les Jésuites un St Xavier en un jour et demi', 348[r].) Others are interested only in money (Pater is punished for this by producing horses that look like cut-outs—'ne pense qu'à gagner de l'argent. et travaille avec furie, sans relâche. Aussi, pas de nature. ses chevaux ressemblent à du carton', 342[v]). Some are simply villains (Loutherbourg). Others toady to the patron—Largillière inserts portraits of local muncipal officers into his paintings, along with images of himself (336[r]). The

[7] Cf. Blanc: Dolci is an 'artiste [. . .] secondaire', Cortona is a mere decorator, Maratti a 'talent secondaire'. Flaubert ignores these comments.

[8] A more or less *verbatim* transcription from Blanc, p. 2: 'Les peintures de Jean Forest ont tellement poussé au noir qu'elles n'existent plus, à proprement parler.'

slippery path of academe leads many astray: Vouet, Brun, and Reynolds, most notably. Others, such as Reynolds and even Hogarth, founded schools and promoted systems, or indulged in 'peinture à idées'.

What are we to think of Reynolds's obsession with taking measurements (335^v), or Metsu's views on the suitability or otherwise of particular kinds of frames (352^r), or the ingenious inventions of, for example, Loutherbourg, who takes enormous pains over the creation of an astonishingly realistic waterfall for an opera set (344^v), or creates paintings which alter in appearance as a light is passed behind them (thus turning them into a kind of *zaïmph*)? What of painters who work to a particular system: Vanloo, who works from wax models (342^r), or Bassano, who learns how to paint animals and then paints all the biblical animal subjects he can find—'étudie les animaux, les accessoires, devance l'école flamande.—quand il fut fort sur les animaux il prit tous les sujets de la Bible où il pourrait en introduire'? Human ingenuity is boundless: Joseph Vernet uses an alphabet to calculate relative intensities of light, and works out how to paint the wind: 'quand il s'agit d'exprimer un coup de vent, il a placé des objets qui lui résistent, à côté d'autres qui lui cèdent ce qui donne à la scène une variété de mouvement' (344^r). Dow paints from an image in a concave mirror (355^r). Are we to 'tonner contre', admire, laugh, reflect how thin the dividing line is between genius and ingenuity, between cleverness and silliness, or not know what we are supposed to think?

BLANC

Blanc himself does not escape unscathed. Sometimes, Flaubert quotes Blanc more or less *verbatim* (no doubt on the grounds that exposition is criticism enough),[9] simply recording examples of Blanc's periodic lapses into an *esprit de système*, his 'correcting' of painters' mistakes (like Homais, wishing he could get Racine to one side for half an hour for a good chat). Thus, Monnoyer is criticized for painting spring and autumn flowers in the same bouquet, 'ce qui prouve que les fleurs n'étaient pour lui qu'un objet de décoration' (Flaubert's paraphrase of Blanc, 338^r); even Titian has

[9] Cf. C2 66, Flaubert praises one of his own early pieces (on the study of *celticisme*) for being 'une exposition *complète* en même temps que la critique'.

faults: 'le contour n'est pas fin, le contour est pesant, il ne poursuit pas les délicatesses il n'indique pas les nuances' (350ʳ). Blanc makes clear-cut distinctions, which are dangerously attractive in their neat memorability: Poussin is 'historique', Claude 'arcadien' (337ʳ). He can appear to be laying down the law, as in his censure of Brun: 'son dessin dans le goût de Carrache est ample mais d'une correction un peu banale [. . .], ses figures courtes tirent de ce défaut même leur caractère mâle et fier. Sa couleur se compose ordinairement de teintes générales sans choix et sans finesse qui ne sont ni assez rompues ni suffisamment reflétées par les tons voisins' (336ʳ).[10]

But where Flaubert is at his most devastating is when he employs the *reductio ad absurdum*. A few examples will suffice. Blanc's assessment of Oudry is unexceptionable, if inclined to verbosity. Stripped of its fat, it becomes comical: how could Oudry ever have aspired to illustrate the *Roman comique* when he has no sense of humour? ('échoue dans l'illustration du Roman-Comique, l'humour lui manque', 338ᵛ)[11]. (The laugh is of course also on those who laugh—why *assume* humour to be necessary?) 'Pierre Le Gd voulut l'enlever à St Petersbourg. Oudry fut obligé de se cacher': Flaubert's succinct prose creates a farcical *image d'Épinal*. Strange details irrupt unexpectedly into a perfectly sober-seeming narrative, as when we learn (without any explanation) that Vernet, during a storm at sea, 'se fait attacher au mât' (344ʳ).[12] Ribera's tumultuous life story comes to an abrupt end, in total bathos: 'On ne sait plus ce qu'il devint ensuite' (339ᵛ).[13] Dürer's complicated calculations about correct proportions include the following phrase which 'fait rêver' in its apparent surrealism: 'De nos jours le pied est à peine la 7ᵉ partie de la figure' (351ʳ). Perfectly 'normal' procedures, such as that of having all the heads in a painting painted by one person, all the bodies by another, become bizarre as presented in Flaubert's words: 'il en résulte des désaccords choquants' such as turbaned figures in Alpine scenes or cheery rustics in an otherwise austere landscape by Hobbema (345ᵛ). Sometimes the deletion of just one word

[10] Flaubert's text is an almost *verbatim* transcription of Blanc.

[11] Cf. Blanc, p. 15: 'Oudry avait un talent si naïf et si honnête, qu'il n'a jamais pu illustrer convenablement le *Roman comique* de Scarron. Pour entrer dans le fond de cette conception grotesque, Oudry n'avait pas assez d'entrain, de gaieté et d'*humour*.'

[12] Vernet did this in order to observe the storm.

[13] This is Flaubert's formulation; CB is more verbose.

or two from the original is sufficient to create an irresistibly comic image in the reader's mind, which supersedes for ever the image of the original painting. Thus, two martyred saints by Valentin become puppets in Flaubert's hands: 'les deux patients sont étendus tête bêche sur un appareil mécanique' (341ʳ). Certain formulations evoke surreal visual images because the verb is too concrete: thus, Hogarth's portraits being so accurate that people shunned him, he 'se replia sur les folies & les travers de son temps' and then almost immediately 's'élève contre la ligne droite' and 's'insurge contre l'idéal grec' (335ʳ). Similarly, as a result of the dearth of nudes in Scotland, Wilkie has to 'se rejeter sur l'expression morale' (335ᵛ).[14] Imitators of Murillo, on the other hand, risk falling into roundness and blandness: 'Il est dangereux de copier Murillo. on tomberait dans la rondeur & le défaut d'accent' (339ʳ). Ribera is so aggressive that he eliminates his rivals one by one, including Domenichino, whom he 'abreuve de déplaisirs' (339ᵛ). Pater is up and down like a yoyo, 'tombé en discrédit, se relève aujourd'hui' (342ᵛ), while England shows a remarkable ability to make a little go a long way: 'L'Angleterre avait son Lenostre [*i.e. Hogarth*] dont elle fit son Michel Ange & son Raphaël' (335ʳ).

But, as is the case with Bouvard and Pécuchet and with the painters they study, what we might interpret as sense and what we might interpret as nonsense shimmer in and out of each other. Blanc's formulations are often sensuous, and can be relished for their own sake. In the following assessment of Bassano, the charm of Blanc's evocation is hardly punctured by the touch of comic bathos haunting the final phrase: 'rien de plus beau que ses manteaux rouges, que ses draperies jaunes qui sont éclairées avec du jaune de Naples, ombrées avec du giallo santo & qui dans les profondeurs du pli sont glacées avec un mélange de laque & de bitume. Il dit à son lit de mort "C'est à peine si je commençais à peindre" ' (347ʳ).

FLAUBERT HIMSELF

Flaubert's own feelings and opinions are caught up in his satire, too. These notes on painters are part of Flaubert's continuing private

[14] This is Flaubert's succinct paraphrase of a more diffuse explanation by Philarète Chasles.

project, his lifelong meditation on art. Sometimes, it is hard to detect any mockery at all. Flaubert's attraction to size, energy, and *trompe-l'œil* of particular kinds is surely responsible for the way he lingers over Blanc's description of Giulio Romano's huge frescos in the palazzo del Te in Mantua, which Flaubert himself never saw:

le plus étonnant morceau est la *salle des géants*. Le spectateur ne sait pas en entrant s'il est dans une chambre ovale, ronde ou quadrangulaire, il n'a devant les yeux que débris, ruines. les géants sont foudroyés de toute part s'ouvrent des échappées de vue qui agrandissent la salle à tel point qu'on se croirait dans une vaste campagne. Le pavé composé de pierres rondes se prolonge fictivement sur la muraille à la hteur de la plinthe de sorte qu'on ne peut savoir où le vrai pavé commence, où le vrai mur finit. Sitôt qu'on allume la cheminée des géants apparaissent dévorés par la flamme du foyer. (346r)

I see no mocking intent there, from any angle, nor in the manifestation of interest in the marriage of fantasy and attention to detail, as exemplified by Dürer, 'ses tableaux comme ses estampes réunissent le plus vague spiritualisme & une exécution minutieuse' (351r). Flaubert singles out this particular Dürer which is the painting of a dream he had had: 'une aquarelle de la collection Ambras de Vienne représente une immense nappe entre des terrains plats où s'élèvent quelques maisons, nuage, vapeur, c'est un songe qu'il a eu & qui est écrit au dessous de sa peinture' (351r). 'Nuage, vapeur [. . .], songe': there is even a mirage, in Poussin's *Polyphème*: 'cette colossale figure baignée dans les lumières supérieures produit l'effet d'un mirage immense' (340r).

Interest in the problematic reading of pictures continues to condition certain of Flaubert's notations. Joshua Reynolds's portrait of Dr Hunter is adorned with a skeleton's dangling feet, to which Blanc himself turns a blind eye (Pl. 10). But Flaubert himself notes this background detail from the illustration (335v). Is this a case of comic over-appropriateness on Reynolds's part? If we laugh, are we philistines?

Elsewhere still, cherished ideas are once more in play, and always with the sense that a lot more would need to be said. Most commentators were worried by the formal consequences of too great a concentration in art on the variety of life. With Flaubert's note on Blanc's appraisal of the early Naturalism of Velazquez we are back with the idea of 'tout sur le même plan' which dogged Flaubert through the whole of his writing career, and of which Blanc

is wholly critical (Flaubert's text here is part verbatim, part summary (Blanc, 'Velasquez', p. 5)): 'si vous considérez l'art comme une simple contr' épreuve de la nature, tout en elle vous enchante. vous attachez à tout la même importance et vous ne sacrifierez aucun détail—les plans se confondent la valeur relative des tons vous échappe et pour avoir mis partout de l'accent vous tombez dans une dureté inévitable' (343r). This opinion looks perfectly reasonable, but leads to unwarranted dismissal of certain painters and paintings. Thus, the 'pro-life' Hogarth was criticized by academically minded critics for having too much accessory detail, as Blanc himself reports ('J. Reynolds et Horace Walpole ne l'ont pas regardé comme un peintre.—La multitude de ses accessoires désoriente le regard', 335r); and Caravaggio's 'materialism' also led to accusations of aesthetic disorderliness: 'il méprise dans la composition l'ordonnance, la symétrie—il donne la plus grande partie d'une œuvre à l'ombre. ses figures s'enlèvent brusquement du noir au lieu de sortir de la demi-teinte, elles demeurent au [*sic*] trois quarts sacrifiées dans l'ombre. Mais un rayon lumineux lui suffit pour les faire saisir toute [*sic*] entières au spectateur' (349v). Too great a concentration of accessory detail is agreed to be a defect. Blanc criticizes the painter Feti on this account: 'il a tant accumulé de pittoresque que la figure principale a perdu presque tout son intérêt' (346r). Cortona is guilty of a quite astounding reversal of primary and secondary interest, relegating his main characters firmly to the background: 'insouciance du sujet, désaccord entre l'idée & les moyens pittoresques qu'il emploie pour l'exprimer. Dans *l'alliance de Jacob & de Laban* il rejette au second plan les acteurs principaux' (349r). Yet the more one reads such criticisms, the more limited they appear to be; and they are counterbalanced by another remark which Flaubert notes from Blanc whereby the triumph of accessory detail may be seen as a 'faute héroïque' (as it is in *L'Éducation sentimentale*). In Terburg's painting, *L'Instruction paternelle*, for example, Terburg lets the grey satin dress run away with him: '*L'instruction paternelle* ou = *la robe de satin*. La robe a plus d'importance que tout le reste, la tête est cachée. "ce triomphe inusité d'un tel accessoire est devenu une faute héroïque" ' (355v). The triumph of the accessory over the main subject, of background over foreground—we have seen Flaubert's preoccupation with these before, and it remains acute.

This essential question—of how far beauty can accommodate discord—is in the event incorporated into *Bouvard et Pécuchet*, in

the form of a farcical one-liner from Bouvard, to the effect that crossed eyes are less beautiful than eyes that are not crossed, *usually*: 'deux yeux louches sont plus variés que deux yeux droits et produisent moins bon effet,—ordinairement' (5: 148).

Other aspects of Flaubert's aesthetic are reflected, parodied, or called into question by being too rigorously and formulaically applied. 'De la forme naît l'idée', certainly; but is that dictum illustrated satisfactorily in Mignard's technique for the dome of the *Val de Grâce*, whereby he paints contemporary figures clearly while altering the tones for the figures who are more distant in time?: 'Il a accusé avec plus de force le groupe d'Anne d'Autriche encore vivante pendant qu'il éloignait par la dégradation de tons les groupes des Martyrs les héros de l'Église et de l'ancien testament à mesure que ces héros s'éloignent de nous, & s'enfoncent dans la perspective de l'histoire' (336ᵛ).[15]

L'art pour l'art is another notion cherished by Flaubert. But how then are we meant to read the following? Is Monnoyer really wrong to eschew 'l'exactitude botanique' out of 'l'amour de la peinture'? Or is the whole statement simply out of focus? Is botanical exactitude part and parcel of 'l'amour de la peinture'?:

deux espèces de peintres de fleurs, les uns les peignent par l'amour des fleurs, les autres par l'amour de la peinture. ici les fleurs sont le prétexte d'un tableau qui représente une gamme s'élevant par l'hyacinthe presqu'au blanc d'ivoire ou par le lis jusqu'au blanc de porcelaine, & descendant par la scabieuse jusqu'au violet brun—d'autres s'attachent à l'exactitude botanique—à la localité de ton, & à force de s'occuper des parties négligent l'ensemble [. . .]. une faute singulière qu'il fit est de mélanger dans le même bouquet des fleurs d'automne & de printemps. ce qui prouve que les fleurs n'étaient pour lui qu'un objet de décoration. (338ʳ)

'Les vrais artistes n'admirent chez les autres que ce qu'ils ont eux-mêmes au fond du cœur' (Blanc, 'Guercino', p. 2). This comes close to describing Flaubert's own position, though 'admire' is too strong. What Flaubert chooses to note from Blanc could often apply to himself. He is Zurbarán, 'aussi mystique dans la pensée que brutal dans le maniement du pinceau (339ʳ); Hogarth, whose realism, 'si vrai qu'on s'écarta de lui', is envisaged as a means of attack: 'Alors il se replia sur les folies et les travers de son temps'; Valentin:

[15] Blanc (p. 13) criticizes Mignard for this.

il y a une classe de peintres qui dédaignent le mysticisme, l'expression <idéale> mais s'ils rencontrent des palpitantes [*sic*] se détachant sur un fond noir, ils s'enthousiasment ce qui leur plaît c'est l'énergie du mouvement, le bonheur des raccourcis. toutes les formes de la nature leur plaisent. Ils ne demandent pas à la matière de penser mais d'être. Parmi ces panthéistes se trouvent surtout les admirateurs de Valentin. (341ʳ)[16]

Above all, Flaubert is detectable in Craesbeke, the only Flemish painter in the selection. A showman and a *saltimbanque*, Craesbeke is a new reincarnation of the Garçon, and always goes too far: his idea of testing whether his wife loves him is to paint a huge red wound on his shirt and pretend to be dead (353ʳ).[17] He is given to self-parody, pulling faces in the mirror (like Flaubert delighting in watching himself shaving) or painting a portrait of himself adorned with a huge eyepatch and a horrible grimace (353ʳ): 'seul, parfois, dans ma chambre, je fais des grimaces dans la glace ou pousse le cri du Garçon' (*Cɪ* 137). In the same way, the painters in these notes present a disguised version of Flaubert's temperament, tastes, and preoccupations.

We can only regret that Flaubert decided in the end to 'cut' this sequence. The Blanc *dossier* remained unused, a further testimony to Flaubert's way of first enjoying and then suppressing the painterly.

[16] Flaubert begins here by paraphrasing the opening words of Blanc's text. The inverted commas 'mais s'ils rencontrent [. . .]' mark the beginning of Flaubert's approximate quoting of Blanc. The quotation ends at 'fond noir'; the rest is paraphrase. Flaubert has omitted the word 'chairs' before 'palpitantes'.

[17] Blanc's text is more detailed than Flaubert's.

7

Figural Sources and Models

Pictorial art is a major source of inspiration for Flaubert, as much as written sources, if not more so.[1] Flaubert draws heavily on pictorial art as a source and as a model. He then subsequently submits it to a process of elision, narrativization, or rationalization, never giving it its head.

SOURCES

A great deal of work has been done on this aspect of Flaubert's writing,[2] so I will confine myself to a few points. Flaubert makes use of pictorial sources in different ways. They often cut in at points where he feels his imagination is flagging.[3] The point has often been made that Flaubert frequently uses figural sources for descriptions which appear from the text to be entirely his own invention. This sort of thing must occur even more frequently than has yet been recognized, as Flaubert never gives any sign in the text that he is using a figural source. Who would have thought, for example, that the following semi-industrial landscape, observed by Frédéric, actually has its source in an engraving?

[1] Cf. R. Debray Genette, 'Flaubert: Science et écriture', *Littérature*, 15 (Oct. 1974), 51: 'Flaubert choisit le pictural plus que le référentiel'. Seznec, '*Madame Bovary* et la puissance de l'image', *Médecine de France*, 8 (1949), is more cautious, and accurate: Flaubert does still base a great deal of his text on texts. Indeed, Seznec's own study of the sources of the *Tentation* shows implicitly that written sources tend to dominate in the first half of the *Tentation* and figural in the second.

[2] See Bibliography for studies by, esp., Seznec, Fairlie, Castellani, and Reff.

[3] See Seznec (notes on art, Taylor Institution, Oxford): Flaubert's 'imagination tourne court—Ou plutôt, il semble qu'il n'ose pas inventer lui-même'. Cf. Flaubert's complaints at the lack of figural sources for *Salammbô* (C2 750) and also his letter to Renan on the *Tentation*: 'Je suis fort à sec quant aux renseignements sur les Dieux de la Perse et sur les Dieux de l'Inde. Connaissez-vous ou plutôt avez-vous quelque chose de précis (et de plastique) qui puisse me servir?' (C4 338: 17 June 1871).

La verdure monotone la faisait ressembler à un immense tapis de billard. Des scories de fer étaient rangées, sur les deux bords de la route, comme des mètres de cailloux. Un peu plus loin, des cheminées d'usine fumaient les unes près des autres. En face de lui se dressait, sur une colline ronde, un petit château à tourelles, avec le clocher quadrangulaire d'une église. De longs murs, en dessous, formaient des lignes irrégulières parmi les arbres; et, tout en bas, les maisons du village s'étendaient. (3: 205)[4]

Such ekphrasis, however, is rare. More usually, the original source is attenuated. Raymonde Debray Genette, for example, has pointed out that 'les *Trois Contes* reposent chacun sur la narration d'un vitrail ou d'une sculpture',[5] but that the tales are in no sense a 'copy' or a 'translation' of the original image: plastic representations are 'toujours subordonnées finalement à des effets propres à l'écriture: celle-ci est capable de suggérer sans jamais traduire ni copier'.[6] Thus, in another example from *L'Éducation sentimentale* (3: 282), what began as an illustration in *Le Musée parisien*, depicting the torchlit procession of corpses after the *fusillade du boulevard des Capucines* in February 1848, ends in Flaubert's text as a distant rumble, which wakes Rosanette and is never explicitly accounted for in the text (if the reader did not 'know' what was causing the sound she might suppose it was the sound of symbolic thunder—which in a sense, of course, it *was*).[7] The distant rumble is Flaubert's way of reflecting the distancing of his source. The point has frequently been made that this is how Flaubert treats *any* source, not just a pictorial source. More often than not, also, the figural source combines with other impressions in a slow process of layering (the *spirale*).

[4] Cf. *L'Éducation sentimentale* (Garnier Flammarion, 1985), 525 n. 136: 'A côté d'un brouillon de cet alinéa, Flaubert a écrit en marge: "Cabinet des Estampes" (ms N.A.F 17604 f°.100 recto). Source d'inspiration assez importante chez lui, comme l'a montré Alan Raitt'. See also ibid., n. 242: 'Le tronc sur une chaise, les caricatures renvoient à des estampes examinées par Flaubert (Raitt).' There are many other examples of Flaubert writing in the light of an unacknowledged picture in this way, e.g. the marginal addition to the *brouillons* of *Un cœur simple*, where Félicité prays for Victor at the foot of a calvary—'comme on représente les saintes femmes au pied de la croix'; see also V. K. Ramazani, *Flaubert and the Free Indirect Mode* (1988), 94, on Flaubert's use of a picture as direct source for images evoked ostensibly by the book Bouvard and Pécuchet are reading. See L. Czyba, 'Flaubert et la peinture', *Littérales* (1994): 'pour produire l'illusion du vrai, Flaubert a regardé des estampes' (p. 131).

[5] 'Les figures du récit dans *Un cœur simple*', *Métamorphoses du récit* (1988), 274.

[6] Ibid. p. 102 ('Comment faire une fin'). Biasi makes the same point in *Flaubert: Trois contes* (1993), 260.

[7] Cf. CHH 3: 440 notes from BMR, ms g 226[4], 144-5[r-v].

However, the more minimalist the source the more likely Flaubert is to *expand* it, rather than contract. That is often the case with images which are in black and white. It is as if he can control these at will, reliving his childhood habit of supplying 'couleur' and 'poésie' to a 'dry little sketch'.[8] As Seznec has pointed out, no sketch is too slight; 'un simple graphique' will do: 'Un ovale, des cercles reliés par des lignes courbes—cela suffit à l'imagination de Flaubert pour engendrer [une] vision étrange, d'une magnificence de rêve'.[9] We have already seen how Flaubert responds to mere lines, half-writing, half-drawing. Maps are similar. Seznec gives the example of Flaubert's extremely detailed evocation of the layout of the Imperial Palace in Constantinople (*TSA* 4: 54): 'The description of the Imperial Palace is magnificent—but it all hangs from the bare, linear, almost abstract framework of the plan.' When Antoine finds his way into the palace, gets lost, and finds his way again, this is a symbolic representation of Flaubert reading the map—'C'est que Flaubert a un plan sous les yeux'.[10]

Sources often emerge strangely altered from Flaubert's treatment of them. The original illustration of the god Knouphis, for example, is quite dull; but Flaubert's evocation in the *Tentation* allowed Redon to uncover depths of horror in it.[11] Maurice Sand's little cartoon-image of a skull on the end of an intestinal worm was sent to Flaubert as a joke, but in Flaubert's hands the joke becomes a nightmare, which, once again, Odilon Redon exploits: 'l'image de Flaubert [. . .] a dégagé, d'une donnée cette fois presque bouffonne, des ressources latentes d'horreur que Redon n'a fait qu'exploiter'.[12]

Flaubert's images do end up by being very much his own, whether grafted onto an original source or not. Both Taine and Baudelaire marvelled at Flaubert's bizarre little Queen of Sheba, with her mad talk and her hopping gait, for which Taine could identify no outside source.[13] Baudelaire was nearest the truth: however many pictures we might adduce as inspiration for this figure, the real source was Flaubert, and she is a 'miniature dansant sur la rétine d'un ascète'.[14]

[8] Cf. Seznec, '*Mme Bovary* et la puissance de l'image', 27: 'ces images dont s'inspire Flaubert sont en elles-mêmes très peu expressives; ce sont de sèches lithographies. Mais il les anime, il leur prête couleur et relief.'
[9] Ibid. 27.
[10] Ibid. 89. Mme Bovary uses a town plan of Paris in the same way (1: 98).
[11] Point made by Seznec, ibid. 88. [12] Ibid.
[13] 'Ou diable avez-vous trouvé ce type moral et physique et ce costume?' (letter of Apr. 1874).
[14] 'Madame Bovary, par Gustave Flaubert', *Curiosités esthétiques*, 651.

In some cases, the pictorial source is detectable in the text because of some strangeness. Flaubert often capitalizes on stasis. He does this to great effect in his depiction of the gods in the *Tentation*. The gods have *come alive*, but they still retain their original fixed, stylized appearance: 'Et tout cela se développe comme une haute frise . . .' (*TSA* 4: 120).[15] This does not happen just because Flaubert was a writer who 'fain would make a film';[16] the cardboard cut-out effect is vital, and reinforces the point that the gods are merely images, sad illusions, an expression of wishful thinking, which humanity does its best to infuse with life.[17] Many of the images in Flaubert's *Tentation* work in this way. Almost every one of St Antoine's visions retains something of the original image which inspired his creator; stylized, hieratic, each is wheeled on, so to speak, to say its piece. The same mechanism is apparent in other works: Emma twirls her lampshade, 'machinalement', and the little painted pierrots and trapeze artists come and go, while remaining eternally frozen in their painted poses (1: 135), or she creates an image from her reading (*The Bride of Lammermoor*?) of a dashing horseman frozen in mid-gallop (1: 81), or she is mesmerized (as Flaubert was) by the three-dimensional plastic art of the hurdy-gurdy, with its little painted figures which are static and yet turn and turn, like the awful mannequins of *Le Château des cœurs*;[18] in *Salammbô*, the life-like tigers in the Holy of Holies turn out in the end to be dummies moved by machinery. Culler (quoted by Robert Griffin, *Rape of the Lock* (1988), 262) observed 'that the figures which beset Antoine are no more frightening than cardboard cutouts'. But that is precisely what makes them frightening—after all, the most frightening monster of all is the statue of Moloch, and he is just a huge machine worked by strings. This obsession with

[15] For his portrayal of the gods, Flaubert uses Creuzer's *Religions de l'antiquité*, the illustrations as much if not more than the text.
[16] Point made first by A. Lombard, *Flaubert et saint Antoine* (1934), 97.
[17] Fellini, who owed so much to Flaubert, played on much the same effects of images 'coming alive' in his film based on Flaubert, *Le Tentazioni del Dottore Antonio* (an episode of *Boccaccio '70*, 1962): the hapless doctor, fixated on a busty idol (Anita Ekberg) displayed on a huge advertisement for milk, and torn between the desire both to suppress and to animate this image, can achieve no further success than to see her transformed from a static two-dimensional image into a huge, floating, alluring, but ghastly and ultimately terrifying plastic doll, a parody of all he ever wanted.
[18] Cf. L. Hourticq, *La Vie des images* (1927), 215: *L'Éducation sentimentale* too is 'un défilé d'images qui parlent'.

lifeless artefacts that are made to move by mechanical means must relate, parodically, to Flaubert's sense of his own artistry as a 'montreur de marionettes'.

Finally, there are the instances when images remain in the text, but as a subterranean presence, literally going to ground. H. Oliver has made a connection between the notes which Flaubert made in 1865 on the bas-reliefs of Assyrian horses in the British Museum, and the detail, much later, of Herod's subterranean cache of wonderful white horses in *Hérodias*.[19] The original image here has gone quite literally underground, lurking as Herod's special secret, in the very heart of his fortress. We could add to this the pictures in the inner sanctum of the Holy of Holies in *Salammbô* (2: 98), based on Flaubert's memory of wall-paintings in, respectively, the temple of Denderah (for the huge woman painted over two walls and the ceiling) and the tombs of the Valley of the Kings (for the animals and strange iconography).

Monumental blocks crammed with secret treasures—Hamilcar, too, possesses a secret inner sanctuary where he can feast his eyes, buried in his strange red palace with the black cross on the door. F. Besson has suggested that the source of this inner sanctum is the enormous tumulus known as the Médragen, which Flaubert noted in *Carthage* (C2 818),[20] and which was believed to contain fabulous royal treasures. Egyptian pyramids might also be suggested as a source. She also points out that Hamilcar's secret chamber is impossible to locate in Flaubert's description: these treasures come from another world.

The temple of Tanit, Hamilcar's treasury, Herod's fortress, Félicité's room, the Pyramids, Médragen, early Christian churches with their mosaics, Flaubert's head: all are magic places, sources of colour and wonder, behind their dull or seemingly impenetrable exteriors. It is, then, too sweeping to suggest that all Flaubert's visual sources, pictorial and other, are 'written out' as the text develops through its various manuscript drafts. They have ways of making their presence felt. Images and the response to images are a powerful subtext throughout the whole of Flaubert's *œuvre*.

[19] H. Oliver, *Flaubert and an English Governess* (1980), 161–4.

[20] F. Besson, 'Le Séjour de Flaubert en Algérie', *Amis de Flaubert* (May 1968), 38 ff.

MODELS

Flaubert himself was the first to make the point that his writing was subject to various mechanisms of control: control of Romantic tendencies, of lyricism, of metaphors—and of pictorialism. After the apprenticeship years, prose, for Flaubert, is the art of occlusion and exclusion, the eradication of everything which, in a telling phrase, 'fait plaisir': 'La prose, art plus immatériel (qui s'adresse moins aux sens, à qui tout manque de ce qui fait plaisir), a besoin d'être bourrée de choses et sans *qu'on les aperçoive*. Mais en vers les *moindres paraissent* [. . .]. Il y a beaucoup de troisièmes et de quatrièmes plans en prose' (C2 446). He resisted obvious pictorialist writing, in the same way as he resisted his natural inclination to over-exuberant use of metaphor (C2 220). During the writing of *Madame Bovary*, he eggs himself on with reminders to himself of huge pictorialist effects. The composition of the *comices agricoles* section (which is to be 'énorme', C2 386), is accompanied in the correspondence by references to a medley of painters and writers, all of whom are associated in his mind with cultivation of the art of excess—Molière, Shakespeare, Hugo, Michelangelo, and Rubens (C2 385). 'Il ne faut jamais craindre d'être exagéré' (C2 356). Plastic description is clearly only one means to this end, though Lheureux opines that the insertion of a little bit of Venetian colour—'deux mâts vénitiens' (1: 176)—would have improved the effect of the *comices agricoles* considerably. Eventually, as we know, Flaubert will reach the point where he envisages writing as the 'mur tout nu', without pictures (15: 446: 3 Apr. 1876).

Flaubert's resistance to the overtly pictorialist springs from a variety of causes: the fear of disunity, mistrust of stasis, an inclination to believe that descriptions are for the learner and that this kind of writing has had its day, and perhaps the realization that the 'description orphique de la Terre', which was a *tentation* for him as much as for Mallarmé, was impossible.[21] Whatever the reason,

[21] The process begins in the aesthetic of 1845, with Jules making a deliberate decision to wean himself off rich, lyrical descriptive writing, and continues through *Par les champs*, where it is Flaubert's turn to bid farewell to Chateaubriand, cf. his pastiche of the master's style in chapter 11 (see introduction to my edn., 1987). A.-M. Christin (1977) has made the point that Fromentin's *Dominique* is essentially description with narrative intrusions, and I shall be arguing that for Flaubert too description at the very least occupies a privileged position. Flaubert himself (like Genette, much later) was dubious about attempts to distinguish description from narrative: C4 850, 'narration descriptive ou description narrative'.

Flaubert continually emphasizes the need to attenuate the image: the spiral has to turn, the 'ventrée de couleurs' has to be digested, and 'mêlée au sang des pensées', and everything that gives pleasure has to be removed. But banishing 'ce qui fait plaisir' proved to be no easy matter. Each of his books represents a different kind of encounter with the pictorialist *tentation*.

(i) Madame Bovary

It was during the writing of *Madame Bovary* that Flaubert first attained a *modus vivendi* with pictorialism. Everything that was suppressed from *Madame Bovary* takes refuge in Flaubert's correspondence. The letters of the *Madame Bovary* years are full of references to painters and painting and related subjects, far more so than at any other time: he continually uses the language of painting, and reflects on the power of painting *vis-à-vis* writing. This is also the period when he refers most to photography and the threat it constitutes to both painting and literature. He is continually trying to carve out a domain for writing separate from the pictorial arts. Even in the later years, when he is writing *Bouvard et Pécuchet*, he still yearns for the *régals de couleur* which are excluded from this 'roman philosophique' (16: 317).

Pictorialist effects certainly have a way of creeping in unwanted. Rereading the first half of *Madame Bovary* for the first time, Flaubert notes their insidious presence: 'par-ci, par-là certains chics pittoresques inutiles; manie de peindre quand meme, qui coupe le mouvement et quelquefois la description elle-même [. . .]. Il ne faut pas être gentil' (C2 333: 26 May 1853).[22] *Madame Bovary* in fact contains the same range and kinds of descriptions as Flaubert's travel writing: from traditional to modern, from great set-piece descriptions to lighter, more allusive pieces. Some of the descriptions in *Madame Bovary* are even direct reworkings of these earlier models: thus, the description of Yonville church (1: 148), with its chiaroscuro and play of different kinds of light reflects the description of Carnac church in *Par les champs* (270–1) (and elements of these descriptions, pared down, recur in *L'Éducation sentimentale*, 3: 361).

[22] Even Debray Genette, who has resisted the idea of a pictorialist Flaubert, admits that the description of Homais's pharmacy is 'traitée dans le style d'un Rembrandt qui aurait trempé son pinceau dans les bocaux d'Homais', *Métamorphoses du récit* (1988), 298.

The following is a classic example of the Flaubertian landscape in *Madame Bovary*, similar to those we have already seen in his travel writing: there is a sense of the incomplete (an interrupted view, and mistiness), a *tentation* for the eye (the river snaking away), a sense of movement in the verbs ('passait' 'marchaient'), but an insistence on the cattle's silence, as if this were a painting ('on n'entendait ni leurs pas, ni leurs mugissements'), with the peaceful but melancholy bell adding a dimension to the scene that painting alone could only suggest:

Par les barreaux de la tonnelle et au delà tout alentour, on voyait la riv-ière dans la prairie, où elle dessinait sur l'herbe des sinuosités vagabondes. La vapeur du soir passait entre les peupliers sans feuilles, estompant leurs contours d'une teinte violette, plus pâle et plus transparente qu'une gaze subtile arrêtée sur leurs branchages. Au loin, des bestiaux marchaient; on n'entendait ni leurs pas, ni leurs mugissements; et la cloche, sonnant tou-jours, continuait dans les airs sa lamentation pacifique. (1: 147)

This is a beautiful landscape, but one that would offer no surprise to a contemporary reader. Others are ahead of their time. New images, of the modern world, are also present, as when Flaubert deliberately sets out, somewhat ironically, to 'give a view' of Rouen ('j'ai la prétention de *peindre* Rouen' C2 575). Rouen duly appears, with its factory chimneys and working ships, laid out 'comme une peinture', some years before such semi-industrial scenes were customary in painting (1: 283).[23] Flaubert's evocation of Yonville's half-built cotton mill (1: 138) is modern not only in subject but in style as well: it is atmospheric and enigmatic, full of unexplained signs and traces.

Flaubert continues to adhere to the pictorialist tradition, then, despite his stated reservations. But his case is not so clear-cut and uncomplicated as that of, say, Gautier, who peppers his texts with celebratory descriptions of scenes and artefacts. Critics have been much exercised by the question of whether Flaubert's 'set-piece' descriptions are actually recuperated by the narrative or not. Culler and Prendergast have both argued against Sherrington's inference of Point of View: can it really be Charles who sees the fine details of dust and ash in Emma's kitchen, and the delicate patterns of the light (1: 67)?

[23] An earlier version of this landscape compares the effect to that of a print, cf. *MB nv* 524: 'navires [. . .] dont les mâts comme des aiguilles perçaient le ciel gris avec une immobilité d'estampe'.

Various answers have been suggested. The most convincing seems to be the idea that these descriptions are aesthetic guarantors; Ramazani has coined the term, 'Free Indirect Mode', to describe the kind of writing illustrated in the last example quoted. This mode is freer than either focalization or Free Indirect Discourse.[24] The question of whether Charles actually *saw* these details or not is irrelevant; the word-painting simply acts as an indirect equivalent to his feelings (and its beauty and delicacy means that most readers then assume authorial approval). The same could apply in connection with many other evocations, where the question of a viewer is similarly left open. The fact that the description of Emma beneath her parasol is like a painting adds a dimension to the scene, giving the reader a sense of beauty and making her believe that this echoes something of what Charles may be experiencing. In these descriptions art is all around, giving value. These visions 'hang in the air', so to speak, unattached, as if they are an intrusion from another world—or genre! This is a privileged moment, thematically and stylistically—description evokes an *ailleurs* which narrative almost cannot contain.

Though Flaubert refuses to hang these descriptions on the peg of a particular observer, they do seem often to be implying some moral dimension. Charles, for example, seems to be more in tune with such intimations of beauty than Emma.[25] 'Plus sentimentale qu'artiste, cherchant des émotions et non des paysages', Emma is usually depicted as averting her eyes, registering other things, or trying to retain and possess this impossible absolute through some more concrete satisfaction. The beautiful evening landscape referred to earlier, which she seems to be observing, simply propels her into the arms of the Church, thanks to the tolling bell; later, a misty October landscape (1: 190–1), with the whole of nature expectant, propels her into the arms of Rodolphe; both Church and Rodolphe being a local manifestation of something far greater than themselves. Sometimes, it is almost certain that only the reader is looking, as in the description of the half-built cotton mill—Charles is suffering too much from the cold, Homais is measuring and hypothesizing,

[24] Aesthetic guarantors: P. Brooks, *Reading for the Plot* (1984), 182; cf. J. Barnes (ironically) on 'approving lyricism', *Flaubert's Parrot* (1985), 113; Ramazani, *Flaubert and the Free Indirect Mode*.

[25] Cf. M. Girard, *La Passion de Charles Bovary* (Editions Imago, 1995) and D. Knight, *Flaubert's Characters* (1985), both of whom make a strong case for seeing Charles as a figure of the artist.

Léon is raising his blue eyes to the sky, Emma is looking at the sun, at Charles, at Léon. It is not clear that anyone but the author and the reader are contemplating the mill. This could suggest that the characters are missing something—beauty, for example—or some moral that might be drawn from the scene: Emma could learn something—about herself, about Yonville, about the future that may await her daughter—if only she looked at the building-site. The same could be said of the ancient summerhouse where Emma sits and broods. It is beautifully evoked by Flaubert. But Emma seems to see, at most, *only* its peeling paint, which reinforces her depression. And does either Emma or Léon admire the wonderful brassy tints of the oil floating on the water in Rouen docks? As Flaubert himself points out in an early comment, aesthetic appreciation requires peace of mind: 'Ne faut-il pas avoir l'âme vide pour chercher à regarder la nature avec plaisir?' (*IS* 10: 355)

Thus, while the pictorialist scenes and descriptions of *Madame Bovary* are attached to the narrative, they seem often to be attached only by contrast, as alien visitors affording glimpses of another world.

(ii) Salammbô

Despite all Flaubert's efforts, *Salammbô* did not convince the critics that Flaubert had succeeded in his aim of toning down his picturesque effects. For several critics, it was precisely his painter's eye that prevented Flaubert from communicating a sense of structure: 'Il a bien "l'œil du peintre", comme on dit; aucun détail, aucun effet partiel ne lui échappe, il *finit* le morceau; mais saisit-il l'ensemble, sait-il *composer*, ce qui demande plus que le regard juste et net [. . .]?' (2: 407).[26] Flaubert did not attempt to deny that *Salammbô* remained a highly visual and descriptive novel, despite his successful attempts to tone it down. But he defended himself vigorously against the charge that the descriptions in *Salammbô* were gratuitous ('Il n'y a point dans mon livre une description isolée, gratuite', *C3* 278). I think this statement was correct. The descriptions are there because 'looking' is one of the novel's main themes.

[26] Alcide Dusolier, article in the *Revue française* (31 Dec. 1862: CHH 2: 402–10).

Nathalie Sarraute makes an extremely astute criticism of *Salammbô*, which is wrong but thought-provoking.[27] She argues that unless we can flesh out Flaubert's evocations by recourse to external knowledge (our having seen depictions of ancient triremes and the like), we are left with a sense of flatness and lifelessness, which only 'subjective description' could have avoided. I would argue that that is precisely what *Salammbô* does give us. 'Seeing' and 'looking' are major themes in the novel. Eyes have an almost physical power: they devour, penetrate, wound, and frighten. Most of the novel is narrated from the point of view of the Barbarians, or of Mâtho as their representative. The novel is the story of their sentimental and intellectual education, as they learn, progressively, to decode what they see. In the early stages, they are mostly in a fog, surrounded by blur, glitter, and mistiness, partly as a result of their own lack of insight, partly because they are unfamiliar with the sign-system of the Carthaginians, partly because these strange representatives of High Capitalism do everything they can to remain opaque, or act in such a way as to beggar belief: 'Quel est ce peuple [. . .] qui s'amuse à crucifier des lions?' (2: 62). Enigmatic effects abound. In chapter 1, the puzzled Barbarians peer through a mixture of mist, fumes, and smoke at strange fragments, weird transformations, and a plethora of images, as the convex mirrors 'multipliaient l'image élargie des choses'. Impression precedes identification: fish are jewels on the move before they are fish (since jewels are embedded in their mouths). Flowers form 'longues paraboles' (2: 49), signifying nothing they can read. Salammbô herself, almost lost to view in her glittering snake-like robe (as Flaubert feared she would be!), appears to the Barbarians as a 'songe'. She speaks to them in song, but they do not know the language, and the image evoked by her words, though strong and clear, is entirely nebulous—just so many ghosts in clouds, as the text puts it. Surreal effects are everywhere, not just here but later in the text, too, as when a lion's head suddenly appears, seeming to be growing out of leaves (2: 61).

But eventually the Barbarians attain insight, along with a sense of solidarity and humanity. Typically, this coincides with the point at which they die and the novel comes to an end. This process—of attaining insight—mirrors the process undergone by Flaubert

[27] Sarraute, 'Flaubert', *Partisan Review* (Spring 1966), 199, quoted M. Praz, *Mnemosyne* (1970), 171.

himself in the writing of *Salammbô* which he called 'fixer un mirage' (*C3* 276). In the early stages of writing, he is himself bemused: 'Que sera-ce? Je l'ignore' (*C2* 783). Significantly, a mirage occurs at the very centre of the novel, constituting a *mise en abyme* of the process of writing the novel and the process enacted in the novel's narrative (2: 155–6). Hamilcar, master of strategy and disguise, advances on the Barbarians. Impression precedes explanation: half-concealed by sand devils, his soldiers are metamorphosed into winged bullocks because of the horns on their helmets and their billowing cloaks, and the army becomes simply 'quelque chose d'énorme'. 'Ceux qui avaient beaucoup voyagé' suggest this is just a mirage, but little do they know: the army's slow approach allows the Barbarians gradually to distinguish the still undecoded 'barres transversales' bristling with points and the objects that resemble black hillocks on the move. Finally, clarity comes: the transversal bars are soldiers and the hillocks are elephants, and these are 'Les Carthaginois!', but when clarity comes, it is once again too late—text and life alike are based on the failure to comprehend.

The first version of the *Tentation* was already a text about look-ing, but it had remained unpublished. *Salammbô* represents a further attempt at the same theme; and the final version of the *Tentation* takes it up once more. Significantly, the *Tentation* too was regarded in much the same way as *Salammbô*, that is, as a 'délire visuel', an overflow channel for Flaubert's visual obsessions.[28] In a sense, as we have seen, the *Tentation is* a conduit for images, but the channel is far more self-critical than is generally recognized; the *Tentation*, like *Salammbô*, does not simply reflect or encourage an obsession with images, but is *about* that obsession. The final version emphasizes the visionary even more than the first:[29] the reader

[28] Cf. M. Hadad, in S. Michaud *et al.* (eds.), *Usages de l'image* (1992), 101: the traditional role of the *Temptation of Saint Anthony* for artists has been to allow them to 'évacuer sans risques leur trop-plein d'images folles et de visions terrifiantes ou grotesques'. The introduction to the CHH edn. of the *Tentation* calls it 'le délire visuel de Flaubert' (4: 24).

[29] Lombard, *Flaubert et Antoine* 52, argues that a shift is apparent between *TSA1*, which presents Antoine's visions as allegories and *TSA3*, which insists on the vision-ary aspect. Cf. also L. Hourticq, *L'Art et la littérature* (1946), 195: the first *TSA* is 'lyrique et oratoire', the second plastic and visual: 'dans l'intervalle, Flaubert avait emmagasiné des images'.

is continually reminded that Antoine is *looking*,[30] and it is Antoine's
final *vision* which almost unhinges him completely.

(iii) Fontainebleau: the Final Fling

Mespoulet has referred to the 'admirables natures-mortes de
l'*Éducation sentimentale*' as being 'les poèmes et les refuges de
Flaubert'.[31] That is true; but 'mortes' is the operative word—
L'*Éducation sentimentale* is both a tribute to traditional pictorial-
ism and a move away from it. The Fontainebleau sequence is a brief
idyll threatened, not only for Frédéric but for Flaubert too. It is
Flaubert's farewell to the great set-piece landscape.

The Fontainebleau episode (3: 312 ff.) was written in 1868 and
drew on Flaubert's notes of his recent fieldwork visit to
Fontainebleau in the month of July.[32] However, it draws on a
palimpsest of records and memories of earlier visits too, not only
on those recounting his own brief idyll at Hampton Court with Juliet
Herbert in 1865[33] but others going further back to his youth
and his earliest experiences of writing and of *tourisme artistique*:
notably Chenonceau (*Par les champs* (1848), chapter 1)—it too, like
Fontainebleau, charged with associations with Diane de Poitiers
—and, further back still, the musée Calvet in Avignon (1845),
Flaubert's first evocation of the particular blend of nature and art
which characterizes the charm of Fontainebleau. At Fontainebleau

[30] Hilarion actually reminds Antoine of that fact, 4: 66 ('comme tu laisses ton imagination t'offrir des banquets, des parfums [. . .]'); and the term 'hallucination' is used at one point in a stage direction, 4: 91.

[31] M. Mespoulet, *Images et romans* (1939), 118. On Fontainebleau cf. also Hourticq, *L'Art*, 231 ff. On the relationship between Fontainebleau and Barbizon cf. T. J. Clark, *The Absolute Bourgeois* (1973), 79–80 (Flaubert is not mentioned). Frédéric's retreat to Fontainebleau is reminiscent of Delacroix's withdrawal to Champrosay in Sept. 1848, where he painted large-scale studies of fruit and flowers: 'They were, finally, Delacroix's response to the events of revolution—a deliberate, grand withdrawal to a world of private sensation, a world of traditional, painterly problems' (ibid. 131).

[32] Cf. CT 419–27 (*Carnet* 12, 39ᵛ–27ᵛ) and C3 768 and 785.

[33] Flaubert's remark to his niece that he had seen in London 'beaucoup de choses très curieuses et plusieurs qui me seront fort utiles pour mon roman' (C3 447) no doubt refers mainly to experiences unconnected with painting. Oliver, *Governess*, 156–61, speculates as to what some of these experiences might be—the visit to Cremorne pleasure gardens, no doubt, which she rightly associates with the 'Alhambra' episode in *ES*; but also the visit to Hampton Court which anticipates in some respects the 'Fontainebleau' episode, especially in the association of human intimacy (Flaubert and Juliet) with the appreciation of art.

nature and art work together in perfect harmony, the paintings glittering in the sun, the blue sky adding a further dimension to the colouring of the beams,[34] and the paintings, in return, peopling the landscape, just as they had done in Flaubert's evocation of the portraits of the ducs de Beauvillier at about the same time in *Par les champs*:

Les dix fenêtres en arcades étaient grandes ouvertes; le soleil faisait briller les peintures, le ciel bleu continuait indéfiniment l'outremer des cintres; et, du fond des bois, dont les cimes vaporeuses emplissaient l'horizon, il semblait venir un écho des hallalis poussés dans les trompes d'ivoire, et des ballets mythologiques, assemblant sous le feuillage des princesses et des seigneurs travestis en nymphes et en sylvains. (3: 313)

The forest, in Flaubert's evocation, is a period-piece, pure Barbizon,[35] a fact reflected in Flaubert's inclusion of the little image of the painter: 'Un peintre en blouse bleue travaillait au pied d'un chêne, avec sa boîte à couleurs sur les genoux. Il leva la tête et les regarda passer' (3: 315).[36] There are many examples of the kind of landscape favoured by the Barbizon school in Flaubert's evocation of the forest of Fontainebleau, just as there were in his travel writing of the 1840s:

La lumière, à de certaines places éclairant la lisière du bois, laissait les fonds dans l'ombre; ou bien, atténuée sur les premiers plans par une sorte de crépuscule, elle étalait dans les lointains des vapeurs violettes, une clarté blanche. Au milieu du jour, le soleil, tombant d'aplomb sur les larges

[34] Cf. R. Griffin, *Rape of the Lock* (1988), 248: 'Paintings, artifacts and trappings in the museum's [sic] compartments require external assistance from sunshine, sky and forest before the scenes of late sixteenth-century mythological ballets "seemed" to come alive.'

[35] Cf. Huysmans, *L'Art moderne/Certains* (1975), 105, on the hackneyed nature of the traditional landscape, the 'site', in which Huysmans specifically includes Fontainebleau, and with which he contrasts Raffaelli's modern, less comfortable vision.

[36] As Hourticq rightly points out (*L'Art*, 231), 'C'est une manière de nous rappeler qu'il [*the Barbizon painter*] est notre initiateur.' He also makes the point (*La Vie des images*, 216) that Frédéric and Rosanette would have been unlikely to see in 1848 what Flaubert himself could only describe in 1868 with the benefit of hindsight and familiarity with the work of particular painters such as Rousseau and Diaz: 's'il a pu voir tant de choses dans un sous-bois, c'est parce que, depuis 20 ou 30 ans, toute une école de peintres paysagistes s'appliquaient à les découvrir [. . .] ces pages n'ont pas été écrites d'après nature; elles copient des peintures de Rousseau et de Diaz. A une pareille date, chez des amoureux en fugue dans la forêt, de telles impressions sont tout à fait prématurées, parfaitement invraisemblables.' But Frédéric was perfectly capable of seeing with an artist's eye.

verdures, les éclaboussait, suspendait des gouttes argentines à la pointe des branches, rayait le gazon de traînées d'émeraudes, jetait des taches d'or sur les couches de feuilles mortes. (3: 316)

There are glimpses of the infinite, the blue sky caught briefly 'entre les cimes des arbres', paths taking the eye. There are also echoes of an older tradition of pictorial representations—here, once again, *Par les champs* has left its mark: 'On pense aux ermites, compagnons des grands cerfs portant une croix de feu entre leurs cornes, et qui recevaient avec de paternels sourires les bons rois de France, agenouillés devant leur grotte' (3: 315).[37]

However, this is 1868, not 1847, and by now the Barbizon figure is beginning to seem like a figure from the past. Flaubert's Fontainebleau does not stay in this mood of gentle nostalgia. New forms are apparent. The signs of primeval struggle in the ancient forest trees suggest that there is more to nature than was caught by the Barbizon school; in addition, Brooks has remarked on the strange 'proto-cubist landscape' of the equally ancient rock formations.[38] Also, history intrudes, not only in the reminder of Titanic struggles, of which the June Days are a contemporary local manifestation, but also in the form of tourism—Rosanette ignores the *paysage* in favour of the Caverne-des-Brigands with its little café and the man with the vipers, who was an acknowledged tourist attraction:[39] there are snakes in this Eden. Flaubert's evocation of the forest is similar to that of the Goncourts in *Manette Salomon* (1867, fictional time *c.*1853), which also does not ignore this aspect of the modern world. Poverty is another, and this only Flaubert includes. As T. J. Clark has pointed out, Barbizon was an outpost in a weird and alien countryside, whose strangeness had been noted even by the officials who filled in the government *Enquête* of 1848:

[37] Cf. *PCG* 108 for an evocation of St Hubert (who also meets a stag).

[38] Brooks, *Reading for the Plot*, 201.

[39] Cf. Anatole in Fontainebleau: 'Il passait des journées avec l'homme des vipères, le vieux aux deux bâtons et aux deux boîtes de reptiles. Il allait causer avec le vendeur d'orangine de la Cave aux Brigands.' Goncourts, *Manette Salomon*, ed. M. Crouzet (Gallimard, Folio, 1996), 350. Cf. Flaubert's comments on the 'Fontainebleau' episode in *Manette Salomon*, *C3* 702 (13. Nov. 1867): 'Fontainebleau m'a semblé un peu long. Pourquoi?' His dissatisfaction with the Goncourts' treatment of Fontainebleau must have affected his own version. For the relationship between *Manette Salomon* and *L'Éducation sentimentale*, cf. *Manette Salomon*, Crouzet edn. (1996), 10 ff.

Barbizon in 1849 was not exactly a respite from conflict. The forest of
Fontainebleau, like every area of woodland around Paris, had been in tur-
moil since the revolution [. . .] in the middle years of the nineteenth cen-
tury the forest was no place to go looking for an idyll. The woodcutters
and the faggot-gatherers were struggling for survival, often violently, all
through this period.[40]

These last, according to Clark, were 'the proletariat of the woods'.
Flaubert does not forget them. Frédéric and Rosanette may enjoy
the illusion of being 'loin des autres, bien seuls' (3: 316), but
Flaubert brings them back to hard facts: 'Mais tout à coup passait
un garde-chasse avec son fusil, ou une bande de femmes en hail-
lons, traînant sur leur dos de longues bourrées.' He also includes
the telegraph, the modern machine *par excellence* whose graceless
profile had figured already in *Par les champs* (Nantes, chapter 3)
as the harbinger of the new industrial era.

In other words, the Fontainebleau sequence is a tribute to the mem-
ory of a golden age, not only in painting and architecture but in
descriptions of nature. Flaubert's descriptions are an expression
of sheer pleasure, like the paintings of Velvet Brueghel, which he
so much admired. On the other hand, the pleasure now is more
perverse, sophisticated—postlapsarian. Landscapes come now not
with the sound of tolling bells or even creaking oars but with
screeching chains, offering a more ambivalent pleasure:

Le ciel, d'un bleu tendre, arrondi comme un dôme, s'appuyait à l'horizon
sur la dentelure des bois. En face, au bout de la prairie, il y avait un clocher
dans un village; et, plus loin, à gauche, le toit d'une maison faisait une tache
rouge sur la rivière, qui semblait immobile dans toute la longueur de sa
sinuosité. Des joncs se penchaient pourtant, et l'eau secouait légèrement
des perches plantées au bord pour tenir des filets; une masse d'osier, deux
ou trois vieilles chaloupes étaient là. Près de l'auberge, une fille en chapeau
de paille tirait des seaux d'un puits; chaque fois qu'ils remontaient,
Frédéric écoutait avec une jouissance inexprimable le grincement de la chaîne.
(3: 318)

Elsewhere in *L'Éducation sentimentale*, landscape occurs only in
the form of glimpses of a lost paradise, the subject of lunch-table
conversations. The following riverscape is typical, being only a
simple sketch, the bare bones, 'aux trois quarts dépouillé' itself:

[40] Clark, *Absolute Bourgeois*, 79.

Par les fenêtres ouvertes, on apercevait tout le jardin avec la longue pelouse que flanquait un vieux pin d'Écosse, aux trois quarts dépouillé; des massifs de fleurs la bombaient inégalement; et, au delà du fleuve, se développaient, en large demi-cercle, le bois de Boulogne, Neuilly, Sèvres, Meudon. Devant la grille, en face, un canot à la voile prenait des bordées.

On causa d'abord de cette vue que l'on avait, puis du paysage en général [. . .]. (3: 112-13)

Landscapes now incorporate the signs of modern life. This one, with its horizontal stream of smoke from the passing train, anticipates one of Monet's best known paintings:

Frédéric, près d'elles, contemplait les carrés de vignes sur les pentes du terrain, avec la touffe d'un arbre de place en place, les sentiers poudreux pareils à des rubans grisâtres, les maisons étalant dans la verdure des taches blanches et rouges; et, quelquefois, la fumée d'une locomotive allongeait horizontalement, au pied des collines couvertes de feuillages, comme une gigantesque plume d'autruche dont le bout léger s'envolait. (3: 367)

There are adumbrations of Impressionism, in the view of the Champs-Elysées (3: 65), which has been much remarked upon,[41] or the extraordinary evocation of the beginnings of the Revolution, all glittering bayonets, *lampions*, and dark indications of an event in the making (3: 281). There are cityscapes and street scenes: Flaubert meets the challenge that T. J. Clark says painters of the time ignored: 'The life of the Paris streets was increasingly what everyone saw but almost no one could find forms for [. . .] painters avoided the streets because life there was unpaintable. The Impressionists recorded the boulevards from a distance, as another form of landscape; the crowd stayed out of focus except when it took its pleasures, at Argenteuil or Asnières.'[42] Above all there is a sense of fragmentation, views consisting of fragments, or fragmentary views,[43] or simple juxtapositions of texture and colour as in the 'grandes places désertes, éblouissantes de lumière, et où les monuments dessinaient au bord du pavé des dentelures d'ombre noire' (3: 100), or sudden vivid images, reminiscent of so many in the *Voyage en Orient*: 'De temps à autre, un rayon de lumière

[41] Flaubert's impressionism in these sequences fits the definitions of literary impressionism given by Brunetière in 'L'Impressionnisme dans le Roman' (1879) in *Le Roman naturaliste* (1883), 75-104. But Daudet's *Les Rois en exil*, which is the subject of Brunetière's essay, postdates *L'Éducation sentimentale* by ten years.

[42] Clark, *Absolute Bourgeois*, 102-3.

[43] Cf. e.g. 3: 176, the party *chez* Dambreuse.

lui passait entre les jambes, décrivait au ras du pavé un immense quart de cercle; et un homme surgissait, dans l'ombre, avec sa hotte et sa lanterne' (3: 109).

After *L'Éducation sentimentale*, there are momentary resurgences of the traditional landscape here and there. The landscapes of Egypt leave their mark on more than one evocation in the *Tentation*, poeticized by time and memory,[44] of Normandy in one privileged moment in *Un cœur simple* (4: 207). They always occur as the sign of a privileged moment, including the last great set-piece of all in the opening scene of *Bouvard et Pécuchet*, where the magnificent cityscape, tawdry and beautiful, with its 'grand ciel pur' which 'se découpait en plaques d'outremer', creates a special *ambiance* for the *coup de foudre* which will unite the two heroes for ever. As in the opening section of the *Tentation* or of *Hérodias*, the gesture towards the pictorial gives the sense of the special, of something waiting to happen.

But more usually, later visual evocations tend to be of the more schematic, fragmentary kind. Flaubert's later works are literally peppered with strange little icons: surrealistic images, descriptions like illustrations from a Book of Hours (as at the beginning of *Saint Julien*), tiny encapsulations (Constantinople seen first in a mirror *TSA*, 4: 54; Julien's reflection framed in a well). Pictorialism has retracted but, arguably, intensified.

[44] Cf. e.g. the opening description, which is like a stage set or panorama of Egypt; and 4: 49, the evocation of drifting down the Nile in a boat; and the strange surreal scene at 4: 42—red sky, black earth, wind devils 'comme de grands linceuls', and the triangle of birds 'pareil à un morceau de métal, et dont les bords seuls frémissent'.

8

The Power of the Image

THE STATUS OF PAINTERS AND OF PICTORIAL ART

All Flaubert's practising artists are painters.[1] None of them represents the 'Artist', in the usual sense, about whom there is nothing to be said. The 'Artist' is a non-subject, the only true monster, genuinely outside the system: 'L'artiste, selon moi, est une monstruosité,—quelque chose de hors nature' (*C1* 720).[2] The average practising artist, whether professional or amateur, is less 'artistic' ('quels imbéciles sont les peintres') than those who confine themselves to *imaginary* art works—visions, fantasies, and dreams. The archetypal practising artist is of course Pellerin.

Pellerin's name (*pèlerin*, seeker of wisdom and truth,[3] but also Pellerin, the creator of the mass-reproduced *image d'Épinal*) reflects his ambivalent status. He is an artist, a seeker after truth and beauty; but he copies, as do all Flaubert's practising artists. However imaginative they may be, however responsive to visual stimulation, their creations are lifeless copies of pre-existing models. Pellerin's ultimate career move into photography simply chimes with the fact

[1] Cf. Ternande (*prix de Rome* and painter of portraits, *ES1*); Vaufrylard (*MB*); Paul (*Le Château des cœurs*); Arnoux (begins as a painter but abandons painting for love and more lucrative pursuits); Pellerin. The central character of Flaubert's important project *La Spirale* is a painter. Then there are the amateurs: Emma, Léon, Frédéric, Pécuchet, St Julien. Two other painters make a brief appearance in the drafts for *Madame Bovary*. One 'ne voit pas de plus beau sujet que le Soldat-Laboureur ni de plus grand peintre que Charlet' (etc.); 'perdu dans les symbolismes [. . .] cherche la Philosophie de l'art. enthousiaste de la Jeune Allemagne. voudrait être Allemand'. He finally hangs himself (*MB nv* 118). The other is Leon's cousin, a hirsute Romantic 'artiste-peintre habitant Paris' (*MB nv* 261).

[2] Contrast the numerous 'novels of the artist' in the 19th cent., by Balzac, Zola, the Goncourts, and others.

[3] Point made by Fairlie, *Imagination and Language* (1981), 408–21. Many of Pellerin's ideas are Flaubert's, or, at least, a formulaic version of them, but are almost inextricably mingled with ideas that are *not* Flaubert's.

that he has been copying all his life, from the earliest days when he imitated those who imitated Callot and Goya. Pellerin is the kind of artist on whom Flaubert reflects in 1851: worse than the artist who has no talent, because he has it and throws it away:

[. . .] il n'y a rien de plus vil sur la terre qu'un mauvais artiste, qu'un gredin qui côtoie toute sa vie le beau sans y jamais débarquer et y planter son drapeau. Faire de l'art pour gagner de l'argent, flatter le public, débiter des bouffonneries joviales ou lugubres en vue du bruit ou des monacos, c'est là la plus ignoble des prostitutions, par la même raison que l'artiste me semble le maître-homme des hommes. (C1 770)

Pellerin's great love and respect for the masters leads him to try to copy them, rather than emulate them in his own way, for his own time. Instead of really *looking* at Rosanette when he paints his portrait of her, he tries to make a Titian of her. Instead of looking at contemporary reality with a fresh eye, he pretends it is something else—hence, his scattering of pennies around Rosanette to signify old gold coins and strategic placing of objects like sardine tins and his jacket to signify precious caskets and drapes, in a parody of Flaubert's own axiom that reality is but a trampoline.

Above all, Pellerin is a hybrid, neither fish nor fowl. He talks too much. In this respect, he is a larger version of Flaubert's little cameo of the painter Vaufrylard in *Madame Bovary*. Vaufrylard is a tiny self-portrait, inserted into Flaubert's canvas, 'Vaufrylard' being one of Flaubert's many pseudonyms.[4] Vaufrylard has Flaubert's temperament. He plays to the gallery, and above all makes verbal puns: 'tout le temps, débita des calembours'. In other words, he is a reverse image of Flaubert: a painter who is good with words, to mirror a writer who is good with images. But Vaufrylard is only a 'walk-on' part: only limited scope is accorded to the painterly in a text which is intended to be all *grisaille*.

Pellerin, too, is far better with words than with paint, and once again we see that the old alliance of words and paint turns out to be uneasy. The purely imaginary portrait of Rosanette which he

[4] Cf. *Madame Bovary* (Garnier, 1971), 465 n. 116: 'E. Feydeau, dans son *Théophile Gautier*, a rapporté que Flaubert était appelé "le sire de Vaufrylard" dans les salons de Mme Sabatier. M. S. Cigada ("Un nuovo documento su *Madame Bovary*: Il pittore Vaufrylard", *Rivista di Letteratura moderne e comparate*, mars 1958, pp. 30–34) en conclut que Flaubert, à la manière des peintres anciens, a voulu figurer dans un coin de son œuvre. Vaufrylard, peintre et débiteur de calembours, représenterait les deux phases du travail de Flaubert: description et ironie.'

creates in his mind is so vivid that the narrative tense slips into the imperfect from the conditional, as if we were reading a commentary on a real painting; but he never translates this vision into paint (which is just as well). In another caricature of Flaubert's practice, Pellerin creates a verbal picture of a woman dancing at Rosanette's party: 'c'est net, sec, arrêté, tout en méplats et en tons crus: de l'indigo sous les yeux, une plaque de cinabre à la joue, du bistre sur les tempes; pif! paf!' (3: 144). In his evocation of the missing portions of his two huge paintings depicting, respectively, Nebuchadnezzar and the burning of Rome, he relies on words to sketch in 'les parties qui manquaient'; and the painting itself will never be finished, the net of lines on the canvas will catch nothing: 'Un réseau de lignes à la craie s'étendait par-dessus, comme les mailles vingt fois reprises d'un filet; il était même impossible d'y rien comprendre. Pellerin expliqua le sujet de ces deux compositions en indiquant avec le pouce les parties qui manquaient' (3: 76).

Even when Pellerin is in his stride and painting well, the sign of his success—and imminent failure—is a rush of words. Words spin off his brush as he paints Rosanette, evoking marvellous images for Frédéric's delight: 'et il était si préoccupé des grands artistes de la Renaissance, qu'il en parlait. Pendant une heure, il rêva tout haut à ces existences magnifiques, pleines de génie, de gloire et de somptuosités avec des entrées triomphales dans les villes, et des galas à la lueur des flambeaux, entre des femmes à moitié nues, belles comme des déesses' (3: 171). The same process occurs when Pellerin paints Rosanette's dead child. At first he simply sketches and maintains a respectful silence, but then, 'l'artiste en lui l'emportant', he lets his *tongue* run away with him, and treats Frédéric to a disquisition on the art of painting portraits. The ultimate apotheosis of Pellerin, at the end of *L'Éducation sentimentale*, is well captured in the huge caricature of him which is plastered all over Paris. With its 'corps minuscule' and 'grosse tête' the caricature says it all—Pellerin was always all head, all imagination, and all talk, a spinner of words in painter's clothing. Pellerin is not a writer *manqué*, though. His words are too much in thrall to images for that, as his images are too much in thrall to words.

As we have seen already, Flaubert likes to juxtapose actual art works with some more successful imaginative alternatives. The *images de Cancale* of *Par les champs* (596–602, discussed in Chapter 3) are a

hideous frame for two beautiful *virtuoso* evocations of Cancale beach, one at low tide, the other at high tide. The equally awful painting of the dying bishop in Quimperlé (*PCG* 361–4, also discussed earlier) is similarly associated by contrast with an outdoor scene, which is where the sacred really is: 'car Dieu est là et pas ailleurs'. Flaubert's mature works frequently play on the same kind of contrast. Pictorial art as generally understood—institutionalized art—is set against alternative art forms. Thus, Emma Bovary's drawings are simply copies, with no life in them, copies of Classical models (her Minerva's head, dedicated (1: 62) with unconscious irony 'A mon cher papa'), and drawings ostensibly 'from the life'. Her drawings are gauche and conventional, but that is not where her talent lies. Her talent lies in 'the concrete, intensely visual imagination she shares with her creator'[5] and with virtually every other character in Flaubert's work. Visions can attain a state of virtual reality—the holograph of Loulou/the Holy Ghost at the end of *Un cœur simple*, of the leper/Christ at the end of *Saint Julien*, and many more.[6] Visions, or imaginative potential, are frequently played off against real pictures. Léon (who paints water colours in his spare time) thinks he is paying Emma a compliment when he tells her she looks like the Muse he has seen in a contemporary simpering print (1: 257); but what he sees when he looks at her is far more original and interesting—the view of the back of her head reflected in the mirror is a Caillebotte *avant la lettre*—and what he sees when he remembers her from the Yonville days is also original: simply a glimpse of two arms hovering over a window box tending cacti. St Julien is taught to confect 'peintures mignonnes' as a child; but his visionary capabilities are far more powerful and disturbing than the pretty pictures he puts on paper.

Most of Flaubert's main characters are given to visual 'reruns', which provide an enhanced, aestheticized version of reality. In Emma's visual replay of the momentous factory visit when she fell in love with Léon, she creates a new image, in addition to those the reader was given in the original description—she now provides a

[5] David Roe, *Gustave Flaubert* (1989), 35.

[6] Emma's honeymoon fantasies (1: 83, 223–4) attain a state of virtual reality; Charles 'se percevait double' (1: 61) during his hallucination on the way to *les Bertaux* for the first time; even Rodolphe sees Emma's face on the military caps 'comme en un miroir magique' (1: 185). Frédéric has repeated 'visions' of Mme Arnoux, e.g. 3: 55, 65, 126, 383.

supplementary (and highly suggestive) detail of Athalie, holding Léon's hand and sucking on a piece of ice (1: 139).[7] The rerun itself is so powerful that it obliterates current reality as well as recreating the past: Emma *looks* at the fire but *sees* ice and snow ('*Regardant* de son lit le feu clair qui brûlait, elle *voyait* [. . .]').[8] Emma is always more than willing to replace present current reality with an alternative image in this way. To the 'real' landscape of Yonville pastures on a balmy April evening, evoked in a word-painting by Flaubert, she prefers the sharp little memory-image of a scene from her convent days:

Elle se rappela les grands chandeliers, qui dépassaient sur l'autel les vases pleins de fleurs et le tabernacle à colonnettes. Elle aurait voulu, comme autrefois, être encore confondue dans la longue ligne des voiles blancs, que marquaient de noir çà et là les capuchons raides des bonnes sœurs inclinées sur leur prie-Dieu; le dimanche, à la messe, quand elle relevait sa tête, elle apercevait le doux visage de la Vierge parmi les tourbillons bleuâtres de l'encens qui montait. (1: 147)

At the ball at la Vaubyessard, she averts her eyes from the 'real-life' image of 'des faces de paysans' pressed to the window, with its connotations, albeit dim, of Revolution, in favour of a more bucolic memory-image of her own peasant origins: 'Elle revit la ferme, la mare bourbeuse, son père en blouse sous les pommiers, et elle se revit elle-même, comme autrefois, écrémant avec son doigt les terrines de lait dans la laiterie' (1: 93–4).

The borderline between image and reality can be effaced entirely, as in the following extraordinary example. Travelling to Nogent, at the end of *L'Éducation sentimentale*, Frédéric has lost almost everything. He aims now to find peace and contentment with his childhood sweetheart Louise: 'A mesure qu'il avançait vers Nogent, elle se rapprochait de lui. Quand on traversa les prairies de Sourdun, il l'aperçut sous les peupliers comme autrefois, coupant des joncs au bord des flaques d'eau; on arrivait; il descendit' (3: 390). There is no sign that Frédéric does not actually *see* Louise from the train,

[7] Frédéric undergoes a similar experience after his first meeting with Mme Arnoux: the scene returns, fresher, fuller: 'il distinguait maintenant des détails nouveaux, des particularités plus intimes' (3: 53).

[8] Elsewhere, Emma studies a map of Paris and creates an image of the city, but does so by *shutting her eyes*: 'elle fermait les paupières, et elle VOYAIT' (1: 99). Cf. *ES* 3: 99, 'Frédéric, debout contre le poêle, contemplait les murs, l'étagère, le parquet; et des images charmantes défilaient dans sa mémoire, devant ses yeux plutôt.'

'comme autrefois, coupant des joncs au bord des flaques d'eau'—
it would be a strange coincidence, but not outside the bounds of
possibility for Louise to be cutting reeds now as she always used
to do. Only when we read on and see Louise and Deslauriers leav-
ing the church do we realize that the earlier image must have been
imaginary. And then, in a complete volte-face, it is this 'real'
image, the wedding, that seems like the hallucination: 'Il se crut
halluciné' (3: 391).

It is when Flaubert's characters evoke visions from words that
they come closest to his image of his ideal reader. The words can
be spoken[9] or written.[10] They can be the words of other people (Damis
mesmerizing St Antoine with his patter) or one's own (the images
evoked by the shared narrative of Frédéric and Deslauriers at the
end of *L'Éducation sentimentale*, this very process being part of what
is encompassed in 'le meilleur'[11]). The link between word and
image is rarely direct. Reading the Bible is not supposed to drive
Antoine to visions so sensual as to produce an orgy of sexual desire
and orgasmic self-flagellation. In the most extreme cases, what the
words actually mean is entirely irrelevant. Bouvard and Pécuchet
dream over names and titles: 'D'après de certains noms, ils ima-
ginaient des pays d'autant plus beaux qu'ils n'en pouvaient rien

[9] Félicité creates visions of whole worlds from the priest's 'abrégé de l'Histoire
sainte': 'Elle *croyait voir* le paradis, le déluge, la tour de Babel' (4: 209).

[10] Bouvard and Pécuchet are continually being bewitched by images from their
reading, e.g. they turn the 'plates descriptions' of the Revolution into vivid pictures
(5: 126); their reading of Scott evokes the kind of image which seduces Madame
Bovary in her visit to the opera ('On suit des yeux un cavalier qui galope le long
des grèves'), and Dumas is a 'lanterne magique' (5: 136); their reading of the New
Testament evokes little *images d'Épinal*, 'L'Évangile dilata leur âme, les éblouit comme
un soleil. Ils apercevaient Jésus, debout sur la montagne, un bras levé, la foule en
dessous l'écoutant; ou bien au bord du lac, parmi les Apôtres qui tirent des filets;
puis sur l'ânesse, dans la clameur des *alleluia*, la chevelure éventée par les palmes
frémissantes; enfin, au haut de la croix, inclinant sa tête, d'où tombe éternellement
une rosée sur le monde' (5: 218); the *litanies de la Vierge* evoke an image of the
Madonna as in a painting, 'Il la rêva comme on la figure dans les tableaux d'église'
(5: 223); also their reading of the history of famous martyrs, 'On les voyait tout
couverts de sang' (5: 236).

[11] Cf. Barbey d'Aurevilly, in *Le XIX^e siècle* (1964), ii. 162: 'ils avisent tout à coup
dans leurs souvenirs le petit tableautin du lupanar'. Flaubert said nobody understood
this conclusion, most contemporaries seeing in it only utter cynicism and perversity.
Most recently, it has been read as a statement about the value of the homoerotic
relationship between Frédéric and Deslauriers (cf. Mary Orr, 'Reading the Other:
Flaubert's *L'Éducation sentimentale* Revisited', *French Studies*, 45 (Oct. 1992),
412–23. Love between the two men is clearly a factor and/or a symptom of the shared
pleasure of telling a story together, with pictures.

préciser. Les ouvrages dont les titres étaient pour eux inintelligibles leur semblaient contenir un mystère' (5: 45). Words, emptied of meaning, become as enigmatic as mute images.

Lovers, too, are shown to be artists in their way. In his review of *L'Éducation sentimentale*, Barbey d'Aurevilly makes an interesting comparison between Frédéric Moreau and Joseph Bonaparte, the brother of Napoleon. Barbey quotes from a letter sent by Napoleon to Joseph, connecting Joseph's chronic indecisiveness with his highly developed visual imagination: 'Vous avez un défaut terrible qui empêche toute action, toute décision et tout courage, c'est le *genre d'imagination*, qui, sur tout, *se fait des tableaux*.' This, according to Barbey, is also what is wrong with Frédéric, and, behind Frédéric, the incorrigibly pictorialist Flaubert: 'Et c'est aussi là l'infirmité de Frédéric Moreau dans *l'Éducation sentimentale*, mais cette infirmité crée le procédé de M. Flaubert, dont la pensée ne fonctionne jamais non plus que sous la forme de tableaux. Moreau, comme Joseph Bonaparte, voit *dans sa tête* toutes les choses qu'il craint et les décrit [*sic*] comme si elles étaient arrivées.'[12]

For Barbey, this picture-making capacity is what sterilizes Frédéric and makes him incapable of action. We might agree with that assumption, without its negative charge. Frédéric has real artistic potential (like Emma), and more manual dexterity than she has, but he is not a painter.[13] Artistic potential is diverted into other paths, such as dreaming, and love for Mme Arnoux. Frédéric never makes the quantum leap from love to art, from the *côté de Méséglise* to the *côté de Guermantes*, but 'love' and 'art' are continually linked, through to the smallest details of the narrative. At the very beginning of the novel, Frédéric appears sporting his icon, the album which he

[12] Barbey d'Aurevilly, in *Le XIXᵉ siècle*, ii. 161. In his early drafts, Flaubert had intended to make Frédéric less impressive as a producer of images than he appears in the final text: Frédéric has an 'esprit <malléable> et flottant avec un sentiment <d'autant plus> concentré <qu'il ne produit pas des formes nettes>' (*Scénarios* (1992), 348). Cf. also CT 296, *Carnet* 19, 39ʳ: 'Un défaut radical d'imagination, un goût excessif, trop de sensualité, pas de suite dans les idées, trop de rêveries, l'ont empêché d'être un artiste.' But the Frédéric who finally emerges is closer to Barbey's description.

[13] The *Scénarios* (1992) bear witness to the extent to which Flaubert was exercised by this question in the writing of *ES*, returning again and again to the subject of what exactly it was that stopped Frédéric from being an artist. The drafts are inclined to emphasize his failure in this respect, just as they are inclined to emphasize the artistic connotations of Frédéric's love for Mme Arnoux. The final text is open-ended on both counts.

carries 'sous le bras'. This icon *could* signify that he was the typical sentimental young bourgeois of 1840, who merely fancied himself as an artist. The fact that the album remains closed would confirm this interpretation. On the other hand, it could equally be argued that Frédéric is an artist, precisely because he does not open the album. He is taking some *other* path to art, a less hackneyed and stylized path than that offered by the album. The encounter with Mme Arnoux focuses his attention for ever on love rather than art; but, none the less, she makes him see things from an artistic point of view:[14] having just met her, and still on the boat, he sees on the bank a little eighteenth-century pastoral scene, which he himself then fleshes out with two imaginary figures walking along one of the paths (3: 52); shortly afterwards, he sees a château with a garden where, again, he notes an avenue of limes and paints in a figure of his own to complete the picture: 'Il se la figura passant au bord des charmilles'. At this point, amazingly, two 'real' figures appear, spontaneously, as if in response to his desire—and then, as suddenly, they are gone—symbolically?: 'A ce moment, une jeune dame et un jeune homme se montrèrent sur le perron, entre les caisses d'orangers. Puis tout disparut.'

Art is one path to *L'Idéal*, love another. If Frédéric can register scenes with pictorial potential which are not at all to his taste (such as views of grubby Paris streets, 3: 132), that is because he is on his way to see Mme Arnoux. Mme Arnoux is often present in a landscape or scene, but present as the trace of an absence, imparting a magic to all the rest. In this wide-angled view from his balcony (a panorama), Mme Arnoux is the last word of the paragraph, but is present only as the owner of an invisible house obscured by the (no doubt symbolic) heavy blue mass of the Tuileries dome:

Il passait des heures à regarder, du haut de son balcon, la rivière qui coulait entre les quais grisâtres, noircis de place en place, par la bavure des égouts, avec un ponton de blanchisseuses amarré contre le bord, où des gamins quelquefois s'amusaient, dans la vase, à faire baigner un caniche. Ses yeux, délaissant à gauche le pont de pierre de Notre-Dame et trois ponts suspendus, se dirigeaient toujours vers le quai aux Ormes, sur un massif de vieux arbres, pareils aux tilleuls du port de Montereau. La tour Saint-Jacques, l'Hôtel de ville, Saint-Gervais, Saint-Louis, Saint-Paul se levaient en face,

[14] Once again, the drafts spell out a connection which the final text leaves unstated. Cf. *Scénarios*, 42: she is 'tour à tour motif à activité cérébrale à projets, à élans de travail, et de génie—et cause de nonchaloir et de fainéantise'.

parmi les toits confondus, et le Génie de la colonne de Juillet resplen-
dissait à l'orient comme une large étoile d'or, tandis qu'à l'autre extrémité
le dôme des Tuileries arrondissait, sur le ciel, sa lourde masse bleue. C'était
par derrière, de ce côté-là, que devait être la maison de Mme Arnoux.
(3: 99)

She provides the necessary unseen further dimension in the scene, the
invisible *ailleurs* which Flaubert liked to see suggested in paintings.

Mme Arnoux is the catalyst whereby life comes to seem like art,
as in Frédéric's first view of her, and art comes to seem like life:

Quelquefois, il s'arrêtait au Louvre devant de vieux tableaux; et son
amour l'embrassant jusque dans les siècles disparus, il la substituait aux
personnages des peintures. Coiffée d'un hennin, elle priait à deux genoux
derrière un vitrage de plomb. Seigneuresse des Castilles ou des Flandres,
elle se tenait assise, avec une fraise empesée et un corps de baleines à gros
bouillons. Puis elle descendait quelque grand escalier de porphyre, au
milieu des sénateurs, sous un dais de plumes d'autruche, dans une robe de
brocart. D'autres fois, il la rêvait en pantalon de soie jaune, sur les
coussins d'un harem [. . .]. (3: 102)

Unlike Proust, Flaubert leaves the association of love and art
entirely unproblematic. The fact that they can be associated is in
itself simply life-enhancing. The connection between love and art
does after all go back a long way in Flaubert, who repeatedly fuses
woman with art-object, or plays one off against another, as in
'Rencontre', where he is so 'ébloui' by the woman in his chance
encounter that he neglects the art works he has come to see.[15] During
Frédéric's first dinner at the Arnoux household, the talk is all of
art: Dittmer speaks of the Orient, Lovarias and Burrieu discuss
l'école florentine, and their conversation 'lui révéla des chefs-d'œuvre,
lui ouvrit des horizons', and Pellerin inveighs against realism in
painting. Meanwhile, Frédéric looks at Mme Arnoux and at a
dimple that comes and goes as she speaks: 'Frédéric, en écoutant
ces choses, regardait Mme Arnoux. Elles tombaient dans son esprit

[15] The episode entitled 'Rencontre' in the *Voyage en Orient* is picked up in con-
nection with Arnoux as well as with Frédéric—Arnoux 'se croyait peintre' at that
time of his life, but, meeting Mme Arnoux for the first time as she comes out of
church, he lets his life change direction, thus anticipating the pattern of Frédéric's
own life (3: 187). Flaubert is not alone in treating this theme at this time, cf. the
Goncourts' *Manette Salomon* (1867) and Zola's *L'Œuvre* (1886). Flaubert particu-
larly admired the Goncourts' counterpointing of love for a woman with painterly
attention to the model in *Manette Salomon*, cf. C3 702.

comme des métaux dans une fournaise, s'ajoutaient à sa passion et
faisaient de l'amour' (3: 85). It is difficult not to think that some
point is being made here about the limits of painting, as practised
by Arnoux and the other distinguished painter guests at the party.

Flaubert, then, likes to set practising painters against what non-
painters can do, through fantasy or freshness of vision. He also
sets them against what writing can do. Flaubert's own portrait of
Rosanette is the antithesis of Pellerin's.[16] Just a sketch, with its sugar
whiskers, it comes as a breath of fresh air a few paragraphs after
the clichés of Pellerin's projected grand Renaissance portrait in its
studio setting: 'et sa figure ressemblait, sous sa capote de soie verte,
à une rose épanouie entre ses feuilles' (3: 172). In the same section,
Flaubert also provides a brilliant cityscape, a better setting for
Rosanette by far than Pellerin's conventional Italianate background
(which had come complete with orange trees and Flaubert's favourite
image of the streaked sky): 'Il faisait un beau temps, âpre et splen-
dide. Le soleil s'abaissait; quelques vitres de maison, dans la Cité,
brillaient au loin comme des plaques d'or, tandis que, par derrière,
à droite, les tours de Notre-Dame se profilaient en noir sur le ciel
bleu, mollement baigné à l'horizon dans des vapeurs grises' (3: 171-2).
Flaubert's scene has enough in common with Pellerin's proposed
setting to point up the differences. Reflecting Pellerin's proposed trans-
formation of pennies into precious coins, Flaubert turns city win-
dows into 'plaques d'or', but keeps both terms of the comparison,
where Pellerin does not; while the towers of Notre Dame black against
blue and the trails of grey city mist stand against Pellerin's 'nuages
blancs' and the conventional icon of orange trees which Pellerin
also imagines as black on blue. Flaubert's is a *modern* scene not a
Renaissance mock-up; and Pellerin's evocation of his projected
portrait is as flat as the average art commentary, whereas Flaubert's
words are music.

That is not the end of the story, however. As we have seen in the
discussion of Flaubert's presentation of bad art in *Par les champs*,
bad art can be retrieved. Time, light, and writing can perform mir-
acles, if not in the case of Nebuchadnezzar or of Christ driving a
train, at least with respect to Pellerin's two major works, which are
both saved.

[16] Point made by Fairlie, *Imagination and Language*, 408-21.

One of these works is the portrait of Rosanette's baby (3: 382). This is a truly bad painting. The fact that the baby is dead when Pellerin paints him is itself significant—others, too, have made the point that portraiture is the art of painting dead people. And since he is dead, where is the *spirit* of this 'véritable nature morte' that Pellerin is aiming to capture? He produces, finally, a 'chose hideuse' that insists only too crudely on its status as 'nature morte'. The child in Pellerin's pastel is simply a piece of rotting meat, in a clash of colours as crude as the crudest *image d'Épinal*: 'Le rouge, le jaune, le vert et l'indigo s'y heurtaient par taches violentes, en faisaient une chose hideuse, presque dérisoire.' None the less, like the similarly abysmal portrait of Camille in *Thérèse Raquin* (1867), this still life turns out to be an accurate anticipation of reality, as putrefaction gains on the corpse. The boy grows to resemble his portrait: the colours in Flaubert's description are as crude and discordant as those of the portrait, and the words reinforce the connection, '*viol*acé' and '*viol*ettes' echoing '*viol*entes' of the first description, and all containing the word *viol*: 'D'ailleurs, le petit mort était méconnaissable maintenant. Le ton violacé de ses lèvres augmentait la blancheur de sa peau; les narines étaient encore plus minces, les yeux plus caves; et sa tête reposait sur un oreiller de taffetas bleu, entre des pétales de camélias, des roses d'automne et des violettes.' Nature (or Flaubert's text) has caught up with the painting, and made sense of it.[17]

The other painting 'saved' eventually by nature/Flaubert's text is the portrait of Rosanette, which seemed entirely beyond redemption. This poor hyper-determined commodity, a *pis-aller* for Mme Arnoux by Titian, used as a pawn in private feuds, almost forgotten by everyone including the reader, crops up once more at the very end of the novel. It emerges transformed and with a kind of grace. Preserved for some reason (inertia?) by Frédéric, remarked on (out of jealousy? or as an attempt at laying old ghosts?) by Mme Arnoux, half-hidden by a curtain, its lavish golden glints muted by the dim light, softened by time and the authorial hand, it passes, almost, for what Pellerin had always wanted it to be, a 'vieille peinture italienne'.

Time, light, and the artist's vision can transform the most mediocre creation, or make something out of nothing: 'je crois que partout

[17] Cf. Fairlie ibid., this sequence cited with a different emphasis.

et *à propos de tout*, on peut faire de l'art' (*C2* 517: 29 Jan. 1854). Even Emma's drawing of a sleeping cat who appears to be running (*MB nv* 194), even Pécuchet's vertical landscape (5: 254), both seeming the antithesis of art, have a charm which a regular art work might not. And Emma's drawings, gauche as they are, are treasured by her father and her husband, just as similar art works are treasured by Flaubert and a cause of horror to the Goncourts when they see them. Even an *image d'Épinal* can come to embody the Holy Ghost, with a little effort on the viewer's part (*Un cœur simple*).

IMAGES, DESIRE, AND DEATH

We saw in the preceding section how images from the imagination are played off against actual pictorial artefacts. In terms of affective power, however, there is little to choose between them: 'Que Frédéric regarde un tableau ou qu'il imagine une scène fantasmagorique, le mode et le degré de présence sont identiques.'[18]

Images, of whatever kind, lie at the heart of things, as they lie at the heart of Flaubert's text. They have divine or mystical connotations. The inner sanctum of *Salammbô*'s temple of Tanit is decorated with painted images, as a sign of the sacred, and so is the *zaïmph*, which lies at the heart of that sanctum (2: 99). In Flaubert's original conception, the *zaïmph* was covered with script rather than pictures, 'une étoffe couverte d'écriture' (letter to Flaubert from Frédéric Baudry, *C3* 1063). Flaubert eventually opted for pictures instead, but pictures that are closely related to text: they themselves tell a story (the sacred story of Eschmoun); and they are also a *mise en abyme* of the text of the novel itself, because, half obscured by the shimmering of the veil and the play of wonderful colours, 'bleuâtre comme la nuit, jaune comme l'aurore, pourpre comme le soleil', the forms and their meaning come and go, in a kind of mirage.[19]

[18] G. Genette, *Figures* (1966), 226–7. In the current debate as to whether images from different sources are comparable, Flaubert would have ranged himself on the side of those who believe that they are (e.g. Mitchell, *Iconology, Image, Text, Ideology*, 5 ff.) (1986).

[19] Cf. esp. R. Griffin, *Rape of the Lock* (1988) on the connections between the Indian goddess Maïa and the veil of illusion (the *zaïmph*). Flaubert's presentation of meaning in terms of the *zaïmph* is similar to the Symbolist concept of meaning, cf. Hautecœur, *Littérature et peinture en France* (1942), 322, on the Symbolists:

Images are frequent in Flaubert's text. Many of them do not occupy 'symbolic space',[20] but are parked like little icons here and there. In *Salammbô* itself, there are the designs inscribed in the strange black windows in Hamilcar's private sanctuary, and which are opaque in all senses of the word: 'Des arborescences, des monticules, des tourbillons, de vagues animaux se dessinaient dans leur épaisseur diaphane . . .' (2: 123). Despite the evidence that Flaubert tried to control their proliferation,[21] they are everywhere in his text, on Emma's bed ('un grand lit à baldaquin revêtu d'une indienne à personnages représentant des Turcs', 1: 62), as tattoos of parrots on interpreters' chests (*Salammbô*, 2: 87), on Arnoux's wine labels, and, above all, on Loulou, who, as a parrot, 'porte la peinture tout entière sur [son] dos', as Duranty puts it.[22] Readers familiar with the *avant-textes* may be able to adduce some private significance for some of these images. Thus, Emma's bed-hangings first appear in Ancenis in 1847 (*PCG* 151), though the reader is none the wiser for knowing that, and the Chinese screens on the *reposoir* at the end of *Un cœur simple* are part of a series of such screens (the ones at which Flaubert marvelled in England in 1851, Mme Dambreuse's Japanese screen (3: 154)). As they stand, these images are entirely gratuitous. They are simply a sign of the limitless fascination of the pictorial. In essence, such images are a development of the faded pictures and sofa patterns of *Quidquid Volueris*, only the reader is not to know that, of course. None of these icons is described, as Gautier would describe them, for the sheer pleasure of evocation, and nor do they play any role in the text, even to give the 'effet du réel'; they are simply there.

Other kinds of pictorial image favoured by Flaubert's text are the semi-obscured, altered images we have seen frequently in the travel writing. 'Real' pictures are usually more powerful when they are half effaced or obscured in some way. Emma's keepsakes (1: 81),

'L'artiste, entre la nature et son regard, tend un voile sur lequel sa fantaisie brode des arabesques.' Cf. also ibid. 323, which extends this idea to the paintings of the Impressionists, where 'la nature disparaît sous un chatoiement'.

[20] Term used by W. Steiner, *Pictures of Romance* (1988), 57.

[21] Flaubert excises quite a large number of them: e.g. the 'petits dessins indistincts' on Emma's *porte-feuille MB nv* 219, or the fan *MB nv* 564 'qui représentait des bergeries'.

[22] Cf. Émile Duranty in his journal *Le Réalisme* (Apr.–May 1857), 'Pour les peintres', 83: painters are like parrots, 'Ces animaux portent la peinture tout entière sur leur dos'.

veiled by their 'papier de soie' even become a kind of *zaïmph*;
the painted plates (1: 79) are all the more alluring for the fact that
their images and captions are scratched and half-obscured. Tiny
images are also very seductive, inviting the viewer to come in close
and peer. This is another of the charms of the keepsake.[23] Semi-
darkness and faulty lighting work wonders, not only for the por-
trait of Rosanette discussed earlier but also for the family portraits
at La Vaubyessard in *Madame Bovary*, which are captivating less
for their subjects than for the delicate effects of the light which
catches them at an angle, and turns them into more subtle, abstract
works of art, squares of black edged with gold and networked with
fine filaments, or decomposes them into far more striking fragments
—a forehead, two eyes, a red coat:

[. . .] la lumière des lampes, rabattue sur le tapis vert du billard, laissait
flotter une ombre dans l'appartement. Brunissant les toiles horizontales, elle
se brisait contre elles en arêtes fines, selon les craquelures du vernis; et de
tous ces grands carrés noirs brodés d'or sortaient, çà et là, quelque por-
tion plus claire de la peinture, un front pâle, deux yeux qui vous regard-
aient, des perruques se déroulant sur l'épaule poudrée des habits rouges,
ou bien la boucle d'une jarretière au haut d'un mollet rebondi. (1: 89)

Similarly, the portrait of Bouvard's 'uncle' (really his father), which
runs through *Bouvard et Pécuchet* as a leitmotif, like the portrait
of Rosanette in *L'Éducation sentimentale*, is undeniably a daub; but
its effects are immeasurably enhanced as time goes on by the com-
bined effects of mildew and light, worked on by a powerful ima-
gination to produce an effect of real terror. At its first appearance,
the painting is a typical stylized 'beau mensonge' like so many por-
traits, and not at all interesting:

Et le flambeau qu'il tenait éclaira un monsieur.
Des favoris rouges élargissaient son visage surmonté d'un toupet frisant
par la pointe. Sa haute cravate, avec le triple col de la chemise, du gilet de
velours et de l'habit noir, l'engonçaient. On avait figuré des diamants sur
le jabot. Ses yeux étaient bridés aux pommettes, et il souriait d'un petit air
narquois. (5: 43)

Later, it begins to become more interesting as some deterioration
is visible, and visitors begin to detect (despite or because of the now

[23] Cf. N. MacManaway, 'Tokens of Remembrance', M. Phil., Dublin 1989:
'A keepsake demands to be handled; the small scale of the images requires close
examination' (p. 60).

grimacing mouth, the squint, and the over-sized sideburns?) a speaking resemblance to Bouvard: 'Les embus reparaissaient à contre-jour, faisaient grimacer la bouche, loucher les yeux, et un peu de moisissure aux pommettes ajoutait à l'illusion des favoris. Les invités lui trouvaient une ressemblance avec son fils' (5: 72). In its final appearance, as one of the central props in the attempts of Bouvard and Pécuchet to raise the spirits of the dead, it transcends itself:

Les rideaux se remuaient avec lenteur, sous le vent qui entrait par un carreau fêlé, et les cierges balançaient des ombres sur le crâne de mort et sur la figure peinte. Une couleur terreuse les brunissait également. De la moisissure dévorait les pommettes, les yeux n'avaient plus de lumière, mais une flamme brillait au-dessus, dans les trous de la tête vide. Elle semblait quelquefois prendre la place de l'autre, poser sur le collet de la redingote, avoir ses favoris; et la toile, à demi déclouée, oscillait, palpitait. (5: 198)

Extraneous factors falsify the painting but in so doing they bring out a truth, confirming (through distortions caused by natural processes) that the uncle is really the father; and they also create an altogether more awesome, composite art work, as the light makes the shadows travel (like Félicité's gaze from the *image d'Épinal* to Loulou) from skull to painted face and back again, and the wind shakes the canvas and the mould seems to eat away at the face. The result is a *happening*, a more mobile art work than 'le statisme pictural' of the original artefact but a pictorial experience all the same, and enough to inspire in Bouvard and Pécuchet a holy terror (as well they deserve!). The same effect is observable elsewhere in the novel, and once again the light is responsible. The sunlight brings out all the true horror of bad religious art: 'le soleil, frappant les verres des cadres, éblouissait les yeux, faisait ressortir la brutalité des peintures, la hideur des dessins' (5: 224). On this occasion, however, perversely (this is *late* Flaubert), Bouvard insists on being indulgent none the less: 'Bouvard, qui, chez lui, trouvait ces choses abominables, fut indulgent pour elles [. . .]'.

Art may also be obscured by being relegated to the background. Background images often serve as awful warnings, only dimly apprehended. Sometimes there is even a religious setting. The iconography of Rouen cathedral is one particularly obvious example, as the two lovers decline the guide's offer to examine the interesting North Door (1: 265) which depicts 'les *Réprouvés* dans les

flammes d'enfer'. Other images are not seen simply because they are too far away. The frescos in the *église de la Madeleine*, for example, depicting the life of Mary Magdalen, might have something to say to Frédéric in his present sinful state, as he chases Mme Dambreuse when only Mme Arnoux will do, only they are too high up. Luckily, or unluckily, Pellerin appears to provide a distraction, chattering on, and burying the emotional charge of the paintings in a long disquisition on the art of the fresco: 'Frédéric, pour se distraire, écouta le *Dies irae*; il considérait les assistants, tâchait de voir les peintures trop élevées qui représentent la vie de Magdeleine. Heureusement, Pellerin vint se mettre près de lui, et commença tout de suite, à propos de fresques, une longue dissertation' (3: 361).

Awful warnings, unheeded by the characters, filter through at least to the reader, in the inn of the *Croix rouge* in Rouen. As Emma and Léon finally plight their troth, as their hands entwine and darkness falls, there emerge from the gloom, beside the 'fenêtre à guillotine', the prints depicting the story of Dumas's play *La Tour de Nesle*.[24] Half obscured in the shadows, their captions too (half of which are in Spanish anyway) are illegible, their message also veiled: 'La nuit s'épaisissait sur les murs, où brillaient encore, à demi perdues dans l'ombre, les grosses couleurs de quatre estampes représentant quatre scènes de *la Tour de Nesle*, avec une légende au bas, en espagnol et en français' (1: 259). Henceforth, their life together will reflect the prints of the *Tour de Nesle* in one long hackneyed orgy. The writing is on the wall, in the form of both image and text (in two languages) but no one but Flaubert is reading it, unless his readers do.[25]

The content of images is often less important than their associations or connotations. Thus, Félicité's *image d'Épinal* of the Holy Ghost may *represent* the Holy Ghost, but it is *really* the portrait of Loulou: 'Avec ses ailes de pourpre et son corps d'émeraude, c'était vraiment le portrait de Loulou' (4: 222). Félicité hangs the *image d'Épinal* next to dead stuffed Loulou so that she can embrace both with one glance and set metonymy to work as she rehearses her sacred texts. The picture of the Holy Ghost takes the place of the portrait of the comte d'Artois, and this portrait too is more important for

[24] Dumas's play is often cited by Flaubert. On the subject of these images, cf. esp. Seznec '*Madame Bovary* et la puissance de l'image', *Médecine de France*, 8 (1949).

[25] They are mentioned again later when the decline in the lovers' relations has begun, as a reminder not apparently heeded (1: 310).

its connotations than for what it represents. Félicité does not kno
or care who the comte d'Artois is; but his portrait connotes her
employer Mme Aubain, whom she fears and loves—and Mme
Aubain, in turn, treasured it because it connoted her dead husband
(who was in the royalist military).

Images are the focus of desire and are also very dangerous. The
essence of Mme Arnoux's attraction for Frédéric is that 'elle
ressemblait aux femmes des livres romantiques'. In *Saint Julien*, the
parents' visions of, respectively, the monk and the Bohemian wild
man produce the psychotic split in Julien which will determine the
course of his future life and the narrative we are about to read. Images
cause characters to do things (Emma's painted plates) or not to
do things—Mme Arnoux imagines her son being carried home
wounded after a duel to defend her honour, and the image is so
powerful that it stops her from keeping her rendez-vous with
Frédéric (3: 280).

Images are also a snare and a delusion. The mistake is to think
that images embody what they represent. Antoine makes this mis-
take while thinking of the wall-paintings he saw in the temple of
Heliopolis in Egypt—'Pour que de la matière ait tant de pouvoir,
il faut qu'elle contienne un esprit. L'âme des dieux est attachée à
ses images . . .' (*TSA* 4: 118). Félicité, on the other hand, knows
(instinctively?) that she has to work at her icons, and that is why
she turns slightly from the *image d'Épinal* of the Holy Ghost to the
stuffed parrot while praying, as if to unite them metonymically.
Indeed, she succeeds in uniting them, at least in her mind, and the
two become one at the moment of her death. Behind Félicité is
Flaubert, obeying Lessing's precepts and uniting two static images
through the metonymy of his writing. (Frédéric works at the image
of Mme Arnoux in the same way, only, less felicitous than Félicité,
he finds that sometimes the image slips and he sees the 'bourgeoise'
(3: 138) or the 'dinde' (3: 212) behind it.) So images are not only
a source of pleasure, of course. When Frédéric creates an *image
d'Épinal* of Mme Arnoux as the future mother of his child, the image
is so vivid that when it leaves him he cries as if he had lost some-
thing tangible: 'Il voyait là, sur le tapis, devant la cheminée, une
petite fille' (3: 344).[26] After the death of her son, Rosanette creates

[26] Parents are particularly given to producing images of the future, so vivid that
the word 'voir' is repeatedly used. Cf. e.g. Charles of Berthe's future, 1: 223, 'Il la
voyait déjà [. . .]', thus repeating his own mother's dreams for him ('le voyant déjà
grand', 1: 54); and Frédéric's less developed fantasy of his son, 3: 367.

es, each depicting the son she has lost at a different
each as vivid as reality, and each as painful as a
l'apercevait dans quelques mois d'ici, commençant
au collège au milieu de la cour, jouant aux barres;
, jeune homme; et toutes ces images, qu'elle se créait,
lui faisaient comme autant de fils qu'elle aurait perdus,—l'excès de
la douleur multipliant sa maternité' (3: 383). Mirror-images, so often
a source of pleasure, as when Emma admires her reflection after mak-
ing love with Rodolphe ('Quelque chose de subtil épandu sur sa per-
sonne la transfigurait! Elle se répétait: "J'ai un amant! un amant!"'
1: 194), also damage and destroy. Disfigured and dying, she asks
for her mirror once more, and looking at her own image is the sig-
nal for the beginning of the end: 'elle resta penchée dessus quelque
temps, jusqu'au moment où de grosses larmes lui découlèrent des
yeux. Alors elle se renversa la tête en poussant un soupir et
retomba sur l'oreiller. Sa poitrine aussitôt se mit à haleter rapide-
ment [. . .]' (1: 336).[27]

Images, in short, are highly dangerous. Homais knows all about
the danger of images, as witness his apoplectic reactions to the illus-
trations in Justin's copy of *L'Amour conjugal*: 'Et des gravures! . . .
Ah! c'est trop fort!' (1: 270). Emma feasts her eyes on her keep-
sakes as she lies in bed, and the light from the bedside lamp seems
to enhance the images from her reading and make them even more
lurid, 'et l'abat-jour du quinquet [. . .] éclairait tous ces tableaux
du monde', while the distant rumble of the passing 'fiacre' is a fore-
taste of her own dark future (1: 82).

Images are the signs of madness and death. People kill for images
('Et devant ces dieux [*i.e. images*], on égorge des hommes . . .', *TSA*
4: 118). Barbarians and Carthaginians are at each others' throats
on acccount of the *zaïmph*. Herod kills Iaokanann, who is the only
good person he knows and whom he loves, for the sake of Salome,
the death-dealing icon, frozen into the posture of the *Marianne
dansant*. By association, images are the sign, textually, of endings,
of lives, and of texts themselves. Thus, Emma's life ends on the
image of 'l'Aveugle', the blind poet and monster, conjured up in
her imagination by the words of his song, now horribly clear, come
to cut the thread and cause her to die laughing; *Salammbô* ends on

[27] Cf. *SJH* 4: 246: Julien too is upset and horrified by his image reflected in the
well water; Charles's feelings as he sees himself reflected, not looking his best, in
Emma's eyeball are not indicated (1: 77).

what Flaubert himself calls the 'tableau' of the double death: Mâtho dies before the fixed, hieratic, mute image of Salammbô, moments before she dies before the awful, mute image of Mâtho. *L'Éducation sentimentale* ends on what Barbey d'Aurevilly called the 'tableautin' of the brothel. The *Tentation* of 1874 ends on the mute image of Christ's face in the sun, *Un cœur simple* and *Saint Julien* end on holograms of, respectively, God the Holy Spirit and God the Son, as each character dies. In *Hérodias*, image, in the form of Salome, kills the Word, in the form of Iaokanann. Images are the end of writing, though in *Hérodias* the Word does after all survive, as John's head is carried to Jesus.

THE STAINED-GLASS WINDOW

The stained-glass window—Flaubert's metaphor for his own vision, as we have seen—is a meta-image. It is a good example of naïve-seeming art; it has strong religious connotations; it relates closely to the questions of image as source, model, and focus of strong emotion. Even though it is marginalized in the text, its effect shimmers through in an atmosphere of magic and mystery.

Though the image of the stained-glass window does not come fully into its own until *La Légende de Saint Julien*, it is adumbrated in *Madame Bovary*, as Léon waits for Emma in Rouen cathedral. At first, the effects of the cathedral windows are evoked in general terms: 'quelques portions de vitrail' are reflected, along with parts of arches, in the water in the fonts, and the colour from the windows splashes around like a brightly coloured carpet: 'La nef se mirait dans les bénitiers pleins, avec le commencement des ogives et quelques portions de vitrail. Mais le reflet des peintures, se brisant au bord du marbre, continuait plus loin, sur les dalles, comme un tapis bariolé' (1: 262). Tired of waiting, Léon finally focuses on part of one of the windows, described as 'un vitrage bleu où l'on voit des bateliers qui portent des corbeilles'. He studies this window at length, with its fish and its figures in doublets. Flaubert does not identify the window in the final text, but the preliminary drafts are quite explicit: this is part of the Julian window,[28] and Léon is

[28] Cf. *MB nv* 497, 'deux vitraux fort remarquables: l'un représentant la vie de saint Julien l'Hospitalier, et l'autre des mariniers qui vendent du poisson'. It is actually one window, not two.

focusing on the fragment which depicts the donors of the window. This fragment is quite incidental to the Julian narrative itself. This in itself is significant. Léon is as unheeding of art at this juncture as he is of awful warnings. He sees in the window only what he happens to see, being preoccupied with other things. He registers only fragments of this powerful story, 'quelques portions de vitrail', reflected in the restricted dimensions of the fonts and disseminated as splashes of colour throughout the church. The window could tell him things, take him *ailleurs*, but 'sa pensée vagabondait à la recherche d'Emma' and he simply counts the scales of the fish and the buttons on the doublets. The windows are subordinate to his feelings for Emma: 'les vitraux resplendissaient pour illuminer son visage'.

This is the clearest adumbration of the *Saint Julien* window before Flaubert incorporates it in the *Légende* itself. But other anticipations in fragmentary form are splashed here and there throughout Flaubert's *œuvre*, in the eventually censored 'kiosque' of *Madame Bovary* with its panes of coloured glass, and elsewhere.[29]

The tense moments in Flaubert's works are also often *coloured*, almost in the way of stained glass or as if lit by rays passing through stained glass: the appearance of the monstrous dog in the first *Éducation sentimentale* ('immobile qu'un dernier reflet de soleil rendait toute rouge et presque sanglante'); Emma standing at the stove is suffused with red light (1: 117); the light from the lantern in the Hirondelle scatters blood-red splashes everywhere ('et le reflet de la lanterne qui se balançait en dehors, sur la croupe

[29] Rosanette tries to make a stained glass window with bits of coloured paper (3: 166), and finally acquires one, courtesy of her Russian prince, who sets her up in an apartment with 'une espèce de boudoir qu'éclairaient confusément des vitraux de couleur' (3: 259). Part of the pleasure Bouvard and Pécuchet have in visiting cathedrals is to see 'les hautes nefs se mirant dans l'eau des bénitiers, les verreries éblouissantes comme des tentures de pierreries' (5: 112). They too finally acquire a fragment of stained-glass window—only a fragment, but enough to have an effect on Mme Bordin, object of Bouvard's desire: 'On y distinguait un manteau d'écarlate et les deux ailes d'un ange. Tout le reste se perdait sous les plombs qui tenaient en équilibre les nombreuses cassures du verre. Le jour diminuait, des ombres s'allongeaient, Mme Bordin était devenue sérieuse' (5: 117). For other references to stained-glass windows, cf. e.g. *PC* 10: 290, on the poetry of old *vitraux* which stop the light penetrating and are more mystical than the new clear glass in the cathedral of Bordeaux; *PCG*, *passim*; *C2* 625, on the church at Montigny near Rouen; *TSA* 4: 52, part of the charm of Alexandria is that 'les maisons [. . .] ont des fenêtres à vitres coloriées'; *CT* 692–3, for the windows of the church of Pont-l'Évêque, carefully noted and transposed to *CS*.

des limoniers, pénétrant dans l'intérieur par les rideaux de calicot chocolat, posait des ombres sanguinolentes sur tous ces individus immobiles', 1: 287–8); Frédéric's first meeting with Mme Arnoux is associated with a red sky, with haystacks seen as giant shadows (3: 53), giving the sense that he is tampering with powerful things. Significantly, the first reference of all in this chain dates from Trouville and the meeting with Mme Schlesinger.[30] These connotations suggest that Flaubert's use of the image of the stained-glass window to refer to his artistic vision is less innocent than it appears.

Flaubert plays games with the reader in *La Légende de Saint Julien*, wilfully obscuring the significance of the window. The statement with which *Saint Julien* concludes is an apparently straightforward statement of fact: 'Et voilà l'histoire [. . .], telle à peu près qu'on la trouve, sur un vitrail d'église, dans mon pays.' Even without the help of the illustration of the original window, which Flaubert had so wanted to include with his text, the 'clever' reader may spot some irony here and wonder whether things are really so simple. But Flaubert's text is cleverer than the clever reader, because the statement is not *only* ironic. As it stands it is also the simple truth. On the most obvious and superficial level, first, it is a fact that the stained-glass window *is* both a source and a model for Flaubert's *conte*, even if it is not the only one. Flaubert does not radically alter the main lines of the narrative as depicted in the window, except to make Julien more solitary. At one point, a description even draws on one particular frame from the window: 'Et bientôt entrèrent dans la chambre un vieil homme et une vieille femme, courbés, poudreux, en habits de toile, et s'appuyant chacun sur un bâton' (4: 240).[31] In another instance, an image appears which *resembles* an image from a stained-glass window though it does not actually appear in the Julian window: Julien sees his reflection framed in a well, as if a line were drawn round it. The point has often been made that the text is a verbal equivalent to the pictorial narrative: 'La *Légende* est résolument construite comme le double littéraire du vitrail médiéval qui en constitue le modèle ludique. La plasticité

[30] Cf. *PCG* 728, referring to Flaubert's memory of a particular red light cast by the setting sun over a table in a room in Trouville. Flaubert's letter to Mme Schlesinger of 2 Oct. 1856 explains why this matters: she sat at the table.

[31] This is image no. 14 in the window: the parents are depicted with their staffs, travelling to Julien's home.

visuelle des évocations, la fragmentation et la symétrie des éléments narratifs, l'ellipse plombée des médiations du récit, la complexité des réseaux symboliques, la structure ogivale de l'ensemble de l'œuvre en font incontestablement une des plus belles réussites de l'auteur.'[32]

In general atmosphere, too, the work captures the spirit of the window: the prophecies, the speech, the 'air of supernatural gravity and dignity. In these respects, *Saint Julien* has something of the stylized but colourful formality of a stained glass window'.[33] Flaubert writes as a chronicler, borrowing the medieval point of view, as Taine was the first to recognize: 'Julien est très vrai, mais c'est le monde *imaginé* par le moyen âge, et non le moyen âge lui-même; ce que vous souhaitiez, puisque vous vouliez produire l'effet d'un vitrail, cet effet y est; la poursuite de Julien par les bêtes, le lépreux, tout du pur idéal de l'an 1200.'[34] This wish to give us 'le monde imaginé par le moyen âge' is responsible too for other, related images in the text, which do not come from the window itself but seem to spring from some old Book of Hours:[35] Debray Genette has pointed out that the monk who teaches Julien to read and to paint illuminations seems himself to have come straight from an illumination.[36]

But the statement is true at a deeper level, too. The narrator's statement is a smoke-screen, both revealing and concealing the fact that there is another source, deeper still, in Flaubert's own psyche, as Sartre was the first to point out, at length, in *L'Idiot de la famille*. Indeed, the conception of *Saint Julien* took place in Trouville, and clearly stirred up the past, or was a product of that disturbance: 'je songe au passé, à mon enfance, à ma jeunesse' (C4 972).[37] Building on Sartre's reading, we might say that the windows are the sign of

[32] Biasi, *CT* 702. Cf. also A. Raitt, *Flaubert: Trois contes* (1991), 39. The idea of the association between literature and stained glass was certainly in the air at the time, cf. Gautier, *Histoire du romantisme*, 56—one of the friends of Joseph Delorme said of certain ballads of Hugo that they were 'vitraux gothiques'—'On voit à tout instant, sur la phrase poétique, la brisure du rythme comme celle de la vitre sur la peinture . . .'.

[33] Raitt, *Flaubert*, 50.

[34] Taine, letter of 4 May 1877, quoted by Raitt, *Flaubert*, 39.

[35] Cf. C. Duckworth (ed.), *Trois contes* (London: Harrap, 1959), 191.

[36] Debray Genette, *Métamorphoses du récit* (1988), 146. Cf. the description of Julien's family home, signified in the window itself simply by a wall and a roof.

[37] For the first plan for *SJH*, cf. C2 614: 1 June 1856.

some primal scene, with strong connotations of danger and death. Hence in the parricide scene we see the direct effect of the window, part cause of the murders: it makes the room dark, causing Julien to make his fundamental mistake ('Les vitraux garnis de plomb obscurcissaient la pâleur de l'aube', 4: 243). The point is reinforced after the murders, as the colours from the window splash all over Julien's bedroom, heightening the lurid colours of the actual bloodstains and adding the appearance of others. This scene, then, is the culmination, in full colour, of the scene which is only adumbrated in Rouen cathedral in *Madame Bovary*, the focus shifting now from desire with connotations of death to death with connotations of desire. In a strange comment in a letter of January 1842 (*C1* 92) to Ernest Chevalier, Flaubert promises that as a lawyer he will defend 'les gens qui hachent menu leurs parents'. That is precisely what he is doing in his presentation of Julien, though in the event his intention has transferred itself from the domain of law to that of literature. Sinful emotion, as caught up as it ever is in Proust with the image of the stained-glass window, becomes an essential element in his artistic vision, and surfaces as much as it dares in this late tale.

There has been a great deal of speculation about how exactly this tale relates to Flaubert's psychology. But we do not need to go into the question of what *exactly* it was in his emotional life that caused such trauma. We do not need to worry what the window 'represents'. It is associated with writing. We need only pursue Flaubert's own equation between stained-glass window and artistic vision. If we do this, window and text become one.[38] By dint of Flaubert's magnificent sleight of hand in *Saint Julien*, image becomes text the only way it can, symbolically.

The stained-glass window is then central, and sums up the function of images generally in Flaubert's *œuvre*. The actual window crystallizes his feelings, as Brueghel's *Temptation* did. It tells a story, but the story is not easy to decipher—as Valéry says, in a stained-glass window, the story comes and goes, submerged at times by the

[38] The window then becomes, in Biasi's words, 'un symbole de l'œuvre, de l'originalité littéraire qui la distingue de sa source plastique [...]. Or le vitrail, on l'a vu, est l'image décalée du texte lui-même dans sa littérarité: c'est Flaubert à l'œuvre', *Trois contes* (1993), 241.

play of colours;[39] this was exactly what Flaubert wanted narrative to do. It also stands, metaphorically, for Flaubert's own way of seeing, and style, for Flaubert, is vision. It lets the light through, in varying degrees, unlike a painting which is opaque and immobile, and in this it resembles Flaubert's other sacred image of the text which is the veil. Flaubert sees through and by means of colours and images but the colours and images are transparent and do not block his view.

[39] Cf. Valéry, 'Mélange', *Œuvres*, ed. J. Hytier (1957), i. 290: 'la petitesse des dessins, qui permet de les négliger ou de les voir—*ad libitum*—de ne voir que des combinaisons, dominées par quelque fréquence, ici, des bleus, là, des rouges, etc [. . .]. Les sujets importent le moins du monde—sont pris et noyés sous le mystère.'

Conclusion

This study has pursued a particular arabesque which runs through the whole of Flaubert's writing. His works enact a continually repeated pattern of invocation and repression of the image, a reliance on the image and a turning away from it, a simultaneous attraction and rejection. The tensions of this lifelong confrontation of Flaubert's with this other art are everywhere to be felt. Behind characters, themes, and leitmotifs we glimpse from time to time the fingers of the master puppeteer, describing a related but quite distinct series of configurations. His comment in a letter of January 1864 to his niece Caroline is true not only of *L'Éducation sentimentale*, to which it was addressed: 'Je rapporte à cette œuvre (suivant mon habitude) tout ce que je vois et ressens' (C3 374). But it is true not in the way in which Du Camp understood it, on a superficial biographical level, but on a deeper structural level. The relationship between image and text is one of the most important elements in Flaubert's way of seeing and feeling.

We have seen it in play in various guises and modes. In the apprenticeship years, Flaubert gives pictorial art all due attention; and later too, he will immerse himself in it to the point of being 'saturé'. He values it for itself and for what it can bring to his own art—thematically and formally, it provides confirmation that he is on the right lines and pointers for new roads to follow, even if sometimes those roads take him where he does not entirely wish to go (as is the case with Brueghel's presentation of 'tout sur le même plan' in the painting of the *Temptation*).

Flaubert is interested in the natural points of contact between image and text: the unreadable traces in the rocks of Gavrinis or in Egyptian temples, or the natural prolongation of one into the other. He is the bibliophile in *Bibliomanie*, who loves a book as a work of plastic art, the date illegible, the letters objects in their own right, of the same nature as the heavy gilding on the drawings, the word *finis* embedded in pictorial images of various kinds—surrounded

by cherubs, inscribed on a ribbon, a fountain, or a tombstone, or forming part of a still life:

ce n'était point la science qu'il aimait, c'était sa forme et son expression; il aimait un livre parce que c'était un livre, il aimait son odeur, sa forme, son titre. Ce qu'il aimait dans un manuscrit, c'était sa vieille date illisible, les lettres gothiques bizarres et étranges, les lourdes dorures qui chargeaient ses dessins [. . .]; c'était ce joli mot *finis*, entouré de deux Amours, porté sur un ruban, s'appuyant sur une fontaine, gravé sur une tombe ou reposant dans une corbeille entre des roses, les pommes d'or et les bouquets bleus. (11: 273)

This is a perfect example of image and text in harmony, each nestling within the other, the book containing pictures, the pictorial figures in turn containing the word. Words are solid objects, from which spring strange meanings. Flaubert's conception here is close to that of Mallarmé: 'L'air ou chant sous le texte, conduisant la divination d'ici là, y applique son motif en fleuron et cul-de-lampe invisibles'.[1] Letters of words (like those of the name 'Arnoux' above his particular artistic establishment) are 'grosses de significations'. Flaubert wants his own writing to produce images too, images as real, present, and vivid as those which inspired him in pictorial art. His images, like many of those he admired, have more than a hint of menace about them. In the example just given from *Bibliomanie*, there are strong connotations of endings and death (the word *finis*, the tombstone, alongside the rich sensual life of the fruit and the 'bouquets velus'). The prosecutor in the trial of *Madame Bovary* was alert to the dangers: 'je ne crois pas qu'il soit possible de donner plus de vivacité à l'image, plus de trait à la peinture'.[2]

On the other hand, images mark the end of the text: *finis*. Conversely, Flaubert's text suppresses the pictorial image by various means. Pictures may be vital but they take second place: a museum is more than its pictures; a portrait is more important for its literary connotations than for its (dubious) plastic value; Taine should stop describing pictures and pursue the creation of his own figures, pictorial or otherwise; pictorial art works in Flaubert are constantly set against the potential pictures of the imagination; his own pictorial sources are occluded, 'written out', continually. Flaubert's images are themselves not always pictorial in the usual

[1] Mallarmé, *Œuvres complètes* (Gallimard, Pléiade, 1970), 387.
[2] *Le procès de Madame Bovary*, 1: 378.

sense of the word: images are reduced to glimpses and fragments, colours and shapes, contrasts of light and dark (the sock in the moonlight), reflecting his leitmotif of paintings half obscured by time, light, shadow, and other things, and becoming, paradoxically, all the more effective for that. Occlusion in these instances is repression but also a perverse kind of tribute to the pictorial, providing a model of what Flaubert felt the pictorial should ideally be. When Baudelaire said that the best kind of literary tribute to a painting might be a sonnet or an elegy he too had something of this kind in mind—not just celebration of the pictorial, in terms of *literary* structures and figures (the sonnet) but lament for its loss (the elegy). Pictorial images figure among the things which marked Flaubert deeply ('il y a des choses qui m'ont marqué d'un fer rouge') and in the light of which he writes. Hourticq remarked that *Bouvard et Pécuchet* read like a series of captions (*légendes*) to missing pictures, and that is true of all Flaubert's works, in a sense, and not only of *Saint Julien* where the word *légende* is part of the title. He set about deliberately to exclude 'ce qui fait plaisir', but those absent images infuse his writing, as in the Egyptian hieroglyphs evoked in the *Tentation de saint Antoine*: 'Les animaux de son zodiaque se retrouvaient dans ses pâturages, emplissaient de leurs formes et de leurs couleurs son écriture mystérieuse' (4: 134). Pictorial images are a source of love, wonder, and awe. As in the case of the Philippeville mosaic, the illumination may be only momentary (the water dries and Flaubert goes away) but the effect remains and infuses his writing. Flaubert is Damis, fascinating Antoine with his narratives and with the strange shapes which he draws at the same time in the dirt with his stick (4: 106). He is also Loulou (another of his pseudonyms), the talking bird 'qui porte la peinture tout entière sur le dos'.

Appendices

APPENDIX A

Italy 1851: Pictures Noted by Flaubert

Most references are to the *Voyage en Orient*, CHH 11
* = mentioned in Murray's *Guide*.

CURRENT IDENTIFICATION	FLAUBERT'S TITLE/DESCRIPTION
NAPLES[1]	
* Rembrandt: self-portrait as an old man[2]	
J. Spilberg: *Ritratto muliebre*	Portrait d'une chanoinesse
* Joos van Cleve: *Crocifissione e donatori, presentati di S Marco e S Margherita*	Lucas van Leyden, *Un dévot*...
* Joos van Cleve: *Adorazione dei Magi*[3]	L. van Leyden
?	'Deux tableaux de l'école allemande, 475 et 460'[4]

[1] These pictures (117–24), which Flaubert saw in the Real Museo Borbonico, are now in the Museo di Capodimonte. However, one particular collection, which belonged to the Prince of Salerno, was sold and dispersed. Many of the paintings which Flaubert saw in the Salerno gallery are now in the musée Condé, Chantilly. See Bibliography, section 3, for a list of guides and catalogues which were helpful in identifying which pictures Flaubert saw. Flaubert himself certainly used B. Quaranta, *Le Mystagogue* (1844), and probably Murray.

[2] This is in fact a copy of the Uffizi self-portrait, cf. B. Molajoli, *Notizie* (1960), 60, no. 187.

[3] Cf. O. Blewitt, *Hand-book* (Murray, 1853), 200: 'Luca von Leyden (?), The Adoration of the Magi, remarkable for its brilliant colouring and varied composition'.

[4] Cf. Quaranta, *Mystagogue*, under the heading ÉCOLE ALLEMANDE no. 460: *La Nativité de Jésus*; under the heading ÉCOLE HOLLANDAISE nos. 474, 475, 476: *L'Adoration des Mages*. Cf. also D. Monaco, *Guide général* (1884), which suggests that nos. 474–6 could be by Martin Schöngauer: '2–3–4 Martin Schöngaur. Trois tableaux formant triptyque. Les deux tableaux sur les côtés représentent, chacun, un des rois Mages suivi d'un homme de sa maison: le tableau du milieu représente deux mages adorant la Ste Vierge et l'Enfant Jésus.'

* Van Oostsanen: *Nativity*

Dürer, *La Nativité de Notre-Seigneur*[5]

*Correggio: *La Zingarella*[6]

L. Bassano: *Resurrezzione di Lazzaro*

* F. Santafede: *Virgin and Child with Saints*

* Giulio Romano: *Madonna del Passeggio*

Raphael?, *La Sainte Vierge (Madonna del passaggio) [sic]*[7]

* Artemisia Gentileschi: *Giuditta e Oloferne*

Caravaggio[8]

* Denis Calvaert: *Noli me tangere*

L da Vinci: 'J-C apparaissant à Marie-Magdalen sous les traits d'un jardinier'[9]

[5] Murray gives this painting high praise and a lengthy description, to which Flaubert's is not indebted.

[6] Cf. Blewitt, *Hand-book*: 'a most beautiful and touching composition [. . .]. It represents the Madonna resting during the flight out of Egypt, with the Infant Saviour sleeping in her lap. The scene is a dark wood, in which the birds and a white rabbit are enjoying themselves without fear, while angels are hovering above the trees.'

[7] See Konrad Oberhuber, *Raffaello* (Milan: Arnoldo Mondadori Editore, 1982), 202, among the works attributed to Raphael cf. no. 11: Giulio Romano, *Sacra Famiglia con san Giovannino (Madonna del Passeggio)*, at present in Edinburgh, National Gallery of Scotland. And cf. Blewitt, *Hand-book*, 192: '(?) The Holy Family, a repetition of the Madonna del Passeggio of the Bridgewater Gallery'.

[8] Attributed to Caravaggio in the 1841 Guide (no. 227), and in Quaranta, *Mystagogue* (no. 301, p. 168). But cf. Blewitt, *Hand-book*, 192, VII: '*Michael Angelo Caravaggio*, A repetition of his Judith cutting off the Head of Holophernes; supposed by some to be a copy by Gentileschi'. It is the same painting as the Gentileschi *Judith* in the Uffizi, as Flaubert himself notes (cf. *Italie et Suisse* in Ch. 3; see also below, under 'Florence').

[9] Cf. Quaranta 1844 in the section entitled 'GUIDE POUR LA PRÉCIEUSE COLLECTION DES TABLEAUX DE SON ALTESSE ROYALE *LE PRINCE DE SALERNE*', no. 2, p. 297: 'Le Rédempteur apparaissant à Marie-Madeleine sous les traits d'un jardinier LEONARDO DA VINCI (École de)'. The painting is now in the Musée Condé at Chantilly, see *Peintures de l'École italienne* (Éditions de la Réunion des Musées Nationaux, 1988), 58, no. 16: Denis CALVAERT, *Noli me tangere*—'conservé à Naples, au Real Museo Borbonico (Quaranta, 1846, p. 261, no. 2); mis en vente avec la collection Salerne [. . .]; acquis par le duc d'Aumale en 1854; envoyé à Twickenham en Grande-Bretagne, puis à Chantilly en 1870'. Ibid. 59: 'Dans la collection du prince de Salerne, le tableau figure sous le titre école milanaise, et même, école de Léonard de Vinci [. . .]. Récemment, E. Fahy (comm. orale, janvier 1984) a proposé le nom de Denis Calvaert, peintre anversois [. . .]. Selon O. Deledenda [. . .], ce type d'iconographie de la Madeleine a été jugée choquante par les théoriciens de la Contre-Réforme. En effet, la Madeleine porte un vêtement somptueux, typique du maniérisme tardif. Ce costume est une évocation de sa vie passée. Il est indigne du moment de la Passion [. . .]'.

Appendix A

* copy of Leonardo: *San Giovanni Battista*	Bernardo Luini, *Saint Jean Baptiste*[10]
* S. Rosa: *Cristo fra i dottori*	
S. Rosa: *Andata al calvario*[11]	
?Errante: portrait of Napoleon[12]	
?Stieler: portrait of Josephine[13]	
Ingres: *Paolo e Francesca*[14]	
Gérard: *Les Trois âges de la vie*[15]	
* Ribera: *Sileno ebbro*[16]	
Il Bertoja: *La Madonna del dente*[17]	Parmigianino, 'La S.V. et l'Enf. J'
Il Parmigianino: *Lucrezia*	
G Bedoli: *Parma abbraccia Alessandro Farnese*[18]	Parmigianino, 'La ville de Parme'
* Agostino Carracci: *Composizione satirica*[19]	Annibal Carrache

[10] Attributed to Luini in the 1841 guide (no. 35) and Quaranta, *Mystagogue* (no. 93). For black and white reproduction, see R. Causa (ed.), *Le collezioni del Museo di Capodimonte* (1982) 121 (described as a copy of Leonardo).

[11] This painting, from the collection of the prince of Salerno, is now in Chantilly, see *Peintures de l'École italienne*, no. 75, p. 144, Salvator Rosa, *Le Portement de croix*. Provenance as for the Calvaert, above.

[12] In the Salerno gallery. Cf. Quaranta, *Mystagogue*, no. 75, p. 304: 'Portrait de Napoléon sous les traits de Jupiter. ERRANTE'. Errante was a Sicilian painter. I have been unable to trace this painting.

[13] In the Salerno gallery, cf. Quaranta, *Mystagogue*, 74: 'Portrait de Joséphine Beauharnais première femme de Napoléon. STIELER (peintre Allemand)'. I have been unable to trace this portrait.

[14] In the Salerno gallery. This painting is one of six versions (see H. Honour, *Romanticism* (1984), 393), and is now in Chantilly, see E. Radius, *L'opera completa di Ingres* (Milan: Rizzole editore, 1968), no. 79, p. 95: *Paolo e Francesca sorpresi da Gianciotto*, 'con ogni verosimiglianza dipinta per Carolina Murat nel 1814, poi appartenuta ai principi di Salerno, presso i quali fu acquistata dal duca d'Aumale (1854)'.

[15] In the Salerno gallery (cf. Quaranta, *Mystagogue*, no. 70). Now in the Musée Condé, Chantilly.

[16] Murray (Blewitt, *Hand-book*) devotes a paragraph to this 'powerful and very characteristic picture'.

[17] Cf. Augusta Ghidiglia Quintavalle, *Il Bertoja* (Milan: Silvana editoriale d'arte, 1963), 8, painting reproduced fig. 5. See also ibid. 52: 'Già ascritta al Parmigianino ed ora al Bertoja, ma forse replica coeva da un originale perduto'.

[18] Painting now in Parma. Cf. Lucia Fornari Schianchi, *La Galleria Nazionale di Parma* (Parma: Artegrafica Silva, n.d.), 108: 'Gerolamo BEDOLI, *Parma abbraccia Alessandro Farnese*: Proviene dalla raccolta farnesiana nel Palazzo del Giardino. Passato a Napoli nel 1734 sotto il nome di Parmigianino fu restituito a Parma nel 1943.'

[19] Cf. B. Molajoli, *Il museo di Capodimonte* (1961), no. 369: 'La strana accolta di figure mostruose e d'animali, evidentemente rittrati da modelli reali . . . Attribuita in antico ad Annibale Carracci.' Cited in Blewitt, *Hand-book*, 190: 'A satirical picture of Caravaggio, who is represented as a savage with two apes on his

* Holbein: *Erasmus*
* Titian: *Ritratto di Filippo II*[20]
* S del Piombo: *Ritratto di Papa* 'Portrait du pape Alex VI'
Clemente VII[21]
*F. Salviati: *Ritratto di gentiluomo* 'Raphael. Portrait du chevalier
 Tibaldeo'[22]
Parmigianino: *Ritratto di Galeazzo* *'Portrait de Christophe Colomb'*[23]
Sanvitale
Scuola Parmense: *Ritratto* Parmignianino, 'Portrait d'Americ
di gentiluomo ritenuto Vespuce'[24]
G. B. Castaldi
* M Spadaro: ?*Masaniello*[25]
* M van Mierevelt: *Grotius*[26]
* Vivarini: *Madonna and Child* CV8 16ʳ: 'Écol vén. 196'[27]

shoulders, and offering food to a parrot, his body covered with feathers, to show that he copied others. In one corner is Annibale Carraci [*sic*] himself, laughing at his rival.'

[20] Cf. below, Rome, palazzo Corsini, for a copy of this painting.

[21] Cf. Blewitt, *Hand-book*, 194: 'a Portrait hitherto called that of Pope Alexander VI, of the Farnese family; but as that Pope died when Sebastiano was only seven years of age, it is believed that this portrait is that of Clement VII (Giulio de' Medici), painted shortly after his elevation to the papacy, and therefore the portrait mentioned by Vasari, who says that Clement did not then wear the beard by which he was afterwards distinguished.'

[22] This attribution appears in the guide of 1841 and in Quaranta, *Mystagogue*. But cf. the catalogue to the Real Museo Borbonico (1827), 'Tavola XXVIII Francesco Salviati (Francesco de' Rossi detto Cecchino Salviati, Firenze 1510–Roma 1563: *Ritratto di gentiluomo*, Tavola, 76 × 59. Erroneamente ritenuto, in passato, ritratto di Antonio Tibaldeo e attributo a Raffaello.' Cf. Blewitt, *Hand-book*: '(?)Portrait of the poet Tibaldeo'.

[23] Attribution as in the guide of 1841 (no. 266) and Quaranta, *Mystagogue* (378). But see Molajoli, *Museo*, which identifies it as a portrait of Galeazzo Sanvitale. Cf. Blewitt, *Hand-book*, 194: '*Parmegiano*, Portrait of a Knight, said to be that of Christopher Columbus; an extremely fine portrait, assigned to Columbus on very doubtful authority; but so many copies have been made for American travellers and sent to different parts of the United States, that it is certain to be handed down to posterity as the genuine portrait of the great navigator'. Murray's hesitation is reflected in Flaubert's own text, cf. 11: 123.

[24] Flaubert's identification is in accordance with the guide of 1841 and Quaranta, *Mystagogue* (87).

[25] Listed as a portrait of Masaniello in Quaranta, *Mystagogue*, 255. Both Monaco, *Guide*, and Rinaldis, *Guida illustrata* (1911), 423, cast doubt on the identification with Masaniello (a famous revolutionary responsible for a revolt in 1647).

[26] In the Salerno collection, cf. Quaranta, *Mystagogue*, 299. Now in Chantilly, musée Condé. Flaubert's note (CV8 16ʳ) is very brief.

[27] Flaubert notes the number '196' by this painting, which enables identification. Cf. Quaranta, *Mystagogue*, under 'École vénitienne': '196 Vivarini, La S.V. couverte d'un manteau de drap d'or avec l'Enf. J sur un trône.'

ROME

S. Maria in Trastevere

Jesus and the Virgin	CV8 20v–21r
Annunciation	CV8 21r
Nativity	CV8 22r
Adoration	CV8 22$^{r–v}$
Presentation at the Temple	CV8 22v
J. Hierensius	CV8 22v, 23r

S. Agnese fuori le mura

Mosaic of St Agnes	CV8 23v; 150

S. Prassede CV8 23v–25r; 150–1

Mosaics of the apse
G. Romano, *Flagellation*

S. Maria Maggiore

Giacomo da Turrita: mosaic of the apse	CV8 25$^{r–v}$; 151–2

Palazzo Corsini CV9 15v–18v; 152–3

* Murillo: *Madonna*	
* Scuola di Utrecht: *Ritratto di Vecchia (la moglie di Martin Lutero)*	Holbein
Carlo Maratta: *Ritratto virile*	Van Dyck, *Portrait d'homme chauve*[28]
Tiberio Tinelli: *Ritratto d'uomo*	Murillo, *Portrait d'homme à grands cheveux noirs*
Rembrandt: *Una vecchia*	
* Titian: *Filippo II*[29]	
Callot: *La vie du soldat*	
* D. Campiglia: *Portrait of Rubens*	CV9 16v: Rubens, self portrait
Philip Wouwermans: *Cacciatori in un paesaggio*	CV9 18v

[28] Cf. F. Hermanin, *Catalogo* (1924), 70–1, 13th room, no. 291: 'Carlo Maratta detto Carlo delle Madonne: Il nostro quadro fu attribuito ora al Van Dyck, ora a Philippe de Champaigne. È opera certa del Maratta, simile in tutto a un ritratto del Museo Imperatore Federico di Berlino, segnato colle cifre del maestro.'
[29] Copy of the painting listed in the Capodimonte, q.v.

Villa Farnesina
Il Sodoma, *Nozze di Alessandro e* CV9 18ʳ; 154
di Rossana

Galleria Colonna CV9 7ᵛ–9ʳ
B van Orley: *Le sette gioie e I setti*
dolore della Vergine Van Eyck³⁰
* Jan Stephan van Calcar (?): Holbein
*Ritratto di Lorenzo Colonna*³¹
* F. Salviati: *Resurrrezione di*
Lazzarro
* Pietro Testa (attr.): *Cimone ed* Poussin, *Sommeil des Bergers*
*Ifigenia*³²

Galleria Doria Pamphilj CV9 9ʳ–11ᵛ
Imitator of Jan Brueghel: J. Brueghel, *Dieu au milieu de la*
*Creazione degli animale*³³ *création*
Jan Brueghel and Hendrick van Jan Brueghel
Valen: *Allegorie dei quattro*
elementi: Acqua; Terra; Aria;
Fuoco

Palazzo Borghese (collection now CV9 11ᵛ–15ᵛ; 155 incomplete
in the Villa Borghese)
* Titian: *Amor sacro e profano*
Titian: *Venere che benda Amore* 'Les trois grâces'
Bassano: *Ritratto di vecchio con*
*barba bianca e berretto nero*³⁴

³⁰ This painting was still attributed to Van Eyck in 1900, cf. E. A. Safarik, *Catalogo* (1981), 101.
³¹ Ibid. 45 (no. 36): 'Si suggerisce l'attribuzione dubitativa al van Calcar per il dipinto che anticamente portava il nome di Holbein.'
³² Ibid. 131–2, no. 185: 'Attribuito nell'inventario del 1714 a Nicolas Poussin, e così catalogato nel 1783, il dipinto fu riferito al Testa da Lucia Lopresti [. . .]. Il soggetto, già indicato come "*Il sonno dei pastori*", fu riconosciuto nel 1848 e interpretato dal Corti, che annotava come esso fosse stato anche l'argomento della prima novella della quinta giornata del *Decameron* di Giovanni Boccaccio, di cui infatti il quadro sembra trasposizione fedele.'
³³ Cf. E. A. Safarik and G. Torselli, *La Galleria Doria Pamphilj* (1982), no. 165.
³⁴ This painting has now disappeared, cf. Edoardo Arslan, *I. Bassano* (Milan: Casa editrice Ceschina, n.d. [c.1960], i. 365: 'ROMA, Galleria Borghese, n. 19: *Ritratto di vecchio con barba bianca e berretto nero*. Secondo la dott. P della Pergola si sone oggi perdute le tracce del dipinto.'

Rubens: *Pianto intorno al Cristo desposto*	Van Dyck
Cranach: *Venere e Amore*	
* L. Lotto: *La Vergine e il Bambino tra S Onufrio e un Santo Vescovo*	
? (insufficient information)	M. Venusti, *Madonna and Child*
* Correggio: *Magdalena* (copy)[35]	
? (insufficient information)	Pomarancio, Virgin and child
* Correggio: *Danae*	
Scarsellino: *Il bagno di Venere*	'J. Romain, *Vénus au bain*'
?	Raphael, *César Borgia*[36]
Botticelli e aiuti: *La Madonna col Bambino Gesù e S. Giovanni bambino e Angeli*	Botticelli
Giampetrino: *Madonna che allatta il Bambino*	Leonardo da Vinci

Capitoline

Veronese: *Europa*	C1 772

Sistine

Michelangelo: *Last Judgement*	C1 772, 780

Vatican

Domenichino: *La comunione di S Girolamo*	VO 11: 163; BMR g 226⁵ 346ᵛ

PERUGIA · CV8 28ʳ; 162–3

S. Lorenzo

Luca Signorelli, *Madonna in trono con Bambino e Santi*	'un vieux tableau de l'école allemande (ou italienne) primitive'

Cambio

Perugino: sages of antiquity, *Trasfigurazione*, *San Giovanni Battista*

[35] The original is in Dresden: 'a very fine and celebrated picture', Blewitt, *Murray's Handbook for Rome* (1858).
[36] Cf. Murray's *Hand-book Central Italy and Rome* (1843), 440: 'Raphael. Portrait of Cesar Borgia: there is some doubt whether this picture be really the portrait of Borgia.' A. Venturi, *Il Museo e la Galleria Borghese* (1893) casts doubt on both title and attribution.

FLORENCE

Uffizi

Fiesole: *I funerali della Vergine,*
Sposalizio della Vergine,
Incoronazione della Vergine
C. Allori: *Santa Maria Maddalena*
nel deserto[37]
C. Allori: *Giuditta con la testa di*
Oloferne[38]
Flemish school: *Testa di Medusa*
F. Lippi (attr.), portrait of an old
man
A. Gentileschi: *Giuditta e*
Oloferne[41]
Albertinelli: *Visitazione*[42]
A del Sarto: *Autoritratto*
R Ghirlandajo: *Esèquie di San*
Zanobi
Vasari: *Lorenzo il Magnifico*
A. Allori: *Sacrificio di Isacco*
Rubens: *Baccanalia*

CV9 22ʳ–26ʳ, 19ʳ–20ʳ, 23ᵛ;

164–9, 171–2

Leonardo da Vinci[39]
Masaccio: *Un portrait de vieillard*
ridé[40]

[37] Cf. *Galerie impériale* (1844), 238: 'belle copie du fameux tableau de Corrège qui était à Modène et qu'on voit aujourd'hui à Dresde'.

[38] Ibid. 237: 'Ce petit tableau est peint d'un finiment extraordinaire: et d'une perfection excessive de dessein et de coloris. C'est une répétition, en petit, du même sujet, peint par le même auteur, et que l'on voit dans la Galerie du Palais Pitti.' Remark made also by Flaubert.

[39] Ibid. 235: 'Du même [ie Leonardo], La tête de Méduse avec les cheveux changés en serpens: c'est un morceau précieux pour la beauté de l'exécution, et pour la rareté'. Cf. *Venezia* (Milan: Touring Club Italiano, 1985), 142, '*Testa di Medusa*, di scuola fiamminga del sec. XVI, già attrib. a Leonardo'.

[40] Cf. *Reale Gallerie* (Serie I Quadri di storia; 1817), i. 57, no. xvii: 'Ritratto d'incognito. Pittura in tegolo di Masaccio [. . .] dipinto a fresco sopra un piano di terra cotta'. The plate confirms it is the same painting as this one, attributed now to Lippi, see L. Berti, *The Uffizi* (1971), 47. Cf. also *Galerie Impériale* (1844), 236: '*Masaccio*. Un Vieillard peint sur une tuile avec une vérité étonnante' and Flaubert's similar remark.

[41] The same painting as that attributed to Caravaggio in Naples, cf. Flaubert's comment. *Galerie impériale* (1844) remarks that it is 'trop fort pour être l'ouvrage d'une femme' (cf. my discussion of the *Judith* paintings in Ch. 3).

[42] Cf. *Galerie impériale* (1844), 243–4: 'Admirable et extraordinaire est la vérité, ainsi que la simplicité et l'ensemble qui règnent dans ce tableau, composé de deux seules figures, qui en remplissent si bien l'espace. La tête de la Vierge ne saurait être rendue avec plus de noblesse et de beauté; celle d'Élisabeth avec plus de nature. On croirait entendre les paroles au moment où les saintes femmes se rencontrent. Les sentiments n'ont jamais été rendus avec tant de clarté comme dans ce tableau. Le dessin en est parfait, le coloris vigoureux, vrai, et plein de relief.'

Dolci: *Santa Maria Maddalena*
Rubens, portrait of Elena Forman[43]
Sassoferrato: *La Vergine*
addolorata
N. Frumenti: *Lazarus*
F. Francken II: *Il trionfo di*
Nettuno e Anfitrite

Clouet: *Francis I*	Holbein
Maestro di Hoogstreten: *Madonna*	Hugo van der Goes de Bruges:
col Bambino e le SS Caterina e	*La Vierge, le Bambino, sainte*
Barbara	*Catherine à genoux et une autre*
	femme[44]

Mieris: *Interior*
A. del Sarto: *Madonna delle arpre* 'Sainte Famille'
Il Franciabigio: *Madonna del* Raphaël: *Le Bambino, saint Jean-*
Pozzo *Baptiste enfant, et la Vierge*
Raphael: *Madonna del Cardellino*
Raphael: *San Giovanni nel deserto*
Michelangelo: *Sacra Famiglia con*
S. *Giovannino*

Cranach: *Eve*
E. Liotard: *Autoritratto* CV9 23v
Bilivert: *La Castità di Giuseppe* CV9 20v
(now in Pitti)
[Parmigianino, *La Madonna dal*
collo lungo and Rembrandt,
self-portrait young, were
formerly in the Pitti, see below]

Pitti CV9 26v–28r, 20v; 169–71

Parmigianino: *La Madonna dal*
collo lungo[45]
Titian: *Concerto di musica* Giorgione[46]
Guido Reni: *Suicidio di Cleopatra*
Raphael: *Ritratto di Tommaso*
Fedra Inghirami

[43] Doubt has since been cast on both subject and attribution, e.g. Max Rooses, *L'Œuvre de P. P. Rubens* (Anvers; Jos. Maes, 1892), 171.

[44] Cf. *Galerie impériale* (1844): 'tableau précieux pour la finesse de son exécution'.

[45] Now in the Uffizi; cf. Berti, *Uffizi*, 97.

[46] Cf. N. Cipriani, *La Galleria Palatina* (1966), no. 185: 'Concerto di musica. Tiziano. Già attribuito al Giorgione.

C. Salviati (Francesco Rossi): Michelangelo[47]
Le tre Parche
Rubens: *Ninfe e Satiri*
Allori: *Giuditta*[48]
Van Dyck: *Ritratto del cardinale
Guido Bentivoglio*
Rubens: *I quattro filosofi*

Tintoretto: *Ritratto di Alvise* Titian[49]
Cornaro
Guido Reni: *San Pietro in lacrime*
Rembrandt: *Autoritratto*
(now in Uffizi)
N. Cassana: *La congiura di* Salvator Rosa[50]
Catilina
Titian: *La Bella*
Botticelli: *Ritratto di giovane* Botticelli: *La Belle Simonette*[51]
donna
S. Rosa: *La Selva dei filosofi*
S. Rosa: *La Paix brûlant des armes*[52]

[47] Ibid. no. 113: 'Le tre Parche Cloto, Lachesi e Atropo [...]. Già attribuito a Michelangelo e al Rosso Fiorentino.'

[48] The same painting as in the Uffizi only larger, as Flaubert says 11: 170.

[49] Cf. Carlo Bernari, *L'opera completa del Tintoretto* (Milan: Rizzole editore, 1970), tav. XVIII, p. 160 no. 158: 'Già ascritto a Tiziano'.

[50] Cf. Luigi Salerno (ed.), *L'opera completa di Salvator Rosa* (Milan: Rizzole Editore, 1975): 'Già attribuito a Salvator Rosa'.

[51] Cf. Cipriani, *Galleria Palatina*, no. 353: 'Ritratto di giovane donna, già ritenuta Simonette Vespucci o Fiorette Gorini.'

[52] Flaubert's notes on Venice are not included, as (a) they were extremely hard to decipher, and (b) most of what Flaubert saw was in the collection of the palazzo Manfrin, which was dispersed in 1856. Further work therefore remains to be done.

APPENDIX B

A Transcription of Flaubert's Notes on Charles Blanc's *Histoire des peintres*

[333] PEINTURE[1]

[334ʳ] Demarne 1744–1829[2]

Pendant que David ramenait l'école aux traditions de l'antique Demarne donnait l'exemple du retour à la Nature. *Grandes routes* exposées au Salon de l'an IX & de l'an X.

esquisse peinte de la *bataille de Nazareth*

travaille à la manufacture de Sèvres & à celle de Mr[Dilh] Dihl.—étable, abreuvoirs.

De Pierre 1715–1789

Directeur de l'Académie de peinture, gouverna les arts en France depuis la mort de Me de Pompadour jusqu'à la \<la\> Révolution Française—p. St Germain des Prés *la Mort d'Hérode* & un *St Pierre guérissant les boiteux* p. \<la coupole de\> St Roch *l'Assomption de la Vierge*, succède à Boucher.[3] \<fait\> supprimer l'Académie de St Luc dont l'institution remontait à Charles V.

[335ʳ] Hogarth[4]

1697–1764

réaction contre Kent, importateur en Angleterre des jardins anglais c'est à dire hollandais. L'Angleterre avait son Lenostre dont elle fit son Michel Ange & son Raphaël.

Hogarth débuta par une caricature qui parodiait sa[5] manière dans un tableau de St Clément de Londres. L'évêque fut obligé de décrocher le

[1] Bibliothèque Municipale de Rouen, ms g 226ˢ, 'Peinture', 333–55ʳ. I have supplied accents where missing but otherwise Flaubert's text is unaltered. For discussion of this manuscript see Ch. 6.

[2] Flaubert's notes on French painters are from Charles Blanc, *Histoire des peintres*, *École française*, 3 vols. (1862–3). Pagination in Blanc begins anew for each painter. The author is Blanc, unless otherwise indicated.

[3] As 'premier peintre du roi', cf. CB 4.

[4] Article by Philarète Chasles, *École anglaise* (1863). [5] 'sa' = of Kent.

tableau—il était alors graveur sur métaux, avait fait des vignettes p.une édition d'Hudibras, p. L'âne d'or d'Apulée.

fréquente l'atelier de Thornill [*sic*]. Mais y retrouve ce qu'il détestait le plus, les poses académiques, les allégories gréco italiennes. il épouse la fille de son maître sans le consentement du père.

Ses portraits étaient si vrais qu'on s'écarta de lui. Alors il se replia sur les folies & les travers de son temps. Son intention fut satyrique & morale, *Harlot's progress* série de gravures représentant la vie d'une fille perdue. Les *Progrès du Mauvais sujet dans la vie* <Rake's progress> lui firent pendant. Watteau & lui sont les antipodes de l'art et expliquent les deux pays— *Le Mariage à la Mode les Actrices nomades*

Résuma ses principes dans un livre intitulé *Analyse de la Beauté* & que pillèrent Diderot & ses amis. Il s'élève contre la ligne droite & est pr. la ligne serpentine.

 Le combat de Coqs
 Les buveurs de Punch
 Le Musicien, étourdi par les Musiciens ambulants.

J. Reynolds & Horace Walpole ne l'ont pas regardé comme un peintre.— La multitude de ses accessoires désoriente le regard. Sa touche est sèche. il sacrifie au détail du caractère et à l'intention philosophique la beauté de la forme & de l'ensemble.—Moraliste avant tout, il [s'inge] s'insurge contre l'idéal grec, il est bien le contemporain de Swift et de Daniel de Foë.

Diderot a propagé ses théories, R. de la Bretonne emprunte à Harlot progress & à Rake progress le Paysan & la Paysanne pervertie. Tous, comme lui, ils répudiaient le monde idéal & impersonnel pr se rapprocher de la réalité vivante & de la variété libre.

 (Philarète Chasles)
 L'analyse de la Beauté trad
 en français par Jansen.
Paris 2 vol in 8 an XIII (1805)

[*335ᵛ*] *Reynolds 1723–1792*

Est parti du traité de peinture de Richardson—<puis> élève de Hudson.— n'admire pas d'abord les maîtres quand il est à Rome & dit à ce propos 'un goût sûr en poésie, une oreille parfaitement musicale ne s'obtiennent qu'à la longue' compare, observe, aussi remarque que [chez] les Vénitiens 'ont donné plus d'un quart du tableau à la lumière en y comprenant le principal clair & les clairs secondaires, un autre quart aux plus fortes ombres possibles & le reste aux demi teintes, tandis que dans les ouvrages de Rembrandt, par exemple, la masse des bruns est 8 fois plus importantes que la masse des clairs.[6]—Les tons chauds tels que le jaune & le rouge doivent

[6] The quotation from Reynolds ends here. From 'Les tons chauds' to 'le principal groupe' Flaubert reproduces CB almost verbatim.

être réservés pr les masses de lumière, & les tons froids tels que le gris, le bleu & le vert doivent être tenus en dehors de ces masses p. les mieux faire valoir. Mais comme <le> tableau ne doit pas être divisé en 2 parties distinctes l'une chaude & l'autre froide, il est nécessaire de rappeler les couleurs fières dans les masses fuyantes ou rembrunies & de mêler qques couleurs tendres à la masse des tons chauds qui colorent le principal groupe.

après [l'am] le portrait de l'amiral Keppel on le compara à Van Dyck.— portrait de Hunter, <accoudé> à sa table, pieds de squelette au fond,— planches d'anatomie ouvertes—est toujours anglais dans toutes ses figures.—Nativité—Ugolino. Ses discours académiques lui donnèrent autant d'influence que sa peinture. Il enrichit de notes curieuses le poème de Dufresnoy trad en anglais par Mason.—Admiration excessive de Michel-Ange—

———

David Wilkie 1785–1841[7]

le Hogarth de l'Écosse—l'école écossaise avait eu déjà Jameson Ramsay Raëburn & Runciman.—Pas moyen d'étudier le nu, par décence on ne trouverait en Écosse aucun modèle.[8] il faut se rejeter sur l'expression morale *Foire de Pitlessie Le recruteur de village, les politiques de village la coupure au doigt.* La vie domestique le préoccupe il n'a d'autre idéal que l'humanité rustique soumise à la moralité épurée par le travail. *Aveugle qui joue du violon* tons gris & lourds. teinte ardoisée & métallique. sécheresse brillante—peu de largeur—des glacis laborieux & multipliés.—*Manse presbytérienne*

[336ʳ] Largillière

1656–1746
élève de Lebrun Mtre d'Oudry.—3 voyages en Angleterre.
 Convalescence de L XIV. Mariage du duc de Bourgogne p. l'hôtel de ville de Paris *portement de Croix.* la croix du Christ est tirée avec des cordes.— à St Etienne du Mt (autrefois c'était à Ste Geneviève) est l'exvoto de la ville de Paris en 1694 p. la famine. Largillière a représenté les officiers municipaux implorant la Ste. il s'est mis [avec] <parmi> les assistants [parmi] <avec> le poète Santeuil.

———

[7] Article by Ph. Chasles. Wilkie is a literary painter, cf. Gautier on Wilkie, quoted M. C. Spencer, *The Art Criticism of Théophile Gautier* (1969), 89: he shows 'ce sentiment littéraire et comique qu'on trouve rarement chez nos peintres et qui fait composer un tableau comme un chapitre de roman ou une scène de drame' (*Moniteur*, 11 May 1862).
[8] 'Pas moyen [. . .] modèle' is Flaubert's paraphrase.

Parmi ses élèves Van Schuppen, fils du graveur de ce nom, le chevalier Descombes, Meusnier fils & Oudry.

Lebrun. 1619–1690

protégé par le chancelier Séguier, élève de Simon Vouet.—conseillé à Rome par Poussin. après 6 ans de séjour à Rome revient en France. *Crucifiement de St André. Frappement du Rocher, Serpent d'airain*
 Peint les murailles de l'hôtel Lambert en même temps que Lesueur. peint un songe mystique d'Anne d'Autriche—JC dans le désert environné d'anges qui le servaient. fut envoyé aux Carmélites de la rue St Jacques.
 décore le château de Vaux de Fouquet
Protégé par Colbert. L XIV vient souvent le voir peindre, comme Philippe IV Vélasquez[9]—direction générale de tout ce qui rapport aux arts.
 Conférences à l'Académie. Les ouvre par l'éloge du St Michel de Raphaël—mémoire sur la manière d'exprimer les différentes passions—*La famille de Darius, Le passage du Granique La bataille d'Arbelles. La défaite de Porus L'entrée d'Alex. à Babylone.* Par scrupule d'archéologue, il fit dessiner à Alep des chevaux persans.
Passe 14 ans à décorer Versailles.—marié—pas d'enfants. amoureux de la femme du graveur Israël Sylvestre.
Louvois, prit le parti de Mignard.[10]
Son dessin dans le goût de Carrache est ample mais d'une correction un peu banale [que] ses figures courtes tirent de ce défaut même leur caractère mâle & fier. Sa couleur se compose ordinairement de teintes générales sans choix & sans finesse qui ne sont ni assez rompues ni suffisamment reflétées par les tons voisins.[11]—

———

[336ᵛ] Pierre Mignard

1610–1695.
Élève de Boucher, de Bourges—puis de François Gentil, sculpteur à Troyes—étudie ensuite à Troyes. puis chez Simon Vouet qui lui propose sa fille, il la refuse—vie studieuse à Rome avec Alphonse Dufresnoy—peint les portraits de Français de distinction à Rome, celui de Urbain VIII & d'Innocent X. *St Charles communiant les malades frappés de la peste* où il s'inspire de la communion de St Jérôme.—portrait d'Alexandre VII.— revient en France, malade, à Avignon où il fait le portrait de la Mquise de Gange—fait en 3 heures le portrait de L XIV p. Marie-Thérèse—entre à la cour.

———

⁹ CB's comparison.
¹⁰ i.e. Louvois supported Mignard whereas Colbert supported Lebrun.
¹¹ Paragraph transcribed almost verbatim.

Coupole du Val de Grâce <fait en un an & demi dans 1663>. Peindre une coupole c'est supposer le ciel ouvert[12]—trop de vivacité dans les oppositions trop d'éclat dans les couleurs dérangerait la tranquillité de l'architecture. Si les figures étaient trop fortement peintes, elles menaceraient de nous écraser. il ne faut pas que le relief des peintures perce les murailles de l'édifice. Mignard se permit à l'instar des Italiens de retoucher ses fresques avec du pastel p. donner un rehaut momentané & séduire la foule. Il a accusé avec plus de force le groupe d'Anne d'Autriche encore vivante pendant qu'il éloignait par la dégradation des tons les groupes des Martyrs les pères de l'Église & de l'ancien testament à mesure que ces héros s'éloignent de nous, & s'enfoncent dans la perspective de l'histoire.

Les contrastes savants des membres agroupez
.
La beauté des contours observés avec soin
point durement traités,—amples, tirés de loin
inégaux ondoyans & tenans de la flâme'

ces vers de Molière semblent une trad. de Dufresnoy.—n'est-ce pas là qu'Hogarth a puisé les idées qu'il développe dans son analyse de la Beauté sur la ligne serpentine qu'il déclare la belle par excellence.—
Décore, rue Plâtrière l'hôtel du contrôleur d'Hervart. = (hôtel des postes) la galerie du château de St Cloud, habité par Monsieur, les appartemens de Monseigneur à Versailles etc.—le portrait de la Mquise de Feuquières sa fille.[13]
publie le poème de son ami Dufresnoy,—après sa mort, sans commentaires, ni notes

———

[337ʳ] *Claude Lorrain (Claude Gellée dit)* 1600–1682

[talen] génic Virgilien.—D'abord ciseleur chez son frère à Fribourg.— apprit [l'] à Naples la perspective [chez] & l'architecture chez Walss peintre de Cologne entre à Rome chez Augustin Tassi, comme domestique. —puis visite Venise Lorette, le tyrol, la Souabe & revient après 12 ans sur les bords de la Moselle—employé à Nancy chez Claude de Ruet à la décoration de la voûte & des chapelles de l'église des Carmes.—retourne à Rome & se loge près du Poussin.—étudie profondément tous les effets du soleil, & la dégradation insensible des objets à partir du second plan jusqu'à l'horizon c'est à dire tous les phénomènes de la perspective aérienne. Le haut prix de ses tableaux engage à des faux sous son nom. il se résolut à garder

———

[12] 'Peindre une coupole [. . .] belle par excellence' is CB verbatim, minus some redundant phrases.
[13] 'Marquise' should read 'Comtesse'—Flaubert's slip.

une esquisse de chacun, de manière à ce qu'on pût le confronter avec l'original. c'est ce qu'il appelait son livre d'invention ou livre de vérité.' il se trouve maintenant en Angleterre chez le duc de Devonshire.

L'art français a toujours mis l'homme au premier plan & laissé la nature au second. Tel paysage de Claude est le *Sacre de David*, un autre représente les apprêts d'un sacrifice—des guerriers en costume héroïque se promènent sur le premier plan de ses ports de mer. [Clau] il a commis une faute commune chez tous les artistes français; il a divisé l'intérêt du paysage.

(Voy. Deperthes hist. de l'art du paysage)

Poussin est historique. Claude arcadien ses paysages sont ceux de l'âge d'or— affectionne le soleil couchant sur la mer—

Ses premiers plans—ordinairement des palais ou des masses d'arbres p. servir de repoussoir sont des poncifs.

'si l'eau courbe un bâton, ma raison le redresse dit La Fontaine mais l'artiste préfère les naïvetés de la nature aux redressements de la raison.'

travaillait à 82 ans! = dessin appartenant à la reine d'Angleterre—prix excessifs.—la galerie de l'Ermitage à St Petersbourg en possède presqu'autant que le Louvre.—National galery.—la Reine de Saba.

100 mil fr.

[338ʳ] Monnoyer 1635–1699 (Fleurs) né à Lille

deux espèces de peintres de fleurs, les uns les peignent p. l'amour des fleurs, les autres pr l'amour de la peinture. ici les fleurs sont les prétexte [*sic*] d'un tableau qui représente une gamme s'élevant par l'hyacinthe jusqu'au blanc d'ivoire ou par le lis jusqu'au blanc de porcelaine, & descendant par la scabieuse jusqu'au violet brun.—d'autres s'attachent à l'exactitude botanique.[14]—à la localité de ton, & à force de s'occuper des parties négligent l'ensemble.

Sous L XIV on peignait les fleurs comme un objet de décor. il ne serait venu à personne l'idée d'aimer les tulipes. c'est en Hollande, en Angleterre dans les pays protestans qu'on a eu le goût passionné des fleurs.

Manière large de Monnoyer. Ses bouquets couvrent les dessus de porte de Trianon & de Marly. il y adjoignait de superbes tapis lourds & garnis de franges d'or.—des porcelaines du Japon—une cuirasse damasquinée ou un casque servant à balancer par ses lumières les clairs principaux du bouquet.

est appelé en Angleterre p. orner la maison de Mylord Montagu pleine d'artistes français La Fosse, peintre d'hist. Rousseau fameux p. les perspectives.

[14] This sentence is Flaubert's paraphrase: the rest is a compressed copy of CB's text.

une faute singulière qu'il fit est de mélanger dans le même bouquet des fleurs d'automne & de printemps. ce qui prouve que les fleurs n'étaient p. lui qu'un objet de décoration.

34 pièces gravées par lui à l'eau forte sont la mine où depuis deux siècles, les dessinateurs d'étoffe vont puiser, à Lyon, surtout.

ses tableaux sont maintenant lourds & noircis. il signait des tableaux seulement de ses prénoms: J. Baptiste

———

[338ᵛ] Oudry. 1686–1755

peint par Largillière—bonne & franche figure à gde perruque.— fils d'un Md de tableaux.—élève de Largillière.—Pierre Le Gd voulut l'enlever à St Petersbourg. Oudry fut obligé de se cacher.

Chasse au Loup (Louvre)

Sa couleur est un peu froide. & ses ciels manquent de l'éclat de ceux de Desportes.

il lut à l'Académie un mémoire ayant p. titre 'réflexions sur la manière d'étudier la couleur en comparant les objets les uns avec les autres'—selon lui, tout doit se régler sur le fond. avant de composer & de peindre il faut savoir sur quel fond on les[15] mettra, en passant derrière le modèle une toile du même ton que celui que l'on destine au fond'—en effet le fond est comme le ton dans lequel on doit chanter.'

Il faut poser les modèles devant soi à la distance qu'on veut qu'ils soient sur la toile.[16]

illustre La Fontaine 150 dessins furent gravés sous la direction de Cochin & ornent l'édition de 1755 publiée par Mr de Montevault—peignit 6 fables p. les appartemens du Dauphin & de la Dauphine—échoue dans l'illustration du Roman-Comique, l'humour lui manque.

———

[339ʳ] Murillo

1618–1682

Dans l'atelier de Juan del Castillo, vit Pedro de Moya qui revenait de Londres tout plein de Vandyck & il allait partir p. Londres quand il apprit la mort de Vandyck—

étudie les Titiens & les Rubens à Madrid & à l'Escurial.—& Vélasquez dans sa 1ère manière il tâche de les fondre—à la 2e appartiennent *l'extatique à la cuisine* (Mˡˡ[17] Soult) *Mort de Ste Catherine*[18] (Aguado)—dans la 3e le clair obscur violent qu'il avait emprunté de Ribera s'adoucit & gagna

———

[15] The word 'les' here refers to 'figures', cf. CB 8.
[16] Blanc's text makes it clear that Oudry is not advocating but criticizing this idea.
[17] 'Mˡ' = 'Maréchal'. [18] For 'Catherine' read 'Claire'—Flaubert's slip.

en transparence. Sa touche devint plus moëlleuse. il conserva un excellent ton gris qui ordinairement sert de fond aux portraits de Vélasquez.

domine ses rivaux Valdes Leal & Herrera le jeune

—la Vierge toujours vêtue de bleu & de blanc—ne montre jamais ses pieds.

entendait le paysage à la manière de Rubens.

Demande à être enterré dans l'église de Santa-Cruz aux pieds de la Descente de Croix de Pedro Campana.

Il est dangereux de copier Murillo. on tomberait dans la rondeur & le défaut d'accent.

François Zurbarán 1598–1662

les premiers principes lui furent enseignés par un disciple de Morales. Son second maître Juan de las Roëlas avait travaillé en Italie sous un élève du Titien et en avait rapporté le goût des belles étoffes.—aussi Zurbarán montra même enfant un goût décidé p. les draperies & surtout les draperies blanches. admire qq toiles du Caravage qui étaient à Séville.

effet prodigieux *du Moine en prières*, quand le Musée d'Espagne s'ouvrit. réception de St Bruno. miracle de St Hugues, évêque de Grenoble qui change en tortues le gibier qui était sur leur table.—chargé par Philippe IV de peindre les travaux d'Hercule au château du Buen-Retiro.

Supérieur au Caravage. il a été aussi mystique dans la pensée que brutal dans le maniement du pinceau.—Sous la pâleur de ses teintes Lesueur montre le croyant rêvant le Paradis, Zurbarán le représente épouvanté par l'idée de l'Enfer.

———

[339*v*] *Ribeira* [sic] = *L'Espagnolet 1588–1656 à Xativa, roy. de Valence*

Ce fut à Valence dans l'école illustrée par les deux Juan de Joanès que Ribeira reçut les premières leçons de peinture de Francisco Ribalta.

débuta à Naples par étudier dans l'atelier de Caravage, dont le tempérament lui était si conforme.—influence passagère du Corrège, dont il fit plusieurs copies.

il passa de l'indigence à la splendeur après son [tabl] *Martyre de Barthélemy* Il est attaché à un arbre, le bras droit dépiauté, le bourreau tient le couteau dans sa bouche. Une couronne avec une palme apparaît dans le ciel au dessus de la tête du saint. Le viceroi le protégea. & avec une bande d'hommes dévoués il exila de Naples tous les confrères dont il est jaloux. Le Guide est obligé de s'enfuir épouvanté il abreuve de déplaisirs le Dominiquin—menait un train de prince.

Don Juan d'Autriche fils naturel de Philippe IV. Envoyé à Naples après l'insurrection de Mazaniello enleva sa fille. On ne sait plus ce qu'il devint ensuite.[19]

———

[19] i.e. Ribera painted Don Juan of Austria; Don Juan was 'envoyé à Naples' to settle affairs of state after the revolt led by Masaniello. Don Juan carried off Ribera's daughter. The 'il' of 'ce qu'il devint' refers to Ribera.

Giovanni Do sut l'imiter de façon à tromper les plus habiles Errico Fiamingo, Bartolomeo Passante, Aniello Falcone, André Vaccaro, César, François Michel & Michel Ange Francanzi & enfin Luca Giordano furent les continuateurs de cette peinture.

Galerie du Ml Soult un *St Pierre aux liens* & une *Ste Famille*
à Naples *Silène, St Sébastien St Jérôme*
à Florence Martyre de St Bartélemy
au Louvre Hercule & un centaure, Caton d'Utique.
eaux fortes au Cabinet des Estampes. Voy le 20e vol du Peintre Graveur de Barsch

[340r] Nicolas Poussin 1594–1665

1ers maîtres sont Ferdinand Elle, de Malines, Georges Lallemant, de Nancy.—voit des dessins originaux et des gravures de Marc-Antoine chez Courtois, mathématicien du roi.

Marini arrive à Paris. fait la *Mort de la Vierge* p. les orfèvres de Paris et part, p. la 3e fois, pr l'Italie où il arrive enfin à Rome.

à Rome se lie avec le sculpteur François Duquesnoy dit le Flamand & moule avec lui des antiques pr. vivre.—*Mort de Germanicus*—p. le Cl Barberini. *La Prise de Jérusalem par Titus. La Peste des Philistins*—une légion de rats se répand dans la ville et on en voit défiler sur les corniches.

L XIII le nomme son peintre ordinaire. il ne quitte Rome que deux ans plutard & est établi aux Tuileries. *La Cène* où les apôtres sont couchés sur des lits, ce qui étaient [*sic*] une innovation.—Ligue de Simon Vouet, Fouquières & l'architecte Lemercier contre Poussin.—*Le Miracle de St François Xavier. le triomphe de la Vérité* puis repart pr Rome

Eliézar & Rebecca vérité archéologique. *Les Funérailles de Phocion* (v. les dialogues des morts de Fénelon. *Écho. Polyphème.* cette colossale figure baignée dans les lumières supérieures produit l'effet d'un mirage immense. *Les Sacrements.* le *Testament d'Eudamidas. Les quatre saisons* p. le printemps = le Paradis terrestre—p. l'été: Booz = l'automne est la terre promise reconnaissable à ses fruits prodigieux et [le ple] l'hiver—. le Déluge, qu'il acheva de peindre dans l'année de sa mort.

[341r] Valentin 1601–1632

il y a une classe de peintres qui dédaignent le mysticisme, l'expression <idéale> 'mais s'ils rencontrent des palpitantes [*sic*][20] se détachant sur un fond noir, ils s'enthousiasment ce qui leur plaît c'est l'énergie du mouvement, le bonheur des raccourcis. toutes les formes de la nature leur plaisent. Ils ne demandent pas à la matière de penser mais d'être.[21] Parmi ces panthéistes se trouvent surtout les admirateurs de Valentin.

[20] CB: 'des *chairs* palpitantes'. The quotation (approximate) from CB ends at 'fond noir' (quotation marks omitted by Flaubert).

[21] This sentence (like the following) is an accurate but compressed rendering of CB.

né à Coulommiers en Brie—on a prétendu qu'il avait étudié chez Simon Vouet les dates s'y opposent. Le plus probable est que se trouvant ensemble alors à Rome ils auront étudié Carravage [*sic*] dont Poussin disait 'cet homme est venu p. détruire la peinture'—

à Rome fréquente les mauvais lieux, les marauds, fait p. le Cardinal Barberini neveu d'Urbain 8 *une vue de Rome avec l'Anio & le Tibre* <&> *La décollation de St Jean Baptiste.* p. la basilique de St Pierre *Le Martyre des Sts Processe & Martinien* les deux patients sont étendus tête bêche, sur un appareil mécanique sur un appareil mécanique [*sic*]. La copie est en mosaïque à St Pierre où elle est placée à côté du Martyre de St Érasme autre mosaïque d'après Poussin (voy Revue britannique mai 1837 art. de F. Pyat.)

Mais ces sujets ne lui allaient pas. p. lui, la Chaste Suzanne (*Innocence de Suzanne reconnue*) sera une servante aux rougies [*sic*],[22] aux durs appas, pudique sans coquetterie (v. Levesque, dict des arts t.IV) Dans le Jugement de Salomon il fait la vraie mère belle, la fausse laide.—l'enfant mort étendu sous les pieds du roi est un chef d'œuvre de modelé, mais ressemble à une statue d'airain. 'Il modèle dans les clairs avec les demi teintes plombées, tandis qu'il exagère en certains cas la transparence des reflets attribuant ainsi à un corps naturellement mat ce qui appartient seulement aux corps durs & polis, car la lumière n'a pas seulement p. effet de donner aux divers objets la couleur qui leur est propre, elle a aussi la propriété de nous faire distinguer la nature de ces objets par la seule manière dont ils la réfléchissent ou l'absorbent. Qque soit l'intensité de la lumière quand elle frappe sur la chair, ses rayons sont légèrement amorties par la surface de l'épiderme, de même que dans la campagne, elle glisse doucement sur les terres labourées & les collines herbues tandis qu'elle éclate sur les rochers.' Il voit un enfant & sa mère et non pas 'le jugement<'> de Salomon.

peint *les Bohémiens* avec amour & poésie tandis que Callot en riait.

[341ᵛ] Son *Concert de famille* au Louvre est plein d'aigrefins.[23]—(femme qui bat la mesure sur une épinette).

Valentin mourut, une [jour] <nuit> qu'étant échauffé il se jeta p. se rafraîchir sur la place d'Espagne dans le bassin de la fontaine del Babbuno—il ne laissa pas de quoi se faire enterrer. Il occupe dans l'école française le même rang que tenaient le Caravage à Rome S. Rosa à Naples, Ribeira en Espagne. Gerard della notte en Hollande. Il est la dernière expression de la réaction contre l'ascétisme gothique.

Louis David l'admirait beaucoup & cependant auprès de Nicolas Poussin & de Lesueur Valentin jouait le même rôle que devaient jouer Géricaud près de David & de Prudhon.

[22] Flaubert omits the word 'mains'.
[23] In CB's version all is clear: these 'prétendus *Concerts de famille*' look very elegant and suave at first but a second look reveals that 'ce lieu est suspect' and that these are probably thieves.

[342ʳ] Carle Vanloo 1705–1765

élève du statuaire Legros 'modelait sa machine, & il en étudiait les
lumières les raccourcis les effets le vague de l'air' (Diderot)—on ne le con-
sidérait pas comme un <peintre de> fantaisie mais comme un très gd des-
sinateur.—immense considération. Croix de St Michel.—à la Comédie, il
fut applaudi par le public. *Halte de chasse.* les [fonds sont] <le paysage est
un peu bleu, les fonds rappellent les décors qu'il fit pr. l'opéra.—tableaux
religieux [*illegible word*]

élèves: Doyen, Lagrenée l'aîné, Lépicié Julien de Parne.—c'est contre sa
descendance aux lignes flamboyantes que Vien & David protestèrent.

Jean Forest. beaupère de Largillière 1636–1712

Ses peintures ont tellement poussé au noir qu'elles n'existent plus.—ses
paysages ont un aspect grandiose, moines ou chartreux en prières, &
entourage harmonique—dans la Madeleine, le lierre entoure le tronc d'un
arbre <énorme> qui se divise en deux branches. il fait passer l'homme avant
la nature & subordonna [l'express] la réalité à la poésie.—Il collectionna
en Italie des tableaux p. Mr de Seignelay.

Noël Nicolas Coypel. 1691–1734

issu du second mariage de Noël Coypel était frère consanguin d'Antoine
& l'oncle paternel de Charles.

Son type de femme est celui qu'offrirait une jolie bourgeoise, au minois
court chiffonné & mignard. gds yeux bouche coquette, petit nez sans
forme vaste front, chevelure négligemment nouée.

[342ᵛ] François Boucher 1704–1770

Il trouvait la nature trop verte & mal éclairée. & Lancret lui répondait 'je
suis de votre sentiment. la nature manque d'harmonie & de séduction' excite
la fureur de Diderot.[24] homme naturel 'et que peut avoir dans l'imagina-
tion un homme qui passe sa vie avec des prostituées du plus bas étage'[25]
Quand il entra chez Lemoine, la tradition de Rubens n'était pas tout à fait
perdue.
Remarquez[26] que Lemoine & Boucher se servirent comme Rubens de ver-
millon dans la plupart des contours & firent les demi teintes de chairs avec
du rose.
faillit mourir d'ennui en Italie (1725).—revient à Paris & ne quitte plus les
coulisses de l'Opéra.—se marie, perd sa femme, se replonge dans le plaisir
—& se remarie à Marie Perdigeon dont Raoux a fait le portrait en

24 'Excite la fureur de Diderot' is Flaubert's pithy paraphrase.
25 This phrase is quoted from Diderot.
26 CB: 'il est remarquable que [. . .]'.

Vestale—sa 2e femme meurt & lui laisse 2 filles qui furent mariées l'une à Deshayes, l'autre à Beaudoin,[27] gendres aussi peu moraux que leurs beaux pères [*sic*].[28]

Gd portrait de Me de Pompadour[29] en damas de soie bleu, parsemé[30] de roses, festonné de rubans & de falbalas.—à ses pieds un King's Charles. Une glace réfléchit son chignon.

les peintures érotiques du boudoir de Me de Pompadour appartiennent à lord Hertford—fait des enfants charmants. est mort devant une 'toilette de Vénus'.

Jean Baptiste Pater 1695–1736

né à Valenciennes comme Watteau. qui ne lui fit pas bon accueil— bambochades—illustrations du Roman Comique—ne pense qu'à gagner de l'argent. & travaille avec furie, sans relâche. Aussi, pas de nature. ses chevaux ressemblent à du carton.[31]—Sa touche moins légère que celle de Watteau est grasse & fondue qqfois lourde.—entente du clair obscur.—tombé en discrédit, se relève aujourd'hui.

Mr Saint & Mr Marcille remirent en honneur ces petits maîtres du 18e siècle. tel Pater[32] se vend mille écus après s'être payés 15fr.

[343ʳ] *Don Diégo Vélasquez 1599–1660*

élève d'Herrera le Vieux—contemporain du Caravage, & brutal comme lui. Puis de François Pachéco, homme châtié & sage.—dont il épouse la fille.

Il avait pris à son service un jeune paysan & l'étudiait sans cesse, épie sa physionomie dans toutes les occasions.

dans sa 1ère manière il est complètement naturaliste. 'si vous considérez l'art comme une simple contr'épreuve de la nature, tout en elle vous enchante. vous attachez à tout la même importance & vous ne sacrifierez aucun détail—les plans se confondent la valeur relative des tons vous échappe & p. avoir mis partout de l'accent vous tombez dans une dureté inévitable.'—à cette 1ère manière *le Mᵈ d'eau de Séville Adoration des Bergers* à Mr de l'Aguila—*les Buveurs*

Dans la 2e il imite la Nature,—non telle qu'elle est. mais telle qu'elle paraît être.

Rubens venant à Madrid lui donne le désir de l'Italie.—à force de caractère sa peinture devint sublime.

ce fut lui qui prépare la tente dans l'île de la Conférence. = île des Faisans

[27] CB 3 has 'Deshays' and 'Baudouin'.

[28] The 'beau-père' in question is Boucher. [29] Portrait reproduced.

[30] 'Parsemée', 'festonnée' (CB).

[31] Cf. CB 4: 'car vraiment les chevaux de Pater ressemblent à ces équipages de carton que les enfants portent dans leurs bras au jour de l'an'.

[32] In this case his *Conversation* (CB).

Alonzo Cano 1601–1667

un Vénitien affaibli. Ses carnations présentent ordinairement une large lumière qui dévore les demi teintes du milieu, de façon que les ombres ne sont prononcées qu'auprès du contour. Sa peinture est empâtée mais les touches en sont fondues.—un peu froide—dessin pur & châtié
en mourant refusant un crucifix parce qu'il est trop mal sculpté ce fut le 1er païen de la peinture espagnole.—après lui l'Art espagnol tomba dans le matérialisme pur.

[344ʳ] Joseph Vernet 1714–1789

fils de peintre, part p. Rome avec 12 louis, recommandé au voiturier—découvre la mer du ht de la *Viste* près Marseille—assailli par une tempête à la hteur de la Sardaigne se fait attacher au mât.—entra à Rome dans l'atelier de Bernardin Fergioni [plu] paye son logeur qui était un perruquier avec ses dessins.—se fait un alphabet p. indiquer les phases successives de la lumière voy. Renou, art de peindre trad en vers français du poëme latin de Dufresnoy. 1789.—se lie avec Locatelli Panini & Solimène.—l'étude de Salvator lui donna ces teintes rembrunies auxquelles on reconnaît ses tableaux faits en Italie.—se marie avec la fille d'un catholique anglais Virginia Parker.
Chez les Hollandais, dans les orages d'Everdingen, Guill. Van de Velde, Backuysen Bonaventure la mer est le véritable héros. chez Vernet c'est l'homme.—il ne soulève la mer que p. exciter en nous de la terreur ou de la compassion p. les marins en péril. on bariole trop la mer, à présent.[33] la sienne est d'un vert sombre & a cette pesanteur qu'a si bien rappelé Géricault dans le Naufrage de la Méduse (voy. Herman[34] essai sur le paysage St Pétersbourg 1800)—quand il s'agit d'exprimer un coup de vent, il a placé des objets qui lui résistent, à côté d'autres qui lui cèdent ce qui donne à la scène une variété de mouvement.
Musicien, lié d'amitié avec Pergolèse. Le stabat fut composé dans son atelier. Pergolèse mourut dans ses bras.—il accueillit Grétry à son arrivée à Paris & lui prédit son avenir.—fautes d'art naval dans ses marines. il s'attachait à l'ensemble voy. Valenciennes: éléments de perspective pratique suivis de Réflexions sur la peinture & particulièrement sur le paysage 1821. .—habile composition les 15 ports de France du Louvre ont été estimés sous la Restaur 375000fr.

Ventes célèbres: Jullienne 1767 —Calonne 1788
 —de la live de Jully 1770 Choiseul Praslin 1793
 —duc de Choiseul 1772 Robit 1801

[33] This is Flaubert's succinct paraphrase of a far more wordy point by CB.
[34] Actually 'Hermann'.

—Lempereur 1773
Comte du Barri 1774
Blondel de Gagny 1776
Prince de Conti 1777
Randon de Boisset 1777
Mquis de Menars 1781

Clos 1812
Laperière 1823
duc de Berri 1837
Perregaux 1841
C^{al} Fesch 1845
——

[344ᵛ] François Casanova 1727–1805

frère de l'aventurier—fils probablement de Georges II d'Angleterre. sa mère Jeannette Farusi était une actrice.—vint de bonne heure à Venise.— étudie chez Simonelli—passe 4 ans à Dresde—pastiche tous les maîtres— puis revient à Paris—gagne près d'un million en 26 ans—dans un de ses tableaux représentant les victoires du Prince de Condé, on se tue dans une atmosphère rosée—imite Berghem & Salvator Rosa..—Malgré ses gains, accablé de dettes, à cause de sa gloire.
Catherine l'invite à peindre ses victoires sur les turcs.—il se rend à Vienne pr cette œuvre—tient sa dignité parmi les gds.—fréquente le prince de Kaunitz.—reste à Vienne & y meurt.

De Loutherbourg 1740–1814—(né à Strasbourg)

élève de Casanova. expose 12 tableaux au Salon de 1765.—paysages, marines, batailles sur terre & sur mer. chasses, animaux.
 passe en Angleterre pr faire les croquis de l'opéra.—devient illuminé par la fréquentation de Cagliostro. suit l'armée anglaise au siège de Valenciennes—à Greenwich se trouve [la perte de] *le Combat de Brest ou le Vengeur.—la perte de l'armada.*
 Catherine II lui commanda le passage du Danube sous les ordres de Romanzow en 1774. sous prétexte de couleur locale il se fit envoyer & garda les modèles de toutes les armes turques & russes.
 S'occupe d'opéra & invente des procédés p imiter l'eau tombant en cascade il découpa les parties claires de ses eaux peintes & fit descendre perpendiculairement derrière & juste au travers de ces découpures une toile de couleur bleu-clair parsemée de lames d'argent. le mouvement accéléré qu'on donne à cette toile imite parfaitement la chute d'eau & produit ce brillant momentané qu'on aperçoit dans les cascades.—il fut le premier, dit-on, qui composa des tableaux susceptibles de plusieurs changements par l'effet de la lumière artificielle qu'on promène derrière une toile préparée avec des substances plus ou moins diaphanes.

——

[345ʳ] Simon Vouet 1590–1649

 Se marie en Italie à une fille de Velletri Virginia qui sait faire des pastels. 2 écoles alors à Rome: les Naturalistes ayant p. chef Michel Ange de

Carravage [*sic*] & les idéalistes conduits par le chevalier Josépin—Simon Vouet est séduit par le Caravage comme il l'avait été à Venise par Véronèse. & il en résulte un éclectisme qui rappelle le goût des italiens en vogue.

tous les succès revenu en France. peintre du roi L XIII—fait des patrons p les tapisseries royales. Sa femme donne des leçons de pastel aux gds seigneurs & gdes dames de la cour—est le fondateur de l'enseignement académique de la peinture..—Ses gdes machines sont connus par le burin de Michel Dorigny son gendre. *La Présentation du temple* est son chef-d'œuvre. les objets s'y détachent avec vigueur, un peu brusquement les plans s'y distinguent avec netteté. la couleur générale d'un vert légèrement bistré n'est pas sans charme qqu'elle sente la convention.—pas d'entente de clair obscur. Il n'a que trop peint de pratique.—Le sentiment voilà ce qui lui fait défaut.—à ses vierges même il donnait des tournures guindées qu'on prenait pr de la noblesse & des airs agréables dont on raffolait.

Jacques Stella. 1596–1657. (de Lyon)—

peu de tempérament. peintre aimé des jésuites qui se plaignaient du Poussin

au Louvre: un petit tableau peint sur marbre = Jésus recevant *sa mère dans les cieux.* Les tons en sont tendres, le faire doucereux & fade. Certaines veines du marbre ont été mises à profit p. imiter des nuages d'or ou des rideaux de portes du paradis.

Carnations tirant sur le rouge, modelé appris par cœur, pâles draperies interrompues çà & là par des tons crus & discordants.

la grâce, la douceur, l'enjouement sont ses traits distinctifs. pastorales: *retour du travail* [Ses] berger qui joue des pipeaux femme par derrière son chapeau de paille mis sur sa hotte de feuillage.

son coloris est tantôt crû comme celui de Périer, tantôt pâle comme celui de Lesueur. localités de ton peu caractérisées & ses carnations enflammées de vermillon ses œuvres ont été burinés par Mellan, Goyrand, François Poilly, & par ses trois nièces——

[346'] Jules Romain (Giulio Pippi, dit) 1492–1546

sur le penchant du Monte-Mario, la Vigne de Médicis,[35] appelée depuis Vigne Madame parce qu'elle appartint à Marguerite Farnèse fille de Charles Quint fut bâtie par Jules Romain sur les ordres de Jules de Médicis = Clément VII. Il avait succédé à Adrien VI qui voulait faire abattre les peintures de Michel Ange à la Sistine, à cause de l'indécence des figures.[36] *la bataille de Constantin* fresque *le baptême de Constantin 1er la donation de Rome,*

[35] 'La vigne Médicis' was a villa built for Giulio de' Medici (Clement VII).
[36] Adrian VI, successor to Leo (a 'païen aimable'), was Dutch and 'hostile aux images' (CB).

bâtit le palais Cenci, sur la place de la Douane—près de Mantoue le palais du *té*

Les estampes de Battista Franco <nous> ont conservé la composition de ces fresques. le plus étonnant morceau est la *salle des géants.* Le spectateur ne sait pas en entrant s'il est dans une chambre ovale, ronde ou quadrangulaire, il n'a devant les yeux que débris, ruines. les géants sont foudroyés de toute part s'ouvrent des échappées de vue qui agrandissent la salle à tel point qu'on se croirait dans une vaste campagne. Le pavé composé de pierres rondes se prolonge fictivement sur la muraille à la hteur de la plinthe de sorte qu'on ne peut savoir où le vrai pavé commence, où le vrai mur finit. Sitôt qu'on allume la cheminée des géants apparaissent dévorés par la flamme du foyer.—

rebâtit la ville de Mantoue.—*La Vierge au bassin* à Dresde. *triomphe de Scipion* et *les amours de Jupiter* gouaches au Louvre

Dominique Feti 1589–1624

On peut le regarder comme un descendant du Caravage, bien qu'il ait été disciple du Cigoli ou Civoli.—empâtements à la Vénitienne, habitude de rehausser les clairs par des touches résolues. *Mélancolie* (au Louvre) il a tant accumulé de pittoresque que la figure principale a perdu presque tout son intérêt. Les attributs des Sciences se trouvent assemblés dans un désert. ses meilleurs ouvrages sont au couvent des Ursulines de Mantoue, une *Nativité*, en collaboration avec sa sœur Lucrina. *Multiplication des pains* p. le même couvent. meurt à Venise à 35, des suites d'excès.

———

Cristofano Allori. 1577–1621 [37]

Son père était le propre neveu de Bronzino. Culte de Michel Ange. Mais il fut rebelle aux leçons de son père—Copie la Madeleine du Corrège.—épris d'une des belles filles de la ville la Mazzafirra, se ruine p. elle, et la peint sous les traits de Judith dans *Judith tenant la tête d'Holopherne.*[38]—au Louvre *Isabelle d'Aragon implorant Charles 8* mauvaise composition. soin des orfèvreries peintes sur le manteau royal.

[346ᵛ] C'est un des rares coloristes de l'école florentine.

Dominiquin (Domenico Zampieri) 1581–1641 [39]

Communion de St Jérôme dessin mou, coloris pesant. (ce qui n'est pas mon avis, autant qu'il m'en souvient[40])

[37] 4 pages by Paul Mantz, *École florentine.* CA is an atypical example of this school: he is 'un des rares coloristes de l'école florentine' and 'avec lui la Florence s'en va' (p. 4). His father was the more famous Alessandro.
[38] One of Flaubert's favourite paintings, cf. *Italie et Suisse* in Ch. 3.
[39] Article by Henri Delaborde, *École bolonaise.* [40] Cf. 11: 163.

élève de Denis Calvart, puis des Carrache.—Fresques de Grotta Ferrata, de St André della Valle. C'est ce qu'on estime le plus maintenant, & ce qu'on critiqua le plus, de son temps. On lui reprocha dans le Martyre de St André un des bourreaux qui tombe en tirant une corde & provoque par sa chute les moqueries de ses voisins. Lanfranc se proposait p. retoucher les fresques de St André.

Les Carrache et leur élève sont les inventeurs du paysage. Les premiers ils imaginèrent de représenter les scènes de la nature p. elle même & comme objet d'intérêt principal.

horriblement malheureux dans son ménage, a peur d'être empoisonné par sa femme.

appelé à Naples p. décorer la chapelle de St Janvier, persécuté par Ribeira & Bélisaire. Corenzio.—Lanfranc obtint que la plus gde partie des peintures de la chapelle fut détruite.

Louis Carrache 1555–1619[41]

un peu plus âgé que ses cousins Augustin & Annibal.

réaction contre la grâce du temps—éclectisme.

étudie chez Fontana.—puis à Venise chez Tintoret.—à Florence chez Passignano. peinture du palais Fava. compositions sur *l'expédition de Jason* & sur *le voyage d'Énée*.

Annibal Carrache 1560–1609

il écrivait 'mettons toute notre attention à nous approprier la belle manière du Corrège, afin de pouvoir mortifier un jour toute cette canaille'

Michel Ange Amerighi de Caravage n'avait qu'un but la reproduction brute du fait, chef des Naturalistes, tandis que [Josaphi] Josépin soutenait l'idéalisme c'est à dire les doctrines surannées de l'école académique. Annibal avec son frère & son cousin [contre] allait donc avoir à lutter contre ces deux écoles.

Annibal ridiculisait ses adversaires dans des caricatures, Augustin se répandait en raisonnements et en explications scientifiques.—ils ouvrent une Académie p. exposer & établir dans leurs doctrines *Academia [sic] degli Desiderosi*, puis *d'egli Incamminati* Annibal passe 8 ans à décorer la galerie & plusieurs chambres du palais Farnèse—ce qui a été le point de départ & la source des gdes décorations de palais sous L XIV. ce qu'on appelait le style romain était le style d'Annibal.

[347'] *Bassan (Giacomo da Ponte dit le) 1510–1592*

Annibal Carrache [(Vasari)] <dans ses remarques> sur Vasari raconte qu'étant entré un jour chez le Bassan il avança la main p. prendre un livre peint sur une table.

[41] This article and the following by Henri Delaborde, *École bolonaise.*

élève de Bonifazio, du Titien. étudie les animaux, les accessoires, devance l'école flamande.—quand il fut fort sur les animaux il prit tous les sujets de la Bible où il pourrait en introduire.

Tintoret s'efforça plus d'une fois d'imiter sa méthode p. la distribution des lumières & des couleurs. P. Véronèse envoya chez lui son fils Carletto p. y apprendre le métier de la peinture.—ses quatre fils, peintres, reproduisaient ses tableaux peu variés.

il invente le mouvement des personnages p. les besoins du clair obscur. Il avait commencé par fondre ses couleurs & par unir l'ombre & la lumière sans aucune apparence de reflet comme Giorgion [*sic*]. Palme le Vieux & Titien, se contentant de rehausser les plus gds clairs p. donner aux objets toute la rondeur désirable. Ses chairs ont de la morbidesse dans les parties molles & sont polies sur les os. Ses verts sont brillants, ses satins éclatants. rien de plus beau que ses manteaux rouges, que ses draperies jaunes qui sont éclairées avec du jaune de Naples, ombrées avec du giallo santo & qui dans les profondeurs du pli sont glacées avec un mélange de laque & de bitume. Il dit à son lit de mort 'C'est à peine si je commençais à peindre'

[348ʳ] Carlo Maratti 1625–1715 [42]

élève d'Andrea Sacchi. *La Nativité* (Louvre) est la première pensée de la gde fresque qu'Alexandre VII <lui> fit peindre dans sa galerie de Monte-Cavallo.—*Destruction des idoles par Constantin* dans St-Jean de Latran.—En faveur auprès de tous les papes comme Lebrun près de L XIV. Coupole du dôme de l'église d'Urbin, détruite par un tremblement de terre en 1782.

Il s'effraie des gdes choses, adoucit l'Évangile, gentillesse, pauvreté—grâce. Conservateur des peintures du Vatican, protège les tableaux par des barres de fer—répare les Stanzes du Vatican & le plafond de la salle d'Héliodore. répare les peintures de la Farnésine. & c'est à lui qu'il faut reprocher les brutales enluminures, les bleus vifs qui encadrent durement les mythologies de la voûte.

Il se fait élever pour lui-même un tombeau dans l'église Ste Marie des Anges.—ses portraits sont ses meilleures œuvres—celui de la Rospigliosi. Il avait une gde recherche dans ses perruques.

précepte à ses élèves. 'si vous voulez bien dessiner, imitez Raphaël. si vous voulez vivre longtemps, soyez sobre'—

———

Luca Giordano

1632–1705

étudie d'abord chez Ribera.—enfant prodige.—puis chez Pierre de Cortone.—puis va à Venise. puis à Florence. S'efforce de s'assimiler toutes

[42] This article and the two following by Paul Mantz, *École romaine.*

les manières. fait des imitations & les vend 'Fa presto' lui dit son père. fait p. les Jésuites un St Xavier en un jour & demi.

Amoindrit le sens de l'Évangile & c'est par là qu'il est compris. Charles II l'appela en Espagne—lui fait faire de gds travaux. Son exemple fut pernicieux p. l'art espagnol. Carmona, Tobar, les Ménendez se montrèrent tout à fait dédaigneux du dessin—pendant que Carlo Maratte & Cortone fermaient <à Rome> le cycle de l'art italien, Giordano vint clore à Madrid celui de l'art espagnol.

Monotonie de ses œuvres. C'est toujours la même combinaison de tons bleus jaunes & roses mêlés souvent de qques gris pâles mais sans accord & sans sagesse. qque soit le sujet, c'est toujours le même sourire & le même air de fête.

———

[348ᵛ] Jean Paul Panini 1695–1768

eut p. maître le florentin Benedetto Lutti [*sic*],[43] Andrea Lucatelli—dessine longtemps d'après Salvator Rosa.—protégé par le Cᴵ de Polignac ambassadeur de France près Benoît XIII. organise à Rome des fêtes p. la naissance du dauphin fils de Louis XV,—sur la Place Navone 'des dauphins qui jetaient l'eau par les narrines'—*Concert vue de la place Navone* au Louvre *intérieur de St Pierre de Rome* (Louvre)

Construit dans les jardins de la villa Sciarra un casino qu'il embellit des merveilles de l'art chinois & japonais.

fut d'un gd secours à Servandoni.—

fait des figures trop gdes comme tous les artistes du 18e siècle qui dans leur préoccupation de l'élégance allongent à l'excès la figure humaine.

L'école romaine finit par lui qui ne s'occupa que de la réalité la plus superficielle. Son œuvre est étrangère à toute poésie—Du soleil & de l'ombre sur des ruines. la personnalité humaine ne fut p. lui qu'un motif d'ornementation—curieux à consulter p. l'histoire des modes italiennes.

———

[349ʳ] Augustin Carrache 1557–1602[44]

facultés universelles, philosophe, médecin, poète, lettré, architecte. grave beaucoup de tableaux des écoles lombardes & vénitiennes.—& des dessins obscènes *Lascivie di Carracci* peint *la Communion de St Jérôme* qui est au Musée de Bologne

———

[43] 'Luti' in Mantz. Cf. Mantz, p. 2, on the nefarious influence of Luti: 'peintre des plus maniérés, mais fort célèbre alors, celui-là même qui, en ces premières années du dix-huitième siècle, donna à Jean-Baptiste et à Carle Vanloo une éducation dont ils ne sont jamais guéris'.

[44] Article by Henri Delaborde.

Il y a encore 3 autres Carrache: Paul frère de Louis [et] François frère d'Augustin & d'Annibal—& Antoine fils naturel d'Augustin, auteur du Déluge qui est au Louvre.[45]

———

Le Guerchin (François Barberini [sic][46] dit) 1590–1666

Louche d'où le nom de Guercino.

Jeune, un *St Mathieu* [sic pour 'Matthieu'] fut pris p. un Carrache. son protecteur le père Mirandola expose tous ses dessins 'la plupart attaqués à la plume avec une vigueur étonnante, poussés à l'effet avec des taches d'encre ou de bistre, hardiment jetées dans les fortes ombres et reliées à la lumière par des hachures, tantôt fermes comme des coups de burin, tantôt inégales et piquantes comme les morsures d'une eau forte.'

Miracle de St Pierre p. Clément XV [sic].[47] clair obscur étonnant, gravé par Corneille Blomaert [sic].—puissant modelé—art de faire fuir les contours & avancer les milieux

Ste Pétronille. au premier plan la Ste entre les mains des fossoyeurs, on la retrouve dans le ht de la composition, elle monte dans les nues vers le père éternel en bas c'est le corps, en ht l'âme. La lumière est invraisemblable, mais éclatante.

Coupole du dôme de Plaisance. = les prophètes & les Évangélistes.

Il a été à Bologne ce qu'était à Rome le Caravage, en France Valentin, en Espagne Zurbarán, à Mantoue le Manfredi, à Naples le Calabrese qui du reste fut un disciple du Guerchin.

———

Pierre de Cortone (Pietro Berettini[48] dit) 1596–1669.

élève d'Andrea Commodo. & d'autre [sic] peintre florentin Baccio Ciarpi.

enlèvement des Sabines, gravé par Pierre Aquila, du sentiment le plus violent & le plus théâtral.

Le plafond du palais Barberini qui représente le triomphe de la Maison Barberini a passé p. un chef d'œuvre jusqu'à la fin du siècle dernier.—décora à Florence le palais Pitti. = *Hercule sur le bûcher.*

insouciance du sujet, désaccord entre l'idée & les moyens pittoresques qu'il emploie p. l'exprimer. Dans *l'alliance de Jacob & de Laban* il rejette au second plan les acteurs principaux.

réussit plus à peindre les [hom] femmes que les hommes. Grâce affadie.

Ses élèves furent: Ciro Ferri, Pietro Testa, Romanelli qui a apporté en France les principes de l'école triomphante.

———

[45] This paragraph comes from the section on Annibal Carrache, which follows in CB (p. 2 n. 1).

[46] 'Barbieri' in CB. [47] 'Grégoire XV' in CB. Also, later, 'Bloemart'.

[48] 'Berrettini' in Mantz.

[*349ᵛ*] *Michel Ange de Caravage <(Amerighi ou Morighi)>*[49]
1559[*sic*][50]–1609.

'Il est venu p. détruire la peinture' mot de Poussin.

Réaction contre l'école académique—chef des Naturalistes.—quand les maîtres représentaient les plus humbles sujets, ils cherchaient à ennoblir,— lui, il fait de la Vierge une Maritorne, de Jésus un sacripant.—Il avoisine Tintoret par le Tintoret [*sic*] par le dessin savant & robuste (*Gd Mtre de Malte* du Louvre), mais aussi les rides, les gibbosités comme Ribeira. il méprise dans la composition l'ordonnance, la symétrie—il donne la plus gde partie d'une œuvre à l'ombre. ses figures s'enlèvent brusquement du noir au lieu de sortir de la demi-teinte, elles demeurent au [*sic*] trois quarts sacrifiées dans l'ombre. Mais un rayon lumineux lui suffit p. les faire saisir toute [*sic*] entières au spectateur.—*Mort de la Vierge* (louvre)—Il réduit le plus possible le nombre de ses tons & devient presque monochrome à force d'austérité—manque de transparence & de profondeur aérienne— Rembrandt devait élever jusqu'au sublime l'élément de vigueur et de nouveauté que le Caravage apporta dans la peinture. Ses élèves: Guerchin, Lionello Spada, le Valentin, Manfredi & Ribeira. Suivent sa manière: le Calabrèse, Lanfranc, Salvator Rosa, Honthorst, Gérard Seghers, les Lenain, Vélasquez lui-même.

vie agitée & batailleuse. meurt au bord d'un chemin

Barthélemy Schidone. [157] 1570–1615.

peint & sent comme le Corrège.

[à Plaisance dans le palais]—à Naples, *Ste Famille*. La plus belle de ses Madones fut p. l'église paroissiale de Formigine—décoration du palais communal de Modène.—*Coriolan se laissant fléchir par sa mère L'harmonie* groupe de sept femmes qui représentent les 7 notes de la musique.—n'a vu dans le christianisme que le côté tendre.—gde délicatesse d'expression

———

[*350ʳ*] *Titien Vecelli*
1477–1576. né à Cadore, dans le Frioul.

p. maîtres: Sébastien Zuccato, mosaïste & Gentil Bellini—s'éprend de la manière de Giorgione & l'imite.—*portrait de Catherine Cornaro*. Fresques de l'Entrepôt.

Assomption de l'église des Frères Mineurs. Les touches sont libres et heurtées, calculées p. être vues à distance. Les frères choqués de cette brutalité furent sur le point de refuser l'ouvrage.

tableau votif de la Famille Pesaro. au lieu de trôner sur des nuages la Vierge s'est assise avec le Bambino sur une corniche du Palais. St Pierre ouvre un

———

[49] Article by Théophile Silvestre. [50] '1569' in Silvestre; Flaubert misreads.

livre, en bas personnages à genoux.[51]—*Baccanales* du Palais del Castello d'Alphonse d'Este à Ferrare, aujourd'hui dans le National Gallery. *triomphe de l'Amour*, Madrid. *Bataille de Cadore St Pierre Martyr*—à l'entrée d'une forêt. le Sénat défendit sous peine de mort qu'on fît sortir ce chef d'œuvre de la République. (église St Jean & St Paul à Venise) Portraits de Charles-Quint, de Philippe II, Don Carlos, l'Arétin. Henri III fait à 97 ans, le Christ déposé en Croix, achevé par Palma le Vieux à 99 ans.—meurt de la peste.

L'opposition des tons clairs aux tons bruns est le moyen par lequel il enlève ses figures les unes sur les autres & c'est en cela que consiste presque toute la science du clair-obscur.—le contour n'est pas fin, le contour est pesant, il ne poursuit pas les délicatesses il n'indique pas les nuances. il ne fait sentir les muscles comme Michelange ni les tendons comme Raphaël. Le type qu'il affectionnait p. les femmes est un type calme, de volupté sans fureur, d'amour sans mystère.

Carlo Dolci 1616–1686.

représentant de l'art jésuite. depuis 200 ans ses figures défraient les marchands d'*agnus* et de chapelets—manière onctueuse, polie & ivoirée, comme le Hollandais Van der Werff. son quiétisme l'a conduit à exprimer l'anéantissement de l'âme dans des masques blêmes qui ont la transparence de la cire & tous les symptômes de la mort mystique: 'je ne saurais m'imaginer le Christ avec une figure de torticolis ou de père douillet' disait Poussin aux Jésuites.

———

Le Giorgione Giorgio Barbarelli.[52] *1478–1511.*

Les deux Bellini avaient déjà rompu avec le Moyen Age

Finesse du modelé. Léonard l'obtient, dans la Joconde, au détriment de la couleur & par une combinaison extrêmement patiente des noirs & des blancs de l'ombre & de la lumière. Giorgione se préoccupe bien moins du clair-obscur que de la coloration, et il modèle largement dans la pâte sans s'exposer à salir ses nuances par la poursuite acharnée du détail—peint l'extérieur des maisons.[53]—*Concert champêtre*. femme nue vue de dos. 2 jeunes gens dont l'un joue de la guitare.[54]

———

[51] This is another example of Flaubert referring to a reproduction of a painting rather than to Blanc's text—the 'tableau votif' in question is also in the church of the Frari.
[52] Article by Paul Mantz.
[53] This was a novel practice, according to Mantz.
[54] Mantz, p. 4: 'Giorgione peint pour peindre et non pour prouver. Quelle adorable toile que le *Concert champêtre*—[. . .] quelle absence de sujet!'

[351ʳ] Albert Dürer.[55] *1471–1528*

né à Nuremberg fils d'un orfèvre—

son plus ancien tableau 1498 est à Florence—tourmenté par sa femme Agnès Frey, qui l'enfermait lui faisait peur.

Marc Antoine de Bologne admire tellement ses estampes qu'il les imite. écrit à un de ses amis, de Venise '. . . mes mains ont eu la gale si fort que je n'ai pu travailler' fréquente <Jean> Bellin. se met en route p. Mantoue[56] & apprend que Mantegna vient de mourir. Le Pontorme ayant à peindre une passion imite la manière gothique de Dürer.—est anobli par Maximilien.

[. . .] à Anvers banquet splendide qu'on lui offre chez les Fugger. Réceptions princières à Gand & Bruges. Se fâche avec la régente Marguerite p. un portrait de Charles Quint.—on lui fait beaucoup d'honneurs mais on le paie très peu.—ami de Melanchton.

Sur sa fin, au lieu de chercher l'abondance des détails, songeait à la simplicité l'harmonie.—c'est alors qu'il fit les *Apôtres* de Munich—si malheureux à cause de sa femme qu'il en était qquefois presque fou.

Série de gravures sur bois représentant *l'Apocalypse*. ses tableaux comme ses estampes réunissent le plus vague spiritualisme & une exécution minutieuse.

Melancolia. le cheval de la mort. une aquarelle de la collection Ambras de Vienne représente une immense nappe entre des terrains plats où s'élèvent qques maisons, nuage, vapeurs, c'est un songe qu'il a eu & qui est écrit audessous de sa peinture. *Le Martyre de la légion chrétienne* (galerie du Belvédère en Autriche) *l'adoration des Mages* (Offices de Florence)

Dans son *traité des proportions du corps humain*. il déclare la longueur de 7 tête 'rustique' celle de dix 'grêle'—

Gérard Audran, d'après les beaux antiques s'est arrêté à 7 têtes & demi qqu'il ait trouvé l'Apollon du Belvédère 8 têtes moins une demi longueur de nez. De Piles, dans ses remarques sur le poème de Dufrenoy fixe à 10 têtes ce qui est la bonne mesure. D'après Vitruve la longueur du pied est égale à la 6e partie du corps. De nos jours le pied est à peine la 7e partie de la figure.

[351ᵛ] Dessins: 15 au Louvre. 5 à la Bibliothèque.

Gravures célèbres Melancolia. le cheval de la Mort. Les armoiries à la tête de mort.

Sculptures à Munich. Prédication de St Jean Baptiste. Adam & Eve à Gotha. a fait: De Urbibus arcibus, castellisque condendis & muniendis—traité des proportions du corps du cheval (perdu).

[55] Article by Auguste Demmin. [56] i.e. to see Mantegna.

[352ʳ] Gabriel Metsu. 1645–1669

peint de riches intérieurs bourgeois—ses visages sont d'un flegme désespérant—observez la forme de ses cheminées, à chambranle corinthien ou composite, colonnes en marbres de couleurs, ou noir avec chapiteau blanc.—Souvent des tête à tête le 3e personnage s'il y en a un est insignifiant la dame a souvent un chien.

(Cadres: il faut éviter p. les estampes des cadres d'ébène ou de palissandre. L'ébène n'est tolérable que lorsqu'il s'agit d'une estampe imprimée au bistre ou très fortement jaunie. le jaune & le noir étant les deux couleurs qui se marient le mieux il faut mettre le jaune au cadre si l'estampe est noire & tenir le cadre noir si l'estampe est jaune.[57]) La plupart de ses tableaux sont de la 1ère manière, chaude, dorée, finie & profonde

plutard il préféra un ton argenté & un coloris frais. L'influence de Rembrandt se fait sentir *dans [sic] la Femme adultère* (Louvre) & le Crucifiement (Fesch) ce dernier[58] tableau n'a guères que les défauts de ce maître: la bizarrerie des costumes & cette vulgarité de détails qu'imitèrent les Van Eeckhout & les Govaert Flinck—

La touche de Metsu est presque l'opposé de celle de Mieris et de Gérard Dow. Celle de Mieris est fondue & sent la peine, celle de Metsu facile, vive, large & hardie. Gérard Dow touche à la minutie. Metsu est pimpant [CB 'piquant'] & décidé. son *chasseur endormi* (Fesch) s'est vendu 74,790 fr.— Metsu modèle par méplats, Terburg arrondit, son exagération serait le beurré & le fondu [?]. tandis que la parodie de Metsu conduirait à une touche par facettes et à ce genre de marqueterie qui est dans certains Greuze.

Hollandaise au clavecin,[59]—vue de profil, cheveux à la chinoise, petit toquet, manches retroussées

Marché aux herbes d'Amsterdam[60]—gd arbre à gauche—canal avec bateau.—façade de maison au fond. Au 1er plan une vieille femme assise sur le manche de sa brouette chargée choux & légumes. derrière elle une poissarde les mains sur les hanches etc. le Militaire galant.—debout, riche baudrier, salue une dame assise, page debout, derrière elle.

les Propos galants. Seigneur tenant un [*illegible word*]—la main gauche sur l'épaule d'une femme. tous deux assis. dans le fond [l'au] l'hôtelière écrit la dépense sur un tableau.—

[352ᵛ] Adrien Van Ostade, 1640[sic]–1685

né à Lubeck, quitte l'Allemagne p. la Hollande comme Isaac Ostade, Backuysen, Lingelback, Gaspar Netscher sont aussi originaux de l'Allemagne.

[57] This paragraph is based on a long footnote by CB.

[58] Flaubert says 'dernier' but he means the first, the *Femme adultère*.

[59] The four descriptions of paintings which follow are all based on reproductions of pictures not on CB's text.

[60] Cf. Du Camp in *PCG*, Ch. 10.

un peintre dans son atelier,[61] escalier de bois tournant, au fond; l'artiste à gauche, en bonnet, du côté de la fenêtre <géminée> à petits vitraux—très appliqué.

Le ménage rustique—escalier au fond, fenêtre ouverte. une petite fille joue avec un chien. vieillard à table regarde sa petite fille parlant [?] [*illegible words*] contre sa gdmère assise. Le père au 2e plan pipe à la main.—un berceau à gauche au 1er plan Panier suspendu aux poutrelles (collection Holferd. Russell Square)

la Danse. des espèces de magots rustiques dansant dans une espèce de grange porte ouverte à droite. Au 1er plan, de dos, un homme qui fume.

Les Musiciens ambulants. le joueur de violon bossu
la tabagie hollandaise: une table un broc un homme en bonnet conique qui le tient. Au-dessus 2 pipes passées dans un support contre le mur tout nu. Un autre allume sa pipe à des charbons & regarde le spectateur
le jeu de galet: en plein air, sous un hangar, sorte de long billard anglais
le Boulanger qui corne le pain chaud[62]

élève de Hals, est tenté d'imiter Rembrandt, étudie Teniers. c'est 'un Rembrandt familier & un Teniers sérieux'[63] s'établit à Amsterdam
la jeunesse de Rembrandt & <de> Van Ostade s'est écoulée au milieu de la guerre de trente ans—sans que leurs travaux s'en ressentent. Préoccupation des mœurs mais non de l'histoire
2 manières l'une qui est en petit celle de François Hals, c'est à dire franche libre & ferme. l'autre fondue au point de ressembler à de la peinture sur émail—*Maître d'École* au Louvre.

Coloris vigoureux & souvent violacé—nourri flou & mœlleux
au Louvre: *Maître d'école*, la *Famille du peintre*, le *Marché aux poissons*
à St Petersbourg *les cinq sens* (série)
Le Marchand de poisson vente Perrier

[353ʳ] ÉCOLE FLAMANDE

Joseph Craësbeke 1608–1661. tabagies, conversations

élève de Brauwer—*l'atelier de Craesbeke* est au Louvre. bel empâtement, draperies souples, ton <moins> chaud que celui de Brauwer mais non moins transparent, beau gris qui rappellent ceux de Vélasquez.

[61] For this and following pictures, Flaubert refers to the reproductions, not to CB's text.
[62] This painting is not one of those reproduced. 'Corner' = to blow on a bugle to announce the bread is ready.
[63] This is a quotation from CB.

Jaloux de Brauwer, il fit la farce d'Argan[64] p. éprouver la tendresse de sa femme, se peignit en assassiné.[65] sa femme pleura. il fut content.[66]
était boulanger. il aimait à peindre les plus ignobles grimaces & passait des heures entières devant son miroir à dessiner les contorsions de son visage. il fit son portrait une emplâtre sur l'œil, ouvrant une bouche effroyable.—Portraits des principaux mtres d'armes d'Anvers dans leurs exercices—Musée d'Amsterdam: portrait en pied de Grotius—

———

[354'] Jacques Ruysdael 1640–1681
avait été d'abord médecin—
sa couleur comme dans une autre gamme que celle de Berghem. les tons gais ou éclatans en sont bannis. le rouge n'y paraît jamais—il a dû étudier Aldert van Everdingen à en juger par la ressemblance dans la disposition & le choix des sujets—aspect mélancolique.—*Cimetière des juifs à Amsterdam*: 3 ou 4 tombes plantes sauvages, au fond un massif d'arbres que surmonte l'aiguille d'une chapelle. Le ciel est sombre.—[un] & percé d'un rayon de soleil qui éclaire les pierres. au-dessus des tombes planent [?] des hirondelles.—affectionne les cascades. Ses tableaux sont tous d'un vert sombre, & uniforme. Mais les paysagistes français ont habitué le public aux arbres roux & aux gazons salis. Le bourgeois crie 'aux épinards'[67] p. faire le connaisseur.
—aucun de ses ouvrages n'indique qu'il ait été en Italie.—Mais il a dû visiter la Norvège, la Vestphalie—ses marines ont des flots sombres & profonds ce n'est pas la mer unie & transparente de Jean Van Goyen, la gde vague savonneuse la dramatique tempête de [De] Bakhuysen, encore moins l'exactitude de Guillaume Van de Velde.
il resta célibataire & pauvre.
sa touche est fondue & peu visible, en comparaison de la manière pâteuse d'Hobbema. il refroidit ses dessous bitumineux par une teinte générale d'un gris bleuâtre & perlé—ses feuillés sont exacts—ses ciels transparens & profonds.—il excelle aux échappés de soleil entre deux orages = buisson de Ruysdaël Louvre—)—génie passionné, triste, élevé.—
La forêt coupée par une rivière Louvre estimée 30 000 fr.
un paysage orné de figure de Van de Velde à la vente Rouge = 29 000 fr.

Minderhout Hobbema. 1635–1700
biographie inconnue. il n'y a guère plus de 30 ans qu'on en entendit parler en France p. la 1ère fois.—Calme aspect humain

[64] 'La farce d'Argan' are Flaubert's words, not CB's.
[65] Cf. CB 2 for enlightenment: 'se peignit sur la poitrine une blessure épouvantable, teignit de rouge sa chemise, ses draps [. . .] *etc*'.
[66] 'Sa femme [. . .] content' are Flaubert's words. [67] See *DIR*: 'paysage'.

Joli mot de Nicolas Berghem 'savoir occuper sa vie dispense de richesses'[68]

ses nuages sont souvent sèchement terminés au contour présentant l'aspect du papier—chalets rustiques. Cabanes faites de planches au bord d'un étang.

[354ᵛ] les paysagistes hollandais n'ayant pas l'habitude de faire les figures de leurs paysages, il en résulte des désaccords choquants. figur [sic] à turbans dans les paysages subalpins de Jean Both—Dans un paysage austère <d'Hobbema> des figures gaies de Lingelback.

Les plus beaux paysages d'Hobbema sont pris aux environs du château d'Alberda Van Dyksterhuys, province de Groningue.

[355ʳ] *Aldert Van Everdingen 1621–1675*

nature rigide, hérissée de sapins—rochers.—a gravé à l'eau forte 162 planches. il comprit la tristesse des sites sauvages de la Norvège.—fut le Salvator Rosa de la Hollande.

Frédéric Moucheron 1655[69]—1686

de l'air de l'espace[70]—Il a mêlé le style d'Asselyn avec celui de Jean Both. comme celui-ci il a hérissé <le devant de> son paysage de plantes épineuses.—un trait particulier c'est son goût p. les jardins à terrasses, les villas élégantes au péristyle corinthien. Son fils Isaac est le dernier paysagiste italien de la Hollande.

Guillaume Mieris. fils de François 1662–1747

comme l'influence de Gérard de Lairesson gagnait toute la peinture, il aborda les sujets poétiques, fit entrer dans ses petits tableaux toutes les gdes figures de la Fable & de l'histoire.—amour du nu. Tarquin & Lucrèce.— Filles de Loth—Betsabé, Suzanne.

Manière blaireautée, ivoirée, finie à l'excès: *Marchand de volailles, bulles de savon La Cuisinière—boutique d'épicier*

Il reproduit souvent un bas relief en grisaille décorant la base de la croisée sur laquelle s'appuient ses personnages.

Arent ou Arnould Van der Neer. 1615–1680

peintre des hivers & des incendies.—des clairs de lune. gravés par Jacques Philippe Lebas

[68] 'Joli mot' is Flaubert's judgement.
[69] Moucheron's birth date is actually 1633 (CB).
[70] CB: 'De l'air, de l'espace, de la transparence, voilà ce qui distingue Moucheron.'

il est douteux qu'il ait été l'élève d'Albert Cuyp.—il est probable qu'il fut séduit par les ouvrages d'Elzeimar qu'avait apportés en Hollande le Cte Palatin Henri de Goudt.

———

[355ᵛ] Gaspard Netscher 1636–1684

p. maîtres: Coster, Gérard Terburg. & se préoccupe plus que lui de la beauté de ses modèles

la leçon de musique. son pinceau est moelleux & passé. il n'arrête nulle part ses épaisseurs et caractérise les objets plutôt par le ton que par les nuances du procédé—on ne rencontre chez lui que des images riantes, la jeunesse, la grâce, l'élégance, des femmes jolies, des enfants adorables—souvent les peintures de ses deux fils Théodore & Constantin ont passé p. les siennes.

Gérard Dow 1613–1680

[soin]—p. maîtres un peintre sur verre nommé Kouwhorn. & Rembrandt. soin infini—peur de la poussière son atelier donnait sur une pièce d'eau dormante—

couleurs broyés par lui-même. cinq jours p. peindre la main d'une femme 3 p. un manche à balai.—*femme hydropique*—le médecin qui examine la fiole d'urine à la lumière—Il se servait d'un miroir concave qui reproduisait en petit son modèle, & copiait d'après le miroir—peinture de porcelaine.[71]—*Lecture de la Bible*

Gérard Terburg. 1608–1681

Gérard T & Metsu s'attachèrent de préférence à représenter ce qu'on appelait des *sujets de mode* = satin, velours, dentelles, damas.—avait l'habitude de chanter en peignant. Guillaume Bauer s'échauffait tellement qu'il parlait à son modèle même inanimé. le Bamboche s'interrompait à chaque minute p. retrousser sa moustache. *Paix de Munster L'instruction paternelle* ou = *la robe de satin.* La robe a plus d'importance que tout le reste, la tête est cachée. 'ce triomphe inusité d'un tel accessoire est devenu une faute héroïque'. On devine la tête, on s'imagine voir les joues rougissantes & l'œil baissé. La mère déguste un verre de vin pendant ce temps-là —ou plutôt se cache la figure dans son verre.[72] ses femmes ressemblent [au] au type donné par Rousseau de M de Warens—elles ont le front démesurément ht & [gar] dégarni de bonne heure, comme chez Miéris & chez Metsu.

———

[71] It was Diaz who compared a Dow painting to 'une assiette de porcelaine de Chine' (cf. CB 8).

[72] 'Ou [. . .] dans son verre' is Flaubert's own comment, based evidently on his study of the reproduction p. 9.

la Proposition = un gros militaire, grisonnant, montrant des florins à une femme assise.

imité <très bien> par son disciple Roelof Koets.

Isaac Ostade 1617–1654

éclipsé par la gloire de son frère[73]—vp. traité de la peinture de Montabert t. VIII p 303 505. où l'auteur veut que tous les sujets quels qu'ils soient soient une leçon sous le pinceau du [peintre] <peintre philosophe> 'le père Montabert peignait lui-même à l'encaustique'.[74]

[73] Adrian van Ostade, q.v.
[74] Cf. CB 4–5 n. 1: 'la peinture encaustique, qu'il appelait le procédé par excellence [. . .]. L'encaustique, on le sait, est appelé ainsi parce qu'on fixe et qu'on parfond les couleurs avec le feu. Il est certain que ce procédé est solide, lumineux et durable.' Montabert's theory, associating the painting of ideas with fixity (the use of 'encaustique') is its own condemnation.

APPENDIX C

A Transcription of Flaubert's Notes on Joseph Milsand's *L'Esthétique anglaise*[1]

L'esthétique anglaise
étude sur John Ruskin—Milsand.

Méthode. L'esthétique finira par comprendre les œuvres d'imagination le jour où elle <en> cherchera l'origine et l'explication dans les lois de la nature humaine, au lieu de les chercher dans les lois des choses, dans les idées hypothétiques que notre raison peut se former de la nature des objets.[2]

La vérité de l'imagination plastique, c'est la réalité même entrant dans l'âme de l'artiste avec toutes les puissances qu'elle possède pr l'affecter, ce sont les choses de ce monde telles qu'elles reviennent & ressuscitent dans son esprit & telles aussi qu'elles y deviennent en s'empreignant de sa propre individualité ou comme dit Bacon 'en conformant leurs apparences aux désirs de son âme'[3]

nos artistes 'à vingt ans, ont déjà une manière, et à la place d'une routine nationale nous avons je ne sais combien de routines individuelles'. (p45)[4]

Les lettrés sont incapables d'apprécier les qualités en qque sorte musicales qui distinguent les tableaux des œuvres peintes.[5]

(idée de Ruskin): *l'art ne doit être qu'un compte rendu*,[6] le mérite d'une sculpture ou d'un tableau est exactement en proportion du nombre, de l'importance & de la justesse de renseignements qu'ils nous fournissent sur la nature des choses.[7]

[1] Bibliothèque Municipale de Rouen, ms g 226¹ 165ʳ⁻ᵛ. These notes have been sifted through by A. Fairlie, *Imagination and Language* (1981), 373–4. Milsand's attitude to Ruskin is admiring but not without reservations. My transcription restores missing accents.

[2] Cf. Joseph-Antoine Milsand, *L'Esthétique anglaise: Étude sur M. John Ruskin* (1864; 2nd edn. Lausanne: Librairie Nouvelle, E. Frankfurter, 1906), 24. Flaubert's text is an almost verbatim paraphrase of Milsand's.

[3] Ibid. 28. This passage is about painting *in the imagination*, so is of particular interest to Flaubert.

[4] Ibid. 51. [5] Ibid. 63, which has 'œuvres écrites' not 'peintes'.

[6] Flaubert's emphasis. [7] Ibid. 63.

Socialisme de l'art antique. il sacrifiait l'individu à l'état—ceci reste à démontrer.[8]

Le Grec n'employait l'ombre & la lumière que pr écrire ses propres inventions, aimait l'ordre la symétrie ce qui ne se trouve pas dans la Nature, n'empruntait de forme à la Nature que par amour pr ses idées propres, enlevait à la feuille sculptée sa souplesse de feuille, la simplifiait, la systématisait & la changeait en un simple moyen de décoration, suivant ses goûts (67)[9]

Défauts du gothique. air de squelette des absides etc. 71[10]

Le gothique (selon Ruskin) était un art bon en toute circonstance, pratique, domestique (v. le développ de cette idée 72–73)[11]

la Renaissance était un engouement idolâtrique pr un certain type d'aspect & un effort aveugle pr forcer quand même toute construction à s'adapter à cette ordonnance.[12]

l'architecture coloriste de St Marc (marbres de couleur etc) a dû exercer une grande influence sur le génie si distinctif des peintres vénitiens. 78[13]

L'école positiviste, réaliste française met un chou bien rendu au dessus de toutes les pensées, de toutes les affections, et est moins inspirée par l'amour du vrai que par le besoin de ravaler toute la partie morale de notre être.[14]

L'amour du réalisme vient après la première jeunesse, après les désillusions. Nous nous vengeons des mensonges de nos rêves par la négation de l'idéal, & nous n'estimons plus que le talent de voir les choses comme elles sont (v.p101)[15]

Mysticisme artistique de Ruskin. intentions qu'il prête aux tableaux (115)[16]

[8] 'Ceci [. . .] démontrer' is Flaubert's comment. This section sums up an idea of Ruskin's, as presented by Milsand, p. 77.
[9] No emphasis in Milsand (ibid. 76–7).
[10] Ibid. 81. These are Ruskin's views, as presented by Milsand.
[11] Milsand (pp. 82–3) is quoting from a lecture Ruskin gave in Edinburgh. The phrase 'selon Ruskin' is Flaubert's.
[12] This is still Ruskin in Edinburgh (Milsand, p. 83).
[13] Ibid. 90. This is an idea of Ruskin's.
[14] Ibid. 113 (a near-paraphrase by Flaubert). Milsand is saying that Ruskin's *Peintres modernes* (vol. i) would give the impression that he is a French Realist. He goes on to say that in later volumes Ruskin reads like a mystic.
[15] Part paraphrase, part almost verbatim transcription of Milsand, pp. 115–16 (he in turn expounding Ruskin's ideas).
[16] Flaubert's summing up of Milsand, p. 125.

165v

La théorie de Ruskin, en dernier terme, aboutit à ravaler l'élément plastique[17]

Les Penseurs qui s'occupent des artistes les engagent sous prétexte de se relever à se dégrader.

L'intérêt humain, pathétique, moral, philosophique sont [precip] précisément ce [que la] que cherche & aime dans un tableau la foule ignorante & les Lettrés qui lui demandent les mérites d'un récit ou d'un roman.[18]

[17] A near-paraphrase of Milsand, p. 149.
[18] Cf. Milsand, p. 178.

BIBLIOGRAPHY

Place of publication Paris, unless otherwise stated. Not all of the works listed are cited in the text but all have contributed to this study.

1. FLAUBERT: MANUSCRIPTS

Carnets de voyage, Bibliothèque historique de la ville de Paris, série 61: 1. *Italie et Suisse*; 2–3. *Par les champs et par les grèves*; 4–9. *Voyage en Orient*.

Bouvard et Pécuchet, dossiers, Bibliothèque Municipale de Rouen, ms g 226^{1-8}. See especially the following:

g 226^1 123–36, notes on Winckelmann, *Histoire de l'Art ches les Anciens*, tr. M. Hubert, 3 vols. (1781); 137–62r, notes on ceramics, artistic journals, sales, collections, crooked practices in the art world, including notes from *L'Artiste* (1839–44, esp. *Salon* listings: 158r–162r); 163r–163v, notes on Fouriérisme; 163v–164r, notes on 'La Mission et le Rôle de l'Artiste', *Salon de 1845*, by Laverdant; 165^{r-v}, notes on Joseph Milsand, *L'Esthétique anglaise* (1864).

g 226^3 48–64, *Esthétique*: 'Extraits de divers auteurs' (including Courbet 56r, Jouffroy 60r, l'abbé Gaume, 63r, Proudhon 63).

g 226^4 90–132, notes on *Salon* (1847) and artistic journals.

g 226^5 333–55, *Peinture*.

g 226^7 230v–233, *Salons* (etc.)

2. FLAUBERT: EDITIONS

Œuvres complètes, 16 vols. (Société Les Belles Lettres, Club de l'Honnête Homme, 1971–5).

Correspondance (Gallimard, Pléiade, 1973–98), i–iv (1830–75); Club de l'Honnête Homme (see preceding) for letters from 1876 to 1880.

Editions of particular interest for individual works:

Souvenirs, notes et pensées intimes (1830–1841) (Buchet/Chastel, 1965).

Par les champs et par les grèves, ed. A. Tooke (Geneva: Droz, 1987).

Voyage en Égypte, ed. Pierre-Marc de Biasi (Grasset, 1991).

Flaubert à l'Exposition de 1851, ed. Jean Seznec (Oxford: Clarendon Press, 1951).

Madame Bovary, new version, preceded by unpublished sketches, ed. J. Pommier and G. Leleu (Librairie José Corti, 1949).

Madame Bovary, ed. C. Gothot-Mersch (Garnier, 1971).

L'Éducation sentimentale: Les Scénarios, ed. T. Williams (Corti, 1992).

La Tentation de saint Antoine, ed. C. Gothot-Mersch (Gallimard Folio, 1983).

Trois contes, ed. Pierre-Marc de Biasi (Éditions du Seuil, 1993).

Le Dictionnaire des idées reçues, ed. A. Herschberg Pierrot (Livre de Poche, 1997).

Carnets de travail, ed. Pierre-Marc de Biasi (Balland, 1988).

3. GUIDES AND CATALOGUES RELEVANT TO FLAUBERT'S ART COMMENTARIES, 1845 AND 1851

1845 (Italie et Suisse)

Catalogue des tableaux qui se trouvent dans les salles de l'I. et R. Académie des Beaux-Arts (Brera) (Milan: chez M. Carrara Typografe Libraire, 1841).

Falchetti, Antonia (ed.), *The Ambrosiana Gallery* (Vicenza: Neri Pozza Editore, 1986).

Galbiati, Giovanni, *Itinerario per il visitatore della biblioteca ambrosiana* (Milan: Biblioteca Ambrosiana, 1951).

Galleria di palazzo Rosso, catalogo provvisorio, 3rd edition (Genoa: Arti fragiche iro stringa, 1971).

Modigliani, Ettore (ed.), *Catalogo della R. Pinacoteca di Brera* (Milan: la Pinacoteca di Brera, 1935).

Murray's Handbook for Travellers in N. Italy (London: John Murray, 1877).

Nouvelle description des beautés de Gênes et de ses environs (Genoa: Gravier, 1819).

Valeri, Francesco Malaguzzi, *Catalogo della R. Pinacoteca di Brera* (Bergamo: Istituto italiano d'arte grafiche, 1908).

1851 (Voyage en Orient)

NAPLES

Blewitt, Octavian, *Hand-book for travellers in Southern Italy and Naples* (London: John Murray, 1853).

Causa, Raffaello, (ed.), *Le collezioni del Museo di Capodimonte Napoli*, in the series *I grandi musei* (Milan: Touring Club Italiano, 1982).

Gargiulo, François, *Recueil des monuments les plus intéressants du Musée National de Naples* 4 vols. (Naples, 1870).

Molajoli, Bruno, *Notizie su Capodimonte: Catalogo delle gallerie e del Museo* (Naples: Arte tipografica, 1960).

—— *Il Museo di Capodimonte* (Naples: Di Mauro editore, 1961).

Monaco, Domenico, *Guide général du musée national de Naples* (Naples: Imprimerie de l'Indicateur Général du Commerce, 1884).

Quaranta, Bernard, *Le Mystagogue: Guide général du musée royal bourbon* (Naples: impr. et papeterie du Fibreno, 1844).

Rinaldis, Aldo de, *Guida illustrata del Museo nazionale di Napoli* (Naples: Richter, 1911).

Real Museo Borbonico (Naples: Dalla Stamperia Reale, 1827–).

Guide du Musée Royal Bourbon, rev. and extended edn. (Naples: impr. du Vésuve, 1841).

Chantilly, musée Condé: Peintures de l'École italienne (Inventaire des collections publiques françaises, no. 34; Éditions de la Réunion des Musées Nationaux, 1988).

ROME

Barbier de Montault, Mgr Xavier, *Les Musées et galeries de Rome* (Rome: J. Spithover, 1870).

Blewitt, Octavian, *Murray's Handbook for Rome and Environs* (London: John Murray, 1858).

Hermanin, Federico, *Catalogo della R. Galleria d'arte antica nel Palazzo Corsini-Roma* (Bologna: Casa Editrice Apollo, 1924).

Longhi, Roberto, *Precisioni nelle gallerie italiane* i. *R. Galleria Borghese* (Rome: Pinacoteca, 1928).

Matthiae, Gugliemo, *Mosaici medioevali delle chiese di Roma* (Rome: Istituto Poligrafico dello Stato P. V., 1967).

Murray's Hand-book Central Italy and Rome (London: John Murray, 1843).

Pergola, Paola della, *Galleria Borghese: I Dipinti*, 2 vols. (Rome: Istituto Poligrafico dello Stato, Libreria dello Stato, 1955).

Safarik, Eduard A., *Catalogo sommario della Galleria Colonna in Roma: Dipinti* (Rome: Bramante Editrice, 1981).

—— and G. Torselli (eds.), *La Galleria Doria Pamphilj a Roma* (Rome: Fratelli Palombi Editori, 1982).

Venturi, Adolfo, *Il Museo e la Galleria Borghese* (Rome: Società laziale, 1893).

FLORENCE

Berti, Luciano, *The Uffizi* (Florence: Becocci Editore, n.d.).

Cipriani, Niccolò (ed.), *La Galleria Palatina nel Palazzo Pitti a Firenze* (Florence: Edizione Arnaud, 1966).

Chiavacci Egisto, *Guide de la galerie royale du palais Pitti* (Florence and
Rome: Imprimerie Bencini, 1888).
Firenze e dintorni, Guida d'Italia del Touring Club Italiano, 6th edn.
(Milan: Aldo Garanti Editore, 1974).
Galerie impériale et royale de Florence (Florence: Real Galleria di Firenze,
1822).
Galerie impériale et royale de Florence, 16th edn. (Florence: Imprimerie
du Giglio, 1844).
R. *Galleria di Firenze illustrata*, 13 vols. and plates (Florence: presso
G. Molini e comp., 1817–33).
*Tableaux, statues, bas-reliefs et camées de la Galerie de Florence et du
Palais Pitti*, dessinés par Wicar, Peintre, et gravés sous la direction de
C. L. Masquelier, 4 vols. (Librairie de Firmin, Didot frères, 1852–6).
Gli Uffizi: Catalogo generale (Florence: Centro Di, 1979).

4. GENERAL BIBLIOGRAPHY

Abel, Elizabeth, 'Redefining the Sister Arts: Baudelaire's Response to the
Art of Delacroix', in W. J. T. Mitchell (ed.), *The Language of Images*
(Chicago: University of Chicago Press, 1980), 37–58.
Alpers, Svetlana and Paul, '*Ut Pictura Noesis*? Criticism in Literary
Studies and Art History', *New Literary History* (Spring 1972), 437–58.
Antosh, Ruth B., 'The Role of Paintings in Three Novels by Joris-Karl
Huysmans', *Nineteenth Century French Studies* (Summer–Fall 1984),
131–46.
Arnheim, Rudolf, 'The Reading of Images and the Images of Reading', in
J. A. W. Heffernan (ed.), *Space, Time, Image, Sign* (New York: Peter
Lang, 1987), 83–8.
Atti del quinto congresso internazionale di lingue e letterature moderne,
Florence, 27–31 March 1851 (Florence: Valmartina, 1955).
Aulnoy, Marie Catherine La Mothe, comtesse d', *Les Contes des fées*,
2 vols. (Vve de T. Girard, 1698).
Babbitt, Irving, *The New Laokoon: An Essay in the Confusion of the Arts*
(Boston and New York, Houghton Mifflin, 1910).
Bailbé, Joseph-Marc, 'Le Voyage en Égypte de Flaubert, illusion et poésie',
Flaubert et Maupassant, écrivains normands (PUF, 1981), 71–89.
Ballerini, Julia, ' "La Maison démolie": Photographs of Egypt by Maxime
Du Camp 1849–50', in S. Nash (ed.), *Home and its Dislocations in
Nineteenth Century France* (Albany, NY: SUNY, 1993), 103–23.
Barbey d'Aurevilly, Jules, *Œuvres romanesques complètes*, ed. Jacques
Petit, 2 vols. (Gallimard, Pléiade, 1964–6).

Barbey d'Aurevilly, Jules, 'Flaubert, *Madame Bovary*', in *Le XIXᵉ siècle, Des œuvres et des hommes*, compiled by Jacques Petit, 2 vols. (Mercure de France, 1964), i. 205–13 (*Le Pays*, 6 Oct. 1857).

—— 'Flaubert, *L'Éducation sentimentale*', in *Le XIXᵉ siècle*, ii. 156–63 (*Le Constitutionnel*, 29 Nov. 1869).

—— 'Flaubert, *La Tentation de saint Antoine*', in *Le XIXᵉ siècle*, ii. 236–8 (*Le Constitutionnel*, xviii. 111: 20 Apr. 1874).

Barnes, Julian, *Flaubert's Parrot* (London: Jonathan Cape, 1984; Picador, 1985).

Bart, Benjamin F., *Flaubert's Landscape Descriptions* (Ann Arbor: University of Michigan Press, 1956).

Barthes, Roland, 'Rhétorique de l'image', *Communications*, 4 (1964), in *L'Obvie et l'obtus*, (Éditions du Seuil, 1982), 25–42.

—— 'La Peinture est-elle un langage?' (1969), in *L'Obvie et l'obtus*, 139–41.

—— 'Requichot et son corps', preface to *L'Œuvre de Bernard Requichot* (Brussels: Éd. de la Connaissance, 1973), in *L'Obvie et l'obtus*, 189–214.

Bassy, Alain-Marie, 'Du texte à l'illustration: Pour une sémiologie des étapes', *Semiotica*, 11 (1974), 297–334.

Baudelaire, Charles, *Curiosités esthétiques*, ed. Henri Lemaître (Garnier, 1962).

—— *Critique d'art, suivi de Critique musicale*, ed. Claude Pichois (Gallimard, Folio, 1992).

Baumgartner, Emmanuèle, 'Images de l'artiste, image du moi dans le *Livre de la cité des dames* de Christine de Pizan', in R. Demoris, *L'Artiste en représentation* (Éditions Desjonquières, 1993), 11–20.

Benjamin, Walter, 'The Work of Art in the Age of Mechanical Reproduction', *Illuminations*, ed. Hannah Arendt (London: Jonathan Cape, 1970), 219–53.

Berchet, Jean-Claude (ed.), *Le Voyage en Orient* (Robert Laffont, 'Bouquins', 1985).

Berg, William J, *The Visual Novel: Emile Zola and the Art of his Times* (Philadelphia: Pennsylvania State University Press, 1992).

Bergerat, Émile, *Souvenirs d'un enfant de Paris*, 4 vols. (1912), ii. *Gustave Flaubert*, 129–50.

Bergot, François (ed.), *Iconographie et littérature* (PUF, 1983).

Berthier, Philippe, *Stendhal et ses peintres italiens* (Geneva: Droz, 1977).

Besson, Fanny, 'Le Séjour de Flaubert en Algérie', *Amis de Flaubert* (May 1968), 4–52.

Biasi, Pierre-Marc de, 'Édition critique et génétique de *La Légende de saint Julien l'Hospitalier*', thèse de 3ᵉ cycle, Paris VII, 1982.

—— 'Barthes et la peinture: Le Désir de l'illisible', *Magazine littéraire*, 314 (Oct. 1993), 68–70.



Biasi, Pierre-Marc de, 'Le Tableau, terre inconnue', *Diogène*, 169, 'Qu'est-ce qu'on ne sait pas?', (Jan.–Mar. 1995), 88–99.

Blanc, Charles, *Histoire des peintres de toutes les écoles*, Vve Jules Renard, Libraire-Éditeur: *École hollandaise* (1861); *École française*, 3 vols. (1862–3); *École anglaise* (1863); *École flamande* (1864); *École vénitienne* (1868); *École espagnole* (1869); *École ombrienne et romaine* (1870), *École bolonaise* (1874); *École allemande* (1875); *École florentine* (1876); *Écoles milanaise, lombarde, ferraraise, génoise et napolitaine* (1876).

Block, Haskell M., 'Flaubert's Travels in Relation to his Art', in *Connaissances de l'étranger: Mélanges offerts à la mémoire de J.-M. Carré* (Librairie Marcel Didier, 1964), 64–72.

Boime, Albert, *The Academy and French Painting in the Nineteenth Century* (London: Phaidon, 1971).

Bonaccorso, Giovanni, 'Due itinerari flaubertiani', *Rivista di letterature moderne e comparate*, 31/3 (Sept. 1978), 200–3.

Bonnefis, Philippe, 'Fluctuations de l'image, en régime naturaliste', *Revue des sciences humaines* (Apr.–June 1974), 283–300.

—— and Reboul, Pierre, *La Description*, 2nd edn. (Lille: Presses Universitaires de Lille, 1981).

—— —— (eds.), *Des mots et des couleurs: Études sur le rapport de la littérature et de la peinture (XIXe et XXe siècles)*: (Lille: Publications de l'Université, 1981; ii, ed. Jean-Pierre Guillerm, 1986).

Bouillon, Jean-Paul, 'Littérature et peinture en France, 1830–1900: Mise au point théorique et méthodologique', *Revue d'histoire littéraire de la France* (1980), 880–99.

Bourdieu, Pierre, *Un art moyen* (Minuit, 1965).

—— *Les Règles de l'art* (Éditions du Seuil, 1988).

—— 'The Link between Literary and Artistic Struggles', in P. Collier and R. Lethbridge (eds.), *Artistic Relations* (New Haven: Yale University Press, 1994), 30–9.

Bowie, Theodore Robert, 'Les Rapports entre la littérature et la peinture en France de 1840 à 1880', Ph.D. thesis, University of California, 1935.

—— *The Painter in French Fiction* (Chapel Hill, NC: University of North Carolina, 1950).

Brassaï, Gilberte, *Marcel Proust sous l'empire de la photographie* (Gallimard, NRF, 1997).

Breton, André, *Le Surréalisme et la peinture* (Gallimard, 1965).

Brookner, Anita, *The Genius of the Future* (London: Phaidon, 1971).

Brooks, Peter, *Reading for the Plot* (Oxford: Clarendon Press, 1984).

Brownlow, Timothy, *John Clare and Picturesque Landscape* (Oxford: Clarendon Press, 1983).

Bruneau, Jean, *Les Débuts littéraires de Gustave Flaubert (1831–1845)* (Armand Colin, 1962).

Bruneau, Jean, 'Les Deux Voyages de Gustave Flaubert en Italie', in *Connaissances de l'étranger: Mélanges offerts à la mémoire de J.-M. Carré* (Librairie Marcel Didier, 1964), 164–80.

—— and Jean A. Ducorneau (eds.), *Album Flaubert* (Gallimard, Pléiade, 1972).

Brunetière, Ferdinand, 'L'Impressionnisme dans le roman' (1879), in *Le Roman naturaliste* (Calmann Lévy, 1883), 75–104.

Bryson, Norman, *Word and Image: French Painting of the 'Ancien Régime'* (Cambridge: Cambridge University Press, 1981).

—— *Tradition and Desire from David to Delacroix* (Cambridge: Cambridge University Press, 1984).

Bustarret, Claire, 'Vers un voyage entre lire et voir: Les Conditions du fonctionnement d'une illustration photographique au XIXe siècle', *Iconotextes* (CRDC—Phrys, 1990), 195–203.

—— 'Vulgariser la civilisation: Science et fiction "d'après photographie" ', in S. Michaud, J. Y. Mollier, and N. Savy (eds.), *Usages de l'image au XIXe siècle* (Céraphis, 1992), 129–41.

Camaraschi, Enzo, *Réalisme et Impressionnisme dans l'œuvre des frères Goncourt* (Pisa: Libreria goliardica, 1971).

Carré, Jean-Marie, *Voyageurs et écrivains français en Égypte*, 2 vols. (Cairo: Imprimerie de l'Institut français d'archéologie orientale, 1932).

Castellani, Francesca, 'Flaubert e la suggestione dell'immagine: Arte e letteratura nella Francia dell'Ottocento', *Ricerche di storia dell'arte*, 40 (1990), 23–33.

Castex, Pierre-Georges, *La Critique d'art en France au XIXe siècle*, 2 vols. (Centre de documentation universitaire, n.d.).

Cento, Alberto (ed.), *Bouvard et Pécuchet* (Nizet, 1964).

—— *Il realismo documentario nell'Éducation sentimentale* (Naples: Liguori, 1967).

Cézanne, Paul, *Letters*, ed. John Rewald, 4th edn. (Oxford: B. Cassirer, 1976).

Champfleury, *Le Réalisme* (Michel Lévy frères, 1857).

—— *Le Réalisme*, compiled and introduced by Geneviève et Jean Lacambre (Coll. Savoir, Hermann, 1973).

—— 'L'Imagerie populaire', from *Histoire de l'imagerie populaire* (1869), in *Le Réalisme* 1973.

Champollion, Jean-François, *Lettres écrites d'Égypte et de la Nubie en 1828 et 1829* (Didot frères, 1833).

—— *Monuments de l'Égypte et de la Nubie*, 2 vols. (Firmin Didot frères, 1844–89).

Chesneau, Ernest, *Peinture—Sculpture: Les Nations rivales dans l'art* (Librairie Académique, Didier et Cie, 1868).

Christin, Anne-Marie, 'L'Écrit et le visible: Le Dix-Neuvième Siècle français', in *L'Espace et la lettre: Écritures, typographies* (Cahiers Jussieu/3, 10/18, 1977), 163–92.

Clark, Kenneth, *Landscape into Art* (London: John Murray, 1949; also Harmondsworth: Penguin, 1956; Beacon Press, 1961).

Clark, Timothy J., *The Absolute Bourgeois* (London: Thames & Hudson, 1973).

—— *The Painting of Modern Life* (London: Thames & Hudson, 1984).

Clemente, Linda M. *Literary 'Objects d'art': 'Ekphrasis' in Medieval French Romance 1150–1210* (New York and Berne: Peter Lang, 1992).

Collier, Peter, and Robert Lethbridge (eds.), *Artistic Relations* (New Haven: Yale University Press, 1994).

Comment, Bernard, *Le XIX^e siècle des panoramas* (Adam Biro, 1993).

Connaissances de l'étranger: Mélanges offerts à la mémoire de J.-M. Carré (Librairie Marcel Didier, 1964).

Cooke, Peter, 'Gustave Moreau, "painter poet" ', D. Phil. thesis, University of Oxford, 1995.

—— 'Gustave Moreau from *Song of Songs* (1853) to *Orpheus* (1866): The Making of a Symbolist Painter', *Apollo* (Sept. 1998), 37–45.

Coste, Didier, 'Salomé vue par: programmes narratifs et programmes visuels', in J.-P. Guillerm (ed.), *Des mots et des couleurs*, ii (Lille: Publications de l'Université de Lille, 1986), 69–87.

Cottin, Madeleine, 'Une image méconnue de Gustave Flaubert: La Photographie prise en 1850 au Caire par son ami Maxime Du Camp', *Gazette des Beaux-Arts* (Oct. 1965), 235–9.

Cousin, Victor, *Du vrai, du beau et du bien* (1836), 5th edn. (Didier, 1856).

Culler, Jonathan, *Flaubert: The Uses of Uncertainty* (London: P. Elek, 1974).

Czyba, Luce, 'Flaubert et la peinture', *Littérales: Art et littérature* (1994), 127–46.

Daunais, Isabelle, *Flaubert et la scénographie romanesque* (Nizet, 1993).

—— *L'Art de la mesure* (Presses Universitaires de Vincennes and Les Presses de l'Université de Montréal, 1996).

—— 'Le Regard décentré', *French Studies*, 52/2 (Apr. 1998), 162–75.

Davies, Cicely, 'Ut Pictura Poesis', *Modern Language Review*, 30 (1935), 159–69.

Davies, Margaret, 'Apollinaire, la peinture et l'image', *Que Vlo-Ve* (1979), 1–20.

Dayot, Armand, *Salon de 1884* (Baschet, 1884).

Debray Genette, Raymonde, 'Flaubert: Science et écriture', *Littérature*, 15 (Oct. 1974), 41–51.

—— 'La Pierre descriptive', in *Métamorphoses du récit* (Paris, Éditions du Seuil, 1988), 209–26.

—— 'Voyage et description: *Par les champs et par les grèves*', ibid. 237–59.

—— 'Traversées de l'espace descriptif', ibid. 289–310.

Delacroix, Eugène, *Œuvres littéraires* (Crès, 1923).

Delacroix, Eugène, *Journal 1822–1863*, ed. A. Joubin (1932; Plon, 1980).
—— *Correspondance générale* (Plon, 1936).
Delaveau, Philippe (ed.), *Écrire la peinture*, colloque de 1987, Institut français du Royaume-Uni, King's College (London: Éditions Universitaires, 1991).
Demoris, René (ed.), *L'Artiste en représentation* (Éditions Desjonquières, 1993).
Dewachter, Michel, and Daniel Oster, *Un voyageur en Égypte vers 1850, 'Le Nil' de Maxime Du Camp* (Sand/Corti, 1987).
Diderot, Denis, *Salons*, ed. J. Seznec and J. Adhémar, 2nd edn. (Oxford: Clarendon Press, 1974), i: 1759, 1761, 1763.
—— *Salon de 1767*, ed. J. Seznec, 2nd edn. (Oxford: Clarendon Press, 1983).
—— *Salon de 1765*, ed. E. K. Bukdahl and A. Lorenceau (Hermann, 1984).
Dodille, Norbert, 'Les "Sensations d'art" de Barbey d'Aurevilly', in Gwenhael Ponnau (ed.), *Fins de siècle* (Toulouse: Presses Universitaires de Mirail, 1989), 183–94.
Du Camp, Maxime, *Égypte, Nubie, Palestine et Syrie, dessins photographiques recueillis pendant les années 1849, 1850 et 1851*, with commentary and introduction, 2 vols. (Gide et Baudry, 1852–3).
—— *Les Beaux-Arts* (Ve Jules Renouard, 1867).
—— *Souvenirs littéraires* (1882; Aubier, 1994).
Duncan, P., 'The "Art" of Landscape in Zola's *L'Œuvre*', *Symposium*, 39/3 (Fall, 1985), 167–76.
Duranty, Émile, 'Notes sur l'art', *Réalisme*, ed. Duranty and Jules Assézat: 10 July 1856, 15 Nov. 1856, Apr./May 1857.
—— *La Nouvelle Peinture* (1876), in Denys Riout, *Les Écrivains devant l'Impressionnisme* (Macula, 1989), 108–34.
Fairlie, Alison, 'Flaubert and Some Painters of his Time', in *Imagination and Language: Collected Essays on Constant, Baudelaire, Nerval and Flaubert* (Cambridge: Cambridge University Press, 1981), 355–78.
—— 'Pellerin et le thème de l'art dans *L'Éducation sentimentale*', ibid. 408–21.
Faure, Gabriel, 'L'Italie de Flaubert', in *Pèlerinages passionnés* (E. Fasquelle, 1919), 97–143.
Finke, Ulrich (ed.), *French Nineteenth Century Painting and Literature* (Manchester: Manchester University Press, 1972).
Flynn, Sarah J. A., *Sir John Gardner Wilkinson: Traveller and Egyptologist* (Oxford: Bodleian Library, 1997).
Fosca, François, *De Diderot à Valéry: Les Écrivains et les arts visuels* (A. Michel, 1960).
Fowler, Alistair, 'Periodization and Interart Analogies', *New Literary History*, 3 (1972), 487–509.

Freedberg, David, *The Power of Images: Studies in the History and Theory of Response* (Chicago and London: University of Chicago Press, 1989).

Freund, Gisèle, *Photographie et société* (Éditions du Seuil, 1974).

Fromentin, Eugène, *Une année dans le Sahel* (1858; Sycomore, 1981).

—— *Les Maîtres d'autrefois* (Garnier, 1972).

Gage, John, *Culture and Colour: Practice and Meaning from Antiquity to Abstraction* (London: Thames & Hudson, 1993).

Gaillard, Françoise, 'Gustave Courbet et le réalisme', *Revue d'histoire littéraire de la France* (1980), 978–96.

—— 'De la vérité en peinture à la vérité de la peinture', *Cahiers de l'Association Internationale des Études Françaises* 37 (1985), 243–57.

Galassi, Peter, *Before Photography: Painting and the Invention of Photography* (New York: MOMA, 1981).

Gamboni, Dario, *La Plume et le pinceau* (Minuit, 1989).

Gautier, Théophile, *Mademoiselle de Maupin* (1836; Garnier Flammarion, 1966).

—— *Tra los montes* (V. Magen, 1843; *Voyage en Espagne*, Charpentier, 1845).

—— *Voyage en Italie* (1852; Charpentier, 1894).

—— *Constantinople* (Michel Lévy, 1853).

—— 'Collection chinoise', in *Les Beaux-Arts en Europe*, 2 vols. (M. Lévy frères, 1855), i. 130–42.

—— *Les Dieux et les demi-dieux de la peinture* (Morizot, 1864).

—— *L'Orient* (Charpentier, 1877).

—— *Tableaux à la plume* (Charpentier, 1880).

—— *Guide de l'amateur du Musée du Louvre* (Charpentier, 1882).

—— *Critique artistique et littéraire* (Larousse, 1929).

—— 'Sur l'art de la gravure', in *Critique artistique et littéraire* (1929).

—— *Histoire du romantisme* (Librairie des Bibliophiles, E. Flammarion, successeur, n.d.).

—— *Critique d'art: Extraits des Salons (1833–1872)* ed. Marie-Hélène Girard (Séguier, 1994).

Genette, Gérard, *Figures* (Éditions du Seuil, 1966).

Geoffroy Saint-Hilaire, Étienne, *Philosophie anatomique* (chez l'auteur, 1818).

Goncourt, Émile and Jules de, *Manette Salomon* (1867), ed. M. Crouzet (Gallimard Folio, 1996).

—— —— *L'Art du XVIIIᵉ siècle* (Bibliothèque Charpentier, n.d. [1881]).

—— —— 'La Peinture a l'Exposition Universelle de 1855', in *Études d'art* (Librairie des Bibliophiles, 1889), 165–209.

—— —— *Journal*, 3 vols. (Robert Laffont, 1989).

—— —— *Notes sur l'Italie (1855–1856)* (Éds Des jonquières, Éds de la Réunion des Musées Nationaux, 1996).

Goodman, Nelson, *Languages of Art* (Oxford: Oxford University Press, 1969).

Gordon, Rae Beth, *Ornament, Fantasy and Desire in Nineteenth-Century French Literature* (Princeton: Princeton University Press, 1992).

Gothot-Mersch, Claudine, 'Le Roman interminable: Un aspect de la structure de *Bouvard et Pécuchet*', in *Flaubert et le comble de l'art: Nouvelles recherches sur Bouvard et Pécuchet, Actes du Colloque tenu au Collège de France 22–23 mars 1980*, ed. P. Cogny *et al.* (Éditions CDU et Sedes réunis, 1981), 9–22.

—— 'Pour une édition du *Voyage en Orient* de Flaubert', *Bulletin de l'Académie royale de langue et de littérature française*, 69/3–4 (14 Sept. 1991).

Gregory, Derek, 'Between the Book and the Lamp: Imaginative Geographies of Egypt, 1849–50', *Transactions of the Institute of British Geographers* (1995), 29–57.

Grésillon, Almuth, Jean-Louis Lebrave, and Catherine Fuchs, 'Ruminer Hérodias: Du cognitif-visuel au verbal textuel', in Daniel Ferrar *et al.* *L'Écriture et ses doubles* (Éds du CNRS, 1991), 'Textes et manuscrits', pp. 27–109.

Griffin, Robert, *Rape of the Lock* (Lexington, KY.: French Forum, 1988).

Guégan, Stéphane, 'Le Théâtre idéal de Théophile Gautier, in *Regards d'écrivain au musée d'Orsay* (Éditions de la Réunion des Musées Nationaux, 1992), 9–41.

—— (ed.), *Théophile Gautier, la critique en liberté* (Éditions de la Réunion des Musées Nationaux, 1997).

Guillerm, Jean-Pierre (ed.), *Des mots et des couleurs*, ii (Lille: Publications de l'Université de Lille, 1986).

Guyot, Armand, *Salon de 1884* (Baschet, 1884).

Hadad, Michèle, 'Une image "déversoir": La Tentation de saint Antoine de la 2e moitié du XIXe siècle', in S. Michaud, J. Y. Mollier, and N. Savy (eds.), *Usages de l'image au XIXe siècle* (Céraphis, 1992), 101–13.

Hagstrum, Jean H., *The Sister Arts: The Tradition of Literary Pictorialism in English Poetry from Dryden to Gray* (Chicago: University of Chicago Press, 1958).

Hamon, Philippe, 'Qu'est-ce qu'une description?', *Poétique*, 12 (1972), 465–85.

—— *Expositions: Littérature et architecture au XIXe siècle* (Corti, 1989).

—— *La Description littéraire* (Éditions Macula, 1991).

—— 'Images à lire et images à voir: Crise de l'image et "image américaine" au XIXe siècle', in S. Michaud, J. Y. Mollier, and N. Savy (eds.), *Usages de l'image au XIXe siècle* (Céraphis, 1992), 240 ff.

—— 'Le Musée et le texte', *Revue d'histoire littéraire de la France* 1 (Jan.–Feb. 1995), 3–12.

Haskell, Francis, 'Art and the Language of Politics', in *Past and Present in Art and Taste* (New Haven: Yale University Press, 1987).

—— Anthony Levi, and Robert Shackleton, *The Artist and the Writer in France: Essays in honour of Jean Seznec* (Oxford: Clarendon Press, 1974).

Hasumi, Shiguéhiko, 'Les Dessins dans les mss de travail de Flaubert' (CNRS—ITEM, Séminaire Flaubert, 20 May 1995).

Hatzfeld, Helmut, *Literature through Art: A New Approach to French Literature* (Chapel Hill, NC: University of North Carolina Press, 1952).

Hautecœur, Louis, *Littérature et peinture en France* (1942; Armand Colin, 1963).

Heffernan, James A. W. (ed.), *Space, Time, Image, Sign: Essays on Literature and the Visual Arts* (New York: Peter Lang, 1987).

—— *The Museum of Words: The Poetics of Ekphrasis from Homer to Ashbery* (Chicago: University of Chicago Press, 1993).

Hobbs, Richard (ed.), *Impressions of French Modernity: Art and Literature in France 1850–1900* (Manchester and New York: Manchester University Press, 1998).

—— 'Visual Display in the Realist Novel', in *Impressions of French Modernity*, 118–34.

Honour, Hugh, *Romanticism* (1979; Harmondsworth: Penguin, 1984).

Hourticq, Louis, *La Vie des images* (Hachette, 1927).

—— *L'Art et la littérature* (Flammarion, 1946).

Houssaye, Arsène, 'Les Breughel', *Revue de Paris*, 15 (1843), 101 ff.

—— *Histoire de la peinture flamande et hollandaise* (Victor Lecou, 1846).

Huysmans, Joris-Karl, *Trois églises et trois primitifs*, 4th edn. (Plon, 1908).

—— *L'Art moderne/Certains* (10/18, 1975).

Iknayan, Marguerite, *The Concave Mirror* (Saratoga, Calif.: Anma Libri & Co. 1983).

Jaffe, Irma B., 'Flaubert: The Novelist as Art Critic', *Gazette des Beaux-Arts* (May–June 1970), 335–70.

Jammes, Marie-Thérèse, and André Jammes, *En Égypte au temps de Flaubert: Les Premiers photographes 1839–1860* (1976): *Ægypten zur Zeit Flauberts* (Stuttgart: Kodak, 1981).

Jefferson, Ann, 'Stendhal's Art History and the Making of a Novelist', in P. Collier and R. Lethbridge (eds.), *Artistic Relations* (New Haven: Yale University Press, 1994), 192–208.

Jones, Owen, *The Grammar of Ornament* (London: Messrs Day and Son, 1856; repr. London: Studio Editions, 1986).

Kelley, David, 'Transpositions', in P. Collier and R. Lethbridge (eds.), *Artistic Relations* (New Haven: Yale University Press, 1994), 178–91.

Knapp, Bettina, *Word, Image, Psyche* (University of Alabama Press, 1985).

Knight, Diana, *Flaubert's Characters: The Language of Illusion* (Cambridge: Cambridge University Press, 1985).

Krauss, Rosalind, *Le Photographique* (Éditions Macula, 1990).

Krieger, Murray, *Ekphrasis: The Illusion of the Natural Sign* (Baltimore and London: Johns Hopkins University Press, 1991).

Kuspit, Donald, 'Traditional Art History's Complaint against the Linguistic Analysis of Visual Art', *Journal of Aesthetic and Art Criticism*, 45 (Summer 1987), 345–9.

Lapp, J. C., 'Art and Hallucination in Flaubert', *French Studies* (1956), 322–34.

Laude, J., 'On the Analysis of Poems and Paintings', *New Literary History* 3 (Spring 1972), 471–86.

Lee, Raensler W., *Ut Pictura Poesis: The Humanistic Theory of Painting* (New York: W. W. Norton, 1967).

Lepschy, Anna Laura, *Taine and Venetian Painting* (Florence: Olschki, 1966).

Lepsius, Richard, *Briefe aus Aegypten*, tr. Kenneth Mackenzie (London, R. Bentley, 1852).

Lessing, Gotthold Ephraim, *Laokoon*, ed. D. Reich (Oxford: Oxford University Press, 1965).

Lethève, Jacques, 'Flaubert et le monde des images', *Bulletin de la Bibliothèque Nationale*, 6 (1981), 31–5.

Lipschutz, Ilse Hempel, *Spanish Painting and the French Romantics* (Harvard Studies in Romance Languages, 32; Cambridge, Mass.: Harvard University Press, 1972).

Littérature et peinture en France (1830–1930), *Revue d'histoire littéraire de la France*, 6 (1980).

Lombard, Alfred, *Flaubert et saint Antoine* (Éditions Victor Attinger, 1934).

Lombardo, P., 'Hippolyte Taine ou la critique sans l'art', *Cahiers de l'Association Internationale des Études Françaises*, 37 (1985), 179–91.

Mainardi, Patricia, *Art and Politics of the Second Empire : The Universal Expositions of 1855 and 1867* (New Haven: Yale University Press, 1987).

Markiewicz, H., 'Ut Pictura Poesis: A History of the Topos and the Problem', *New Literary History* (Spring 1987), 535–58.

Martino, Pierre, 'Rapports de la littérature et des arts plastiques: Parnasse et symbolisme', in *Atti del quinto congresso internazionale di lingue e letterature moderne* (Florence: Valmartina, 1955), 399–410.

Mavrakis, A., 'Les Leçons de la peinture: Proust et l'*ut pictura poesis*', *Poétique*, 94 (Apr. 1993), 171–84.

May, Gita, *Diderot et Baudelaire, critiques d'art* (Geneva: Droz, 1957; 1973).

MacManaway, Norma, 'Tokens of Remembrance: A Study of the English "Keepsake" Book', M. Phil. thesis, Trinity College, Dublin, 1989.

Meltzer, Françoise, *Salome and the Dance of Writing* (Chicago: Chicago University Press, 1987).

Mérimée, Prosper, *H.B.* (Les Éditions dérives/solin, 1983).

Merriman, J. D., 'The Parallel of the Arts: Some Misgivings and a Faint Affirmation', *Journal of Aesthetics and Art Criticism* (1972–3), 154–64.

Mespoulet, Marguerite, *Images et romans* (Société d'édition, 'Les Belles-Lettres', 1939).

Michaud, S., J. Y. Mollier, and N. Savy (eds.), *Usages de l'image au XIXᵉ siècle* (Céraphis, 1992).

Miller, David C. (ed.), *American Iconology: New Approaches to Nineteenth-Century Art and Literature* (New Haven: Yale University Press, 1993).

Millin, Aubin Louis, *Voyage dans les départements du Midi de la France* 5 vols. (De l'Imprimerie Impériale, 1807–11).

Milsand, Joseph-Antoine, *L'Esthétique anglaise: Étude sur M. John Ruskin* (1864), 2nd edn. (Lausanne: Libraire Nouvelle, E. Frankfurter, 1906).

Mitchell, T., *Colonizing Egypt* (Cambridge: Cambridge University Press, 1988).

Mitchell, W. J. T. (ed.), *The Language of Images* (Chicago and London: University of Chicago Press, 1980).

—— *Iconology, Image, Text, Ideology* (Chicago: University of Chicago Press, 1986).

—— 'Going Too Far with the Sister Arts' in J. A. W. Heffernan (ed.), *Space, Time, Image, Sign* (New York: Peter Lang, 1987), 1–11.

—— *Picture Theory* (Chicago and London: University of Chicago Press, 1994).

Mortier, Roland, *La Poétique des ruines en France* (Geneva: Droz, 1974).

Moss, Armand, *Baudelaire et Delacroix* (Nizet, 1973).

Mossman, Carol, 'Iconographie brulardienne: Les Figures d'une écriture', *Stendhal Club*, 112 (1986), 339–53.

Naaman, Antoine-Youssef, *Les Lettres d'Égypte de Gustave Flaubert* (Nizet, 1965).

Nash, Suzanne (ed.), *Home and its Dislocations in Nineteenth-Century France* (Albany, NY: State University of New York Press, 1993).

Niderst, Alain (ed.), *Iconographie et littérature* (PUF, 1983).

Nochlin, Linda, *Realism* (Harmondsworth: Penguin, 1971).

Oliver, Hermia, *Flaubert and an English Governess* (Oxford: Clarendon Press, 1980).

Panofsky, Erwin, *Iconology* (1939; New York: Harper & Row, 1962).

Parvi, Jacques, 'La Composition et l'art du paysage dans *Par les champs et par les grèves* de Flaubert', *Kwartalnik Neofilologiczny*, 12 (1865), 3–15.

Ponnau, Gwenhael (ed.), *Fins de siècle: Terme—Évolution—Révolution*, Actes du Congrès de la Société Française de Littérature générale et comparée, Toulouse, 22–24 Sept. 1987 (Toulouse: Presses Universitaires de Mirail, 1989).

Prawer, Siegbert, 'Heine and the Photographers', in S. Zantop (ed.), *Paintings on the Move* (Lincoln, Nebr., and London: University of Nebraska Press, 1989), 75–90.

Praz, Mario, *Mnemosyne: The Parallel between Literature and the Visual Arts* (Oxford: Oxford University Press, 1970).

Prendergast, Christopher, *The Order of Mimesis: Balzac, Stendhal, Nerval, Flaubert* (Cambridge: Cambridge University Press, 1986).

Proust et les peintres (Chartres: Musée des Beaux-Arts, 1991).

Raitt, Alan, *Flaubert: Trois contes* (London: Grant & Cutler, 1991).

—— 'Flaubert Off-Stage and On Stage', *Essays in Memory of Michael Parkinson and Janine Dakyns, Norwich Papers*, iv (1996), 107–12.

—— *Flaubert et le théâtre* (Berne: Peter Lang, 1998).

Ramazani, V. K., *Flaubert and the Free Indirect Mode* (Charlottesville, Va.: University Press of Virginia, 1988).

Raser, Timothy, *A Poetics of Art Criticism: The Case of Baudelaire* (Chapel Hill, NC: University of North Carolina, 1989).

Reff, Theodore, 'Images of Flaubert's Queen of Sheba in Later 19th Century Art', in F. Haskell *et al.* (eds.), *The Artist and the Writer in France* (Oxford: Clarendon Press, 1974), 126–33.

Regards d'écrivain au musée d'Orsay (Éditions de la Réunion des Musées Nationaux, 1992).

Régnier, Mme R. E. (pseud. Daniel Darc), *La Princesse Méduse*, told by Daniel Darc, illustrated by Félix Frédéric Regamey (Charpentier, 1880).

Reid, Martine, 'Editor's Preface: Legible/Visible', in *Boundaries: Writing and Drawing, Yale French Studies*, 84 (1994), 1–12.

Rewald, John, *The History of Impressionism* (New York: MOMA, 1946).

Riout, Denys, *Les Écrivains devant l'impressionnisme* (Macula, 1989).

Roe, David, *Gustave Flaubert* (London: Macmillan, 1989).

Roos, J., 'Théophile Gautier et les Beaux-Arts', in *Atti del quinto congresso internazionale di lingue e letterature moderne* (Florence: Valmartina, 1955), 391–7.

Rosen, Charles, and Henri Zerner, *Romanticism and Realism: The Mythology of Nineteenth Century Art* (London: Faber & Faber, 1984).

Rosenthal, Léon, *Du romantisme au réalisme* (1914; Macula, 1987).

Rouillé, André, *La Photographie en France: Textes et controverses: Une anthologie 1816–1871* (Macula, 1989).

Said, Edward, *Orientalism* (London: Routledge & Kegan Paul, 1978).

Saisselin, R. G. de, '*Ut pictura poesis*: Du Bos to Diderot', *Journal of Aesthetics and Art Criticism* (Winter 1961), 143–56.

Sand, George, 'Dialogue avec Delacroix', in *Impressions et souvenirs*, 3rd edn. (Lévy, 1873), 72–90 (dialogue first published 1841).

Sartre, Jean-Paul, *L'Idiot de la famille*, 3 vols. (Gallimard, 1971).

—— *Qu'est-ce que la littérature?* (Gallimard Folio, 1996), esp. section 1.

Savy, N., 'Charles Baudelaire ou l'espoir d'autre chose', in *Regards d'écrivain au musée d'Orsay* (Éditions de la Réunion des Musées Nationaux, 1992), 43–74.

Schaeffer, Jean-Marie, *L'Art de l'âge moderne: L'Esthétique et la philosophie de l'art du XVIIIᵉ siècle à nos jours* (Gallimard, 1992).

Scott, David, *Pictorialist Poetics* (Cambridge: Cambridge University Press, 1987).

Seznec, Jean, 'Flaubert and the Graphic Arts', *Journal of the Warburg and Courtauld Institutes*, 8 (1945), 175–90.

—— 'Madame Bovary et la puissance de l'image', *Médecine de France*, 8 (1949).

—— *Nouvelles études sur la Tentation de saint Antoine* (London: Warburg Institute, University of London, 1949).

—— *Literature and the Visual Arts in Nineteenth Century France* (Hull: University of Hull publications, 1963).

—— *John Martin en France* (London: Faber & Faber, 1964).

—— 'Art and Literature: A Plea for Humility', *New Literary History*, 3/3 (1972), 569–74.

—— 'Odilon Redon and Literature', in U. Finke (ed.), *French Nineteenth Century Painting and Literature* (1972), 280–98.

—— Notes on art, Taylor Institution, University of Oxford:
 1. Notes on the *Tentation de saint Antoine*; Notes on the 'images de Cancale' sequence from *Par les champs* and on the 'assiettes peintes' from *Madame Bovary*; Notes for a lecture (pp. 1–2 missing) on Flaubert in certain art galleries (concerned mainly with depictions of *Judith and Holofernes* and the *Tour de Nesle*)
 2. On artistic depictions of the *Tentation de saint Antoine*
 3. On 'la reine de Saba' (*TSA*)
 4. 'Les sources figurées dans l'œuvre de Gustave Flaubert'—Steuben, Schopin, the *Tour de Nesle*.
 5. Notes for a lecture on art and literature ('Flaubert est un visuel, et s'inspire volontiers de sources plastiques'), on Flaubert's taste for particular paintings and for bad art.

Sherrington, R. J., *Three Novels by Flaubert* (Oxford: Clarendon Press, 1970).

Shiff, Richard, *Cézanne and the End of Impressionism* (Chicago: University of Chicago Press, 1984).

—— 'To Move the Eyes: Impressionism, Symbolism and Well-Being, c. 1891' in R. Hobbs (ed.), *Impressions of French Modernity* (1998), 190–210.

Snell, Robert, *Théophile Gautier: A Romantic Critic of the Visual Arts* (Oxford: Clarendon Press, 1982).

Souriau, Étienne, *La Correspondance des arts: Éléments d'esthétique comparée* (Flammarion, 1947; repr. 1968).

Spencer, Michael C., *The Art Criticism of Théophile Gautier* (Geneva: Droz, 1969).

Steiner, Wendy, *The Colors of Rhetoric: Problems in the Relation between Modern Literature and Painting* (Chicago: University of Chicago Press, 1982).

Steiner, Wendy, *Pictures of Romance* (Chicago: University of Chicago Press, 1988).

Stendhal, *Œuvres complètes*, 50 vols. (Geneva: Cercle du Bibliophile, 1968–74).

—— *Rome, Naples et Florence* (1817), *L'Italie en 1818*, *Promenades dans Rome* (1829) in *Voyages en Italie*, (Gallimard, Pléiade, 1973).

—— *Histoire de la peinture en Italie* (1817), in *Œuvres complètes*, xxxiv–xxxv (Geneva: Cercle du Bibliophile, 1969).

Stevens, Mary Anne (ed.), *The Orientalists* (London: Royal Academy of Arts in association with Weidenfeld & Nicolson, 1984).

Sweeney, John L. (ed.), *Henry James: The Painter's Eye* (London: Rupert Hart-Davis, 1956).

Taine, Hippolyte, *Philosophie de l'art* (Germer-Baillière, 1865).

—— *Philosophie de l'art en Italie* (Germer-Baillière, 1866).

—— *Voyage en Italie*, 2 vols. i *Naples et Rome*; ii *Florence et Venise* (1866; Hachette 1921).

—— *Philosophie de l'art dans les Pays-Bas* (Germer-Baillière, 1868).

—— *De l'intelligence*, 2nd edn. (Hachette, 1870), i, livre 2, *Les Images*, i, ch. i, pp. 76–144, 'Nature et réducteurs de l'image', ch. 2, pp. 145–86.

Taine, sa vie et sa correspondance, 4 vols. (Hachette, 1902–7).

Tooke, Adrianne, 'A Study of *Par les champs et par les grèves*', Ph.D thesis, Cambridge, 1978.

—— 'Flaubert on Painting: The Italian Notes (1851)', *French Studies*, 48 (1994), 155–73.

Tuzet, Hélène, 'Le théâtre romantique français et ses Peintres', in *Atti del quinto congresso internazionale di lingue e letterature moderne* (Florence: Valmartina, 1955), 363–74.

Valéry, Paul, *Œuvres*, 2 vols. (Gallimard, Pléiade, 1957–60).

—— 'Autour de Corot', in *Œuvres*, ii. 1307–25.

Van der Tuin, Henri, *Les Vieux Peintres des Pays-Bas, et la critique artistique en France de la première moitié du XIX^e siècle* (Publication de la Faculté des Lettres de l'Université de Lille, 1948; Nizet, 1953).

Vincent, Émile, *Histoire de la République de Gênes*, 3 vols. (Firmin-Didot, 1842).

Vouilloux, Bernard, 'La Description du tableau dans les *Salons* de Diderot', *Poétique*, 73 (Feb. 1988), 27–50.

—— 'Peinture, écriture et figuralité chez Flaubert' (CNRS—ITEM Séminaire Flaubert: 'Esthétique de Flaubert' 3 Apr. 1993).

Webb, Ruth, 'Ekphrasis et description: Théories antiques' (Table Ronde sur l'ekphrasis, Paris, Mar. 1994).

Wind, Edgar, *Pagan Mysteries in the Renaissance* (London: Faber & Faber, 1958; enlarged and revised, Peregrine Books, Harmondsworth: Penguin in association with Faber, 1967).

Wood, John, 'Flaubert, Love and Photography', *The Southern Review*, 30/2 (1994), 350 ff.

Wright, Barbara, and James Thompson, *La Vie et l'œuvre d'Eugène Fromentin* (ACR Ed. (20 ter rue des Bezons, 1192 Les Poissons), 1987).

Zantop, Susanne (ed.), *Paintings on the Move* (Lincoln, Nebr. and London: University of Nebraska Press, 1989).

—— 'Liberty Unbound: Heine's "Historiography in Colour"', in *Paintings on the Move*, 31–49.

Zola, *Correspondance*, ed. B. H. Bakker and H. Mitterand, 10 vols. (Montreal and Paris: Presses de l'Université de Montréal, CNRS, 1978–95).

Zola, *Salons* (Geneva: Droz, 1959).

Zola, 'Proudhon et Courbet', *Mes Haines*, in *Écrits sur l'art* (Gallimard Flammarion, 1991).

INDEX